Volker Matthews

Vermessungskunde 1

Volker Matthews

Vermessungskunde 1

Lage-, Höhen- und Winkelmessungen

29., vollständig überarbeitete Auflage 2003

B. G. Teubner Stuttgart · Leipzig · Wiesbaden

Bibliografische Information der Deutschen Bibliothek
Die Deutsche Bibliothek verzeichnet diese Publikation in der Deutschen Nationalbibliographie;
detaillierte bibliografische Daten sind im Internet über <http://dnb.ddb.de> abrufbar.

Nach seinem Studium promovierte **Prof. Dr.-Ing. Volker Matthews** am Institut für Eisenbahn- und Verkehrswesen der Universität Stuttgart. Nach der Ausbildung des Baureferendars war er in verschiedenen Bereichen des S-Bahn-Baus und der Planung von Neubaustrecken sehr erfolgreich tätig. Seit 1980 lehrt er an der Georg-Simon-Ohm- Fachhochschule in Nürnberg und ist zudem Sachverständiger für den Eisenbahnbau- und -betrieb, Ingenieurvermessungen sowie Vermessung im Bauwesen.

23. Auflage 1972
24. Auflage 1975
25. Auflage 1980
26. Auflage 1985
27. Auflage 1992
28. Auflage 1996
29. Auflage Mai 2003

Alle Rechte vorbehalten
© B. G. Teubner Verlag / GWV Fachverlage GmbH, Wiesbaden 2003

Der B. G. Teubner Verlag ist ein Unternehmen der Fachverlagsgruppe BertelsmannSpringer.
www.teubner.de

Umschlaggestaltung: Ulrike Weigel, www.CorporateDesignGroup.de

Gedruckt auf säurefreiem und chlorfrei gebleichtem Papier.

ISBN-13: 978-3-519-25252-8 e-ISBN-13: 978-3-322-84882-6
DOI: 10.1007/978-3-322-84882-6

Vorwort

Grundlage für sinnvolles Planen und geordnetes Bauen sind Pläne und Karten, die durch Vermessungen geschaffen werden. Vermessungstechnische Arbeiten im Sinne dieses Buches sind das Erfassen ortsbezogener Daten über Bauwerke und Anlagen, Grundstücke und Topografie, das Erstellen von Plänen, das Übertragen von Planungen in die Örtlichkeit sowie die Überprüfung und die Überwachung der Bauausführung nach Lage und Höhe während der Bauphase.

Die Bauaufnahme kann als Umkehrung des vermessungstechnischen Arbeitsablaufes beim Bauen angesehen werden. Vorhandene Bauobjekte werden durch Vermessungen erfasst und in Plänen dokumentiert. Die in diesem Buch beschriebenen Arbeitsabläufe sind auch Grundlage der Bauaufnahme.

Sinn und Zweck dieses Buches ist es, den Studierenden und den in der Praxis stehenden Ingenieuren der Fachrichtungen Architektur, Bauingenieurwesen und Vermessungswesen zu helfen, die in ihren Arbeitsbereichen anstehenden Vermessungsaufgaben zu lösen.

Beim Nivellement und bei Winkelmessungen können die Messwerte neben den herkömmlichen analogen (optischen) Methoden auch digital (elektronisch) ermittelt und erfasst werden. Der durchgehende Datenfluss von der Aufnahme bis zum jeweils gewünschten Endprodukt ist weitgehend realisiert. Die vorhandene Software bestimmt den Arbeitskomfort. Auf die herkömmlichen Messmethoden, auf das Führen und Auswerten von Feldbüchern, auf Berechnungen mit Hilfe von Taschenrechnern und auf das Kartieren der Ergebnisse kann deshalb aber nicht verzichtet werden.

Im vorliegenden Teil 1 werden Anwendung und Prüfung der Rollbandmaße für die Längenmessung, der analogen (optischen) und digitalen (elektronischen) Nivellierinstrumente für die Höhenmessung sowie der analogen und digitalen Theodolite eingehend besprochen. Geräte zur elektronischen Streckenmessung, digitale Tachymeter und Computertachymeter werden im Teil 2 behandelt.

Die wichtigsten Verfahren der einfachen Lagemessungen, der Höhen- und Winkelmessungen sind in leicht verständlicher Form erläutert und werden durch eine Anzahl sorgfältig ausgewählter und vollkommen durchgerechneter Beispiele ergänzt. Die Berechnungen erfolgten mit technisch-wissenschaftlichen Taschenrechnern ohne Verwendung von Programmen. Somit können alle Beispiele mit einem handelsüblichen Taschenrechner nachvollzogen werden.

Die praktischen Hinweise am Ende einzelner Abschnitte können dem Studierenden und dem Praktiker in zusammengefasster Form Hinweis und Richtlinie für die auszuführende Tätigkeit sein.

Mein Dank gilt den Benutzern des Buches, vornehmlich den Herren Professoren der Fachhochschulen und Universitäten für viele wertvolle Hinweise und den Hersteller-firmen geodätischer Instrumente für die Überlassung von Unterlagen und Bildern.

Nürnberg, im Frühjahr 2003 Volker Matthews

Inhalt

1 Grundlage der Vermessungen

Die Vermessungskunde umfasst eine Vielzahl technischer Einzelgebiete, deren Zweck es ist, örtliche Vermessungen als Aufnahme oder Absteckung durchzuführen und die Ergebnisse zahlenmäßig in Feldbüchern und Rissen oder graphisch in Karten und Plänen festzuhalten. Die Vermessungen unterteilt man in Lage- und Höhenmessungen. Hierbei werden Teile der Erdoberfläche einschließlich der Verkehrswege, Gebäude usw. lage- und höhenmäßig aufgenommen oder Punkte der Erdoberfläche nach Lage und Höhe abgesteckt. Um den weitgespannten Bogen der Vermessungsaufgaben abgrenzen zu können, spricht man von der Geodäsie [1]) und der Vermessungskunde.

Die Geodäsie befasst sich mit der Erdmessung und mit der Landesvermessung. Wie die Namen bereits andeuten, beziehen sich diese Vermessungen auf die ganze Erde oder auf große Gebiete (Länder) der Erde; dabei sind die Erdkrümmung und die Schwerebeschleunigung auf der Erdoberfläche zu berücksichtigen. Diese Vermessungen werden in diesem Buch nicht behandelt.

Die Vermessungskunde, die Inhalt dieses Buches ist, beschäftigt sich mit Lagemessungen (Horizontalmessungen) und Höhenmessungen (Vertikalmessungen) und den daraus resultierenden Berechnungen. Die Lagemessungen werden in der Größenordnung soweit eingeschränkt, dass die Erde noch als Ebene behandelt werden kann.

1.1 Bezugsflächen

Die als Grundlage der Vermessungen dienenden Bezugsflächen sind durch die Erdgestalt bedingt, wobei die Rotationsachse der Erde und das Erdlot die Hauptrichtungen darstellen. Man kennt eine physikalische und eine mathematische Definition der Erdgestalt.

Die physikalische Definition führt zum Geoid [2]), das durch eine Fläche bestimmt ist, die in jedem Punkt senkrecht zur Schwerkraftrichtung steht. Diese Fläche fällt annähernd mit der Meeresoberfläche zusammen, die man sich unter dem Festland fortgesetzt denkt. Die Form des Geoids ist nicht ganz regelmäßig, da die Massen im Erdinnern nicht gleichmäßig verteilt sind und so die Richtung der Schwerkraft Unregelmäßigkeiten aufweist (1.1).

[1]) Geodäsie (griech.) = Erdeinteilung.
[2]) Geoid (griech.) = Erde.

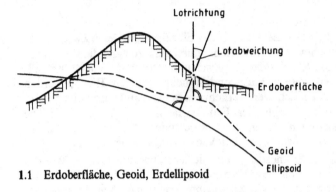

1.1 Erdoberfläche, Geoid, Erdellipsoid

Um den Abstand zwischen zwei Punkten der Erdoberfläche zu finden, projiziere man diese Punkte auf das Geoid. Die Entfernung zwischen den Lotfußpunkten auf dem Geoid ist der gesuchte Abstand. Die Höhe eines Punktes, die man auch als Meereshöhe bezeichnet, ist die Länge des Lotes vom Punkt auf das Geoid.

Das Geoid ist wegen seiner Abweichungen in seiner Form nicht genau bekannt. Deshalb bedient man sich bei Berechnungen für die Lagemessungen von Ländern mittlerer Größe der mathematischen Definition, die zum Rotationsellipsoid (Erdellipsoid) führt, dessen kleine Halbachse (Umdrehungsachse) mit der Erdachse identisch ist. Die größten Abweichungen zwischen Geoid und Rotationsellipsoid betragen ≈ 80 m.

Durch die Internationale Union für Geodäsie und Geophysik wurden 1980 die Dimensionen für das Geodätische Bezugssystem festgelegt:

Äquatorradius der Erde $a = 6\,378\,137$ m

Kleine Halbachse (Drehachse) $b = 6\,356\,752$ m

Abplattung $\dfrac{a-b}{a}$ $f = 1:298,25$

Für Lagemessungen von der Größe kleinerer Länder genügt es, die Erde als Erdkugel[1]) anzusehen und auf ihrer Oberfläche zu rechnen.

Für kleine Vermessungsgebiete bis zur Größe 10 km × 10 km vernachlässigt man die Erdkrümmung ganz und rechnet für Lagemessungen in der Ebene.

Nimmt man an, dass das Vermessungsgebiet von 10 km × 10 km die Erde in der Flächenmitte berührt, so löst sich die Erde (als Kugel) von der Tangentialebene bei $x = 5$ km um

$$y \approx \frac{x^2}{2R} \approx \frac{5^2}{2 \cdot 6380} \approx 0,002 \text{ km} \approx 2 \text{ m}$$

[1]) Man wählt den Radius der Schmiegungskugel des Erdellipsoids mit $R = \sqrt{M \cdot N}$;
M = Meridiankrümmungsradius, N = Querkrümmungsradius des Erdellipsoids in der Mitte des Vermessungsbereiches. Für Näherungsrechnungen genügt $R \approx 6380$ km.

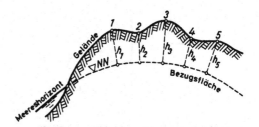

1.2 Bezugsfläche für Höhenmessungen

Deshalb kann die Näherung, die bei Lagemessungen ausreicht, für Höhenmessungen nicht gelten; für sie bleibt das Geoid die Bezugsfläche (Meereshorizont) (1.2). Bei dem geometrischen Nivellement (s. Abschn. 10) wird jedoch automatisch auf dieser Bezugsfläche gemessen und gerechnet, ohne dass besondere Mess- und Rechenmethoden anzuwenden wären.

1.2 Koordinatensysteme

Ein Punkt P (1.3) ist

lagemäßig durch seine rechtwinkligen Koordinaten x und y oder durch den Polarwinkel φ und die Strecke s

höhenmäßig durch den Höhenwinkel α bzw. Zenitwinkel z und die Strecke s

bestimmt. Von diesen Möglichkeiten wird im Vermessungswesen Gebrauch gemacht. Einzelne Punkte können somit durch Strecken und Winkel festgelegt werden.

Zenitwinkel und Höhenwinkel ergänzen sich zu 100 gon,

also $\quad z + \alpha = 100\,\mathrm{gon}$

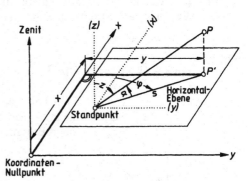

1.3 Rechtwinklige Koordinaten x, y
Polarkoordinaten φ, s
Höhenwinkel α, Zenitwinkel z

1.2.1 Rechtwinklige Koordinaten

Im rechtwinkligen ebenen Koordinatensystem (1.4) ist der Schnittpunkt der Achsen Koordinaten-Nullpunkt. Der x-Wert heißt Abszisse, der y-Wert Ordinate; beide zusammen sind die rechtwinkligen Koordinaten eines Punktes P. Die senkrechte Achse ist die x-Achse, die waagerechte die y-Achse (im Gegensatz zur analytischen Geometrie, dort ist

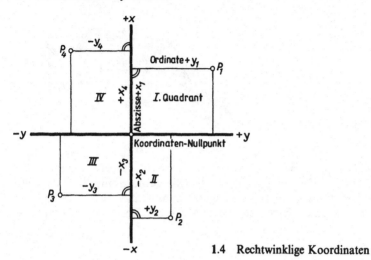

1.4 Rechtwinklige Koordinaten

es umgekehrt). Vom Nullpunkt aus nach oben und rechts rechnen die Werte positiv, nach unten und links negativ. Man wählt das Koordinatensystem nach praktischen Gesichtspunkten als örtliches System, wobei die x-Achse z. B. eine Polygonseite, die Tangente eines Kreisbogens, die Achse einer Straße usw. sein kann. In dem geodätischen Koordinatensystem (Abschn. 1.2.5) zeigt die positive x-Achse nach Norden. Die rechtwinkligen Koordinaten spielen im Vermessungswesen eine wichtige Rolle.

1.2.2 Polarkoordinaten

In Polarkoordinaten ist Punkt P lagemäßig durch den Polarwinkel φ und die Strecke s gegeben (1.5). Man kann Polarkoordinaten in rechtwinklige Koordinaten und umgekehrt rechtwinklige in Polarkoordinaten umrechnen. Es ist

$$y_p = s \cdot \sin \varphi \quad x_p = s \cdot \cos \varphi$$

und

$$\tan \varphi = \frac{y_p}{x_p} \qquad s = \sqrt{y_p^2 + x_p^2}$$

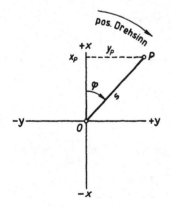

Den Polarkoordinaten kommt durch die aktuellen Aufnahme- und Absteckverfahren nach der Polarmethode beim Einsatz digitaler Tachymeter besondere Bedeutung zu.

1.5 Polarkoordinaten

1.2.3 Geographische Koordinaten

Auf der Erdoberfläche ist ein Punkt P durch seine geographischen Koordinaten – die geographische Länge λ und die geographische Breite φ – bestimmt (**1.6**). Zum Zwecke der Ortsbestimmung hat man in der Nord-Süd-Richtung 180 Meridiane um die Erde gelegt. Am Äquator sind sie 111 km voneinander entfernt und laufen an den Polen zusammen. Nullmeridian ist der Meridian der Sternwarte Greenwich [1]), von dem aus nach Westen (westliche Länge von Greenwich) und nach Osten (östliche Länge von Greenwich) gezählt wird. Die Breitenkreise verlaufen parallel zum Äquator. Man zählt nach Norden und Süden je 90 Breitenkreise und spricht somit von nördlicher Breite (n. Br.) und südlicher Breite (s. Br.).

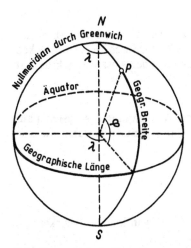

1.6 Geographische Koordinaten

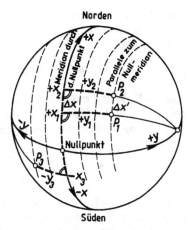

1.7 Soldner Koordinaten auf dem Ellipsoid

1.2.4 Soldner Koordinaten

Großräumig kann man für Vermessungen verschiedene Systeme rechtlinkliger Koordinaten anwenden. Hierbei haben die von Soldner und Gauß entwickelten Koordinatensysteme Bedeutung. Das geodätische Koordinatensystem ist nach dem Prinzip von Gauß-Krüger aufgebaut.

Soldner [2]) wählte für ein Vermessungsgebiet von der Größe eines Landes einen Zentralpunkt (Kirchturm, Sternwarte). Der Meridian durch diesen Zentralpunkt wurde x-Achse, Koordinaten-Nullpunkt der Zentralpunkt (**1.7**). Die Ordinaten y sind die ellipsoidischen Lote von dem jeweiligen Punkt auf den Hauptmeridian durch den Nullpunkt. Abszissen und Ordinaten können positiv und negativ sein.

[1]) Früher lag der Nullmeridian bei Ferro (eine der Kanarischen Inseln) 17° 39′ 59″ westlich von Greenwich.

[2]) Georg Soldner, 1776 bis 1883, Astronom, Direktor der Münchener Sternwarte.

1.8 Soldner Koordinaten in der Ebene

Die ellipsoidischen Abszissen und Ordinaten werden in ihrer wahren Länge in einem ebenen rechtwinkligen Koordinatensystem abgetragen (1.8). Dadurch werden Strecken gedehnt und Richtungen verschwenkt. Der Dehnungsfaktor in der Abszissenrichtung ist

$$\left(1 + \frac{y^2}{2\,R^2}\right). \qquad (R = 6380\,\text{km}).$$

Um die Dehnung möglichst klein zu halten, hat man die Ausdehnung des Systems auf beiden Seiten des Hauptmeridians auf 64 km begrenzt. Die Dehnung ist dabei für eine 1000 m lange Strecke bei $y = 64$ km

$$\Delta x - \Delta x' = 1000 \cdot \frac{64^2}{2 \cdot 6380^2} = 0,05\,\text{m}.$$

In dem Soldner-Koordinatensystem ist einfach zu rechnen, da in kleinen Bezirken die Koordinaten wie ebene Koordinaten betrachtet werden können.

Es gab fast 50 solcher Koordinatensysteme in Deutschland, mit Nullpunkten in München[1]), Tübingen, Mannheim, Darmstadt usw.

1.2.5 Gauß-Krüger-Koordinaten

Die erwähnten vielen Koordinatensysteme in Deutschland sind durch das Gauß-Krüger-System mit einigen wenigen Meridianstreifensystemen abgelöst worden, wobei die Meridiane 6°, 9°, 12°, 15° östlich Greenwich (1.9) jeweils die Abszissenachsen bezeichnen. Der Abszissen-Nullpunkt eines jeden Systems liegt am Äquator; in der Nord-Süd-Richtung gehen die Systeme über das ganze Gebiet hinweg. Die Ost-West-Ausdehnung ist auf 1°40′ nach jeder Seite begrenzt, das sind ≈ 100 km. Dabei überlappen sich die benachbarten Systeme um 20′ (~ 20 km), damit Messungen größerer Gebiete in einem System gerechnet werden können. In dem jeweiligen Überlappungsgebiet (in Bild 1.9 z. B. zwischen 7°20′ und 7°40′) sind für die Trigonometrischen Punkte die Koordinaten in beiden Systemen angegeben.

[1]) Im bayerischen Soldnersystem zeigt die positive Ordinatenachse nach Westen.

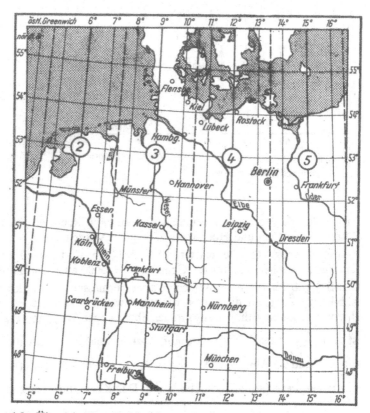

1.9 Übersicht über die Meridianstreifensysteme

Die einzelnen Systeme sind durch Kennziffern unterschieden, die den Ordinaten vorangesetzt werden. Die Kennziffer ist „Gradzahl des Hauptmeridians dividiert durch drei"; die Kennziffern sind in Bild 1.9 durch eingekreiste Zahlen hervorgehoben. Um negative Zahlenwerte zu vermeiden, werden zu jeder Ordinate 500 000 m addiert. Im Gauß-Krüger-System gibt es somit keine negativen Koordinaten. Die Abszissen bezeichnet man als Hochwerte, die um 500 000 m vergrößerten Ordinaten als Rechtswerte.

Beispiel. Punkt P_1 (1.10) hat die Koordinaten Rechts: 3 522 209,15 Hoch: 5 891 158,52

Die Kennziffer 3 des Rechtswertes gibt den Hauptmeridian 9° des Systems an. Den Abstand (Ordinate) des Punktes vom Hauptmeridian erhält man nach Abzug von 500 000 m vom Rechtswert: 522 209,15 − 500 000 = +22 209,15 m. Der Hochwert zeigt, dass der Lotfußpunkt 5 891 158,52 m vom Äquator entfernt ist.

Punkt P_2 (1.10) hat die Koordinaten Rechts: 3 419 317,60 Hoch: 5 906 234,16

Der Punkt liegt ebenfalls im 3. Meridianstreifensystem ($L_0 = 9°$). Der Abstand vom Hauptmeridian ist 419 317,60 − 500 000 = −80 682,40 m; der Abstand des Lotfußpunktes vom Äquator ist 5 906 234,16 m.

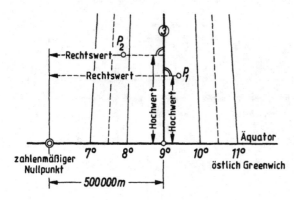

1.10 Rechts- und Hochwerte im Meridianstreifensystem

Die großen Zahlen der Koordinaten können beim Rechnen durch Fortlassen gleicher Ziffern der Rechts- und Hochwerte verkleinert werden.

Amtliche topographische Karten sind mit dem Gauß-Krüger-Koordinaten- und Gitternetz versehen, das für die Grundkarte 1:5000 auch die Blattbegrenzung angibt.

Gauß[1]) gab für die hannoversche Landesvermessung dieses konforme (winkeltreue) Abbildungssystem an, das Krüger[2]) später weiterentwickelte. Wie bei Soldner wird der Hauptmeridian in wahrer Länge in der Ebene abgebildet; der Abszissendehnungsfaktor ist $\left(1 + \dfrac{y^2}{2\,R^2}\right)$. Um Winkelverzerrungen zu vermeiden, werden auch noch die Ordinaten entsprechend der Abszissendehnung an den Lotenden korrigiert (1.11). Man erhält damit eine winkeltreue (konforme) Abbildung. Der Korrektionsbetrag der Ordinate ist $\dfrac{y^3}{6\,R^2}$

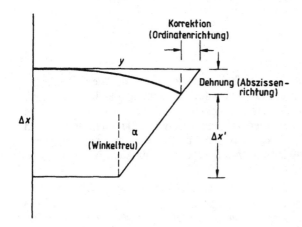

1.11 Abszissendehnung und Ordinatenkorrektion in der differentiellen Abbildung

[1]) Karl Friedrich Gauß, 1777 bis 1855, Professor der Mathematik und Geodäsie, Direktor der Sternwarte in Göttingen.
[2]) Joh. Heinrich Louis Krüger, 1857 bis 1923, Professor und Abteilungsvorsteher des Geodätischen Instituts in Potsdam.

($R = 6380\,\text{km}$). Das ist der Unterschied zwischen Soldner- und Gauß-Krüger-Ordinate, der folgende Werte ausmacht:

sphärische Ordinate y_{Soldner} (km)	0	25	50	75	100
Korrektion der Ordinate $y_{\text{Gauß}} - y_{\text{Soldner}} = y_{\text{Soldn}}^3/6\,R^2$ (m)	0	0,06	0,51	1,73	4,09

Im Gauß-Krüger-Koordinatensystem wird wie im ebenen Koordinatensystem gerechnet, jedoch ergibt sich durch Dehnung und Korrektion eine Streckenverzerrung, die zu berücksichtigen ist.

Streckenreduktion

Eine in der Örtlichkeit gemessene Strecke S ist gebenüber der Abbildung in der Koordinatenebene zu kurz und muß deshalb gedehnt werden. Der Unterschied zwischen beiden Längen beträgt

$$s - S = \frac{y_m^2}{2\,R^2} \cdot S$$

y_m = mittlerer Abstand vom Hauptmeridian
$R = 6380\,\text{km}$

und damit die Streckenlänge s in der Koordinatenebene

$$s = S + S \cdot \frac{y_m^2}{2\,R^2}.$$

Für eine 1000 m lange Strecke zeigt die Zusammenstellung die Reduktion bei der Abbildung in die Koordinatenebene:

mittlerer Abstand vom Hauptmeridian (km)	0	25	50	75	100
Zuschlag für eine Strecke von 1000 m (m)	0	0,008	0,031	0,069	0,123

Beispiel. Ein Polygonzug von 1,4 km Länge, der an Punkt P_2 (1.10), dessen Abstand vom Hauptmeridian 80 682,40 m beträgt, angeschlossen ist, erhält einen Zuschlag von $1400 \cdot \dfrac{80,7^2}{2 \cdot 6380^2} = 0,112\,\text{m}$ zum örtlich gemessenen Maß.

Bei Präzisionsvermessungen ist diese Korrektur anzubringen, bei einfachen Vermessungen kann sie vielfach vernachlässigt werden.

Höhenreduktion

Nun ist noch eine weitere durch die Höhenlage des Messgebietes bedingte Reduktion der gemessenen Strecke zu berücksichtigen. Man spricht von der Höhenreduktion. Durch die Projektion der Lagepunkte auf das Ellipsoid werden die Streckenlängen verkürzt. Mit ausreichender Genauigkeit kann für die Streckenmessung das Erdellipsoid mit dem

Landeshorizont (NN) verglichen werden, so daß die in der Höhe H über NN örtlich gemessene Strecke S beim Projizieren auf den Landeshorizont, in dem die Gauß-Krüger-Koordinaten angelegt sind, um ΔS gekürzt werden muss.

Aus Bild 1.12 ist zu entnehmen

$$s' = S - \Delta S$$

$$\Delta S = S \cdot \frac{H}{R + H} \quad \text{oder näherungsweise} \quad \Delta S \approx S \cdot \frac{H}{R}$$

$$s' = S - S \cdot \frac{H}{R}$$

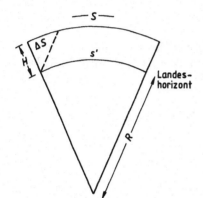

hierin bedeuten

s' = auf den Landeshorizont reduzierte Strecke

S = gemessene Strecke

H = durchschnittliche Höhe des Messungsgebietes über NN

R = Erdradius = 6380 km

1.12 Höhenreduktion

Beispiel. Die Kürzung des Polygonzuges von der Länge $S = 1400$ m beträgt bei einer durchschnittlichen Höhenlage des Messungsgebietes von $H = 400$ m bei der Reduktion auf den Landeshorizont

$$\Delta S = S \cdot \frac{H}{R} = 1400 \cdot \frac{400}{6380 \cdot 10^3} = 0{,}088 \text{ m}$$

Merke: Eine Strecke wird beim Übergang zu Gauß'schen Koordinaten durch Dehnung vergrößert, bei der Projektion auf den Landeshorizont aber verkleinert. Man kann beide Reduktionen in einer Formel berücksichtigen

$$\Delta S' = S \left(\frac{y_m^2}{2\,R^2} - \frac{H}{R} \right).$$

1.2.6 UTM-System

Von der Internationalen Union für Geodäsie und Geophysik (UGGI) wurde 1951 das UTM-System (Universale-Transverse-Merkator-System) empfohlen. Die Meridian-streifeneinteilung fällt bei diesem System mit der Einteilung der Internationalen Weltkarte 1:1000000 zusammen (Gradabteilungsblätter von 4° Breite und 6° Länge). Es ist wie bei der Gaußschen Abbildung eine ebene konforme Meridianstreifenabbildung, jedoch mit 6° Meridianstreifenbreite. Der x-Abstand wird mit N (North = Nord) bezeichnet und auf dem Mittelmeridian vom Äquator in m angegeben, nach Norden mit 0, nach Süden mit +10000000 m beginnend. Der y-Wert ist die ebene konforme Ordinate plus 500000 m; er

wird mit E (East = Ost) bezeichnet. Vorgesetzt wird als Kennziffer die Streifenbezeich-
nung; sie beginnt mit 1 für den Streifen 180° West bis 174° West und schreitet in östlicher
Richtung fort. Es gilt für

die Kennziffer der westlichen Längen: $30 - \dfrac{1}{6}(L_0 - 3)$

die Kennziffer der östlichen Längen: $31 + \dfrac{1}{6}(L_0 - 3)$.

Dabei ist L_0 der Mittelmeridian des jeweiligen Systems.

Beispiel. Der Streifen 180° West bis 174° West hat den Mittelmeridian $L_0 = 177°$ West. Kennziffer
des Systems: $30 - \dfrac{1}{6}(177 - 3) = 1$.

Beispiel. Die Bundesrepublik liegt in der Zone 9° östlicher Länge. Kennziffer: $31 + \dfrac{1}{6}(9 - 3) = 32$.

Die Ausdehnung nach Norden und Süden ist bis auf 80° nördl. bzw. südl. Breite begrenzt.

1.3 Maße

Die Maßeinheiten gehen auf Grundeinheiten zurück, die mit ihren abgeleiteten Größen
Maßsysteme bilden. Das Gesetz über Einheiten im Messwesen vom 2. 7. 69 mit seiner
Ausführungsverordnung vom 26. 6. 70 [1]) legt die Einheiten verbindlich fest. Damit wurde
das Internationale Einheitensystem, abgekürzt SI (Système International) eingeführt.
Gesetzliche Einheiten sind:

a) die für die Basisgrößen festgelegten Basiseinheiten,
b) hieraus abgeleitete Einheiten,
c) dezimale Vielfache und Teile der Einheiten.

zu a): Das Gesetz nennt in §3 folgende Basisgrößen und Basiseinheiten:

Basisgröße	Basiseinheit (Einheitenzeichen)	Basisgröße	Basiseinheit (Einheitenzeichen)
Länge	Meter (m)	Thermodynamische	
Masse	Kilogramm (kg)	Temperatur oder	
Zeit	Sekunde (s)	Kelvin-Temperatur	Kelvin (K)
Elektrische		Lichtstärke	Candela (cd)
Stromstärke	Ampere (A)	Stoffmenge	Mol (mol)

[1]) Bundesgesetzblatt 59/1969 vom 5. 7. 69 und 62/1970 vom 30. 6. 70 sowie Kommentar in den DIN-
Mitteilungen 49/1970 vom 1. 9. 70.

zu b): Folgende abgeleitete SI-Einheiten[1]) seien hier genannt:

Bezeichnung	abgeleitete SI-Einheit (Einheitenzeichen)	Bezeichnung	abgeleitete SI-Einheit (Einheitenzeichen)
Fläche	Quadratmeter (m²)	Geschwindigkeit	Meter durch Sekunde (m/s)
Volumen	Kubikmeter (m³)	Beschleunigung	Meter durch Sekunden-
Ebener Winkel	Radiant (rad)		quadrat (m/s²)
Räuml. Winkel	Steradiant (sr)	Kraft	Newton (N; 1 N = 1 kg · m/s²)
Dichte	Kilogramm durch	Druck, mechan.	Pascal (Pa; 1 Pa = 1 N/m²
	Kubikmeter (kg/m³)	Spannung	= 1 kg/m s²)

zu c): Dezimale Vielfache oder Teile von Einheiten können durch Vorsetzen von Vorsilben (Vorsätze) vor den Namen der Einheit bezeichnet werden.

Beispiel. 1 Dezi-Meter $= 10^{-1}$ m = 1 dm

Vorsätze und deren Kurzzeichen sind für

das Billionenfache	10^{12}	Tera	(T)	das Zehntel	10^{-1}	Dezi	(d)
das Milliardenfache	10^{9}	Giga	(G)	das Hundertstel	10^{-2}	Zenti	(c)
das Millionenfache	10^{6}	Mega	(M)	das Tausendstel	10^{-3}	Milli	(m)
das Tausendfache	10^{3}	Kilo	(k)	das Millionstel	10^{-6}	Mikro	(µ)
das Hundertfache	10^{2}	Hekto	(h)	das Milliardstel	10^{-9}	Nano	(n)
das Zehnfache	10^{1}	Deka	(da)	das Billionstel	10^{-12}	Piko	(p)

1.3.1 Längen

Die Basiseinheit ist das Meter (Einheitenzeichen: m).

Eine Kommission der französischen Nationalversammlung schlug bereits 1790 für die Maßeinheit das Meter als den 40 000 000. Teil des Erdumfanges, über Nord- und Südpol gemessen, vor. Als später neuere Messungen bessere Werte für den Erdumfang ergaben, paßte man das Meter diesen Werten nicht an, sondern stellte ein „Urmeter" aus Platin-Iridium[2]) her, dessen Marken bei einer Temperatur von 0 °C maßgebend sind für die Kopien, die an die Staaten mit metrischem System verteilt wurden[3]). Deutschland erhielt 1889 den Prototyp Nr. 18.

Der internationale Prototyp des Meters wird vom „Internationalen Büro für Maß und Gewicht" im Pavillon von Breteuil bei Sèvres in der Nähe von Paris aufbewahrt. Nach neueren Messungen ist das Urmeter 0,2 mm kürzer als der 40 000 000. Teil des Erdumfangs.

Die Genauigkeit des internationalen Meterprototyps reicht für die heutigen Anforderungen der Physik nicht mehr aus. Deshalb ist auf der 17. Generalkonferenz für Maß und Gewicht 1983 als von Raum und Zeit unabhängige und jederzeit reproduzierbare Grundlage die Längeneinheit Meter als Länge der Strecke festgelegt worden, die das Licht während des Zeitintervalls von 1/299 792 458 Sekunden durchläuft.

[1]) s. Ausführungsverordnung vom 26. 6. 1970.
[2]) Platin-Iridium ist eine Edelmetall-Legierung aus 80–95% Platin und 5–20% Iridium; es hat eine sehr geringe Ausdehnung.
[3]) Durch die Maß- und Gewichtsordnung vom 17. 8. 1868 wurde ab 1872 das metrische System in Deutschland eingeführt.

Vielfache und Teile des Meters sind (Verwandlungszahl 10):

$$
\begin{aligned}
1000\,\text{m} \quad &= 10^3 \ \text{m} = 1\,\text{km} \ = 1\,\text{Kilometer} \\
100\,\text{m} \quad &= 10^2 \ \text{m} = 1\,\text{hm} \ = 1\,\text{Hektometer} \\
10\,\text{m} \quad &= 10^1 \ \text{m} = 1\,\text{dam} = 1\,\text{Dekameter} \\
0{,}1\,\text{m} \quad &= 10^{-1}\,\text{m} = 1\,\text{dm} \ = 1\,\text{Dezimeter} \\
0{,}01\,\text{m} \quad &= 10^{-2}\,\text{m} = 1\,\text{cm} \ = 1\,\text{Zentimeter} \\
0{,}001\,\text{m} \quad &= 10^{-3}\,\text{m} = 1\,\text{mm} = 1\,\text{Millimeter} \\
0{,}001\,\text{mm} \quad &= 10^{-6}\,\text{m} = 1\,\mu\text{m} \ = 1\,\text{Mikrometer}
\end{aligned}
$$

1.3.2 Flächen

Die abgeleitete SI-Einheit der Fläche ist Quadratmeter (Einheitenzeichen: m^2). Ein Quadratmeter ist gleich der Fläche eines Quadrates von 1 m Seitenlänge.

Vielfache und Teile des Quadratmeters sind (Verwandlungszahl $10^2 = 100$):

$$
\begin{aligned}
1\,000\,000\,\text{m}^2 \quad &= (10^3)^2\,\text{m}^2 \ = 1\,\text{km}^2 \ = 1\,\text{Quadratkilometer} \\
10\,000\,\text{m}^2 \quad &= (10^2)^2\,\text{m}^2 \ = 1\,\text{hm}^2 \ = 1\,\text{Quadrathektometer} = 1\,\text{ha} = 1\,\text{Hektar} \\
100\,\text{m}^2 \quad &= (10^1)^2\,\text{m}^2 \ = 1\,\text{dam}^2 = 1\,\text{Quadratdekameter} = 1\,\text{a} = 1\,\text{Ar} \\
0{,}01\,\text{m}^2 \quad &= (10^{-1})^2\,\text{m}^2 = 1\,\text{dm}^2 \ = 1\,\text{Quadratdezimeter} \\
0{,}0001\,\text{m}^2 \quad &= (10^{-2})^2\,\text{m}^2 = 1\,\text{cm}^2 \ = 1\,\text{Quadratzentimeter} \\
0{,}000\,001\,\text{m}^2 &= (10^{-3})^2\,\text{m}^2 = 1\,\text{mm}^2 = 1\,\text{Quadratmillimeter}
\end{aligned}
$$

Bei der Angabe der Flächen von Grundstücken und Flurstücken ist nach § 48 der Ausführungsverordnung zum Gesetz über Einheiten im Messwesen für die Flächeneinheit Quadratdekameter (dam^2) das Ar (Kurzzeichen: a) beibehalten. Das Hundertfache des Ar wird weiter als Hektar (Kurzzeichen: ha) bezeichnet.

1.3.3 Volumen

Die abgeleitete SI-Einheit des Volumens ist Kubikmeter (Einheitenzeichen: m^3).
Teile des Kubikmeters sind (Verwandlungszahl $10^3 = 1000$):

$$
\begin{aligned}
0{,}001\,\text{m}^3 \quad &= (10^{-1})^3\,\text{m}^3 = 1\,\text{dm}^3 = 1\,\text{Kubikdezimeter} = 1\,\text{Liter} \\
0{,}000\,001\,\text{m}^3 &= (10^{-2})^3\,\text{m}^3 = 1\,\text{cm}^3 = 1\,\text{Kubikzentimeter}
\end{aligned}
$$

1.3.4 Winkel

Die abgeleitete SI-Einheit des ebenen Winkels ist Radiant (Einheitenzeichen: rad). Ein Radiant ist gleich dem ebenen Winkel, der als Zentriwinkel eines Kreises vom Halbmesser 1 m aus diesem Kreis einen Bogen der Länge 1 m ausschneidet.

Nach Bild **1**.13 ist

$$2\pi: 1 = 4_{\llcorner} : 1\,\text{rad} \qquad 1\,\text{rad} = \frac{2_{\llcorner}}{\pi}$$

$$1\,\text{Vollwinkel} = 4_{\llcorner} = 2\pi\,\text{rad}$$

$$1\,\text{rechter Winkel} = 1_{\llcorner} = \frac{\pi}{2}\,\text{rad}$$

1.13 SI-Einheit des ebenen Winkels

$$1\,\text{rad} = \frac{2_{\llcorner}}{\pi}$$

Der Vollwinkel, der 4 rechte Winkel oder Rechte (Kurzbezeichnung: ∟) umfasst, wird

bei Sexagesimalteilung (Grad-Teilung) in 360° (Grad),

bei Zentesimalteilung (Gon-Teilung) in 400 gon (Gon) eingeteilt.

Seit 1937 ist im Vermessungswesen die Gon-Teilung (Vollwinkel = 400 gon) vorgeschrieben, die wegen der Dezimalteilung viele Vorteile bietet. Dennoch kann auf die Grad-Teilung (Vollwinkel = 360°) nicht verzichtet werden. In der Mathematik, in vielen Anwendungsbereichen der Praxis, in der Geographie, Astronomie und Nautik verwendet man sie. Deshalb lässt das Gesetz über Einheiten im Messwesen beide Winkelteilungen zu. Für die Sexagesimalteilung (Grad-Teilung):

Grad (Einheitenzeichen: °) als neunzigster Teil des rechten Winkels,
Minute (Einheitenzeichen: ′) als sechzigster Teil des Grad,
Sekunde (Einheitenzeichen: ″) als sechzigster Teil der Minute

Für die Zentesimalteilung (Gon-Teilung) ist nur die Einheit Gon (Einheitenzeichen: gon) als hundertster Teil des rechten Winkels anzuwenden. In Verbindung der Vorsätze und Kurzzeichen können dezimale Vielfache und Teile des Gon angegeben werden.
Es gelten folgende Bezeichnungen:

Vollwinkel		$= 2\pi$ rad	$= 400$ gon
1 rechter Winkel 1∟		$= \dfrac{\pi}{2}$ rad	$= 100$ gon
1 Gon	$= 1$ gon	$= \dfrac{\pi}{200}$ rad	$= 100$ cgon
1/10 Gon	$= 0{,}1$ gon	$= 1$ Dezigon	$= 1$ dgon
1/100 Gon	$= 0{,}01$ gon	$= 1$ Zentigon	$= 1$ cgon
1/1000 Gon	$= 0{,}001$ gon	$= 1$ Milligon	$= 1$ mgon
1/10 000 Gon	$= 0{,}0001$ gon	$= 1/10$ Milligon	$= 1/10$ mgon

Es entsprechen

in der **Sexagesimalteilung** (Grad-Teilung)	in der **Zentesimalteilung** (Gon-Teilung)
1 Vollwinkel $= 2\pi$ rad $= 360°$ (Grad)	1 Vollwinkel $= 2\pi$ rad $= 400$ gon
1 rechter Winkel $= \dfrac{\pi}{2}$ rad $= 90°$ (Grad)	1 rechter Winkel $= \dfrac{\pi}{2}$ rad $= 100$ gon
$1° = \dfrac{\pi}{180}$ rad $= 60′$ (Minuten)	1 gon $= \dfrac{\pi}{200}$ rad $= 100$ cgon
$1′ = \dfrac{\pi}{10800}$ rad $= 60″$ (Sekunden)	$0{,}01$ gon $= \dfrac{\pi}{20000}$ rad $= 1$ cgon
$1″ = \dfrac{\pi}{648000}$ rad	$0{,}0001$ gon $= \dfrac{\pi}{2000000}$ rad $= 0{,}1$ mgon
Schreibweise: $35°17′45″$	Schreibweise: $127{,}1482$ gon

Die Umwandlung von einer zur anderen Teilung ist einfach durchzuführen.

Beim Übergang von Grad in Gon findet man: 90° entsprechen 100 gon

$$1° \text{ entspricht } \frac{10}{9} \text{ gon} = 1,111\ldots \text{gon}$$

$$1' = \left(\frac{1}{60}\right)° \text{ entspricht } \frac{10}{9 \cdot 60} \text{ gon} = 0,0185 \text{ gon} = 1,85 \text{ cgon}$$

$$1'' = \left(\frac{1}{60 \cdot 60}\right)° \text{ entspricht } \frac{10}{9 \cdot 60 \cdot 60} \text{ gon} = 0,00031 \text{ gon} = 0,31 \text{ mgon}$$

und beim Übergang von Gon in Grad: 100 gon entsprechen 90°

$$1 \text{ gon entspricht } \left(\frac{9}{10}\right)° = 0,9°$$

$$0,01 \text{ gon} = 1 \text{ cgon entspricht } \left(\frac{9}{10 \cdot 100}\right)° = 0,009° = 0,54'$$

$$0,0001 \text{ gon} = 0,1 \text{ mgon entspricht } \left(\frac{9}{10 \cdot 100 \cdot 100}\right)° = 0,00009° = 0,32''$$

Für die Überschlagsrechnungen merke man sich

$$1' \approx 0,02 \text{ gon} \approx 2 \text{ cgon}$$

$$1'' \approx 0,0003 \text{ gon} \approx 0,3 \text{ mgon}$$

Beim Umwandeln von Grad in Gon ist also mit 10/9, beim Umwandeln von Gon in Grad mit 9/10 zu multiplizieren.

Beispiel. 58° 46′ 30″ sind in Gon umzuwandeln. Zunächst wird der Winkelwert in Dezimalen ausgedrückt: 30:60 = 0,5′ 46,5:60 = 0,775° 58,775 · 10/9 = 65,3056 gon

Beispiel. 126,1370 gon sind in Grad umzurechnen. 126,1370 gon · 9/10 = 113,52330°
Dieser Wert ist in ° ′ ″ auszudrücken.

$$0,5233° \cdot 60 = 31,3980' 0,3980' \cdot 60 = 23,880'' 126,1370 \text{ gon} = 113° 31' 24''.$$

Die Umrechnung des Winkelwertes der Sexagesimalteilung in Dezimalen und umgekehrt kann bei vielen Taschenrechnern mittels einer Funktionstaste erfolgen. Das notwendige Format des Sexagesimalteilung ist bei der Eingabe zu berücksichtigen. Minuten und Sekunden werden ohne Leerzeichen und ohne Kennung eingegeben und von der Gradangabe durch einen Punkt getrennt.

Beispiel. 58°46′30″ sind in Dezimalen anzugeben.
Eingabe: 58.4630, Funktionstaste betätigen, Anzeige: 58,775°

Vielfach benutzt man das natürliche Bogenmaß (arcus), das die Länge des zum Winkel gehörenden Kreisbogens angibt, wenn der Radius des Kreises gleich 1 ist.

Nach Bild **1.14** findet man für die Umwandlung von Gradmaß in Bogenmaß

$$\alpha : 4_\llcorner = \text{arc}\, \alpha : 2\pi \text{arc}\, \alpha = \frac{\pi}{2_\llcorner}\, \alpha = \frac{\alpha}{\text{rad}}$$

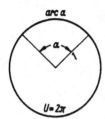

1.14 Natürliches Bogenmaß $\operatorname{arc}\alpha = \dfrac{\alpha}{\text{rad}}$

und daraus für die Umwandlung von Bogenmaß in Gradmaß

$$\alpha = \frac{2\llcorner}{\pi}\operatorname{arc}\alpha = \text{rad}\cdot\operatorname{arc}\alpha{}^1)$$

Die Umwandlungsfaktoren rad und $\dfrac{1}{\text{rad}}$ sind für die

Gon-Teilung

$\text{rad (gon)} = 200\,\text{gon}/\pi \quad = 63{,}661\,977\ldots\text{gon} \qquad \dfrac{1}{\text{rad (gon)}} = \dfrac{\pi}{200\,\text{gon}} \qquad = 0{,}015\,707\,96\ldots$

Grad-Teilung

$\text{rad}(°) = 180°/\pi \qquad\quad = 57{,}295\,7795\ldots° \qquad\quad \dfrac{1}{\text{rad}(°)} \quad = \dfrac{\pi}{180°} \qquad\quad = 0{,}017\,453\,29\ldots$

$\text{rad}(') = 180\cdot 60'/\pi \quad\ = 3437{,}7467\ldots' \qquad\quad\ \dfrac{1}{\text{rad}(')} \quad = \dfrac{\pi}{180\cdot 60'} \qquad = 0{,}000\,290\,88\ldots$

$\text{rad}('') = 180\cdot 3600''/\pi \ = 206\,264{,}80\ldots'' \qquad \dfrac{1}{\text{rad}('')} \quad = \dfrac{\pi}{180\cdot 3600''} \ = 0{,}000\,004\,84\ldots$

Allgemein gilt an einem Kreis mit dem Radius r nach Bild 1.15 die Proportion

$$\alpha:b = 4\llcorner:2r\pi = \text{rad}:r$$

und daraus

$$\alpha = \frac{b\cdot 2\llcorner}{r\cdot\pi} = \frac{b}{r}\cdot\text{rad}$$

$$b = \frac{r\pi\alpha}{2\llcorner} = r\cdot\alpha\cdot\frac{1}{\text{rad}}$$

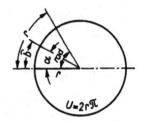

Beispiel. $\alpha = 42\,\text{gon}$ ist in Bogenmaß anzugeben.

1.15 Kreisbogenlänge

$$\operatorname{arc}\alpha = \frac{1}{\text{rad}}\,\alpha = 0{,}015\,708\cdot 42 = 0{,}659\,74$$

Beispiel. $\operatorname{arc}\alpha = 1{,}248\,30$ ist in Winkelmaß (Gon) umzuwandeln.

$$\alpha = \text{rad (gon)}\cdot\operatorname{arc}\alpha = 63{,}661\,98\,\text{gon}\cdot 1{,}248\,30 = 79{,}4692\,\text{gon}$$

Für kleine Winkel ($\leqq 6°$ bzw. 7 gon) gilt $\sin\alpha \approx \tan\alpha \approx \operatorname{arc}\alpha$. In diesen Fällen ($\alpha \approx 7\,\text{gon}$) kann anstelle der Sinus- oder Tangens-Funktion das Bogenmaß treten.

Beispiel. Ein 100 m entferntes Ziel soll um 0,80 m seitlich verschoben werden. Welchen Winkel ergibt das im Standpunkt?

$$\alpha = \frac{b}{r}\,\text{rad (gon)} = \frac{0{,}80}{100}\cdot 63{,}7\,\text{gon} = 0{,}51\,\text{gon} = 51\,\text{cgon}$$

[1]) Im Vermessungswesen wird auch noch die Bezeichnung $\dfrac{2\llcorner}{\pi} = \varrho$ (Rho) verwendet.

Beispiel. Welche Querverschiebung bewirkt ein Winkelfehler von 5 cgon auf eine Entfernung von 30 m?

$$b = r \cdot \alpha \cdot \frac{1}{\text{rad}} = 30 \cdot 0{,}05 \cdot 0{,}016 = 0{,}024\,\text{m}$$

Steigungen und Gefälle der Straßen und Rohrleitungen gibt man in % (vom Hundert, Prozent), die der Eisenbahn in ‰ (vom Tausend, Promille) an; damit ist jeweils der Winkel der Strecke gegen die Waagerechte festgelegt. Böschungen, Rampen-, Mauer-, Weichen-neigungen usw. werden in einer Verhältniszahl 1:n ausgedrückt. Im Bild 1.16 ist die Beziehung

$$\tan\alpha = 1:n = I:100 = I':1000$$

abzulesen.

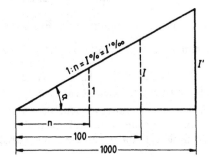

1.16 Beziehung zwischen Verhältniszahl, Prozent, Promille und Neigungswinkel (unmaßstäblich)

Daraus werden folgende Werte berechnet:

1:n	1:1	1:2	1:5	1:10	1:20	1:50	1:100
$I\%$	100	50	20	10	5	2	1
α gon	50	29,5	12,6	6,3	3,2	1,3	0,6

Beispiel. Unter welchem Winkel steigt eine Eisenbahn mit einer Steigung $I' = 11{,}450\,‰$?

$$\tan\alpha = \frac{I'}{1000} = \frac{11{,}450}{1000} = 0{,}01145 \qquad \alpha = 0{,}729\,\text{gon}$$

$$\text{oder } \alpha = \frac{I'}{1000} \cdot \text{rad} \cdot \text{gon} = \frac{11{,}450}{1000} \cdot 63{,}7\,\text{gon} = 0{,}729\,\text{gon}$$

Beispiel. Wieviel m steigt eine Straße mit einer Steigung $I = 2{,}200\%$ auf einer Länge von 300 m?

$$\Delta h : 300 = I : 100 \qquad \Delta h = \frac{300 \cdot I}{100} = \frac{300 \cdot 2{,}200}{100} = 6{,}60\,\text{m}$$

Die handelsüblichen technisch-wissenschaftlichen Taschenrechner können in den Winkel-modi Deg, Grad und Rad bedient werden. Mit der Wahl des Winkelmodus wird festge-legt, wie der Rechner die eingegebenen Zahlenwerte interpretiert. Manche Rechner behalten den gewählten Modus nach dem Ausschalten bei. Andernfalls ist der Modus jeweils nach dem Einschalten des Rechners neu zu wählen. Rechner, die den Modus nicht speichern, befinden sich nach dem Einschalten i. a. im Deg-Modus.

Es bedeuten:

Deg = Dezimalgrad. Die Eingabe des Winkels zur Abfrage zugehöriger trigonometrischer Funktionen muss in Dezimalform erfolgen. Die Umwandlung von Grad/Minute/Sekunde in Dezimalgrad erfolgt über eine Funktionstaste des Rechners.

Grad = Gon-Teilung. Nach Eingabe des Winkels in Gon können die zugehörigen trigonometrischen Funktionen abgerufen werden.

Rad = Radiant. Aufruf des Modus über die Tastatur. Nach Eingabe des Radianten können die zugehörigen trigonometrischen Funktionen abgefragt werden.

Sind die trigonometrischen Funktionen vom Rechner nur vom Bogenmaß zu berechnen, ist der Winkel in der Dezimalgrad-Angabe durch Multiplikation mit $\dfrac{1}{\text{rad}\,(°)}$ = 0,01745329 und in der Gon-Teilung durch Multiplikation mit $\dfrac{1}{\text{rad}\,(\text{gon})}$ = 0,01570796 in das Bogenmaß umzuwandeln.

Es sei darauf hingewiesen, dass die Hersteller der Taschenrechner unterschiedliche Symbole für die Umwandlungsfunktionen verwenden. Über die jeweils anzuwendenden Symbole/Befehle geben die Benutzerhandbücher Auskunft.

1.3.5 Maßstab

In Karten und Plänen wird die Örtlichkeit (Natur) in einem bestimmten Verkleinerungsverhältnis dargestellt. Das Verkleinerungsverhältnis von Strecken wird gegenüber ihrer wirklichen Länge als Maßstab angegeben. So bedeutet der Maßstab 1 : 1000, dass 1 cm der Karte 1000 cm = 10 m in der Natur entsprechen.

Das Verkleinerungsverhältnis wird ausgedrückt durch

$$1 : M = s_K : s_N,$$

hierin bedeuten

s_K = Strecke auf der Karte

s_N = Strecke in der Natur

M = Modul oder Verhältniszahl

$1 : M$ = Maßstab

Hieraus folgt

$$s_N = s_K \cdot M \qquad s_K = \frac{s_N}{M} \qquad M = \frac{s_N}{s_K}.$$

Beispiel. In einem Plan im Maßstab 1 : 500 wird eine Strecke mit s_K = 8,25 cm abgegriffen. Die Strecke ist in der Natur $s_N = s_K \cdot M = 8{,}25 \cdot 500 = 4125$ cm = 41,25 m.

Beispiel. Eine Strecke s_N = 105,00 m ist in einem Plan im Maßstab 1 : 2000 darzustellen.

$$s_K = \frac{s_N}{M} = \frac{10\,500\,\text{cm}}{2000} = 5{,}25\,\text{cm}.$$

Beispiel. Eine in der Örtlichkeit mit $s_N = 105{,}20$ m ermittelte Strecke wird in einer Kartierung mit $s_K = 8{,}43$ cm abgegriffen. Es ist dann

$$M = \frac{s_N}{s_K} = \frac{10\,520\,\text{cm}}{8{,}43\,\text{cm}} = 1248. \quad \text{Der Maßstab der Kartierung ist } 1:1250.$$

Für das Kartieren von Karten und Plänen gibt es Maßstäbe, die den zu übertragenden Wert direkt angeben. Man unterscheidet dabei große und kleine Maßstäbe. Bei einem großen Maßstab (1:50, 1:100, 1:200, 1:500, 1:1000, 1:2000) werden die darzustellenden Gegenstände groß und deutlich gezeichnet; bei einem kleinen Maßstab (1:5000, 1:10 000, 1:25 000, 1:100 000) wird das Darzustellende zusammengedrängt. Bei großen Maßstäben spricht man von Plänen, bei kleinen Maßstäben von Karten.

Eine Fläche ergibt sich aus dem Produkt zweier Strecken. Entnimmt man die Strecken einem Plan oder einer Karte und rechnet damit die Fläche, so erhält man für den Maßstab $1:M$

$$A_N = A_K \cdot M^2 \qquad \text{oder} \qquad A_K = \frac{A_N}{M^2},$$

hierin bedeuten

A_N = Fläche in der Natur,

A_K = Fläche auf der Karte.

Beispiel. In einem Plan im Maßstab 1:1000 wird eine Fläche mit $A_K = 72{,}50$ cm^2 festgestellt. Die Fläche in der Natur ist dann

$$A_N = 72{,}50 \cdot 1000^2 = 72{,}50 \cdot 10^6\,\text{cm}^2 = 72{,}5\,\text{a}.$$

1.4 Fehler, Standardabweichung, Vertrauensbereich

Alle Messungen sind wegen der Unzulänglichkeit des Menschen und wegen der zur Messung verwendeten Instrumente und Geräte nicht frei von Fehlern. Hierbei ist der „Fehler" nicht als falsch gemessener und somit fehlerhafter Wert zu verstehen, sondern es soll damit ausgedrückt werden, dass der gemessene Wert mit unvermeidbaren kleinen Ungenauigkeiten behaftet ist. Diese werden als Abweichungen bezeichnet. Es gilt somit, den wahrscheinlichsten Wert einer Messung zu finden.

Wenn z. B. zwei Beobachter mit dem gleichen Bandmaß und unter gleichen Bedingungen ein Maß messen, dass A mit 14,530 m und B mit 14,532 m ermittelt, so kann man weder A noch B den Vorzug geben. Man bildet das arithmetische Mittel mit 14,531 m und erhält so den wahrscheinlichsten Wert der zu bestimmenden Größe. Weiter soll eine Aussage über den Charakter der Genauigkeit für eine Einzelmessung und für den Mittelwert einer Messreihe getroffen werden; man spricht von der Standardabweichung der Messung. Schließlich gilt es für den Erwartungswert und für die Standardabweichung bei einer vorgegebenen prozentuellen Sicherheit eine Vertrauensgrenze zu finden; hier spricht man vom Vertrauensbereich des Messungsergebnisses.

Drei Arten von Abweichungen sind zu unterscheiden: grobe, systematische und zufällige Abweichungen. Durch geeignete Mess- und Rechenmethoden versucht man, ihnen entgegenzutreten.

Grobe Abweichungen entstehen durch falsches Zählen der Bandmaßlagen, grobes Versehen beim Ablesen an Instrumenten und Geräten usw. Um sich dagegen zu sichern, misst man Kontrollen.

Systematische Abweichungen treten auf, wenn z.B. nicht geeichte Längenmessgeräte verwendet werden; sie haben einseitige (positive oder negative) Wirkung. Diese Abweichungen lassen sich durch Eichen der Messgeräte und durch messtechnische und rechnerische Anordnungen ausscheiden.

Zufällige Abweichungen sind persönlicher und instrumenteller Art und schwer erfassbar. Die Unzulänglichkeit der menschlichen Sinne, die Grenze der Genauigkeit bei der Herstellung der Instrumente, Änderung der äußeren Bedingungen (Wettereinflüsse) während der Ausführung einer Messung sind die Ursachen, die nach dem Wegfallen der groben und systematischen Abweichungen noch Abweichungen zwischen mehrfachen Messungen derselben Größe ergeben. Diese können positiv und negativ sein.

Man wird den wahren Wert einer Messreihe nur selten feststellen können. Als Beispiel wird meistens die Winkelsumme im Dreieck angeführt, deren wahrer Wert genau 200 gon beträgt. Misst man nun die drei Winkel im Dreieck, so wird die Summe dieser Winkelgrößen nicht genau 200 gon sein. Die Abweichung der Winkelsumme vom wahren Wert kann somit festgestellt werden, es gibt aber keine Aussage über den wahren Wert (Erwartungswert) eines jeden gemessenen Winkels.

Man hat festgestellt, dass in einer Messreihe größere Umfanges, die vorwiegend mit zufälligen Abweichungen behaftet ist, die Häufigkeit bestimmter Abweichungsgrößen den Gesetzen der Wahrscheinlichkeit unterliegt. Für die relative (prozentuale) Häufigkeit des Auftretens einer bestimmten Abweichung in einer Reihe zufälliger Abweichungen gibt das Gaußsche Varianzgesetz ein Maß an. Danach kommt eine zufällige Abweichung von der dreifachen Größe der Standardabweichung unter 370 Fällen, von der 1,5fachen Größe jedoch unter 8 Fällen einmal vor. Die Vermessungsbehörden haben deshalb den 3- bis 4fachen Betrag der zu erwartenden Standardabweichung als zulässige Abweichung für verschiedene Messungsarten festgesetzt (s. Abschn. 2.4.3). Für Ingenieur-Vermessungen sind die Grenzen schärfer zu ziehen.

Man kann nach der „Methode der kleinsten Quadrate"[1] die Messungswidersprüche, die meistens auf zufällige Abweichungen zurückzuführen sind, ausgleichen. Für die in diesem Buch behandelten Vermessungen wird dies nicht erforderlich sein. Jedoch sollen die Beobachtungen möglichst frei von Willkür abgestimmt und Standardabweichungen für die Vermessungen bestimmt werden, um über die Genauigkeit, Wirtschaftlichkeit und Zweckmäßigkeit der Arbeiten eine Aussage zu finden.

Im Vermessungswesen werden vielfach Größen bestimmt

> die zur Genauigkeitssteigerung und zur Kontrolle mehrmals gemsssen werden,

> die sich aus einer Anzahl Einzelmessungen zusammensetzen,

> die nicht direkt gemessen, sondern aus gemessenen Werten abgeleitet werden. Die Abweichungen der gemessenen Größen wirken sich dann auf die abgeleiteten und berechneten Werte aus. Das Varianzfortpflanzungsgesetz gibt hier die Möglichkeit, die Standardabweichung der abgeleiteten Größen zu ermitteln.

[1] Großmann, W.: Grundzüge der Ausgleichsrechnung. 3. Aufl. Berlin 1969.

Diese Fälle sind zu unterscheiden.

Fall 1. Eine Größe wird mit gleicher Genauigkeit n-mal gemessen; den wahrscheinlichsten Wert findet man durch Bilden des arithmetischen Mittels.

Wenn x der gesuchte Wert ist, l_1, l_2 ... l_n die gemessenen Werte sind und n die Anzahl der Messungen bedeutet, ergibt sich das arithmetische Mittel mit

$$x = \frac{l_1 + l_2 + l_3 + ... l_n}{n} = \frac{[l]}{n} \quad [\] \text{ Summenzeichen}$$

Nach der Berechnung des arithmetischen Mittels x findet man die Verbesserungen v für jede Einzelmessung

$$v_1 = x - l_1 \qquad v_2 = x - l_2 \qquad v_3 = x - l_3 \qquad v_n = x - l_n$$

deren Summe wegen der ersten Gleichung gleich Null ist.

$$[v] = 0$$

Als Kennzeichen der Genauigkeit der Messwerte dient die Standardabweichung einer Einzelmessung

$$s = \sqrt{\frac{[vv]}{n-1}} \qquad \begin{array}{l} n = \text{Anzahl der Messungen} \\ n-1 = \text{Anzahl der überschüssigen Messungen} \end{array}$$

Bei mehrmaliger Messung verringert sich die Standardabweichung einer Messung mit der Wurzel aus n.

$$s_x = \frac{s}{\sqrt{n}} = \sqrt{\frac{[vv]}{n(n-1)}}$$

Wenn Messungen mit verschiedenem Gewicht p vorliegen, ist

$$s = \sqrt{\frac{[vvp]}{n-1}} \qquad \text{und} \qquad s_x = \frac{s}{\sqrt{[p]}}$$

In der mathematischen Statistik wird die Anzahl der Überbestimmungen mit f (Freiheitsgrad) bezeichnet. Weiter wird einleuchtend festgestellt, dass mit steigender Anzahl der Überbestimmungen sich der Prozentsatz an Sicherheit für die Messung vergrößert. Man kann einen Vertrauensbereich für das Ergebnis einer Messung mit einer vorgegebenen Sicherheit ermitteln, wobei die Sicherheit gewöhnlich mit 99% oder 95% gewählt wird. Der Vertrauensbereich ist dann durch $x \pm t \cdot s_x$ auszudrücken. Hierin ist x die aus n Messungen ermittelte Größe, s_x die Standardabweichung und t ein Faktor (sog. t-Verteilung nach Gosset), der von dem Freiheitsgrad f und der Sicherheit in Prozenten abhängig ist.

Einige Werte für t seien angegeben:

Freiheitsgrad f (Überbestimmung)	2	4	5	6	10	20
t bei gewählter Sicherheit von 99%	9,9	4,6	4,0	3,7	3,2	2,8
95%	4,3	2,8	2,6	2,4	2,2	2,1

Für die Bestimmung des Vertrauensbereiches ist t der Tabelle zu entnehmen.

Beispiel. Eine Strecke ist mit den gleichen Längenmessgeräten (gleiche Gewichte) fünfmal gemessen ($n = 5$). Ihre Länge, die Standardabweichung und der Vertrauensbereich sind zu bestimmen.

Messung l m	$l' = l - l_0$ cm	v	vv
1	2	3	4
228,34	34	+3	9
228,38	38	−1	1
228,41	41	−4	16
228,33	33	+4	16
228,39	39	−2	4
$[l'] = 185$ $[l']/n = 37$		$[v] = 0$	$[vv] = 46$

gewählter Näherungswert: $l_0 = 228,00$

gesuchte Streckenlänge: $l_0 + [l']/n = 228,37$ $v = [l']/n - l'$ (Sp. 3)

Kontrolle: Die Summe aller v (Sp. 3) muss bis auf Abrundungsungenauigkeiten Null sein. In Sp. 4 werden die vv gebildet (sie sind frei von Vorzeichen) und summiert.

$$s = \sqrt{\frac{[vv]}{n-1}} = \sqrt{\frac{46}{5-1}} = 3,4 \, \text{cm (Standardabweichung einer Einzelmessung)}$$

$$s_x = \frac{s}{\sqrt{n}} = \frac{3,4}{\sqrt{5}} = 1,5 \, \text{cm (Standardabweichung des arithmetischen Mittels)}$$

Ergebnis: $l = 228,37 \, \text{m} \pm 0,015 \, \text{m}$

Der Vertrauensbereich (für Freiheitsgrad f = Anzahl der überschüssigen Messungen = $5 - 1 = 4$) ist

bei 99% Sicherheit: $x \pm t \cdot s_x = 228,37 \pm 4,6 \cdot 1,5 = 228,37 \pm 6,9 \, \text{cm}$

bei 95% Sicherheit: $x \pm t \cdot s_x = 228,37 \pm 2,8 \cdot 1,5 = 228,37 \pm 4,2 \, \text{cm}$

Vielfach werden Messungen doppelt ausgeführt, wie z. B. ein Nivellement im Hin- und Rückweg. Dann findet man die Standardabweichung einer Messung, die aus den Messdifferenzen d zu errechnen ist, mit

$$s = \sqrt{\frac{[dd]}{2n}}$$

und die Standardabweichung einer gemittelten Doppelmessung

$$s_x = \frac{s}{\sqrt{2}} = \frac{1}{2}\sqrt{\frac{[dd]}{n}}$$

Für ungleiche Messungen, z. B. ungleich lange Nivellementsstrecken, sind Gewichte einzuführen. Die Standardabweichung einer einzelnen Messung vom Gewicht 1 ist dann

$$s = \sqrt{\frac{[ddp]}{2n}} \, {}^{1)}$$

und die Standardabweichung einer Doppelmessung (Mittel aus zwei Messungen vom Gewicht 1)

$$s_x = \frac{s}{\sqrt{2}} = \frac{1}{2} \sqrt{\frac{[ddp]}{n}}$$

Beim Nivellement ist das Gewicht der reziproke Wert der Länge der Nivellementstrecke R; $p = \dfrac{1}{R}$.

Fall 2. Eine Größe x ergibt sich aus der Summe von n-Einzelmessungen mit der gleichen Standardabweichung s. Dieser Fall liegt z.B. vor beim Messen einer Strecke mit Meßbändern.

$$x = l_1 + l_2 + l_3 + \dots l_n$$

Die Standardabweichung s_x von x wächst dann mit der Wurzel aus der Anzahl der Einzelmessungen.

$$s_x = s \sqrt{n}$$

Beispiel. Eine Strecke von 120 m Länge wird mit einem Messband von 20 m Länge gemessen; somit werden die 20 m Bandlängen 6-mal addiert. Die Standardabweichung einer Bandlage sei $s = \pm 3$ mm. Damit ergibt sich die Standardabweichung der Gesamtstrecke mit

$$s_{120} = 3 \sqrt{6} = 7,3 \, \text{mm}.$$

Fall 3 : Eine Größe x kann nicht direkt bestimmt werden, sondern ihr wahrscheinlichster Wert wird aus gemessenen Werten l berechnet. x ist also eine Funktion der gemessenen Werte $l_1, l_2 \cdots l_n$ mit den Standardabweichungen $s_1, s_2 \dots s_n$.

$$x = f(l_1, l_2 \dots l_n)$$

Da die Abweichungen verhältnismäßig kleine Größen sind, kann die nicht lineare Funktion näherungsweise nach der Taylorschen Reihe auf eine lineare Funktion zurückgeführt werden, was zum Varianzfortpflanzungsgesetz führt:

$$s_x = \sqrt{\left(\frac{\partial f}{\partial l_1}\right)^2 s_1^2 + \left(\frac{\partial f}{\partial l_2}\right)^2 s_2^2 + \dots \left(\frac{\partial f}{\partial l_n}\right)^2 s_n^2}$$

Die Differentialquotienten werden mit Hilfe der Näherungswerte von $l_1, l_2 \dots l_n$ bestimmt.

[1] Beispiel s. S. 152

Beispiel. Eine Strecke x wird in zwei Teilstrecken l_1 und l_2 (Angabe in m) gemessen. Die Länge der Strecke und deren Standardabweichung sind zu bestimmen.

$$l_1 = 230,46 \pm 0,04 \qquad l_2 = 217,52 \pm 0,06$$

$$x = l_1 + l_2 = 447,98 \text{ m}$$

$$s_x = \sqrt{1^2 \cdot 0,04^2 + 1^2 \cdot 0,06^2} = 0,07$$

$$x = 447,98 \pm 0,07$$

Beispiel. Die Fläche eines Rechtecks errechnet sich nach

$$A = a \cdot b$$

Es wurden gemessen

die Strecke $a = 142,37 \pm 0,06$

die Strecke $b = \;\; 98,49 \pm 0,05$

Die Fläche ist dann

$$A = a \cdot b = 142,37 \cdot 98,49 = 14\,022 \text{ m}^2 = 1,4022 \text{ ha}$$

Die Standardabweichung s_A der Fläche ist nach dem Varianzfortpflanzungsgesetz

$$s_A = \sqrt{\left(\frac{\partial A}{\partial a}\right)^2 s_a^2 + \left(\frac{\partial A}{\partial b}\right)^2 s_b^2}$$

$$s_A = \sqrt{b^2 \cdot s_a^2 + a^2 \cdot s_b^2}$$

$$s_A = \sqrt{98,49^2 \cdot 0,06^2 + 142,37^2 \cdot 0,05^2} = \pm 9,2 \text{ m}^2$$

Ergebnis: $A = 1,4022 \text{ ha} \pm 9 \text{ m}^2$

Vielfach wird eine Genauigkeitsforderung an das Ergebnis gestellt. Dann geht man den umgekehrten Weg. Wenn z. B. bei der Bestimmung der Fläche A eine Standardabweichung s_A vorgegeben ist, findet man aus der vorstehenden Ableitung, unter der Annahme, daß für die beiden Strecken die gleiche Standardabweichung s_s gilt

$$s_A = \sqrt{b^2 s_s^2 + a^2 s_s^2} = s_s \sqrt{b^2 + a^2}$$

$$s_s = \frac{s_A}{\sqrt{b^2 + a^2}}$$

Beispiel. Die Fläche eines rechteckigen Grundstücks mit $a = 42,35$ m und $b = 46,78$ m errechnet sich aus

$$A = a \cdot b = 42,35 \cdot 46,78 = 1981 \text{ m}^2 = 19,81 \text{ a.}$$

Die Genauigkeitsaussage der Flächenangabe soll so sein, dass die Standardabweichung dieser Fläche $s_A = 2$ m² beträgt. Die beiden Strecken sind dann mit einer Genauigkeit von

$$s_s = \frac{2}{\sqrt{46,78^2 + 42,35^2}} = \frac{2}{63,10} = 0,03 \text{ m}$$

zu bestimmen.

1.5 Toleranzen im Bauwesen

Bei der Erstellung von Bauteilen oder Bauwerken sind deren Maße in Plänen und Zeichnungen vorgegeben. Dies sind Soll- oder Nennmaße (DIN 18201). Auch bei gewissenhafter Arbeit wird es zu Abweichungen von den Nennmaßen kommen. Dies liegt nicht allein an der Vermessung sondern auch an der erreichbaren Genauigkeit der einzelnen Gewerke, die am Bau beteiligt sind. Um Folgegewerken eine Kalkulationssicherheit im Rahmen der Vertragsgestaltung zu gewährleisten, müssen Vorgewerke ihre Bauteile innerhalb definierter Maßtoleranzen erstellen.

Grundlegende Begriffe sind nach DIN 18201 definiert (Bild 1.17):

Nennmaß:	Maß, das zur Kennzeichnung von Größe, Gestalt und Lage (Sollmaß) eines Bauteils oder Bauwerks angegeben und in Zeichnungen eingetragen wird.
Istmaß:	Ein durch Messung festgestelltes Maß.
Istabmaß:	Differenz zwischen Istmaß und Nennmaß.
Größtmaß:	Das größte zulässige Maß (Nennmaß + Grenzabmaß).
Kleinstmaß:	Das kleinste zulässige Maß (Nennmaß − Grenzabmaß).
Grenzabmaß:	Differenz zwischen Größtmaß und Nennmaß oder Kleinstmaß und Nennmaß.
Maßtoleranz:	Differenz zwischen Größtmaß und Kleinstmaß.

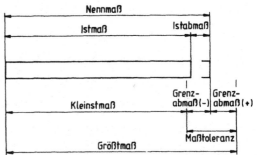

1.17 Begriffe der Toleranzen im Bauwesen

Neben Längenmaßen sind bei Bauteilen und Bauwerken auch Ebenen und Winkel in den zulässigen Toleranzen einzuhalten (Bild 1.18, 1.19).

Ebenheitstoleranz:	Bereich für die zulässige Abweichung einer Fläche von der Ebene.
Winkeltoleranz:	Bereich für die zulässige Abweichung eines Winkels vom Nennwinkel.
	Der Begriff Winkeltoleranz wird als Oberbegriff für Rechtwinkligkeitstoleranz und Neigungstoleranz verwendet. Daraus ist ersichtlich, daß mit dieser Toleranz nicht die Abweichung der Winkelmessung mit einem Theodolit gemeint ist (s. Abschn. 12).

Ebenheits- und Winkeltoleranz werden mit Hilfe des Stichmaßes, dies ist der Abstand eines Punktes von einer Bezugslinie, kontrolliert.

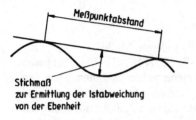

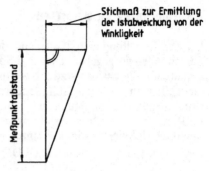

1.18 Prüfung der Ebenheitstoleranz

1.19 Prüfung der Winkeltoleranz

Die zulässigen Toleranzen im Hochbau (Bauwerke; vorgefertigte Teile aus Beton, Stahlbeton und Spannbeton; vorgefertigte Teile aus Stahl; Bauteile aus Holz und Holzwerkstoffen) sind in den Blättern der DIN 18202 angegeben.

2 Lagemessungen (Horizontalmessungen)

Es handelt sich hier um die einfachste Form der Lagemessung für das Aufmessen und Abstecken kleiner Geländeflächen, Gebäude, Verkehrswege usw. Für die höheren Stufen der Lagemessung sind nach Koordinaten bestimmte Lagefestpunkte erforderlich, die als fehlerfreier Rahmen für die im folgenden zu erläuternde Stückvermessung anzusehen sind (s. Abschnitt „Bestimmen von Lagefestpunkten" in Teil 2).

2.1 Bezeichnen von Punkten in der Örtlichkeit

In der Örtlichkeit können nur Einzelpunkte sichtbar gemacht, abgesteckt oder aufgemessen werden. Man steckt von einer Strecke wohl Anfangs-, End- und auch Zwischenpunkte ab, jedoch immer nur einzelne Punkte dieser Strecke, deren Richtung und Länge damit festgelegt ist.

Grundsätzlich ist zwischen der ständigen und vorübergehenden Bezeichnung von Punkten in der Örtlichkeit zu unterscheiden.

Eine ständige Bezeichnung ist die dauerhafte Vermarkung von Grenzpunkten durch Grenzsteine, von Trigonometrischen Punkten durch Granitpfeiler mit unterlegter Platte, von Polygonpunkten durch Drainrohre, Eisenrohre, Polygonsteine usw. (s. Teil 2).

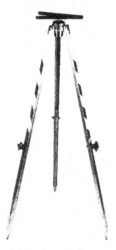

2.1 Fluchtstab

2.2 Fluchtstabstativ

Eine vorübergehende Bezeichnung von Punkten für einen etwas längeren Zeitraum geschieht durch angespitzte Holzpfähle (30 … 50 cm lang, 5 … 10 cm Durchmesser) mit Loch oder Nagel in Kopfmitte. Für einen kurzen Zeitraum während der Messung bezeichnet man die Punkte durch Fluchtstäbe (**2.1**).

Fluchtstäbe bestehen aus gut abgelagertem, astfreiem Holz, aus Kunststoff oder Leichtmetall. Die Fluchtstäbe haben einen Durchmesser von 2,8 cm und sind 2,0 m oder 2,50 m lang (DIN 18705); sie sind in 0,5 m lange Felder abwechselnd rot und weiß unterteilt, am oberen Ende mit einem weißen oder roten Feld beginnend. Die Farben werden durch Lack, Kunststoffüberzug oder Leuchtfarbe erzielt. Ein Stahlschuh mit Spitze dient zum Feststellen des Stabes im Boden.

Gefordert wird, dass der Fluchtstab gerade ist und der Stahlschuh festsitzt.

Zum Aufstellen eines Fluchtstabes auf einen Grenzstein, Polygonstein oder auf einen Punkt auf der Straße dient ein Fluchtstabstativ. Dies ist ein Dreibeinstativ mit Kugelgelenkkopf und Halteklammer (**2.2**). Die Stativbeine sind mit einem Warnanstrich versehen und können teleskopartig ausgezogen werden.

2.2 Abstecken von Geraden

Ein Punkt, der sich ohne Richtungsänderung vorwärts bewegt, beschreibt eine gerade Linie. Man nennt sie eine Gerade, wenn sie nach beiden Seiten beliebig lang gedacht werden kann, einen Strahl, wenn sie auf einer Seite, eine Strecke, wenn sie auf beiden Seiten begrenzt ist.

Eine gerade Linie ist in ihrer Richtung durch zwei Punkte festgelegt; diese Punkte macht man in der Örtlichkeit durch Fluchtstäbe sichtbar, die mit einem Lot (**2.3**) in zwei zueinander senkrechten Richtungen, mit einem Lattenrichter (**2.4**) oder durch Vergleich mit senkrechten Hauskanten lotrecht gestellt werden.

2.3 Schnurlot (Senklot)
Birnenform

a) *b)*

2.4 Lattenrichter
a) aus Metall
b) aus Holz (gleichzeitig
Wasserwaage)

Das Schnurlot (Senklot, Senkel) besteht aus Eisen oder Messing mit Stahlspitze und hat zylindrische oder Birnenform. Der Lattenrichter aus Metall ist 10 cm lang und hat 2 Schlitzlöcher zum Anschrauben an eine Nivellierlatte. Der Lattenrichter aus Holz hat die Form einer kleinen Wasserwaage. Er ist 10 cm lang, 3 cm hoch und 2 cm stark und besitzt eine Kerbe zum Anlegen an einen Fluchtstab. Er vereint Wasserwaage und Lattenrichter.

Eine Strecke bezeichnet man außer an den Endpunkten auch an Zwischenpunkten im Abstand von 40 ⋯ 50 m durch Fluchtstäbe, die zwischen die Endpunkte einzurichten sind.

Folgende Fälle kommen beim Abstecken von Geraden in der Praxis häufig vor:

1. Einfluchten von Zwischenpunkten

Die Endpunkte der Strecke AB (2.5) sind durch Fluchtstäbe bezeichnet. Die Zwischenpunkte C, D und E werden eingefluchtet (eingewiesen, eingerichtet).

2.5 Einfluchten von Zwischenpunkten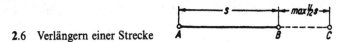

Der Beobachter tritt etwa drei Schritte hinter den Fluchtstab A mit dem Blick auf B und sieht beim Einweisen der Zwischenpunkte links und rechts an den Stäben vorbei. Grundsätzlich wird auf den Beobachter zu gearbeitet, also erst Punkt C, dann D und zuletzt E eingefluchtet. Beim Einfluchten hält der Gehilfe den Fluchtstab pendelnd zwischen zwei Fingern mit Blick auf den Beobachter. Dieser gibt durch Winkzeichen mit dem rechten oder linken Arm an, in welcher Richtung der Stab zu verschieben ist. Decken sich der einzuweisende Fluchtstab und die Fluchtstäbe der Anfangs- und Endpunkte, so zeigt er dies durch senkrechtes Ausstrecken beider Arme an. Der Gehilfe stellt den Fluchtstab fest in den Boden und mittels Lot oder Lattenrichter senkrecht. Der Beobachter kontrolliert die Flucht und gibt durch Zeichen an, ob der Fluchtstab genau in der geforderten Richtung steht oder erneut um einen geringen Betrag zu verschieben ist. Strecken bis zu 200 m richtet man mit bloßem Auge mit der Genauigkeit einer Stabbreite (2 cm) durch, darüber hinaus verwendet man ein Fernglas. Für lange Strecken und in hügeligem Gelände ist zweckmäßig ein Theodolit einzusetzen.

2. Rückwärtsverlängern

Man verlängert eine Strecke mit bloßem Auge höchstens um die Hälfte ihrer Länge, um Ungenauigkeiten zu vermeiden.

Die Verlängerung ist von einer Person auszuführen, die den Fluchtstab C genau in die Verlängerung von AB stellt (2.6). Nach dem Senkrechtstellen des Stabes C tritt der Beobachter etwa drei Schritte hinter C und kontrolliert die Flucht.

2.6 Verlängern einer Strecke

3. Gegenseitiges Einfluchten

Zwischen zwei nicht zugänglichen oder zwischen zwei gegenseitig nicht sichtbaren Punkten (z. B. wegen eines Hügels) wird eine Gerade durch gegenseitiges Einfluchten abgesteckt.

Hierzu sind 2 Personen erforderlich, die in den Punkten C_1 und D_1 je einen Fluchtstab aufstellen (2.7). C_1 und D_1 sind so zu wählen, dass der entferntere Endpunkt der Strecke jeweils zu sehen ist. (2.8). Von C_1 fluchtet man in Richtung B den Punkt D_1 ein und erhält D_2. Von diesem Punkt fluchtet der zweite Beobachter auf A und korrigiert C_1, was den Punkt C_2 ergibt. Dies wird fortgesetzt, bis in beiden Richtungen keine Abweichungen mehr auftreten und die Punkte C_3 und D_4 gewonnen sind.

In gleicher Weise steckt man eine Linie ab, wenn A und B auf Anhöhen liegen und die Gerade durch ein Tal geht (2.9). Diese Aufgabe wäre jedoch genauer mit dem Theodolit zu lösen.

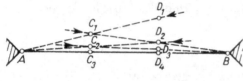

2.7 Gegenseitiges Einfluchten zwischen zwei Mauerecken (Endpunkte unzugänglich)

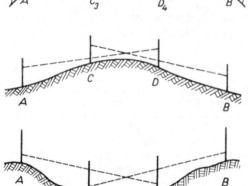

2.8 Gegenseitiges Einfluchten zwischen zwei gegenseitig nicht sichtbaren Punkten

2.9 Gegenseitiges Einfluchten zwischen zwei gegenseitig sichtbaren und zugänglichen Punkten durch ein Tal

4. Bilden von Geradenschnitten

Der Schnittpunkt P (**2.10**) der örtlich ausgesteckten Geraden AB und CD, die möglichst rechtwinklig aufeinander stehen sollten, wird gesucht.

Zwei Personen fluchten von A nach B und von C nach D eine dritte Person in P wechselweise ein. Eine Person allein kann den Schnitt ebenfalls bilden, wenn auch umständlicher. Es sind dann zunächst die Hilfspunkte E und F als Verlängerungen von AB und CD zu bestimmen und daraufhin der Punkt P als Schnitt von FD und EB festzulegen.

Ein spitzer Schnitt (schleifender Schnitt) ist örtlich nur ungenau anzugeben (**2.11**). Hier hilft man sich durch die Aufmessung der Punkte A und B auf die Linie CD. Punkt B sollte möglichst dicht bei P liegen. Man mißt y_a, y_b und a und rechnet

$$(y_a - y_b):a = y_b:b \qquad b = \frac{a \cdot y_b}{y_a - y_b}$$

Das Maß b wird in der Geraden CD abgesetzt und damit Punkt P genau gefunden.

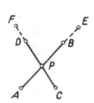

2.10 Schnitt zweier Geraden

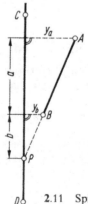

2.11 Spitzer Schnitt zweier Geraden

5. Einfluchten von Zwischenpunkten bei Sichtbehinderung

Dies geschieht über eine Hilfslinie, die schräg oder parallel zu der durchzurichtenden Geraden liegen kann.

In Bild **2**.12 ist die Sicht durch ein Gebäude behindert.

2.12 Einfluchten eines Punktes bei Sichtbehinderung

A wird auf die Hilfslinie BC rechtwinklig aufgemessen und der willkürliche Punkt N genau in die Gerade BC eingefluchtet. Gemessen werden AM, BM, BN. Das zu errechnende Maß

$$NF = \frac{AM \cdot BN}{BM}$$

wird in N winkelrecht zu BM abgesetzt. Der gefundene Punkt F liegt in der Geraden AB. Den Schnitt der Geraden AB mit dem Gebäude findet man durch Verlängern der Geraden AF bis zur Gebäudeflucht.

Nach Bild **2**.13 soll in C winkelrecht zu AB eine Gerade abgesteckt werden.

2.13 Abstecken einer Winkelrechten bei Sichtbehinderung

Man wählt in der Nähe von C den Hilfspunkt C_1 (möglichst rundes Maß) in der Geraden AB, errichtet in ihm das Lot (s. Abschn. 2.3), das mit 2 oder besser 3 Punkten (D_1, E_1, F_1) festzulegen ist. Die Parallelverschiebung CC_1 wird von diesen 3 Punkten winkelrecht abgesetzt und damit D, E und F gefunden, $CFED$ ist dann die gesuchte Gerade, die winkelrecht zu AB liegt.

2.3 Abstecken von rechten Winkeln

In der Bautechnik und in der Vermessungstechnik spielt der rechte Winkel eine große Rolle. Es ist deshalb naheliegend, zur Absteckung rechter Winkel und zum Fällen von Loten Instrumente zu verwenden, die den rechten Winkel als feststehenden Winkel angeben. Den rechten, feststehenden Winkel kann man mechanisch durch Diopterinstrumente oder optisch durch Winkelprismen erzeugen.

2.3.1 Mechanische Rechtwinkelinstrumente (Diopterinstrumente)

Die Kreuzscheibe (2.14) ist ein noch vereinzelt verwendetes Diopterinstrument. Die vier ≈ 0,5 mm breiten und 65 mm langen geraden Diopterschlitze legen paarweise Ziellinien fest, die senkrecht aufeinanderstehen. Mit der auf der Oberseite des Kegelstumpfes angebrachten Dosenlibelle wird der Stahlrohrstab, auf den die Kreuzscheibe aufgeschraubt ist, senkrecht gestellt. Das aufgesetzte Pentagonprisma dient zum leichteren Auffinden des Lotfußpunktes beim Fällen eines Lotes. Der Vorteil der Kreuzscheibe liegt in der mühelosen und genauen Bestimmung rechter Winkel auch im gebirgigen Gelände mit Sichten bis zu 35 gon nach oben und unten. Die Genauigkeit beträgt bei Ordinaten von 40 m etwa ± 2 cm unabhängig von der Geländeneigung.

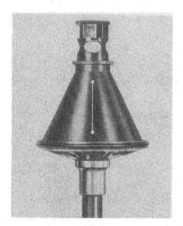

2.14 Kreuzscheibe mit aufgesetztem
 Pentagon-Prisma

2.15 Fällen eines Lotes mit der
 Kreuzscheibe

Zum Abstecken eines rechten Winkels stellt man die Kreuzscheibe in dem Punkt der Messungslinie, in welchem das Lot zu errichten ist, auf, lässt die Dosenlibelle einspielen, dreht die Kreuzscheibe mit 2 Sehschlitzen in die Richtung der Messungslinie, kontrolliert diese Richtung zur entgegengesetzten Seite und richtet mit dem zweiten Sehschlitzpaar einen Fluchtstab ein. Beim Fällen eines Lotes (2.15) wird der Lotfußpunkt C mit dem aufgesetzten Prisma bestimmt, die Kreuzscheibe in diesem Punkt senkrecht aufgestellt, mit einem Sehschlitzpaar die Richtung der Messungslinie $A B$ festgelegt und mit dem zweiten Sehschlitzpaar die winkelrechte Richtung zum Punkt D bestimmt. Um den geringen Abstand $D P = a$, der mit dem Meterstock gemessen wird, ist Punkt C zu verbessern. Punkt E ist der genaue Lotfußpunkt.

2.3.2 Optische Rechtwinkelinstrumente (Winkelprismen)

Es sind zu Prismen geschliffene Glaskörper, die als Einzelprisma oder – übereinandergesetzt – als Doppelprisma Verwendung finden. Für das Bilden des feststehenden rechten Winkels spielen die optischen Gesetze der Reflexion und die Brechung des Lichtes eine Rolle.

Reflexionsgesetz

Beim Auftreten eines Lichtstrahls (2.16) auf eine glatte Fläche (Spiegel) wird ein Teil von ihm verschluckt, der andere von der Fläche zurückgeworfen (reflektiert). Der einfallende und der reflektierte Strahl liegen mit dem Einfallslot in einer Ebene und bilden mit ihm gleiche Winkel.

Einfallswinkel α = Reflexionswinkel β

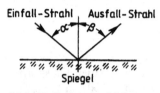

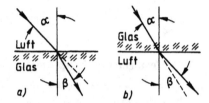

2.16 Reflexion des Lichtes

2.17 Brechung des Lichtstrahls
 a) beim Übertritt von Luft in Glas
 b) beim Übertritt von Glas in Luft

Brechungsgesetz

Ein auf die Trennungsfläche von Luft und Glas schräg auffallender Lichtstrahl wird gebrochen (2.17) und zwar beim Übergang

 von Luft in Glas zum Einfallslot hin,
 von Glas in Luft vom Einfallslot fort.

Zwischen Einfallswinkel α und Brechungswinkel β besteht beim Übergang von Luft in Glas (2.17a) das Verhältnis [1] $\dfrac{\sin \alpha}{\sin \beta} = \dfrac{3}{2}$

und beim Übergang von Glas in Luft (2.17b) $\dfrac{\sin \alpha}{\sin \beta} = \dfrac{2}{3}$.

Totale Reflexion

Für den Übergang von Glas in Luft gibt es einen Grenzwert des Einfallswinkels, von dem ab der Lichtstrahl nicht mehr gebrochen, sondern wieder zurückgeworfen wird und somit nicht aus dem Glas austritt (2.18); man nennt dies Total-Reflexion. Das Reflexionsgesetz ist auch hier gültig ($\alpha = \beta$). Der Grenzwinkel α_3 ergibt für $\beta_3 = 100\,\text{gon}$

$$\sin \alpha_3 = \frac{2}{3} \sin \beta_3 = \frac{2}{3} \cdot 1 = 0{,}666 \qquad \alpha_3 \approx 46{,}5\,\text{gon}$$

[1] $\sin \alpha / \sin \beta = n$ heißt Brechungskoeffizient, dessen Größe von der Glassorte abhängt (Kronglas $n = 1{,}52$, Flintglas $n = 1{,}62$).

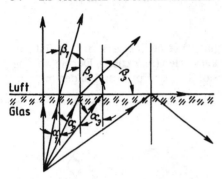

2.18 Totale Reflexion des Lichtstrahls

2.3.2.1 Pentagon (Fünfseitprisma)

Von einem Vierseitprisma hat man eine Ecke abgeschnitten und so einen Glaskörper erhalten, dessen Flächen sich unter 125 gon und an einer Ecke unter 100 gon schneiden (2.19). Die hervorgehobenen Flächen tragen einen Spiegelbelag.

In A und B wird der Lichtstrahl gebrochen, in C und D reflektiert. Ein- und ausfallender Lichtstrahl bilden einen rechten Winkel.

Aus den Dreiecken CGD und CDE folgt

$$\gamma + \delta = 50 \, \text{gon} \qquad \varepsilon = 2\gamma + 2\delta$$

und daraus

$$\varepsilon = 100 \, \text{gon}$$

Da der Winkel in H gleich 100 gon ist, stehen die Einfallslote senkrecht aufeinander, so dass die Einfallswinkel in A und B gleich groß $= \alpha$ sind.

Daraus folgt aus Viereck $BFAH$ als Sehnenviereck

$$\varphi = 100 \, \text{gon}.$$

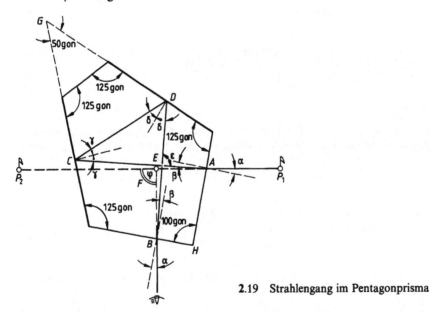

2.19 Strahlengang im Pentagonprisma

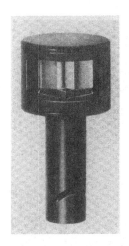

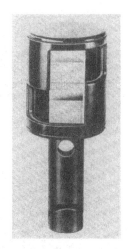

2.20 Pentagon

2.21 Steilsicht-Doppel-
 Pentagon

Das Pentagon (**2.20**) hat ein Gesichtsfeld mit Sichtflächen von 15 mm × 15 mm, der Scheitel des rechten Winkels liegt innerhalb des Glaskörpers. Als Steilsichtprisma sind Grund- und Deckfläche verspiegelt.

Die Genauigkeit beträgt bei einer Ordinate von 30 m ± 2 cm.

2.3.2.2 Doppel-Pentagon

Es besteht aus zwei übereinandergestellten Pentagonprismen mit zwischengekitteter Planplatte zur freien Durchsicht und einer Durchblicköffnung im Griff (**2.21**). Die Sichtflächen beider Pentagone liegen in einer Ebene. Die verspiegelten Grund- und Deckflächen lassen Steilsichten zu. Es hat große Fenster, besonders geschützte Spiegelflächen und ein Gehäuse mit Drehverschluß. Die Genauigkeit des Ablenkungswinkels beträgt 1′.

In Bild **2.22** ist der Strahlengang dargestellt.

Das Doppel-Pentagon eignet sich gut für die orthogonale Geländeaufnahme (Abschn. 3.1), zum Einfluchten zwischen zwei Punkten und zum Absetzen und Prüfen rechter Winkel.

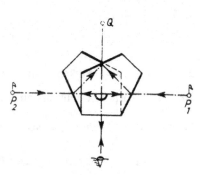

2.22 Strahlengang im Doppel-Pentagon

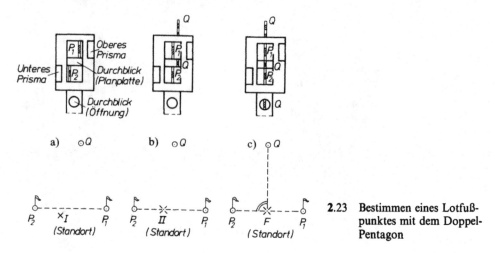

2.23 Bestimmen eines Lotfußpunktes mit dem Doppel-Pentagon

Um den Lotfußpunkt des Punktes Q auf der Geraden $P_1 - P_2$ (2.23) zu finden, entstehen folgende Prismenbilder:

In Bild 2.23a fallen die Bilder in den Prismen auseinander. Der Standort des Doppel-Pentagons wird nun so lange verschoben, bis im oberen und unteren Prisma die Bilder der Fluchtstäbe (oder Hausecken) P_1 und P_2 genau untereinander stehen (2.23b). Jetzt liegt der Standort des Doppel-Pentagons genau in der Geraden $P_1 - P_2$. Der Fußpunkt F des Lotes von Q auf $P_1 - P_2$ wird gefunden, indem man den Standort auf der Geraden $P_1 - P_2$ verschiebt, bis die Bilder der Fluchtstäbe P_1 und P_2 mit dem in der Mittendurchsicht und in der Durchblicköffnung sichtbaren Fluchtstab Q genau eine Gerade bilden (2.23c). Mittels Schnurlot oder Pendel-Fallstab (Abschn. 2.3.2.4) wird der Lotfußpunkt F markiert.

Bild 2.24 zeigt das einklappbare Doppel-Pentagon. Der besonders ausgeführte Mitteldurchblick zwischen den beiden übereinanderstehenden Pentagon-Winkel-Prismen gestattet Steilsichten bis rd. 50 gon. Nachteilig sind die kleinen Fenster.

2.24 Doppel-Pentagon mit Klappverschluss

2.3.2.3 Wollaston Winkelprisma [1]), Kreuzvisier

Der Grundkörper besteht aus einem Vierseitprisma, dessen eine Ecke (100 gon) abgeschnitten wurde, so dass ein Fünfseitprisma mit zwei Winkeln von je 75 gon und drei Winkel von je 150 gon entstand (2.25).

[1]) William Hyde Wollaston, englischer Physiker, 1766 bis 1828.

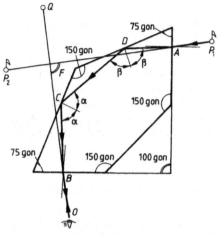

2.25 Strahlengang im Wollaston-Winkelprisma

2.26 Kreuzvisier

Eine Verspiegelung einzelner Seiten ist nicht erforderlich, da der Lichtstrahl in C und D so flach auf die Seiten fällt, dass Total-Reflexion eintritt. Der Scheitel des durch den ein- und ausfallenden Lichtstrahl gebildeten rechten Winkels liegt außerhalb des Glaskörpers. Die Genauigkeit bei einer Ordinate von 30 m ist \pm 2 cm.

Zwei übereinandergestellte Wollaston-Prismen nennt man Kreuzvisier. Die Prismen befinden sich in einer Metallfassung, die nur einen kleinen Einblick freigibt (**2.26**).

Im Griff, der zentrisch unter dem Scheitelpunkt des festen rechten Winkels liegt, ist ein Durchblickschlitz angebracht. Der Strahlengang ist im Bild **2**.27 wiedergegeben. Mit dem Kreuzvisier kann man sich auch selbst in eine Gerade einfluchten.

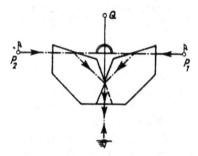

2.27 Strahlengang im Kreuzvisier

2.28 Pendel-
Fallstab

2.3.2.4 Zubehör zu Winkelprismen

Der durch ein Winkelprisma festgestellte Lotfußpunkt muss in der Aufnahmelinie am Boden genau bezeichnet werden. Dies geschieht mit einem Schnurlot oder mit dem Pendel-Fallstab (ausziehbarem Lotstock).

Der Pendel-Fallstab (**2.28**) besteht aus fünf mit Gewindezapfen verbundenen Rohrstücken. Der mit einer Ausklinkvorrichtung versehene Handgriff hält das obere Rohrstück in einer kardanischen Aufhängung, so dass der Pendelstab immer senkrecht hängt. Das untere Rohrstück trägt eine Lotspitze. Die Normallänge des Fallstabes ist 1,36 m, ausgeklinkt 1,56 m. Zusammengelegt ist er in einer Aktentasche unterzubringen.

2.3.3 Abstecken rechter Winkel ohne Rechtwinkelinstrument

In einfachen Fällen kann man mit hinreichender Genauigkeit durch Längenmessung einen rechten Winkel abstecken oder ein Lot fällen.

Der rechte Winkel in B (**2.29**) wird abgesteckt, indem von B nach beiden Seiten die gleiche beliebige Länge l abgesetzt wird. Von den so erhaltenen Punkten H_1 und H_2 findet man Punkt C durch Bogenschlag mit demselben Maß. Die kongruenten Dreiecke CBH_2 und BCH_1 sollen ungefähr gleichschenklig sein.

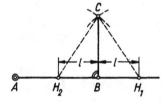

2.29 Abstecken eines rechten Winkels durch Längenmessung (Schnurdreiecke)

Der rechte Winkel ist auch durch das Seitenverhältnis $3:4:5$ im rechtwinkligen Dreieck abzustecken, das auch vergrößert werden kann, z. B. $6:8:10$. Es wären dann abzusetzen: $BH = 6$ m und durch Bogenschlag $BC = 8$ m und $HC = 10$ m.

Wenn umgekehrt der Lotfußpunkt von C zu bestimmen ist, so schlägt man um C mit einem beliebigen Maß einen Kreisbogen und bestimmt die Schnittpunkte H_1 und H_2. Die Mitte zwischen diesen Punkten ergibt den Lotfußpunkt.

2.4 Einfache Längenmessung

Im Hochbau, im Ingenieurbau und im Vermessungswesen arbeitet man mit Längenmaßen, die in der Örtlichkeit abzustecken oder aufzumessen sind. Diese Maße werden in der Waagerechten bestimmt, denn nur waagerechte Maße haben eine Bedeutung.

Es gibt einige Ausnahmen, bei denen man in der Schrägen misst, wie z.B. bei der Stationierung von Verkehrswegen und bei der Aufmessung für die Bauabrechnung schräger Flächen.

Für einfache Messungen verwendet man Bandmaße. Die früher eingesetzten 5 m-Messlatten sind wegen ihrer Sperrigkeit kaum noch im Gebrauch. Sie werden deshalb nicht mehr behandelt. Das Messen mit Messlatten und deren Prüfung ist in der 26. Auflage des Buches eingehend beschrieben.

Vielfach tritt an die Stelle der manuellen Längenmessung die elektro-optische Entfernungsmessung (s. Teil 2).

2.4.1 Rollbandmaße

Sie sind vorwiegend aus normalem oder nichtrostendem Stahl mit Längen von 10, 20, 25, 30 und 50 m und einem Querschnitt von 13 mm × 0,2 mm in cm-Teilung (DIN 6403). Am Anfang ist ein kleiner Haltering angeordnet. Das Band wird mit einer Kurbel in einen Rahmen (2.30) oder in eine Kapsel aufgerollt.

Bei Glasfaser-Bandmaßen sind in zwei Kunststoff-Folien vorgestreckte Glasfaserfäden eingeschweißt; sie sind knick- und reißfest, witterungsbeständig und gegen fast alle Chemikalien unempfindlich.

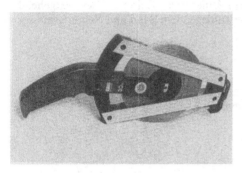

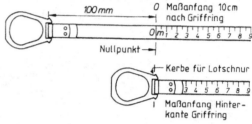

(nach DIN 6403)

2.30 Rollbandmaß auf V-Rahmen (BMI) 2.31 Nullpunkte bei Rollbandmaßen

Der Nullpunkt liegt bei den Rollbandmaßen nicht einheitlich (2.31). Unerfahrene Messgehilfen müssen daher genau unterwiesen werden.

Die zulässige Längenabweichung bei ebener Auflagerung, 50 N Zugspannkraft und 20 °C Temperatur ist \pm 1 mm auf 10 m.

Die Rollbandmaße werden gewöhnlich ohne Spannkraftmesser verwendet. Bei einer Toleranz der Spannkraft von \pm 30 N[1]) ergibt das für ein 20 m-Bandmaß mit dem Querschnitt 13 mm × 0,2 mm einen Fehler von \pm 1 mm. Für genaue Messungen gibt es jedoch zur Einhaltung der vorgeschriebenen Bezugsspannkraft von 50 N Bandmaße, in deren Griff ein Spannkraftmesser eingebaut ist. Diese Griffe sind gegen gewöhnliche Griffe austauschbar.

Isolierte Bandmaße verwendet man bei Messungen auf dem Bahnkörper der Schienenbahnen, um Betriebsstörungen an Signal- und Sicherungsanlagen zu vermeiden, da die Schienen als Folge der Sicherungstechnik vielfach Schwachstrom führen.

Für Tiefenvermessungen (Brunnen- und Grundwassermessungen) gibt es Spezialbandmaße mit Messingrahmen in Revolverform für senkrechten Bandablauf. Zur genauen lotrechten Messung wird am Bandmaßanfang ein Lot oder eine Brunnenpfeife (beim Eintauchen in Flüssigkeit ertönt ein Pfeifsignal) oder ein Lichtlot (beim Eintauchen in Flüssigkeit leuchtet dieses auf) befestigt.

Leinenbandmaße, gleich welcher Art, sind für Vermessungszwecke nicht geeignet.

[1]) N (Newton) = Krafteinheit. $1 \text{ N} = 1 \dfrac{\text{kg} \cdot \text{m}}{\text{s}^2}$ $1 \text{ kp} = 9{,}81 \text{ N} \approx 10 \text{ N}$.

2.4.1.1 Messen mit dem Rollbandmaß

Beim Messen wird eine Bandmaßlänge an die andere gefügt. Bei geneigtem Gelände ist bei Anwendung des Staffelverfahrens ein Ende des Bandmaßes herauf- oder abzuloten. Das Bandmaßende soll höchstens bis Brusthöhe hochgehalten werden, da man sonst nicht mehr einwandfrei ablesen kann. Ist dies wegen der Steilheit des Geländes nicht möglich, so setzt man ein kürzeres Maß, das unrund sein kann, ab. Der Vordermann nennt laut das abgesetzte Maß und gibt dem Hintermann diese Stelle des Bandmaßes in die Hand, der mit dem genannten Wert an dem Zwischenpunkt anhält (also nicht mit null). So wird bergauf oder bergab gestaffelt, bis 20 m abgesetzt sind; dann erst ist das Band weiterzuziehen (**2.32**). Damit schaltet man Anlegefehler und Additionsfehler weitgehend aus. Bei Geländeneigungen bis zu 10% kann mit aufliegendem Band und Neigungsmesser (Handgefällmesser) gearbeitet werden.

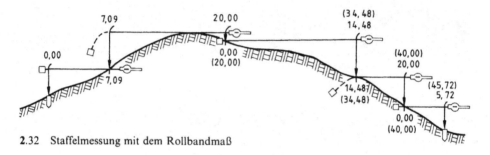

2.32 Staffelmessung mit dem Rollbandmaß

Der Neigungsmesser dient zur Bestimmung der Neigung des im Gelände liegenden Bandmaßes, er ist aber auch für das Aufsuchen von Linien gleicher Steigung im Gelände einzusetzen. Es ist darauf zu achten, dass die Ziellinie für die Neigungsmessung parallel zum Bandmaß verläuft, der Neigungsmesser also in Höhe des Zieles gehalten wird.

2.33 Optischer Handgefällmesser NECLI (Breithaupt)
mit 4 Teilungen, freihändig zu bedienen

Der optische Handgefällmesser „NECLI" von Breithaupt (**2.33**) hat ein gebrochenes Fernrohr, in dessen Bildebene ein durchsichtiger, frei schwingender Teilkreis angeordnet ist, der jeweils durch ein Pendelgewicht zur Lotrichtung orientiert wird. Der Teilkreis trägt vier Teilungen: Gon, Grad, Prozent und die Funktion $100\,(1 - \cos h)$ für die Reduktion einer 100 m langen Strecke in die Waagerechte. In Lage I (Okulareinblick links) erscheinen die Gon- und Prozentteilung (**2.34**), in Lage II (Okulareinblick rechts) die Grad- und Reduktionsteilung (**2.35**). Das jeweilige Ziel dient als Ablesemarke.

2.34 Okulareinblick mit Gonteilung
und Prozentteilung

2.35 Okulareinblick mit Gradteilung
und Reduktionsteilung

Ein Stahlbandmaß ändert seine Länge bei unterschiedlicher Temperatur. Für eine mit einem Stahlbandmaß gemessene Strecke von 100 m Länge errechnet sich die Verbesserung aus $100 \cdot 0,0115 \cdot \Delta t$ (in mm). Die folgende Übersicht gibt die Längenänderung für $s = 100$ m bei Δt Temperaturunterschied an:

Δt in K [1])	1	5	10	15	20	25	30
s in mm	1	6	12	17	23	29	34

Bei Messungen mittlerer Genauigkeit sind diese Verbesserungen anzubringen. Bei Präzisionsmessungen sind weiter die Dehnung durch Änderung der Zugspannung und der Durchhang des Bandes zu berücksichtigen. Durch ein in der Mitte um h durchhängendes Bandmaß (2.36) ergibt sich eine Längenverbesserung von

$$r_\mathrm{d} = s - l = -\frac{8\,h^2}{3\,l},$$

das ist bei einem Durchhang von 30 cm für ein 20 m-Band 1 cm.

Die Genauigkeit der Messung mit dem Rollbandmaß beträgt $2 \cdots 3$ cm auf 100 m.

2.36 Bandmaß mit Durchhang

2.4.1.2 Prüfen der Rollbandmaße

Die Länge L des aufliegenden Bandes ist von der Temperatur sowie von der Zugspannkraft und damit vom Querschnitt des Bandes abhängig.

Allgemein lautet die Gleichung

$$L = A + a + k_\mathrm{t} + k_\mathrm{d}$$

[1]) Nach dem Gesetz über Einheiten im Messwesen (s. S. 11) ist K (Kelvin) die Einheit für Temperaturdifferenzen; 1 K = 1 grd = 1 °C.

Darin ist

A = Sollänge des Bandes in m

a = Fehler des Bandes bei der Bezugstemperatur und Bezugsspannkraft in mm

k_t = Längenverbesserung durch Temperaturänderung in mm

$$k_t = \alpha \cdot l(t - t_0) = 0{,}0115 \cdot l(t - 20°C)$$

α = Ausdehnungskoeffizient für Stahl = 0,0115 mm je m und K

l = Länge des Bandes in m

t_0 = Temperatur bei der das Bandmaß die vorgeschriebene Länge hat (vielfach = 20 °C)

k_d = Längenverbesserung durch Änderung der Zugspannkraft in mm

$$k_d = \frac{\Delta P \cdot l \cdot 10^3}{q \cdot E}$$

ΔP = Differenz zwischen Gebrauchsspannkraft P und Bezugsspannkraft P_0 in N (50 N für Bandmaße)

q = Querschnitt des Bandes in cm²

E = Elastizitätsmodul = $2 \cdot 10^7$ N/cm²

Für ein 20 m-Rollbandmaß mit einem Querschnitt 13 mm × 0,2 mm findet man bei $t_0 = 20$ °C und $P_0 = 50$ N

$$k_t = 0{,}0115 \cdot 20 \, (t - 20°C) = 0{,}23 \, (t - 20°C) \, \text{mm}$$

$$k_d = \frac{(P - 50) \cdot 20 \cdot 10^3}{1{,}3 \cdot 0{,}02 \cdot 2 \cdot 10^7} \left(\frac{\text{N} \cdot \text{mm} \cdot \text{cm}^2}{\text{cm}^2 \cdot \text{N}} \right) = 0{,}038 \, (P - 50) \, \text{mm}$$

und damit die Gleichung des Rollbandmaßes

$$L = 20 \, \text{m} + a \, (\text{mm}) + 0{,}23 \, (t - 20°) \, \text{mm} + 0{,}038 \, (P - 50) \, \text{mm}$$

Für genaue Vermessungen wird das Rollbandmaß über einen Komparator geprüft, der aus zwei im Abstand von etwas über 20 m auf einer möglichst waagerechten Ebene angebrachten Teilungen besteht (2.37). Der Abstand der beiden Nullmarken ist mit Normalmetern (Prüfmeterstäben) im Hin- und Rückgang zu bestimmen.

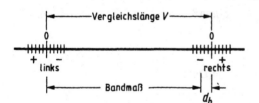

2.37 Komparator zur Prüfung von Bandmaßen mit Angabe der Vorzeichen für die Bandablesung

Die Prüfmeterstäbe mit der Bezeichnung A und B (1 Satz) sind aus nicht gehärtetem Stahl von 10 mm × 10 mm Querschnitt und haben schneidenförmige Enden, die Bezugstemperatur ist 20 °C. Den Abstand der Endschneiden stellt die Physikalisch-Technische Bundesanstalt als Eichbehörde fest und legt ihn in einem Prüfschein nieder. Die allgemeine Gleichung der Prüfmeterstäbe lautet

$$A = 1 \, \text{m} + K_a \, \text{mm} + 0{,}0115 \, (t°C - 20°) \, \text{mm}; \quad B = 1 \, \text{m} + K_b \, mm + 0{,}0115 \, (t°C - 20°) \, \text{mm}$$

K_a und K_b sind die Abweichungen gegenüber der Soll-Länge, die die Eichbehörde feststellt, z. B. 0,002 mm. 0,0115 ist der Ausdehnungskoeffizient für Stahl in mm, t ist die vorhandene Temperatur in °C, die mit einem Schleuderthermometer gemessen wird.

Die Vergleichsstrecke zwischen den Nullmarken ist dann $V = 10A + 10B + k$. Der Wert k ist die Ablesung an der festen Teilung. Die Länge des mit der Bezugsspannkraft eingelegten Bandes wird fünfmal gemessen und daraus die Gleichung des Bandes unter Berücksichtigung der Normaltemperatur aufgestellt.

Beispiel. Ein 20 m-Rollbandmaß ist zu überprüfen und seine Gleichung aufzustellen.

Die Komparatorlänge (Vergleichslänge V) ist durch zweimalige Messung mit den Normalmeterstäben mit $V = 20,000\,\text{m} + 2,51\,\text{mm}$ festgelegt worden.

Tafel 2.38 Rollbandmaßprüfung

Messung	Ablesung		d_b	Zugspannkraft	Temperatur t
	links	rechts	Sp. 2 + Sp. 3		
	mm	mm	mm	N	°C
1	2	3	4	5	6
1	+4,2	−9,6	−5,4	50	10
2	+2,6	−8,1	−5,5	50	10
3	+1,0	−6,5	−5,5	50	10
4	−1,8	−3,8	−5,6	50	10
5	−3,4	−2,1	−5,6	50	11
			d_b (Mittel) −5,5		

Das Rollbandmaß wird mit 50 N Zugspannkraft eingelegt und fünfmal bei unterschiedlichen Nullpunktslagen unter Berücksichtigung des Vorzeichens abgelesen (2.37 und 2.38).

$$
\begin{aligned}
\text{Vergleichsstrecke} \quad V \quad & 20,000 + 2,51\,\text{mm} \\
d_b \quad & \underline{ - 5,5\ \text{mm}} \\
& 20,000 - 2,99\,\text{mm}
\end{aligned}
$$

Länge des Rollbandmaßes bei $t = 10\,°\text{C}$ und $P = 50\,\text{N}$

Das Band ist somit bei $t = 10\,°\text{C}$ und $P = 50\,\text{N}$ um 2,99 mm zu kurz.

Auf die Bezugstemperatur $t = 20\,°\text{C}$ umgerechnet, erhält man

$$-2,99 = a + 0,23\,(t - 20°) \qquad a = -2,99 - 0,23\,(-10) = -0,69$$

Die Gleichung des Rollbandmaßes lautet

$$L = 20\,\text{m} - 0,69\,\text{mm} + 0,23\,(t - 20°)\,\text{mm} + 0,038\,(P - 50)\,\text{mm}$$

Da immer mit derselben Zugspannkraft P gemessen wird, ist die Länge des Bandes nur noch von der Temperatur abhängig. Für jedes Bandmaß stellt man sich zweckmäßig eine Reduktionstabelle für 100 m Entfernung bei verschiedenen Temperaturen von Grad zu Grad auf.

Die Prüfung des Bandmaßes kann auch auf einer $\approx 100\,\text{m}$ langen Vergleichsstrecke V erfolgen, deren Länge mit geprüften elektronischen Entfernungsmessern ermittelt und so als fehlerfrei angenommen wird (Sollwert). Die Strecke ist dann fünfmal mit dem zu vergleichenden Bandmaß bei 50 N Zugspannkraft zu messen (Istwert).

Aus $d = $ Sollwert $-$ Istwert $= 0,0115\,V\,(t - t_0) = -\,0,0115\,V\,(t_0 - t)$ findet man

$t_0 = -\dfrac{d}{0,0115\,V} + t$, also die Temperatur, bei der das Bandmaß genau 20,000 m lang ist. Eine mit dieser Temperatur aufgestellte Tabelle der Streckenverbesserung für 100 m ergibt für die jeweils vorhandene Temperatur den Korrektionswert.

Beispiel. Das im vorigen Beispiel auf dem Komparator abgeglichene Rollbandmaß wird auf einer Vergleichsstrecke überprüft.

Tafel 2.39 Rollbandmaß-Prüfung mittels Vergleichsstecke bei aufliegendem Band

Datum	Temperatur t °C	Zugspannkraft N	Vergleichsstrecke m	mm
1	2	3	4	
Länge der Vergleichsstrecke (Soll)			$V = 126$	369

20 m-Rollbandmaß Nr. ...
(Messung mit aufliegendem Band)

15.6.	15	50	126	382
	15	50	126	380
	15	50	126	377
	15	50	126	381
	16	50	126	383
Mittel	15	Mittel (Ist)	126	381
			d (Soll $-$ Ist)	-12

Streckenverbesserung für 100 m $v_{100} = 100 \cdot 0,0115\,(t - 23)$

t °C	v_{100} mm	t °C	v_{100} mm
0	-26	16	-8
2	-24	18	-6
4	-22	20	-3
6	-20	22	-1
8	-17	23	0
10	-15	24	$+1$
12	-13	26	$+3$
14	-10	28	$+6$

$$t_0 = -\frac{d}{0,0115 \cdot V} + t = -\frac{-12}{1,45} + 15 = +8 + 15 = 23\,°C$$

genaue Länge bei $t_0 = 23\,°C$

2.4.2 Indirekte Streckenmessung einfacher Art

Vielfach können Strecken nicht direkt gemessen werden, weil sie nicht zugänglich sind oder ein Hindernis im Weg steht. Beim Einsatz elektronischer Tachymeter ist die Bestimmung solcher Strecken problemlos (s. Teil 2). Jedoch kann man sich auch mit geometrischen Hilfskonstruktionen helfen, aus denen rechnerisch die nicht messbare Strecke abzuleiten ist. Einige dieser Hilfskonstruktionen sollen hier aufgezeigt werden:

1. Die Teilstrecke BC (2.40) ist direkt nicht messbar, da ein Teich dazwischenliegt. In B und C werden die Lote $BB_1 = CC_1$ und $BB_2 = CC_2$ unabhängig voneinander abgesteckt. Das Mittel aus den gemessenen Strecken B_1C_1 und B_2C_2 ist die gesuchte Strecke BC.

2. Ein Haus verhindert die Strecke AB direkt zu messen (2.41). Auf die beliebige Gerade BP wird Punkt A angewinkelt; AC sowie BC sind zu messen. Dann findet man

$$AB = \sqrt{(AC)^2 + (BC)^2} .$$

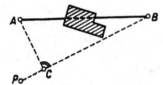

2.40 Indirekte Bestimmung der nicht messbaren
 Entfernung BC durch Parallelen

2.41 Indirekte Bestimmung von
 AB durch eine Hilfslinie

3. Ein Fluss wird von einer Messungslinie geschnitten. Die Hilfskonstruktion (2.42) zur Ermittlung der nicht messbaren Strecke AB zeigt die Verlängerung von AB bis C, das Lot in C bis E und das Lot in B bis zum Schnitt mit AE in D. ΔAEC sollte ungefähr gleichschenklig sein. Es ist

$$AB = BD\,\frac{BC}{CE - BD}$$

4. Die Aufgabe unter 3 lässt sich auch einfach über den Höhensatz lösen (2.43). In B wird ein Lot errichtet und D gefunden. Das auf AD in D errichtete Lot schneidet die Verlängerung von AB in C. ΔADB sollte ungefähr gleichschenklig sein. Nach dem Höhensatz findet man

$$AB = \frac{BD^2}{BC}$$

2.42 Indirekte Bestimmung von
 AB über zwei Hilfsdreiecke

2.43 Indirekte Bestimmung von
 AB mittels Höhensatz

2.4.3 Zulässige Abweichungen bei Längenmessungen

Im Abschn. 1.4 wurde nach groben, systematischen und zufälligen Abweichungen unterschieden, die auch bei Längenmessungen auftreten können. Der Ingenieur sollte sie kennen und wissen, wie man sie vermeidet oder herabmindert. Im folgenden werden die am häufigsten vorkommenden Abweichungen aufgezählt und die Maßnahmen zur Verhütung in Klammern angegeben.

1. Grobe Abweichungen: Große Ablesefehler, z.B. 1 m, 5 m, 20 m (mit Zählnadeln zählen, doppelte Ablesungen, Kontrollen messen).

2. Systematische Abweichungen: Falsches Anlegen am Nullpunkt (achtgeben); falscher Nullpunkt des Längenmessgerätes (feststellen und in Rechnung setzen); Messen mit nicht geprüften Längenmessgeräten (auf Komparator prüfen, bei Bandmaßen Temperatur berücksichtigen); Durchhang des Bandmaßes (unterstützen); Ausweichen aus der zu messenden Geraden (Linie durch genügend Fluchtstäbe sichtbar machen); Abweichen von der horizontalen Lage des Messgerätes (mit Libelle waagerecht legen); zu schwaches oder zu starkes Anziehen des Bandmaßes (bei Präzisionsmessungen Spannungsmesser verwenden); pendelndes Lot durch Wind (in Windrichtung vor das Lot stellen).

3. Zufällige Abweichungen: Es sind schwer oder nicht erfassbare Abweichungen, die nach Ausschalten der groben und systematischen Abweichungen zurückbleiben. Sie entstehen durch die menschliche Unzulänglichkeit in der Fertigung und Handhabung der Vermessungsinstrumente sowie durch veränderliche Messbedingungen.

Für das amtliche Vermessungswesen sind zulässige Abweichungen [1] festgelegt, die nicht überschritten werden sollen.

Zulässige Abweichungen für Längenmessungen

Für die nachstehenden Formeln bedeutet s die Länge der Strecke in m.

Die größte zulässige Abweichung in Metern zwischen zwei für dieselbe Strecke unmittelbar nacheinander mit demselben Messgerät ermittelten Längen beträgt:

$$D_s = 0,006 \sqrt{s} + 0,02$$

Die zulässigen Abweichungen erreichen nach dieser Formel folgende Größen:

s in m	10	20	40	80	100	200	300	500
D_s in m	0,04	0,05	0,06	0,07	0,08	0,10	0,12	0,15

Die größte zulässige Abweichung in Metern zwischen zwei dieselbe Strecke zu verschiedenen Zeiten oder mit verschiedenem Messgerät ermittelten Längen sowie zwischen gemessenen und berechneten Strecken beträgt:

$$D = 0,008 \sqrt{s} + 0,0003 s + 0,05$$

[1] Hier gibt es in einzelnen Bundesländern Unterschiede.

Nach dieser Formel ergeben sich die Größen:

s in m	10	20	40	80	100	200	300	500
D in m	0,08	0,09	0,11	0,15	0,16	0,22	0,28	0,38

Für Gebiete mit hohem Grundstückswert sind die zulässigen Abweichungen zu halbieren. Diese zulässigen Abweichungen stellen Grenzwerte dar. Sie sind der dreifache Betrag der zu erwartenden Standardabweichung. Eine Messung kann somit als hinreichend genau bezeichnet werden, wenn die Differenz aus der Doppelmessung der Strecke die Hälfte der genannnten Beträge nicht überschreitet.

Für Ingenieur-Vermessungen sind die Grenzen zulässiger Abweichungen enger zu ziehen.

2.4.4 Praktische Hinweise zur Längenmessung mit Bandmaßen

1. Bandmaße sind in größeren Zeitabständen zu überprüfen. Zweckmäßig legt man sich für jedes Band eine Tabelle an, aus der die Verbesserungen bei der jeweiligen Außentemperatur abzulesen sind. Diese Verbesserungen können an Ort und Stelle beim Bestimmen der einzelnen Längen sofort berücksichtigt werden.

2. Bei der Messung mit dem Bandmaß ist auf die gleichmäßige Spannung des Bandes zu achten. Ein Spannungsmesser im Griff des Rollbandmaßes ist eine ausgezeichnete Hilfe.

3. Die zu messende Strecke ist mit einer ausreichenden Anzahl Zwischenpunkten durch Fluchtstäbe sichtbar zu machen, damit der Vordermann am Bandmaß sich selbst in die Messrichtung einfluchten kann.

4. Im geneigten Gelände wird das Bandmaß entweder waagerecht gehalten und mit dem Staffelverfahren sofort die waagerechte Entfernung ermittelt oder auf den Boden gelegt und die gemessene schräge Entfernung in die Waagerechte reduziert.

5. Nicht beschichtete Stahlbandmaße sind nach Gebrauch zu säubern und einzufetten, um sie vor Rost zu schützen.

3 Geländeaufnahme (Stückvermessung)

Zweck der Aufnahme einer Geländefläche (Grundstück, Flurstück, Gebäude, Verkehrsweg, Waldstück usw.), ist, ihre Größe zu bestimmen, ihre Umringsgrenze in einem Plan sichtbar zu machen und Zahlenmaterial für die Wiederherstellung einzelner Punkte zu gewinnen. Von einer Fläche können nur Einzelpunkte der sie umhüllenden Figur aufgemessen werden; diese Aufmessung nennt man Stückvermessung, deren Aufnahmemethoden das Rechtwinkelverfahren, Einbindeverfahren und Polarverfahren sind.

Rechtwinkel- und Einbindeverfahren, die mit den behandelten Längenmessgeräten und Rechtwinkelinstrumenten ausgeführt werden, kann man auch gemeinsam anwenden.

Für das Polarverfahren ist der Einsatz eines Theodolits erforderlich und die Anwendung der elektronischen Distanzmessung (s. Teil 2) zweckmäßig. Das Polarverfahren ist eine wirtschaftliche Messmethode, da eine EDV-gestützte Auswertung leicht möglich ist.

3.1 Rechtwinkelverfahren

Man nennt es auch Orthogonal- oder Koordinatenverfahren. Auf eine oder mehrere innerhalb oder außerhalb der aufzunehmenden Fläche gelegten Linien werden von den einzelnen Punkten (Grenzpunkte, Häuserecken, topographische Gegenstände) die Lote gefällt und mit einem Rechtwinkelinstrument die Lotfußpunkte bestimmt (3.1). Die Messungslinie (Abszissenachse) wird vom Nullpunkt beginnend fortlaufend durchgemessen. Die Lote (Ordinaten) werden einfach gemessen; Abszissen und Ordinaten sind durch Kontrollmaße zu sichern (s. Abschn. 3.6). Die Länge der Ordinaten sollte aus wirtschaftlichen und Genauigkeitsgründen 30 m nicht übersteigen.

Die Punkte 2 und 3 sind nicht auf die Hauptmessungslinie (Abszissenachse), sondern auf die Linie 1−4 rechtwinklig aufgenommen. Als „seitwärtsgelegene Punkte" sind die Koordinaten dieser Punkte – auf die Hauptmessungslinie bezogen – zu berechnen (s. Abschn. 5.3).

Es ist ein einfaches Verfahren, mit dem die einzelnen Punkte festzulegen sind und im umgekehrten Fall von der Messungslinie aus eindeutig wiederhergestellt werden können.

3.2 Einbindeverfahren

Ein Dreieck ist durch seine drei Seiten bestimmt. Man kann sich deshalb bei einfachen Aufmessungen mit Dreieckskonstruktionen helfen, in deren Seiten die sonstigen Linien (Grenzen, Hausflucht) einzubinden sind (3.2). Spitze Schnitte sollte man vermeiden, im Ausnahmefall ist nach Bild 2.11 zu verfahren. Die für die weitere Berechnung zu verwendenden Dreieckseiten sind doppelt zu messen, wie dies in Bild 3.2 angegeben ist.

3.1 Aufnahme nach dem Rechtwinkel-
 verfahren

3.2 Aufnahme nach dem Einbindeverfahren

3.3 Vereinigtes Rechtwinkel- und Einbindeverfahren

Rechtwinkel- und Einbindeverfahren können kombiniert werden. In vorhandene oder neu zu legende Polygonseiten (s. Teil 2) werden Linien eingebunden. Es entsteht ein Netz von Messungslinien, deren Lage so zu wählen ist, dass mit möglichst kurzen Ordinaten und kurzen, unter günstigen Schnittwinkeln auf die Messungslinie auftreffende Verlängerungen die Punkte aufzunehmen sind. Dabei soll jedes Maß kontrollierbar sein.

In Bild 3.3 wird das aufzunehmende Gebiet im Norden und Osten von zwei Wegen abgegrenzt, in denen jeweils Polygonseiten verlaufen (strich-punktierte Linien). Im Süden wurde Polygonpunkt **92** mit einem (nicht dargestellten) Polygonpunkt verbunden und damit Punkt 652 gefunden. Von diesem wiederum wurde eine Messungslinie zum Punkt 582 geführt, der in der Polygonseite **83–84** liegt. Die Koordinaten der vier Hauptpunkte wurden berechnet (s. Teil 2); sie sind in Bild 3.3 angegeben. Damit ist ein Rahmen für das Aufnahmegebiet geschaffen, in den wiederum Messungslinien eingebunden sind, über die nunmehr jeder Grenzpunkt, jede Hausecke und die Nutzungsarten erfasst sind.

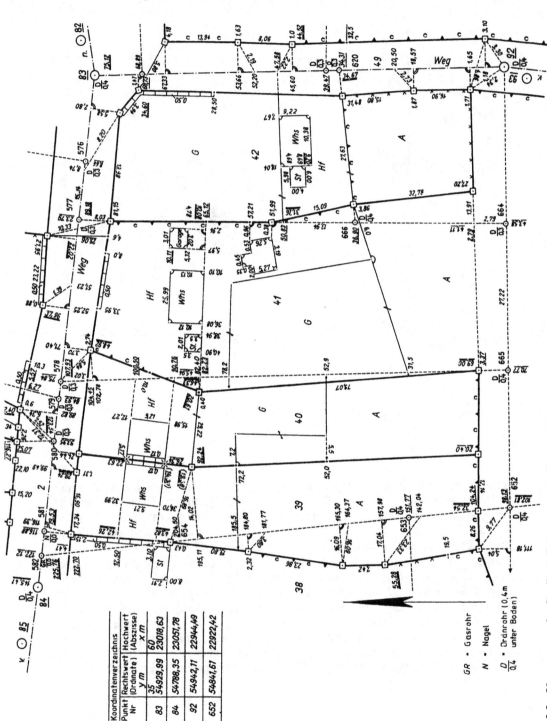

Koordinatenverzeichnis		
Punkt Nr	Rechtswert (Ordinate) y m 35	Hochwert (Abszisse) x m 60
83	54929,99	23018,63
84	54788,35	23051,78
92	54942,11	22944,49
652	54841,61	22922,42

GR = Gasrohr
N = Nagel
$\frac{D}{0,4}$ = Dränrohr (0,4 m unter Boden)

3.3 Vermessungsriss für die Aufnahme eines größeren Gebietes nach dem Rechtwinkel- und Einbindeverfahren

3.4 Polarverfahren

Die Entwicklung der elektro-optischen Distanzmessgeräte und der digitalen Tachymeter hat das Vermessungswesen entscheidend beeinflusst. Damit ist das Polarverfahren als Aufnahme- und Absteckverfahren in den Vordergrund gerückt.

Von einem koordinatenmäßig bekannten Standpunkt, dem Pol (Punkt 5 in den Bildern 3.4 und 3.5) und von einer gegebenen Richtung aus (von Punkt 5 nach Punkt 6) werden die einzelnen Punkte in Richtung und Entfernung aufgemessen. Die Winkelmessung erfolgt mit dem Theodolit, die Streckenmessung zweckmäßig mit einem elektro-optischen Distanzmesser, in einfachen Fällen mit dem Bandmaß. Neben dem Vordruck für die Winkel- und Streckenmessung ist ein Lagefeldbuch mit der Darstellung der aufgenommenen Punkte mit ihren Nummern zu führen. Zur Kontrolle werden die Steinbreiten und die Gebäudeumringsmaße gemessen; einige Punkte sind von einem zweiten Standpunkt aus anzuschneiden.

3.4 Aufnahme nach dem Polarverfahren 3.5 Polarverfahren

Bild 3.5 zeigt einen Ausschnitt des Bildes 3.4. Die Koordinaten des Standpunktes 5 und des Anschlusspunktes 6 sind gegeben, damit ist der Richtungswinkel $t_{5,6}$ der Anschlussrichtung bekannt

$$t_{5,6} = \arctan \frac{y_6 - y_5}{x_6 - x_5}$$

Der Winkel β_1 und die Strecke s_1 werden örtlich gemessen. Dann ist der Richtungswinkel zum Punkt 101

$$t_{5,101} = t_{5,6} + \beta_1$$

und die rechtwinkligen Koordinaten für den Aufnahmepunkt 101

$$y_{101} = y_5 + s_1 \cdot \sin t_{5,101}$$
$$x_{101} = x_5 + s_1 \cdot \cos t_{5,101}$$

Dieses Thema wird bei der Koordinatenberechnung in Teil 2 umfassend behandelt.

Ein elektronisches Feldbuch erfasst automatisch die örtlich ermittelten Messdaten, die gespeichert werden und zur weiteren Auswertung an einen Rechner übergeben werden. So wird der Arbeitsablauf von der örtlichen Vermessung bis zur Koordinatenberechnung einzelner Punkte und bis zur Herstellung der Karte automatisiert. Näheres hierüber in Teil 2.

3.5 Verfahren der freien Standpunktwahl (freie Stationierung)

Bei dem Polarverfahren ist der Instrumentenstandpunkt nach Koordinaten gegeben. Dies ist bei der freien Standpunktwahl nicht erforderlich. Hier sind die Kriterien der Standpunktwahl allein örtliche Gegebenheiten. Es sollen nur vom Instrumentenstandpunkt mindestens zwei nach Koordinaten bekannte Punkte sowie die aufzunehmenden oder abzusteckenden Punkte gut sichtbar sein (3.6). Die Standpunktkoordinaten werden zunächst in einem örtlichen System gerechnet und dann im Landesnetz bestimmt. Zur Kontrolle wird ein weiterer nach Koordinaten bekannter Festpunkt angezielt und die Richtung und Entfernung zu diesem gemessen. Sodann werden die Koordinaten dieses Punktes zur Kontrolle bestimmt, die mit den gegebenen Werten innerhalb bestimmter Grenzwerte übereinstimmen müssen. Der Berechnungsvorgang wird im Teil 2 eingehend behandelt.

3.6 Messungsproben

Kontrollmaße sollen die Messung sichern und eventuelle Fehler aufdecken; sie müssen deshalb so angelegt sein, dass eine durchgreifende Kontrolle möglich ist. Bei einer fortlaufend gemessenen Strecke kontrolliert jedes zweite Maß als Einzelmaß die gemessenen Werte. Dabei wird aber nichts über die gerade Richtung der Strecke ausgesagt; die Flucht ist somit ebenfalls zu überprüfen, es sei denn, dass diese durch seitliche Maße verprobt werden kann.

In Bild 3.7 ist eine Strecke mit zwei Zwischenpunkten fortlaufend gemessen. Die Differenzen der fortlaufend ermittelten Maße ergeben die Einzelmaße von Punkt zu Punkt.

$$114{,}17 - 83{,}25 = 30{,}92$$
$$83{,}25 - 39{,}17 = 44{,}08$$
$$39{,}17 - 0{,}00 = 39{,}17$$

3.6 Freie Standpunktwahl

3.7 Kontrollmaße bei
 fortlaufender Messung

Die beiden gemessenen Maße 39,18 und 30,90 – sogen. Kopfbreiten – sichern die Messung durchgreifend.

Eine Messungsprobe bieten auch die Verbindungslinien der rechtwinklig aufgenommenen Punkte (Steinbreiten, Hausbreiten), die aus den Koordinatenunterschieden nach dem Pythagoras einfach nachzurechnen sind (3.8).

Die Differenz zwischen errechnetem und gemessenem Maß darf die in Abschn. 2.4.3 angegebenen Fehlergrenzen nicht übersteigen.

3.8 Messungsproben bei der Rechtwinkelmethode

Beispiel. Die in Bild **3.8** angegebenen Messungszahlen sind nach dem Pythagoras zu prüfen. In der Praxis werden bei der Berechnung mit dem elektr. Rechner die im folgenden angegebenen Quadrate der Strecken und deren Summen nicht aufgeführt. Der Vergleich der Differenz d von Soll- und Istwert der Strecke mit der Angabe der größten zulässigen Abweichung D nach Abschn. 2.4.3 lässt eine Aussage über die Güte der Messung zu.

Geprüft wird nach $c = \sqrt{a^2 + b^2}$

$(a = 16{,}58 - \ \ 6{,}05)$	10,53	110,88 (a^2)
$(b = 70{,}45 - 58{,}80)$	11,65	135,72 (b^2)
$(c = \sqrt{a^2 + b^2})$	15,70	246,60 $(a^2 + b^2)$
gemessen	15,72	$d = -0{,}02$
		$(D: 0{,}09)$
$(a = 18{,}12 - 16{,}58)$	1,54	2,37 (a^2)
$(b = 85{,}07 - 70{,}45)$	14,62	213,74 (b^2)
$(c = \sqrt{a^2 + b^2})$	14,70	216,11 $(a^2 + b^2)$
gemessen	14,69	$d = +0{,}01$
		$(D: 0{,}09)$

Das Maß 15,72 verprobt die Ordinaten 6,05 und 16,58 sowie die Abszissen 58,80 und 70,45; das Maß 14,69 kontrolliert aber nur den Abszissenunterschied $85{,}07 - 70{,}45 = 14{,}62$, nicht aber den Ordinatenunterschied $18{,}12 - 16{,}58 = 1{,}54$. Denn wäre die Ordinate 18,12 um 0,20 m falsch (18,32), so würde sich die Hypotenuse mit 14,72 ergeben und läge gegenüber dem gemessenen Maß von 14,69 innerhalb der gesetzten Fehlergrenzen. Da die Ordinate 16,58 bereits über das Maß 15,72 mitkontrolliert wurde, ist für die Ordinate 18,12 noch eine Probe erforderlich, die man mit der eingezeichneten Strebe 23,26 findet.

(a)	18,12	328,33 (a^2)
$(b = 85{,}07 - 70{,}45)$	14,62	213,74 (b^2)
$(c = \sqrt{a^2 + b^2})$	23,28	542,07 $(a^2 + b^2)$
gemessen	23,26	$d = +0{,}02$
		$(D: 0{,}09)$

Weitere Kontrollmöglichkeiten von gemessenen Maßen sind in Bild **3.3** angegeben.

Bei der Polaraufnahme entstehen durch die gemessenen Werte (Winkel und Strecken) Dreiecke, aus denen nach dem Cosinussatz Kontrollen abgeleitet werden.

Allgemein gilt, wenn b, c und α gemessen werden (3.9)

$$a = \sqrt{b^2 + c^2 - 2 \cdot b \cdot c \cdot \cos \alpha}$$

3.9 Cosinussatz

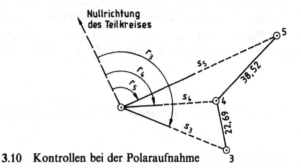

3.10 Kontrollen bei der Polaraufnahme

Beispiel. Bei der polaren Aufnahme der Fläche in Bild 3.1 wurden u.a. für die Punkte 3, 4 und 5 folgende Werte ermittelt (3.10)

$$s_5 = 70{,}96 \, \text{m} \qquad r_5 = 96{,}542 \, \text{gon}$$
$$s_4 = 33{,}12 \, \text{m} \qquad r_4 = 106{,}067 \, \text{gon}$$
$$s_3 = 37{,}95 \, \text{m} \qquad r_3 = 146{,}500 \, \text{gon}$$

Mit diesen Werten ergeben sich die Kontrollen für

$$\text{Strecke } \overline{5-4} = \sqrt{s_5^2 + s_4^2 - 2 \cdot s_5 \cdot s_4 \cdot \cos (r_4 - r_5)}$$
$$= 38{,}53 \, \text{m (gemessen 38,52)}$$

$$\text{Strecke } \overline{4-3} = \sqrt{s_4^2 + s_3^2 - 2 \cdot s_4 \cdot s_3 \cdot \cos (r_3 - r_4)}$$
$$= 22{,}66 \, \text{m (gemessen 22,69)}$$

Allgemein ist zu beachten: Jedes Maß soll verprobt sein, es sollen aber nie mehr Maße gemessen werden, als unbedingt erforderlich.

3.7 Führen des Risses (Feldbuches)

Die in der Örtlichkeit gemessenen Maße werden in einen Riss (Feldbuch), der aus transparentem Papier oder einer Folie, z.B. Hostaphan oder Ultraphan, besteht und in einem als Schreibunterlage dienenden Feldbuchrahmen einzuklemmen ist, eingetragen. Den Riss führt man zweckmäßig ungefähr maßstäblich (1:100 bis 1:1000) mit einem mäßig harten Bleistift (Härte F). Im DIN-Blatt 18702 sind die Zeichen und die Schreibweise der Maßzahlen für Vermessungsrisse angegeben. Spezielle Zeichen wie z.B. für Anlagen der Eisenbahn, an Wasserstraßen und Gewässern sind entsprechenden Zeichenvorschriften und Musterblättern zu entnehmen. Jede Zahl und jedes Zeichen müssen in dem Riss eindeutig sein, damit ein Fachkundiger danach einen Plan oder eine Karte herstellen kann. In Tafel 3.12 sind einige der häufig vorkommenden Zeichen zusammengestellt.

Die Maße der Durchmesser sind in mm, die der Mauerdicken in m angegeben; die Strichbreite 2 (St. 2) beträgt 0,2 mm, die Strichbreite 3 (St. 3) 0,3 mm usw. Größe und Strichbreite der Zeichen gelten für Darstellungen im Maßstab 1 : 1000. Für andere Maßstäbe sind die Zeichen entsprechend zu vergrößern oder zu verkleinern.

3.11 Schreibweise der Maßzahlen in Rissen
(nach DIN 18 702)
1 Verlängerung
2 Endmaß (Ende der Messungslinie)
3 Spannmaß
4 Steinbreite
5 Strebe
6 gerechnetes Maß
7 mehrere Punkte auf der Senkrechten
8 Gebäudeeinmessung
9 abgehende Messlinie
10 Einmessung eines top. Gegenstandes
11 Schnittpunkt
12 angelegtes Maß

Unter Beachtung des Bildes 3.11 und der Tafel 3.12 merke man sich folgende Regeln:

1. Jeder Messungspunkt wird im Riss durch einen Punkt bezeichnet, der nicht zugezogen werden darf. Die Längenangaben – Abszissenmaße – sind bei durchlaufender Messung der Messungslinien quer zu ihnen, mit dem Fuß zum Anfangspunkt gerichtet, neben die Punkte einzutragen, und zwar bei abgehenden Messlinien, Fußpunkten von Ordinaten und Verlängerungen auf der freien Seite der Messungslinie.

Bei vermarkten Messungspunkten ist die Art der Vermarkung anzugeben, z.B. *B* (Bolzen), *D* (Drainrohr), *Fl* (Flasche), *Pf* (Pfahl), *MB* (Mauerbolzen), *R* (Rohr). Bei Vermarkungen an Gebäuden, Mauern usw. kann die Höhe der Marke über dem Erdboden, bei unterirdischer Vermarkung die Tiefe der Marke (Oberkante) unter dem Erdboden in Metern angegeben werden, z.B. $\dfrac{0,5}{MB}$, $\dfrac{Fl}{0,6}$

Tafel 3.12 Zeichen für Vermessungsrisse (Auswahl aus DIN 18702)

Polygonpunkte (PP)	**wasserführender Graben**
dauerhaft vermarkt	**trockener Graben**
zugleich Grenzstein	**überspringende Grenz-einrichtung (hier Hecke)**
unvermarkt	
Kleinpunkte (KlP)	**Vermessungslinien und -Zeichen**
dauerhaft vermarkt	Polygonseite
zugleich Grenzstein	Messlinie
unvermarkt	mit Messgerät be-stimmte Senkrechte
Nivellementpunkte (NivP) Stein	nach Augenmaß be-stimmte Senkrechte
Pfeiler	
Mauerbolzen	spitzer und stumpfer Winkel (bei Gebäuden)
Rohrfestpunkt	Verlängerung einer Linie
Grundstücks- und topographische Grenzen	Geradheitszeichen
Eigentumsgrenze	parallele Linien
Flurstücksgrenze	
Grenze von Nutzungs-arten (wenn nicht gleichzeitig Flurstücksgrenze)	**Grenzpunkte von Grundstücksgrenzen**
	Grenzpunkt ist Steinmitte
Grenzeinrichtungen	Grenzpunkt ist Mitte der Oberkante bzw. eine Ecke des Steins
Hecke (Laub- und Nadelhölzer)	Grenzstein unter den Erdboden versenkt
Zaun	Grenzhügel
Mauern	Grenzkreuz
Erdwall	Grenzbaum
Grenzrain	sonstiges Grenzmal (hier Rohr)

2. Grenzlinien und Gebäudeseiten werden durch Voll-Linien, Polygonseiten (s. Teil 2) durch strichpunktierte Linien und einfache Messungslinien durch gestrichelte Linien dargestellt.

3. Vermarkte Punkte abgehender Messlinien sind durch kleine Kreise, Fußpunkte der Ordinaten durch einen oder zwei Viertelkreisbogen (je nachdem, ob nach Augenmaß oder mit Messgerät ermittelt), Verlängerungen durch Pfeilspitzen zu kennzeichnen.

4. Das Maß am Endpunkt einer Messlinie ist doppelt zu unterstreichen. Die Angabe 0,0 kann für den Anfangspunkt entfallen. Die Maße an Einbindepunkten und Schnittpunkten von Messungslinien sind einmal zu unterstreichen.

5. Bei Verlängerungen von Messungslinien über deren Endpunkt hinaus (doppelt unterstrichenes Endmaß) sind die Maße weiter fortlaufend anzugeben. Am letzten Punkt ist eine Pfeilspitze anzubringen.

 Bei Verlängerungen von Messungslinien über deren Anfangspunkt hinaus ist am letzten Punkt eine Pfeilspitze einzuzeichnen und das Maß für die Verlängerung längs der Messungslinie mit dem Fuß zu dieser einzutragen. Sind mehrere Punkte auf der Verlängerung über den Anfangspunkt hinaus eingemessen, so sind die Maße wie bei der Messungslinie vom Anfangspunkt ab, aber in Richtung der Verlängerung (also umgekehrt zu den Zahlen der Messungslinie) anzugeben.

6. Die Längen der rechtwinkligen Abstände – Ordinaten – sind in der Regel von der Messungslinie aus gerechnet jenseits der Endpunkte der Abstände mit dem Fuß zum Anfangspunkt der Messungslinie einzutragen. Liegen mehrere Messungspunkte auf einer Ordinate, können die Maße wie bei durchlaufenden Messungslinien geschrieben werden. Anfangspunkt ist stets der Fußpunkt.

7. Einzellängen (z. B. Steinbreiten, Sicherungsmaße bei rechtwinkligen Abständen usw.) sind längs der Grenzen oder Linien mit dem Fuß zu diesen einzutragen.

8. Die durchlaufende Schreibweise der Messungszahlen ist das Kennzeichen für die Geradlinigkeit einer Grenze oder Linie. An Schnittpunkten von Messungslinien mit geraden Grenzen, die selbst nicht durchlaufend gemessen wurden, sind an den Grenzen Geradheitszeichen (halbe Kreisbogen) anzubringen.

9. Von krummen Linien sind so viele Punkte aufzunehmen, dass ihre geradlinige Verbindung ihre Form im Kartierungsmaßstab hinreichend genau ergibt.

10. Bei Gebäuden wird in der Regel das aufsteigende Mauerwerk an zwei oder drei Ecken durch Verlängerungen oder rechtwinklige Abstände festgelegt, alle übrigen Punkte durch Umfangsmaße. Die Gebäudeflächen bleiben weiß und werden durch Whs, St, Sch (Wohnhaus, Stall, Scheune) usw. bezeichnet.

11. Bei freien Flächen wird die Nutzungsart wie Hf, G, A, W (Hofraum, Garten, Acker, Wiese) usw. angeschrieben.

12. Bei Straßen und Wegen sind Begrenzung der Fahrbahn, Fußwege, Gräben usw. einzumessen; ferner ist ihre Klassifikation wie Autobahn, B82, L1198, Weg anzugeben. Bei Wasserflächen sind Uferlinien, Böschungsgrenzen, Uferbauten usw. aufzunehmen und ihre Art, wie Fluss, Bach, Kanal usw., zu vermerken. Gegebenenfalls ist die Fließrichtung einzutragen.

13. Bei Gleisen werden nur Punkte der Gleisachse aufgenommen (nicht jede einzelne Schiene). Die Gleisachse wird durch einen Strich dargestellt. Von den Weichen sind die Achspunkte am Anfang und Ende aufzunehmen. Weichenmitte wird durch einen

Kreis bezeichnet. Näheres s. Zeichenvorschrift für vermessungstechnische Pläne der Deutschen Bahn AG.

14. Auf allen Rissen ist die Nordrichtung durch einen Pfeil anzugeben.

Bei der Polaraufnahme werden in dem Vermessungsriß die Richtungen zu den einzelnen Punkten durch einen Pfeil, bei Doppelmessung durch zwei Pfeile, bezeichnet (3.13). Die aufgemessenen Punkte werden durchnummeriert. Auf Übereinstimmung der Punktnummern des Vermessungsrisses mit dem Feldbuchformular ist besonders zu achten. Bei Verwendung elektronischer Feldbücher ermöglichen Adressennummern und Kommentarzeilen eine Zuordnung der registrierten Werte zu den aufgenommenen Punkten. Bild 3.13 zeigt einen Ausschnitt des Aufnahmegebietes von Bild 3.3 mit den koordinierten Polygonpunkten 83 und 92 als Aufnahmestandpunkte.

Für die freie Standpunktwahl gilt dies entsprechend.

3.13 Vermessungsriss für die Aufnahme nach dem Polarverfahren, Aufnahmestandpunkte **83** und **92**

4 Fertigen von Lageplänen

Die Kurzschrift des Ingenieurs ist der Plan und die Karte. Diese entstehen durch Kartieren der Messungsergebnisse. Der Einsatz EDV-gestützter Konstruktionsweisen ist üblich. Die herkömmliche Kartierung kann bei kleinen Projekten weiterhin sinnvoll sein.

Ein Lageplan stellt maßstäblich ein Stück der Erdoberfläche dar. Je nach Art und Zweck sind der Maßstab und der Zeichenträger, auf dem der Lageplan gezeichnet wird, verschieden. Gebräuchlich sind für kleine Lagepläne die Maßstäbe 1:250, 1:500 und 1:1000. Als Zeichenträger verwendet man transparentes Zeichenpapier oder Zeichenfolien, die beide lichtdurchlässig sind, und Zeichenkarton, der zur Erhöhung der Maßhaltigkeit mehrfach kaschiert oder mit einer Metalleinlage versehen sein kann. Während auf Zeichenpapier und -karton mit normaler Zeichentusche gezeichnet werden kann, ist für viele Zeichenfolien eine Spezialtusche erforderlich.

An Hand des örtlich aufgenommenen und im Vermessungsriss (Feldbuch) niedergelegten Zahlenmaterials wird der Plan kartiert. Zur Kartierung braucht man einen Anlegemaßstab (möglichst flach), eine Kopiernadel, ein Sägeblattlineal, zwei Zeichendreiecke aus durchsichtigem Material, einen Bleistift (2 H) und eventuell Kurvenlineale sowie Klothoidenlineale. Mit Klein-Kartiergeräten kann man die Kartiergenauigkeit auf 0,1 bis 0,2 mm steigern.

Wenn die Stückvermessung in ein Koordinatensystem einbezogen ist, bildet ein Quadratnetz die Grundlage der Kartierung (Abschn. 4.1).

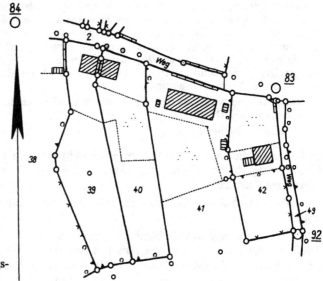

4.1 Kartierung 1:2000
(nach dem in Bild 3.3
dargestellten Vermessungs-
riss)

Lagepläne werden nach Norden orientiert; die Nordrichtung des Planes, die durch einen Nordpfeil anzugeben ist, liegt nach oben, nach links oder nach links oben. Beim Entwerfen von Verkehrswegen wird von dieser Regel abgewichen. Diese Pläne werden unabhängig von der Nordrichtung im Sinne der Kilometrierung des Verkehrsweges (Straße, Eisenbahn) von links nach rechts orientiert.

Das Liniennetz ist das Gerippe des Planes; von diesem ausgehend werden die Einzelpunkte kartiert, mit Bleistift verbunden und jedes gemessene Kontrollmaß nachgegriffen. Sodann wird der Plan in schwarzer Tusche ausgezogen (4.1), wobei die Messungslinien ausgenommen sind; auch werden keine Maßzahlen in den Plan eingetragen.

In DIN 18702 sind neben den in Tafel 3.12 im Auszug wiedergegebenen Zeichen für Vermessungsrisse auch solche für Karten und Pläne angegeben.

Einige wichtige Zeichenregeln für den Maßstab 1:1000 seien genannt:

1. Eigentums- und Flurstücksgrenzen werden in Strichbreite 3 (0,3 mm), Grenzen von Nutzungsarten, Gebäudeumrisslinien, Begrenzung von Fahrbahnen und Bahnkörpern in Strichbreite 2 (0,2 mm) gezeichnet.

2. Bei Wasserläufen und Gräben sind die Uferlinien darzustellen, wenn ihr Abstand im Plan mindestens 1,0 mm beträgt, sonst nur die Mittellinien.

3. Polygonpunkte erhalten einen Kreis von 2,5 mm Durchmesser mit beigeschriebener Punktnummer; Kleinpunkte einen Kreis von 1 mm Durchmesser.

4. Wohngebäude und öffentliche Gebäude – diese mit Zusatz über Art des Gebäudes, z. B. Kirche, Rathaus, Post – werden unter 50 gon zu den Begrenzungslinien, Wirtschaftsgebäude parallel zur kürzeren Seite schraffiert.

5. Die Beschriftung ist so anzuordnen, dass sie vom unteren Blattrand aus lesbar ist und in der Regel parallel zu diesem verläuft; an oder in Verkehrswegen und Wasserläufen folgt sie dem Verlauf der Anlage. Hausnummern sind mit dem Fuß oder Kopf zur Straße gerichtet einzutragen. Gemeinde- und Flurnamen werden in senkrechter, Gebäudebezeichnungen und Punktnummern in rechtsgeneigter Schrift geschrieben. Straßen und Wege haben in der Laufrichtung rechtsgeneigte, Gewässernamen linksgeneigte Schrift. Schriftgröße und -breite sind dem Maßstab sowie der Ausdehnung der zu beschriftenden Gegenstände anzupassen.

6. Zeichen für die Nutzungsarten des Bodens sowie Zeichen für topographische Gegenstände (Bäume u. dgl.) s. DIN 18702.

7. Der Maßstab ist anzugeben.

Bild **4.1** zeigt die nach den aufgeführten Gesichtspunkten gefertigte Kartierung des im Bild **3.3** dargestellten Vermessungsrisses. Dabei handelt es sich um einen Lageplan begrenzten Ausmaßes.

Für größere Aufnahmen bedient man sich einer EDV-Anlage mit entsprechender Software.

Lagepläne für Baugesuche[1]) beinhalten die Flurstücks- und Grundstücksgrenzen mit den Grenzzeichen und den Maßen zwischen den Grenzzeichen; Straße und Hausnummer der Grundstücks; die Gebäude auf dem Grundstück und auf den Nachbargrundstücken (mit Geschoßzahl und Dachform); Höhenangaben des Grundstücks, der Straße und des Fußbodens vom Erdgeschoß des Neubaus; ober- und unterirdische Leitungen, Ölbehälter; Flurstücksnummern, Größen der Flurstücke, Grundbuchbezeichnungen, Eigentümer; topographische Einzelheiten (Böschungen, Bäume); Nordpfeil und alle Angaben, die

[1]) in den einzelnen Ländern nicht einheitlich

nach dem Bebauungsplan festgelegt sind. In den Lageplänen sind Teile farbig darzustellen, und zwar: Baugrundstücksgrenzen gelb; Verkehrsflächen: vorhandene Wege braun, geplante blassrosa; Gebäudeflächen: vorhandene grau, geplante rot, abzubrechende gelb; Grünflächen grün.

4.1 Auftragen von Punkten nach Koordinaten

In der Regel sind die Koordinaten des übergeordneten Netzes bekannt; die Koordinaten der aufgenommenen Punkte werden berechnet. Zur Kartierung dieser Punkte bedient man sich zweckmäßig eines Quadratnetzes, dessen Gitterlinien runde Koordinatenwerte darstellen. Das Quadratnetz mit runden Maßen für die Maschenweite (meistens 10 cm) muss sehr sorgfältig konstruiert werden. Es vereinfacht die Kartierung und steigert die Genauigkeit. Die Schnittpunkte des Gitternetzes werden durch kleine Kreuze bezeichnet; am Rand werden die runden Koordinatenwerte an den Gitterlinien vermerkt.

Zur Kartierung des Quadratnetzes zieht man zwei annähernd durch die Ecken des Zeichenblattes gehende Diagonalen (4.2). Wenn das Netz nicht parallel zum Blattrand verlaufen soll, sind die Linien entsprechend zu drehen. Vom Mittelpunkt M aus werden auf den Linien gleiche Strecken mit einem Zirkel oder mit einem Sägeblattlineal abgesetzt und die so gewonnenen Punkte verbunden. Man

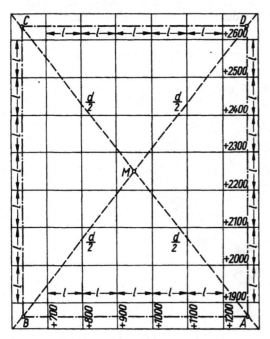

4.2 Auftragen eines Quadratnetzes nach der
 Diagonalmethode

4.3 Auftragen eines nach Koor-
 dinaten bekannten Punktes

erhält das Rechteck $ABCD$, auf dessen Seiten die Netzabstände l unter Berücksichtigung der Randbreiten abzusetzen sind. Die Verbindungslinien zusammengehöriger Punkte ergeben das Quadratnetz. Es wird vorteilhaft mit einem Sägeblattlineal geprüft, das neben der Teilungseinheit l auch die Teilung $l\sqrt{2}$ (Diagonalteilung) aufweist.

In jede mögliche Diagonale der Quadrate wird dieses Lineal gelegt. Dabei müssen die diagonal liegenden Quadratnetzpunkte mit der Linealkante zusammenfallen und mit den Strichen der $l\sqrt{2}$-Teilung übereinstimmen.

Ein einfaches Hilfsmittel zum Auftragen des Koordinatennetzes ist die Quadratnetzplatte aus Hartaluminium mit Bohrungen zum Punktieren eines 10×10-cm-Netzes; die Genauigkeit beträgt \pm 0,05 mm.

Zum Kartieren der einzelnen Punkte werden von der Gitterlinie die Koordinatendifferenzen Δy und Δx zwischen dem Koordinatenwert der Gitterlinie und dem Koordinatenwert des Punktes abgesetzt (4.3). Ein Nadelstich mit Kreis und Punktnummer bezeichnen den Punkt. Alle gemessenen Maße wie Steinbreiten, Gebäudemaße usw. sind im Plan nachzuprüfen.

Für das Auftragen einer größeren Anzahl von Punkten und für genaueste Arbeiten verwendet man Koordinatographen. Ein solches Kartiergerät besteht aus einem mit einer Teilung versehenen Abszissenlineal und einem daran verschieb- und einstellbaren Ordinatenlineal mit Teilung. Moderne Kartierautomaten mit einer Zeichenfläche bis $\approx 1{,}20/1{,}60$ m werden elektronisch gesteuert. Hierbei können über Zusatzeinrichtungen die Koordinaten rückgelesen und in Klarschrift ausgegeben werden.

Rechtwinkel-Kleinkoordinatographen (4.4) haben eine Auftragsfläche bis etwa 55×50 cm. Sie können für die Maßstäbe 1:250, 1:500, 1:1000 und 1:2000 verwendet werden. Abszisse und Ordinate werden mit Hilfe von Nonien eingestellt. Ein Punktiermikroskop ermöglicht das genaue Markieren der Punkte. So kann eine Auftragsgenauigkeit von $\approx 0{,}2$ mm erzielt werden.

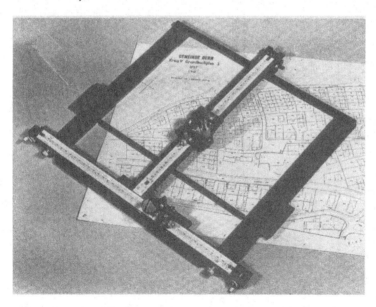

4.4 Rechtwinkel-Koordinatograph (Haag Streit)

4.2 Vervielfältigen von Plänen

Die am häufigsten verwendete Vervielfältigung von Plänen ist die Lichtpause. Die Vorbedingungen für ihre Fertigung sind sehr einfach; man braucht ein lichtdurchlässiges Original, ein Belichtungsgerät, ein Entwicklungsgerät, den Entwickler und Lichtpauspapier.

Man kann das Positiv auch direkt auf elektrostatischem oder wärmetechnischem Weg erhalten. Es werden meistens elektrostatische Verfahren (Xerographie), die Größen bis DIN A0 vervielfältigen, angewandt. Die Herstellung dieser Vervielfältigungen ist preiswert und rationell.

5 Einfache Koordinatenberechnung

Es ist vielfach vorteilhaft, die Vermessung in ein Koordinatensystem einzubinden. Die Koordinatenberechnung wird im Teil 2 behandelt. Dabei wird es sich um die Berechnung der Koordinaten von Lagefestpunkten und um die weiterführende Koordinatenberechnung von Punkten für die Aufnahme und Absteckung handeln. Soweit hier Koordinaten für Lagefestpunkte (wie in Bild 3.3) angegeben sind, werden diese als bekannt vorausgesetzt.

Es werden bei der Auswertung von Einzelvermessungen und Flächenberechnungen auch Koordinaten für weitere Punkte (Grenzpunkte, Hausecken usw.) erforderlich sein. Diese einfache Berechnung rechtwinkliger Koordinaten wird hier besprochen.

Im Bild 5.1 sind die Punkte P_1 und P_2 mit ihren rechtwinkligen Koordinaten y_1, x_1 und y_2, x_2 dargestellt. Die Quadranten zählen im rechtsläufigen Sinn. Die Richtung der positiven x-Achse ist willkürlich nach praktischen Gesichtspunkten gewählt; bei Berechnungen im Gauß-Krüger-Koordinatensystem wird sie nach Norden orientiert.

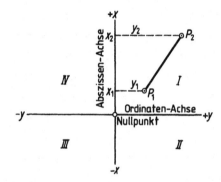

5.1 Rechtwinklige Koordinaten

5.1 Höhe und Höhenfußpunkt

Wenn in einem Dreieck die drei Seiten a, b und c gemessen sind, kann man die Koordinaten von C (5.2) in bezug auf c, das sind die Höhe h und die Hypotenusenabschnitte p und q, berechnen.

$$h^2 = a^2 - p^2 = b^2 - q^2 \qquad p^2 - q^2 = a^2 - b^2$$

$$(p + q)(p - q) = a^2 - b^2 \qquad p - q = \frac{a^2 - b^2}{p + q} = \frac{a^2 - b^2}{c}$$

$$\frac{p + q}{2} = \frac{c}{2} \qquad \frac{p - q}{2} = \frac{a^2 - b^2}{2c}$$

beide Gleichungen addieren und subtrahieren

Wenn $a > b$

$$p = \frac{c}{2} + \frac{a^2 - b^2}{2c} = \frac{c^2 + a^2 - b^2}{2c}$$

$$q = c - p \qquad h = \sqrt{b^2 - q^2}$$

Probe: $h = \dfrac{a^2 - p^2}{h}$

Wenn $a < b$

$$q = \frac{c}{2} - \frac{a^2 - b^2}{2c} = \frac{c^2 + b^2 - a^2}{2c}$$

$$p = c - q \qquad h = \sqrt{a^2 - p^2}$$

Probe: $h = \dfrac{b^2 - q^2}{h}$

5.2 Höhe und Höhenfußpunkt

5.3 Höhe und Höhenfußpunkt zu Bild 3.2
Die geklammerten Maße sind berechnet

Beispiel. In Bild 3.2 wird die aufgemessene Fläche durch die Diagonale in zwei Dreiecke geteilt. Die Eckpunkte 1 und 3 (5.3) sind auf die gemessene Diagonale $4-2$ als x-Achse zu koordinieren.

Rechengang für Dreieck $4-1-2$

Gegeben:

$$a = 105{,}92\,\text{m}, \qquad b = 68{,}12\,\text{m}, \qquad c = 119{,}05\,\text{m}$$

Da $a > b$ ist, wird

$$p = \frac{c^2 + a^2 - b^2}{2c} = \frac{119{,}05^2 + 105{,}92^2 - 68{,}12^2}{2 \cdot 119{,}05} = 87{,}16\,\text{m}$$

$$q = c - p = 119{,}05 - 87{,}16 = 31{,}89\,\text{m}$$

$$h = \sqrt{b^2 - q^2} = \sqrt{68{,}12^2 - 31{,}89^2} = 60{,}19\,\text{m}$$

Probe: $$h = \frac{a^2 - p^2}{h} = \frac{105{,}92^2 - 87{,}16^2}{60{,}19} = 60{,}18\,\text{m}$$

Rechengang für Dreieck $2-3-4$

Gegeben:

$$a = 86{,}98\,\text{m}, \quad b = 72{,}26\,\text{m}, \quad c = 119{,}05\,\text{m}$$

Da $a > b$ ist, wird

$$p = \frac{c^2 + a^2 - b^2}{2c} = \frac{119{,}05^2 + 86{,}98^2 - 72{,}26^2}{2 \cdot 119{,}05} = 69{,}37\,\text{m}$$

$$q = c - p = 119{,}05 - 69{,}37 = 49{,}68\,\text{m}$$

$$h = \sqrt{b^2 - q^2} = \sqrt{72{,}26^2 - 49{,}68^2} = 52{,}47\,\text{m}$$

Probe: $$h = \frac{a^2 - p^2}{h} = \frac{86{,}98^2 - 69{,}37^2}{52{,}47} = 52{,}47\,\text{m}$$

Damit sind die Koordinaten der Punkte 1 und 3 auf die x-Achse $4-2$ bezogen

$$y_1 = -60{,}19 \qquad x_1 = 31{,}89$$
$$y_3 = 52{,}47 \qquad x_3 = 69{,}37$$

5.2 Einrechnen von Kleinpunkten auf der Linie

Es sind die Koordinaten y_1 und x_1 (5.4) des auf der Linie AE liegenden Kleinpunktes 1 zu berechnen; die Koordinaten von A und E sind gegeben, die Strecken s und Δs_1 gemessen, womit auch Δs_e gegeben ist.

Zunächst ist die gemessene Strecke s zu überprüfen:

$$S = \sqrt{(y_e - y_a)^2 + (x_e - x_a)^2}$$

Die Differenz aus gerechneter Strecke S und gemessener Strecke s muss innerhalb der im Abschn. 2.4.3 angegebenen Fehlergrenzen liegen.

Aus Bild 5.4 findet man die Proportionen

$$(y_1 - y_a):\Delta s_1 = (y_e - y_a):s \qquad (x_1 - x_a):\Delta s_1 = (x_e - x_a):s$$
$$(y_e - y_1):\Delta s_e = (y_e - y_a):s \qquad (x_e - x_1):\Delta s_e = (x_e - x_a):s$$

und daraus

$$y_1 = y_a + \frac{y_e - y_a}{s}\,\Delta s_1 \qquad x_1 = x_a + \frac{x_e - x_a}{s}\,\Delta s_1$$

$$y_e = y_1 + \frac{y_e - y_a}{s}\,\Delta s_e \qquad x_e = x_1 + \frac{x_e - x_a}{s}\,\Delta s_e$$

Die Quotienten $\dfrac{y_e - y_a}{s}$ und $\dfrac{x_e - x_a}{s}$ kommen als konstante Faktoren vor und werden mit o und a bezeichnet:

$$o = \frac{y_e - y_a}{s} \qquad a = \frac{x_e - x_a}{s}$$

und damit

$$y_1 = y_a + o \cdot \Delta s_1 \qquad x_1 = x_a + a \cdot \Delta s_1$$
$$y_e = y_1 + o \cdot \Delta s_e \qquad x_e = x_1 + a \cdot \Delta s_e$$

Es können viele Punkte zwischen A und E liegen, die fortlaufend nach vorstehenden Formeln einzurechnen sind, am Schluss erhält man zur Kontrolle die Koordinaten des Punktes E (bis auf die Abrundungsdifferenzen). Da die Strecken $\Delta s_1 \cdots \Delta s_e$ durch Messung ermittelt sind, werden die Messungsungenauigkeiten, die sich in $f_s = S - s$ ausdrücken, automatisch proportional der Streckenlängen verteilt. Voraussetzung hierfür ist, dass bei der Berechnung von o und a durch die gemessene Strecke s dividiert wird; darauf ist zu achten. o und a sollen möglichst exakt in die Rechnung eingehen (≥ 5 Nachkommastellen).

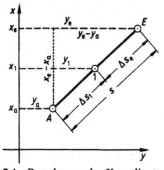

5.4 Berechnung der Koordinaten
 von Kleinpunkten

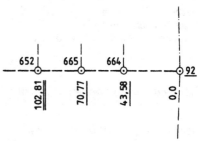

5.5 Kleinpunktberechnung

Beispiel. Von den in Bild 3.3 auf der Strecke 92−652 liegenden Punkten 664 und 665 sind die Koordinaten zu berechnen. Die Koordinaten der Punkte 92 und 652 sind im Bild 3.3 angegeben, deren erste Stellen bei der Berechnung fortgelassen werden.

In dem Vordruck (Tafel 5.6) werden in Sp. 1 die aus den Koordinatenunterschieden errechnete Strecke S, der Fehler $f_s = S - s$ und die nach Abschn. 2.4.3 erlaubte Differenz vermerkt. In Sp. 2 sind

Tafel 5.6 Vordruck und Beispiel für die Kleinpunktberechnung

$$S = \sqrt{(y_e - y_a)^2 + (x_e - x_a)^2} \qquad o = \frac{y_e - y_a}{s} \qquad y_i = y_{i-1} + o \cdot \Delta s_i$$

$$f_s = S - s \qquad a = \frac{x_e - x_a}{s} \qquad x_i = x_{i-1} + a \cdot \Delta s_i$$

gerechnete Strecke S f_s	fortl. gemess. Strecke s_i [Δs] = s	$\Delta s =$ $s_{i+1} - s_i$	o $\Delta y = o \cdot \Delta s$ y	a $\Delta x = a \cdot \Delta s$ x	Punkt Nr.
1	2	3	4	5	6
			− 0,97753	− 0,21467	
	0,00		+942,11	+944,49	92
		43,58	− 42,60 ($o \cdot \Delta s$)	− 9,36 ($a \cdot \Delta s$)	
	43,58		+899,51	+935,13	664
		27,19	− 26,58 ($o \cdot \Delta s$)	+ 1 − 5,84 ($a \cdot \Delta s$)	
	70,77		+872,93	+929,30	665
		32,04	− 31,32 ($o \cdot \Delta s$)	− 6,88 ($a \cdot \Delta s$)	
	102,81		+841,61	+922,42	652
102,89 +0,08 D:0,16	102,81 = s	102,81 = s	−100,50 = $y_e - y_a$	− 22,07 = $x_e - x_a$	

die Maße der fortlaufend gemessenen Strecke angegeben. In Sp. 3 sind die Strecken Δs von Punkt zu Punkt und deren Summe eingetragen. In die Sp. 4 und 5 trägt man zunächst die Koordinaten der gegebenen Punkte ein, errechnet die Differenzen $y_e - y_a$ und $x_e - x_a$ und damit o und a, die im Kopf dieser Spalten stehen. Sodann sind die einzelnen Δy und Δx zu errechnen, deren fortlaufende Addition die gesuchten Koordinaten ergeben.

5.3 Einrechnen von seitwärts der Linie gelegenen Punkten

Der Punkt P ist mit seinem Lot d und dem Lotfußpunkt F auf der Strecke AE festgelegt; seine Koordinaten sind zu berechnen (5.7).

Die Dreiecke EAD und FPB sind ähnlich; daraus folgt

$$\frac{y_e - y_a}{s} = \frac{FB}{d} \qquad FB = \frac{y_e - y_a}{s} d = o \cdot d$$

$$\frac{x_e - x_a}{s} = \frac{BP}{d} \qquad BP = \frac{x_e - x_a}{s} d = a \cdot d$$

Mit den Koordinaten des Fußpunktes F, die nach Abschn. 5.2 zu berechnen sind, findet man

$$y_p = y_f + BP \qquad\qquad x_p = x_f - FB$$

$$y_p = y_a + o \cdot \Delta s_f + a \cdot d \qquad x_p = x_a + a \cdot \Delta s_f - o \cdot d$$

Der seitliche Abstand d ist im Sinne der gemessenen Strecke rechts liegend positiv, links liegend negativ.

5.7 Seitwärts gelegener Punkt

Wenn mehrere Punkte seitlich der Messungslinie aufgenommen sind, werden die Abstandsunterschiede Δd in die Rechnung eingeführt, wie das Beispiel in Tafel 5.8 zeigt. Allgemein ist

$$y_i = y_{i-1} + o \cdot \Delta s + a \cdot \Delta d \qquad x_i = x_{i-1} + a \cdot \Delta s - o \cdot \Delta d$$

Tafel 5.8 Vordruck und Beispiel für die Berechnung seitwärts liegender Punkte

$$S = \sqrt{(y_e - y_a)^2 + (x_e - x_a)^2} \qquad o = \frac{y_e - y_a}{s} \qquad y_i = y_{i-1} + o \cdot \Delta s + a \cdot \Delta d$$

$$f_s = S - s \qquad\qquad a = \frac{x_e - x_a}{s} \qquad x_i = x_{i-1} + a \cdot \Delta s - o \cdot \Delta d$$

gerech-nete Strecke S f_s	fortl. gemess. Strecke s_i	$\Delta s =$ $s_{i+1} - s_i$ $[\Delta s] = s$	seitl. Ab-stand der Punkte d	$\Delta d =$ $d_{i+1} - d_i$ $[\Delta d] = 0$	o $o \cdot \Delta s$ $a \cdot \Delta d$ y	a $a \cdot \Delta s$ $-o \cdot \Delta d$ x	Pkt. Nr.
1	2	3	4	5	6	7	8
					− 0,20745	+ 0,97779	
	0,00		0,00		−13,50	± 0,00	1
		25,06			− 5,20 $(o \cdot \Delta s)$	+24,50 $(a \cdot \Delta s)$	
					−18,70	+24,50	
				−6,83	− 6,68 $(a \cdot \Delta d)$	+1 − 1,42 $(-o \cdot \Delta d)$	
	25,06		−6,83		−25,38	+23,09	2
		26,29			− 5,45 $(o \cdot \Delta s)$	−25,71 $(a \cdot \Delta s)$	
					−30,83	+48,80	
				+9,61	+ 9,40 $(a \cdot \Delta d)$	+ 1,99 $(-o \cdot \Delta d)$	
	51,35		+2,78		−21,43	+50,79	3
		22,50			− 4,67 $(o \cdot \Delta s)$	+22,00 $(a \cdot \Delta s)$	
					−26,10	+72,79	
				−2,78	− 2,72 $(a \cdot \Delta d)$	− 0,58 $(-o \cdot \Delta d)$	
	73,85		0,00		−28,82	+72,21	4
73,82 −0,03 $(D{:}0,14)$		73,85 $= s$	0,00		−15,32 $= y_e - y_a$	+72,21 $= x_e - x_a$	

Beispiel. Bei der Aufmessung der Fläche im Bild 3.1 wurden die Punkte 2 und 3 auf die Messungslinie 1–4 aufgenommen (Spalten 2 und 4 des Vordrucks Tafel 5.8).

Es sollen die Koordinaten der Punkte 2 und 3 (auf die Hauptmessungslinie bezogen) berechnet werden (5.9).

5.9 Seitwärts gelegene Punkte

In Spalte 3 des Vordrucks wird $\Delta s = s_{i+1} - s_i$, in Spalte 5 wird $\Delta d = d_{i+1} - d_i$ unter Beachtung der Vorzeichen gebildet. Diese Werte werden mit o bzw. a multipliziert und in den Spalten 6 und 7 niedergeschrieben, deren Summation zu den gesuchten Koordinaten führt.

Mit einem Taschenrechner sind die einzelnen Rechnungen einfach auszuführen. Die zuvor dargelegte Aufbereitung des Rechenweges in Tabellenform eignet sich hervorragend für Berechnungen mit Hilfe eines Tabellenkalkulationsprogramms. Am Markt wird auch hinreichend Software angeboten, mit deren Hilfe die Berechnung der Koordinaten der Einzelpunkte nach Eingabe der Koordinaten der Anfangs- und Endpunkte sowie der Strecken und seitlichen Abstände der Punkte ohne weiteren Aufwand erfolgt.

5.4 Schnittpunkt zweier Geraden

Für viele bautechnische und vermessungstechnische Vorhaben sind die Koordinaten der Schnittpunkte von Geraden zu bestimmen, deren Endpunkte koordinatenmäßig erfasst sind.

Aus Bild 5.10 entnimmt man

$$\tan t_{2,3}{}^{1)} = m_1 = \frac{y_3 - y_2}{x_3 - x_2} \qquad \tan t_{4,1} = m_2 = \frac{y_1 - y_4}{x_1 - x_4}$$

Der Richtungswinkel t wird durch die Parallele zur x-Achse in rechtsläufiger Drehung bis zur Strecke gebildet; er gibt die Richtung der Strecke an. Die Richtung kann in beiden Endpunkten der Strecke ermittelt werden. Diese Richtungswinkel unterscheiden sich um 200 gon.

$$t_{3,2} = t_{2,3} \pm 200\,\text{gon}$$

m nennt man den Richtungskoeffizienten. Um diesen zu bestimmen, ist es gleichgültig, ob

$$\tan t_{2,3} = \frac{y_3 - y_2}{x_3 - x_2} \qquad \text{oder} \quad \tan t_{3,2} = \frac{y_2 - y_3}{x_2 - x_3}$$

gebildet wird.

Der Schnittpunkt P ist der einzige Punkt, für den die Richtungskoeffizienten beider Geraden gültig sind.

$$m_1 = \frac{y_P - y_2}{x_P - x_2} \qquad \text{und} \quad m_2 = \frac{y_P - y_4}{x_P - x_4}$$

[1]) Bezeichnung nach DIN 18709.

5.10 Schnittpunkt zweier Geraden

hieraus folgt

$$y_P - y_2 = m_1 (x_P - x_2)$$
$$y_P - y_4 = m_2 (x_P - x_4)$$

Beide Gleichungen werden subtrahiert und $(m_2 x_2 - m_2 x_2)$ auf der rechten Seite hinzugefügt

$$x_P = x_2 + \frac{(y_4 - y_2) - m_2(x_4 - x_2)}{m_1 - m_2}$$

oder, wenn nach der Subtraktion $(m_1 x_4 - m_1 x_4)$ auf der rechten Seite hinzugefügt wird

$$x_P = x_4 + \frac{(y_4 - y_2) - m_1(x_4 - x_2)}{m_1 - m_2}$$

Aus der Ausgangsgleichung errechnet sich

$$y_P = y_2 + m_1 (x_P - x_2)$$

und $$y_P = y_4 + m_2 (x_P - x_4)$$

mit den Kontrollen

$$m_1 = \frac{y_3 - y_P}{x_3 - x_P} \qquad m_2 = \frac{y_1 - y_P}{x_1 - x_P}$$

Die Koordinaten des Schnittpunktes sind auch einfach über die Achsenabschnittsgleichung zu berechnen. Hierbei schneiden nach Bild 5.10 die Verlängerungen der beiden Geraden auf der y-Achse die Werte b_1 und b_2 ab.

$$b_1 = y_2 - m_1 \cdot x_2 = y_3 - m_1 \cdot x_3$$
$$b_2 = y_1 - m_2 \cdot x_1 = y_4 - m_2 \cdot x_4$$

Die Koordinaten y_p und x_p des Punktes P sind die einzigen Werte, die die Gleichungen der beiden Geraden erfüllen.

$$y_p = m_1 \cdot x_p + b_1 = m_2 \cdot x_p + b_2$$

daraus $x_P = \dfrac{b_2 - b_1}{m_1 - m_2}$

und $y_P = \dfrac{m_1 \cdot b_2 - m_2 \cdot b_1}{m_1 - m_2}$

Das Ergebnis wird kontrolliert mit

$$m_1 = \frac{y_3 - y_P}{x_3 - x_P} \qquad m_2 = \frac{y_1 - y_P}{x_1 - x_P}$$

Der Schnittwinkel der beiden Geraden ist $\gamma = t_{4,1} - t_{2,3}$ und somit

$$\tan \gamma = \tan(t_{4,1} - t_{2,3}) = \frac{\tan t_{4,1} - \tan t_{2,3}}{1 + \tan t_{2,3} \cdot \tan t_{4,1}}$$

$$\tan \gamma = \frac{m_2 - m_1}{1 + m_1 \cdot m_2}$$

Für parallele Geraden gilt

$$m_1 = m_2;$$

für senkrecht aufeinander stehende Geraden ist

$$m_1 \cdot m_2 = -1.$$

Beispiel. Die Koordinaten des Schnittpunktes der Geraden $2-3$ und $1-4$ (3.1 und 5.11) sind zu bestimmen. Die Koordinaten der Punkte 2 und 3 (auf die Hauptmessungslinie bezogen) wurden in Tafel **5.8** berechnet.

Gegebene Koordinaten:

Punkt	1	2	3	4
y	$-13,50$	$-25,38$	$-21,43$	$-28,82$
x	$0,00$	$+23,09$	$+50,79$	$+72,21$

5.11 Geradenschnitt

$m_1 = \dfrac{y_3 - y_2}{x_3 - x_2} = \dfrac{+\ 3,95}{+27,70} = +0,14260$

$b_1 = y_3 - m_1 \cdot x_3 = -21,43 - 0,14260 \cdot 50,79 = -28,6727$

$m_2 = \dfrac{y_1 - y_4}{x_1 - x_4} = \dfrac{+15,32}{-72,21} = -0,21216$

$b_2 = y_4 - m_2 \cdot x_4 = -28,82 + 0,21216 \cdot 72,21 = -13,4999$

$x_P = \dfrac{b_2 - b_1}{m_1 - m_2} = \dfrac{+15,1728}{+0,35476} = +42,77$

$y_P = \dfrac{m_1 \cdot b_2 - m_2 \cdot b_1}{m_1 - m_2} = \dfrac{0,14260 \cdot -13,4999 - (-0,21216 \cdot -28,6727)}{0,14260 - (-0,21216)} = -22,57$

Kontrollen:

$$m_1 = \frac{y_3 - y_P}{x_3 - x_P} = \frac{+1{,}14}{+8{,}02} = +0{,}142\ldots$$

$$m_2 = \frac{y_1 - y_P}{x_1 - x_P} = \frac{+9{,}07}{-42{,}77} = -0{,}212\ldots$$

Beispiel. Die Koordinaten des Schnittpunktes P der Verlängerung des Gebäudes $A-B$ mit der Senkrechten zur Grenze $C-D$ im Punkte D sind zu berechnen (5.12).

Gegebene Koordinaten:

Punkt	A	B	C	D
y	$+114{,}06$	$+140{,}64$	$+100{,}68$	$+67{,}24$
x	$+41{,}52$	$+92{,}13$	$+21{,}90$	$+92{,}09$

5.12 Schnittpunkt

$$m_1 = \frac{y_b - y_a}{x_b - x_a} = \frac{+26{,}58}{+50{,}61} = +0{,}52519$$

$$b_1 = y_a - m_1 \cdot x_a = +114{,}06 - 0{,}52519 \cdot 41{,}52$$

$$b_1 = +92{,}2541$$

$$m_2 = \frac{y_d - y_c}{x_d - x_c} = \frac{-33{,}44}{+70{,}19} = -0{,}47642$$

$$m_3 = -\frac{1}{m_2} = -\frac{1}{-0{,}47642} = +2{,}09899$$

$$b_3 = y_d - m_3 \cdot x_d = +67{,}24 - 2{,}09899 \cdot 92{,}09$$

$$b_3 = -126{,}0560$$

$$x_P = \frac{b_3 - b_1}{m_1 - m_3} = \frac{-218{,}3101}{-1{,}57380} = +138{,}72$$

$$y_P = \frac{m_1 \cdot b_3 - m_3 \cdot b_1}{m_1 - m_3} = \frac{0{,}52519 \cdot -126{,}0560 - (2{,}09899 \cdot 92{,}2541)}{0{,}52519 - 2{,}09899} = 165{,}11$$

Kontrollen:

$$m_1 = \frac{y_P - y_a}{x_P - x_a} = \frac{51,05}{97,20} = 0,525\ldots$$

$$m_3 = \frac{y_P - y_d}{x_P - x_d} = \frac{97,87}{46,63} = 2,098\ldots$$

Beispiel. Von Punkt 3 wird das Lot auf die Gerade $1-2$ gefällt (5.13). Die Koordinaten des Lotfußpunktes 4 sind zu berechnen. Die Aufgabe ist einfach als Schnitt zweier Geraden zu lösen. Gegeben sind die Koordinaten der Punkte 1, 2 und 3.

Punkt	1	2	3
y	826,52	872,14	880,07
x	632,41	687,65	642,90

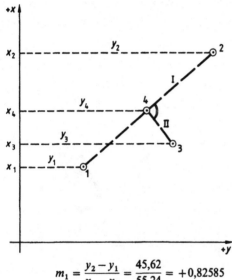

5.13 Lotfußpunkt als Schnitt
zweier Geraden

$$m_1 = \frac{y_2 - y_1}{x_2 - x_1} = \frac{45,62}{55,24} = +0,82585$$

$$b_1 = y_2 - m_1 \cdot x_2 = 872,14 - 0,82585 \cdot 687,65 = 304,2442$$

$$m_2 = -\frac{1}{m_1} = -\frac{1}{0,82585} = -1,21087$$

$$b_2 = y_3 - m_2 \cdot x_3 = 880,07 - (-1,21087 \cdot 642,90) = 1658,5383$$

$$x_4 = \frac{b_2 - b_1}{m_1 - m_2} = \frac{1354,2941}{2,03672} = 664,94$$

$$y_4 = \frac{m_1 \cdot b_2 - m_2 \cdot b_1}{m_1 - m_2} = \frac{0,82585 \cdot 1658,5383 - (-1,21087 \cdot 304,2442)}{0,82585 + 1,21087} = 853,38$$

Kontrollen:

$$m_1 = \frac{y_4 - y_1}{x_4 - x_1} = \frac{26,86}{32,53} = 0,825\ldots$$

$$m_2 = \frac{y_4 - y_3}{x_4 - x_3} = \frac{-26,69}{22,04} = -1,210\ldots$$

6 Flächenberechnungen, Flächenteilungen

Neben der Festlegung von Einzelpunkten sollen bei der Stückvermessung auch Flächen bestimmt werden. Die Methode der Aufmessung und die geforderte Genauigkeit bestimmen die Art der Flächenberechnung, die

nach örtlich gemessenen oder daraus abgeleiteten Maßen

halbgraphisch (mit z. T. gemessenen, z. T. abgegriffenen Maßen) oder

graphisch (mit nur aus der Karte abgegriffenen Maßen)

erfolgen kann.

6.1 Flächenberechnung aus örtlich gemessenen Maßen (aus Dreiecken und Trapezen)

Die Grundfiguren der Flächenberechnung sind das Dreieck und das Trapez, in die eine nach rechtwinkligen Koordinaten aufgemessene Fläche zu zerlegen ist. Man vereinfacht die Rechnung, wenn man von allen Einzelflächen zunächst den doppelten Inhalt rechnet und deren Summe zum Schluss durch 2 dividiert.

Nach Bild **6.1** ist der doppelte Flächeninhalt

des Dreiecks: $\quad 2A = y_3 (x_4 - x_3)$

des Trapezes: $\quad 2A = (y_3 + y_2)(x_3 - x_2)$

des verschränkten Trapezes: $\quad 2A = (y_2 - y_1)(x_2 - x_1)$

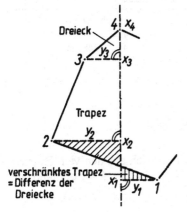

6.1 Dreieck, Trapez und verschränktes Trapez

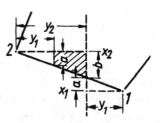

6.2 Verschränktes Trapez

Die Flächenformel für das verschränkte Trapez als Differenz der schraffierten Dreiecke in Bild 6.1 ergibt sich, wenn das senkrecht schraffierte in das schräg schraffierte Dreieck so eingelegt wird, dass sich die spitzen Winkel decken (6.2). Dann ist das in 6.2 schraffierte Trapez die Flächendifferenz der beiden Dreiecke.

$$2A = (y_2 - y_1)(a + b)$$

und, da $(a + b) = x_2 - x_1$ ist,

$$2A = (y_2 - y_1)(x_2 - x_1)$$

Das Ergebnis der Flächenberechnung wird in vollen Quadratmetern angegeben.

Beispiel. Die in Bild 3.1 dargestellte Fläche ist zu ermitteln. Es wird zunächst aus Dreiecken und Trapezen die doppelte Fläche $1 - 4 - 5 - 6 - 7 - 1$ gerechnet und dann die verschränkte doppelte Fläche $1 - 2 - 3 - 4 - 1$ berücksichtigt. Im folgenden ist F mit der Punktnummer = Fußpunkt des jeweiligen Punktes.

Trapez $1 - 4 - F4 - F1$	$(13,50 + 28,82)$ $(72,21 - 0,00) =$	$42,32 \cdot 72,21 =$	$+ 3055,93$	
Dreieck $4 - 5 - F4$	$28,82$ $(97,74 - 72,21) =$	$28,82 \cdot 25,53 =$	$+ 735,77$	
Dreieck $5 - 6 - F6$	$19,98$ $(97,74 - 62,17) =$	$19,98 \cdot 35,57 =$	$+ 710,69$	
Trapez $6 - 7 - F7 - F6$	$(19,98 + 25,32)$ $(62,17 - 16,69) =$	$45,30 \cdot 45,48 =$	$+ 2060,24$	
Verschr. Trapez $7 - 1 - F1 - F7$	$(25,32 - 13,50)$ $(16,69 - 0,00) =$	$11,82 \cdot 16,69 =$	$+ 197,28$	
Dreieck $1 - 2 - F2$	$6,83$ $(25,06 - 0,00) =$	$6,83 \cdot 25,06 =$	$+ 171,16$	
Verschr. Trapez $2 - 3 - F3 - F2$	$(6,83 - 2,78)$ $(51,35 - 25,06) =$	$4,05 \cdot 26,29 =$	$+ 106,47$	
Dreieck $4 - 3 - F3$	$- 2,78$ $(73,85 - 51,35) =$	$-2,78 \cdot 22,50 =$	$- 62,55$	

$$+ 7037,54 - 62,55$$
$$2A = 6974,99$$
$$A = 3487 \, \text{m}^2$$

Diese Flächenberechnung müsste verprobt werden (aus Koordinaten, halbgraphisch, graphisch).

6.2 Flächenberechnung aus rechtwinkligen Koordinaten

Der Flächeninhalt des Vierecks $1 - 2 - 3 - 4$ (6.3) bestimmt sich aus den vier Trapezen $1 - 2 - F2 - F1$; $2 - 3 - F3 - F2$; $4 - 3 - F3 - F4$; $1 - 4 - F4 - F1$ (F = Fußpunkt des jeweiligen Punktes) mit den Flächen A_I, A_{II}, A_{III}, A_{IV}.
Die doppelte Fläche von A_I ist dann

$$2A_I = (y_1 + y_2)(x_1 - x_2)$$

In gleicher Weise findet man den doppelten Flächeninhalt von A_{II}, A_{III}, A_{IV} und damit den des Vierecks mit

$$2A = (y_1 + y_2)(x_1 - x_2) + (y_2 + y_3)(x_2 - x_3)$$
$$- (y_3 + y_4)(x_4 - x_3) - (y_4 + y_1)(x_1 - x_4)$$

Die beiden letzten Glieder werden innerhalb und außerhalb der Klammer der x-Werte mit (-1) multipliziert:

$$2A = (y_1 + y_2)(x_1 - x_2) + (y_2 + y_3)(x_2 - x_3)$$
$$+ (y_3 + y_4)(x_3 - x_4) + (y_4 + y_1)(x_4 - x_1)$$

Dies ergibt die Gaußsche[1]) Trapezformel (Eckzahl der Fläche unbeschränkt)

$$2A = \sum (x_i - x_{i+1})(y_i + y_{i+1})$$

Wenn die Punkte 1 bis 4 in Bild 6.3 auf die y-Achse projiziert werden, erhält man in gleicher Weise

$$2A = \sum (y_{i+1} - y_i)(x_i + x_{i+1})$$

Nach Ausmultiplizieren der Klammern und Ordnen der Gleichung einmal nach steigendem y, zum anderen nach steigendem x, findet man

$$2A = y_1(x_4 - x_2) + y_2(x_1 - x_3) + y_3(x_2 - x_4) + y_4(x_3 - x_1)$$
$$2A = x_1(y_2 - y_4) + x_2(y_3 - y_1) + x_3(y_4 - y_2) + x_4(y_1 - y_3)$$

oder allgemein die Gaußsche Dreiecksformel (Eckzahl der Fläche unbeschränkt)

$$2A = \sum y_i(x_{i-1} - x_{i+1}) = \sum x_i(y_{i+1} - y_{i-1})$$

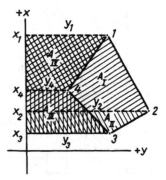

6.3 Flächenberechnung aus rechtwinkligen Koordinaten

Die beiden Gleichungen liefern auch noch als Sonderfall die Fläche des Vierecks aus zwei Produkten:

$$2A \text{ (Viereck)} = (y_1 - y_3)(x_4 - x_2) + (y_2 - y_4)(x_1 - x_3)$$

Die Flächenberechnung aus rechtwinkligen Koordinaten erfolgt zweckmäßig im Vordruck; hierzu ist die Fläche im rechtsläufigen Sinn zu beziffern; die Koordinaten sind mit ihren Vorzeichen (darauf besonders achten) einzusetzen.

Beispiel. Die Fläche des in Bild 6.4 dargestellten Grundstücks ist zu berechnen. Es sind die in Bild 3.1 angegebenen Werte mit den in Tafel 5.8 errechneten Koordinaten für die Punkte 2 und 3 zusammengestellt.

[1]) Karl Friedrich Gauß, 1777 bis 1855, Professor der Mathematik und Geodäsie und Direktor der Sternwarte in Göttingen.

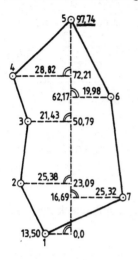

6.4 Flächenberechnung aus rechtwinkligen Koordinaten
(zu Tafel 6.5)

Tafel **6.5** Vordruck und Beispiel für die Flächenberechnung aus rechtwinkligen Koordinaten

Punkt Nr.	y_i ±		x_i ±		Δy_i $=y_{i+1}-y_{i-1}$ +	−	Δx_i $=x_{i-1}-x_{i+1}$ +	−	$y_i \cdot \Delta x_i$ (Sp.2 × Sp.5) +	−	$x_i \cdot \Delta y_i$ (Sp.3 × Sp.4) +	−
1		2		3	4		5		6		7	
1	−	13,50	±	0,00								
2	−	25,38	+	23,09		7,93		50,79	1289,05			183,10
3	−	21,43	+	50,79		3,44		49,12	1052,64			174,72
4	−	28,82	+	72,21	21,43			46,95	1353,10		1547,46	
5	±	0,00	+	97,74	48,80		10,04		0,00		4769,71	
6	+	19,98	+	62,17	25,32		81,05		1619,38		1574,14	
7	+	25,32	+	16,69		33,48	62,17		1574,14			558,78
1	−	13,50	±	0,00		50,70		6,40	86,40			0,00
2	−	25,38	+	23,09								
					95,55	95,55	153,26	153,26	6974,71		7891,31	916,60
					0		0				6974,71	

$$A = 3487 \, \text{m}^2$$

Rechengang: In den Spalten 2 und 3 werden die Koordinaten der Punkte (Sp. 1) mit Vorzeichen eingetragen. Die ersten beiden Punkte sind am Schluss zu wiederholen, um die Rechnung zu vereinfachen. Die Summe der in den Sp. 4 bzw. 5 gebildeten Koordinatenunterschieden muss Null sein. Die Summen der Sp. 6 bzw. 7 ergeben jeweils den doppelten Flächeninhalt.

Die in den Sp. 6 und 7 angegebenen Produkte werden in der Praxis meist nicht aufgeschrieben, da mit den elektr. Rechnern die Addition mit der Multiplikation gekoppelt auszuführen ist.

Für die elektronischen Rechenanlagen und elektronischen Tischrechner gibt es zur Flächenberechnung Rechenprogramme.

6.3 Flächenberechnung aus Polarkoordinaten

Wenn die Aufmessung einer Fläche nach dem Polarverfahren (Abschn. 3.4) erfolgt, kann die Fläche berechnet werden, ohne die gemessenen Werte vorher in rechtwinklige Koordinaten umzurechnen.

Die doppelte Fläche eines Dreiecks (6.6) ist

$$2A = b \cdot c \cdot \sin\alpha\,^1)$$

6.6 Dreiecksfläche

6.7 Flächenberechnung aus Polarkoordinaten

In Bild **6.7** wird die nach der Polarmethode aufgenommene Fläche $1-2-3-4$ über Dreiecke berechnet. Die doppelte Fläche ist:

$$2A = 2A_1 + 2A_2 + 2A_3 - 2A_4$$

mit den Einzelflächen

$$2A_1 = s_1 \cdot s_2 \cdot \sin\,(r_2 - r_1)$$
$$2A_2 = s_2 \cdot s_3 \cdot \sin\,(r_3 - r_2)$$
$$2A_3 = s_3 \cdot s_4 \cdot \sin\,(r_4 - r_3)$$
$$-2A_4 = -s_1 \cdot s_4 \cdot \sin\,(r_4 - r_1) = s_4 \cdot s_1 \cdot \sin\,(r_1 - r_4)$$

Allgemein gilt

$$2A = \sum_{i=1}^{n} s_i \cdot s_{i+1} \cdot \sin\,(r_{i+1} - r_i)$$

[1]) $h = b \cdot \sin\alpha \qquad 2A = c \cdot h = b \cdot c \cdot \sin\alpha.$

Beispiel. Die in Bild 6.4 dargestellte Fläche wurde polar aufgenommen (6.8). Die Richtungen r und die Strecken s wurden mit einem elektronischen Tachymeter (s. Teil 2) gemessen. Dabei ist die Ausgangsrichtung die Nullrichtung des Tachymeters.

Die gemessenen Strecken und Richtungen sind aufgelistet. Der erste Punkt in der Zusammenstellung wird wiederholt, um den Rechenvorgang zu vereinfachen.

6.8 Berechnung der Fläche Bild 6.4
aus Polarkoordinaten

Punkt Nr.	s_i m	r_i gon	$r_{i+1} - r_i$ gon	$s_i \cdot s_{i+1} \cdot \sin(r_{i+1} - r_i)$ m^2
1	73,44	192,305		
			$- 6,414$	$- 355,96$
2	48,19	185,891		
			$-39,391$	$-1060,75$
3	37,95	146,500		
			$-40,433$	$- 745,69$
4	33,12	106,067		
			$- 9,525$	$- 350,32$
5	70,96	96,542		
			34,505	2884,10
6	78,79	131,047		
			32,485	3600,79
7	93,57	163,532		
			28,773	3001,14
1	73,44	192,305		

$$2A = 6973{,}31$$
$$A = 3487\,\text{m}^2$$

6.4 Halbgraphische Flächenberechnung

Sie ist vorteilhaft anzuwenden, wenn sich die zu berechnende Fläche in schlanke Dreiecke zerlegen lässt. Die Maße für die Flächenberechnung sind z.T. gemessen und werden z.T. einer genauen Kartierung entnommen. Man wird im Hinblick auf die halbgraphische Flächenberechnung bei der Stückvermessung bereits die erforderlichen Maße ermitteln. Dabei gilt der Grundsatz, die kurze Grundseite eines Dreiecks zu messen und die lange Höhe abzugreifen (6.9). Der in dem graphisch bestimmten Maß liegende Fehler wird dann mit einem kleinen Wert multipliziert und so der Flächenfehler gering. Die Genauigkeit steht der Flächenberechnung aus örtlich gemessenen Maßen nur wenig nach.

Beispiel. In Bild 6.9 sind die eingetragenen Maße in der Örtlichkeit gemessen. Die Höhen h_1 bis h_5 der einzelnen Dreiecke werden abgegriffen. Damit findet man die Fläche des

oberen Flurstücks:
$$2A_1 = 16,52 \cdot 35,9 + 15,80 \cdot 38,4 = 1199,79 \qquad A_1 = 600\,\text{m}^2$$

unteren Flurstücks:
$$2A_2 = 10,00 \cdot 35,0 + 11,18 \cdot 30,5 + 15,80 \cdot 35,1 = 1245,57 \qquad A_2 = 623\,\text{m}^2$$

6.9 Halbgraphische
 Flächenberechnung

6.10 Verwandeln eines Sechsecks
 in ein flächengleiches Dreieck

6.5 Graphische Flächenbestimmung

Die Kartierung ist die Grundlage der graphischen Flächenbestimmung, die vielfach zur Kontrolle rechnerischer Verfahren dient. Die Ausführung ist verschieden und richtet sich nach Form und Größe der Fläche und nach dem zur Verfügung stehenden Hilfsmittel. Einfach ist es, eine unregelmäßige Fläche in ein Dreieck gleichen Flächeninhalts umzuwandeln, dessen Grundseite und Höhe abgegriffen werden. Die Flächenverwandlung basiert auf dem Lehrsatz: Dreiecke mit gleicher Grundseite und gleicher Höhe sind flächengleich.

In Bild **6.10** ist das Sechseck $1-2-3-4-5-6$ in das flächengleiche Dreieck $A-3-B$ verwandelt worden. Dabei werden jeweils Ecken „abgeschnitten". Zur Linie $1-3$ wird durch 2 die Parallele gezogen und Punkt A gefunden. Die Verbindungslinie $A-3$ ergibt

den Flächenausgleich der schraffierten Dreiecke. Zum Beweis fällt man die gleichlangen Lote von 2 und A auf die Linie $3-1$. Dann haben die Dreiecke $1-2-3$ und $A-3-1$ dieselbe Grundseite $1-3$ und die gleiche Höhe; somit sind sie flächengleich. Da das nicht schraffierte Dreieck in beiden Flächen enthalten ist, sind auch die schraffierten Dreiecke flächengleich. Dann wird Punkt 5 und zuletzt Punkt 4 „abgeschnitten". AB als Grundseite und h als Höhe des Dreiecks sind abzugreifen.

6.5.1 Zerlegen von Flächen, Planimeterharfe, Quadratglastafel

Grundfiguren sind das Dreieck, das Trapez und das Rechteck. In solche zerlegt man geradlinig begrenzte Flächen auf dem Plan und greift zu ihrer Flächenbestimmung Grundseite und Höhe ab. Hilfsmittel wie die Planimeterharfe und die Quadratglastafel vereinfachen die graphische Flächenberechnung.

Die Planimeterharfe besteht aus einer Schar von Geraden, die parallel und in gleichem Abstand auf Transparentpapier aufgezeichnet sind (6.11). Der Abstand richtet sich nach dem Maßstab. Mit der aufgelegten Harfe teilt man die Fläche in Trapeze gleicher Höhe h und greift die Mittellinien m der Trapeze ab.

$$A = h \cdot m_1 + h \cdot m_2 + \ldots h \cdot m_n = h \cdot \sum_1^n m$$

Da alle Trapeze die gleiche Höhe h haben, summiert man die abgegriffenen m graphisch. Dazu nimmt man m_1 in den Zirkel, setzt es an m_2 an und addiert dies dazu usw. Kleine überstehende Flächen versucht man auszugleichen oder berechnet sie gesondert. Besonders bei langgestreckten Flächen (Verkehrswege, Gewässer) ist die Planimeterharfe vorteilhaft anzuwenden.

6.11 Flächenberechnung mit der Planimeterharfe

Für den Maßstab 1:1000 ist in Bild 6.11 der Abstand der Parallelen $h = 5\,\text{m}$. Die Summe der Mittellinien erhält man mit $\sum m = 54{,}8\,\text{m}$ und den Flächeninhalt mit $A = 54{,}8 \cdot 5 = 274\,\text{m}^2$. Planimeterharfen kann man selbst herstellen; sie werden jedoch auch für die gebräuchlichsten Maßstäbe gefertigt.

Die Quadratglastafel trägt auf der Unterseite ein Quadratnetz in Millimeterteilung mit hervorgehobenen 5 und 10 mm Linien. Durch Auflegen der Tafel auf den Plan und Auszählen der von der Figur eingeschlossenen Millimeterquadrate erhält man unmittelbar den Flächeninhalt. Die Einteilung in 10 mm breite Streifen (Trapeze) erleichtert die Flächenbestimmung. Die Umrechnung der in dem Plan ermittelten Fläche in mm² in die Fläche in der Natur unter Berücksichtigung des Maßstabsverhältnisses erfolgt nach Abschn. 1.3.5.

6.6 Planimeter

Für die Berechnung von Flächen mit unregelmäßigem Umriss sind die genannten Hilfsmittel wenig geeignet. Die Bestimmung solcher Flächen lässt sich schneller, einfacher und genauer mit einem Planimeter durch Umfahren ihrer Umgrenzungslinien ausführen.

Das Polarplanimeter ist ein mechanisches Integrationsgerät; es besteht aus dem Polstab P (6.12) mit dem Pol B, dem Fahrstab F mit der Fahrlupe L und der Messrolle M. Fahrstab und Polstab sind durch das Gelenk G verbunden. Der Pol B ist als Polplatte mit Kugelpol ausgebildet. Der Messbereich des Planimeters mit Pol außerhalb der Fläche ist 150 mm × 520 mm bis 500 mm × 600 mm. Er ist bedingt durch die Länge des Fahrstabes (166 ⋯ 330 mm) und des Polstabes (194 ⋯ 370 mm).

6.12 Kompensations-Polar-
planimeter mit Polplatte
und Fahrlupe (Ott)

Bei der Messung wird die Umgrenzungslinie der Figur genau in ihrer ganzen Länge im rechtsläufigen Sinn umfahren. Die Bewegungen des Fahrstabes übertragen sich auf die mit ihrem Stahlrand auf dem Papier laufenden Messrolle M, deren Umfang 60 mm beträgt. Mit der Messrolle M verbunden ist eine Teilung mit 100 Teilstrichen, der ein Nonius mit einer Ablesegenauigkeit von $^1/_{10}$ Teilstrich gegenüberliegt. Die Länge der Noniuseinheit ist somit $^1/_{1000}$ des Rollenumfangs. Eine Zählscheibe gibt die vollen Umdrehungen an. Die Ablesung am Zählwerk ist vierstellig.

6.6.1 Fahrstabeinstellung

In der Regel legt man den Pol des Planimeters außerhalb der zu umfahrenden Fläche fest. Wenn f die Länge des Fahrstabes, u der Umfang der Messrolle und n die Anzahl der Rollenumdrehungen in Noniuseinheiten (Endablesung minus Anfangsablesung) bedeuten, ist die Fläche auf dem Papier (n in Noniuseinheiten)

$$A_p = \frac{f \cdot u \cdot n}{1000} \qquad \frac{u}{1000} = \text{Länge der Noniuseinheit}$$

Bei gleicher Fahrstablänge ist $\dfrac{f \cdot u}{1000}$ konstant; man bezeichnet diesen Ausdruck mit k. Er ist gleich der Papierfläche in mm², die der Abwicklung $n = 1$ (Noniuseinheiten) entspricht.

6.13 Grundkreis

Damit ist die Papierfläche im Maßstab $1:1$ bei n Rollenumdrehungen

$$A_p = k \cdot n$$

Bei großen Flächen kann der Pol auch innerhalb der zu umfahrenden Fläche liegen. Jetzt ist

$$A_p = k \cdot n + A_g \quad \text{(Pol innerhalb)}$$

A_g ist die Fläche des Grundkreises, bei dessen Umfahren die Messrolle schleift, also keine Umdrehungen stattfinden. Bild 6.13 zeigt diese Stellung des Planimeters.

Die Konstante für die Grundkreisfläche ist auf der dem Planimeter beigegebenen Tabelle vermerkt. Sie kann auch einfach über eine bekannte Vergleichsfläche A_v von der ungefähren Größe des Grundkreises, die mit dem Planimeter zu umfahren ist, errechnet werden:

$$A_g = A_v - k \cdot n$$

Die Flächenbestimmung mit Pol innerhalb der Fläche sollte sich wegen der Unsicherheit der Grundkreisfläche A_g auf Ausnahmen beschränken. Man wird große Flächen sinnvoller in einige Teilflächen zerlegen und deren Größe mit dem Pol außerhalb bestimmen.

Für den Kartenmaßstab $1:M$ findet man die Fläche (Pol außerhalb)

$$A = A_p \cdot M^2 = \frac{f \cdot u \cdot n}{1000} M^2 \quad \text{mit } A \text{ in mm}^2$$

oder $\quad A = \dfrac{f \cdot u \cdot n}{1000} \cdot \dfrac{M^2}{1000^2} = \dfrac{f \cdot u \cdot M^2}{1000^3} \, n = K \cdot n \quad$ mit A in m^2

Die Noniuseinheit K ist bei gleichbleibender Fahrstablänge und demselben Maßstab konstant

$$K = \frac{f \cdot u \cdot M^2}{1000^3}$$

Sie ist gleich der Naturfläche in m^2, die der Abwicklung $n = 1$ (Noniuseinheiten) entspricht. K wird als runder Wert gewählt und ist in kleinen Tabellen, die den Polarplanimetern beigefügt sind, angegeben.

Es gibt Polarplanimeter mit konstanter und veränderlicher Fahrstabeinstellung. Bei variabler Fahrstabeinstellung ist die Teilung auf dem Fahrstab meistens $^1\!/_2$ mm oder $^5\!/_6$ mm; der Nullpunkt der Teilung liegt vielfach nicht beim Fahrstift.

Beispiel. Für ein Polarplanimeter mit dem Rollenumfang $u = 60$ mm und konstantem Fahrstab $f = 166{,}66$ mm ist die Noniuseinheit K für verschiedene Maßstäbe anzugeben.

Die Fahrstablänge $f = 166{,}66$ mm ergibt sich für $K = 10$ m^2 (gewählt), $u = 60$ mm und $1:M = 1:1000$ aus der Gleichung für $K = f \cdot u \cdot M^2/1000^3$:

$$f = \frac{1000^3 \cdot K}{u \cdot M^2} = \frac{1000 \cdot 10}{60} = 166{,}66 \text{ mm}$$

Nach $K = f \cdot u \cdot M^2/1000^3 = M^2/100\,000$ findet man die Noniuseinheit für den jeweiligen Maßstab in m^2.

Tafel **6.14** Noniuseinheit K für ein Polarplanimeter mit konstantem Fahrstab $f = 166,66$ mm

Maßstab 1:M	Fahrstabeinstellung mm	Noniuseinheit K
1: 500	166,66	2,5 m^2
1:1000		10 m^2
1:2000		40 m^2
1:2500		62,5 m^2
1:5000		250 m^2

Die Rollenumdrehungen in Noniuseinheiten (End- minus Anfangsablesung), multipliziert mit K, geben die gesuchte Fläche in m^2.

Beispiel. Für ein Polarplanimeter ($u = 60$ mm) mit veränderlichem Fahrstab und $^5/_6$ mm Teilung ist K für verschiedene Maßstäbe anzugeben.

Man berechnet die Fahrstabeinstellungen für die einzelnen Maßstäbe nach

$$f = \frac{1000^3\,K}{u \cdot M^2}$$

(in mm) für jeweils einen runden (gewählten) Wert für K. Da der Fahrstab in $^5/_6$ mm geteilt ist, muß dieser Wert durch $^5/_6$ dividiert oder mit $^6/_5$ multipliziert werden.

Tafel **6.15** Noniuseinheit K für ein Polarplanimeter mit veränderlichem Fahrstab und $^5/_6$ mm Teilung.

Maßstab 1:M	Fahrstabeinstellung $^5/_6$ mm	Noniuseinheit K
1: 500	160,00	2 m^2
1:1000	200,00	10 m^2
1:2000	100,00	20 m^2
1:2500	128,00	40 m^2
1:5000	80,00	100 m^2

Die $^5/_6$ mm Teilung am Fahrstab hat den Vorteil der runden Einstellwerte.

Man kann die Fahrstabeinstellung auch über eine bekannte Vergleichsfläche finden.

Aus $\quad K_1 = \dfrac{f_1 \cdot u \cdot M_1^2}{1000^3} \quad$ und $\quad K_2 = \dfrac{f_2 \cdot u \cdot M_2^2}{1000^3} \quad$ folgt $\quad \dfrac{K_1}{f_1 \cdot M_1^2} = \dfrac{K_2}{f_2 \cdot M_2^2}$

Bei konstantem f ist $\quad \dfrac{K_1}{K_2} = \dfrac{M_1^2}{M_2^2}$

bei konstantem M $\quad \dfrac{f_1}{f_2} = \dfrac{K_1}{K_2}$

bei konstantem K $\quad \dfrac{f_1}{f_2} = \dfrac{M_2^2}{M_1^2}$

Mit diesen Gleichungen kann jede Fahrstabeinstellung oder die Konstante K berechnet werden.

6.6.2 Flächenbestimmung mit dem Polarplanimeter

Die Kartierung wird plan auf dem Tisch befestigt und das Planimeter in die Grundstellung (6.16) gebracht, so dass die Linie Pol–Messrolle mit dem Fahrstab ungefähr einen rechten Winkel bildet, wenn der Fahrstift (Fahrlupe) im Schwerpunkt der Fläche ist. Der Pol wird festgelegt und durch eine Umfahrung der Fläche sichergestellt, dass die Messrolle auf dem Papier bleibt und mit dem Fahrstift die ganze Fläche zu erfassen ist.

Auf der Umgrenzungslinie markiert man scharf einen Punkt (6.17), stellt den Fahrstift (Fahrlupe) darauf ein und liest 4stellig am Zählwerk ab. Die Fläche wird sodann rechtsläufig freihändig einmal umfahren, bis der Fahrstift (Fahrlupe) wieder genau am Ausgangspunkt ist. Nach der Ablesung am Zählwerk ist die Fläche nochmals zu umfahren und wieder am Zählwerk abzulesen. Unter Festhalten des Poles führt man die Messrolle unter dem Polstab hindurch und bringt sie in eine symmetrische Stellung zu Lage 1 (6.18). In dieser 2. Lage wird von einem Punkt ausgehend die Fläche erneut zweimal umfahren.

| 6.16 | Grundstellung des Polarplanimeters | 6.17 | Umfahren einer Fläche mit dem Polarplanimeter | 6.18 | Umfahren einer Fläche in zwei Lagen des Planimeters |

Beispiel. Mit einem Kompensations-Planimeter mit konstantem Fahrstab ist eine Fläche im Maßstab 1:500 zu bestimmen. Nach Tafel 6.14 ist $K = 2,5 \, \text{m}^2$.

	Lage 1			Lage 2		
Rollen-ablesung	· Rollen-abwicklung n	Mittel	Rollen-ablesung	Rollen-abwicklung n	Mittel	
5320			7504			
	2121			2123		
7441		2120	9627		2122	
	2119			2121		
9560			1748			

Mittel aus Lage 1 und 2: $n = 2121$ Fläche $A = K \cdot n = 2,5 \cdot 2121 = 5302 \, \text{m}^2$

Die Fläche wird in beiden Lagen je zweimal umfahren.

Durch die Messung in 2 Lagen wird eine eventuelle Rollenschiefe (Rollenachse nicht parallel zum Fahrarm) kompensiert[1]; man spricht deshalb von Kompensations-Planimetern.

[1] kompensieren = ausgleichen.

Eine einfache und immer anwendbare, von der Fahrstabeinstellung unabhängige Art der Flächenbestimmung mit dem Polarplanimeter ist die über eine Vergleichsfläche A_v. Es wird ein Quadrat mit den Seitenlängen a (z. B. $a = 10$ cm) gezeichnet; bei Karten mit Gitternetz wird dieses als Vergleichsfläche genommen, womit der Papiereingang gleich mit berücksichtigt ist. Die Größe der quadratischen Vergleichsfläche ist dann für den Maßstab $1:M$

$$A_v = a \cdot \frac{M}{100} \cdot a \cdot \frac{M}{100} = a^2 \cdot \frac{M^2}{10\,000} \qquad A_v \text{ in m}^2, a \text{ in cm}$$

Ein dem Planimeter beigegebenes Kontroll-Lineal dient zum Umfahren einer Kreisvergleichsfläche bekannten Flächeninhaltes (z. B. 100 cm²), ohne die Fläche zeichnen zu müssen.

Die Vergleichsfläche und die zu bestimmende Fläche werden mit dem Polarplanimeter in 2 Lagen umfahren. Wenn n_v die Rollenabwicklung für die Vergleichsfläche A_v und n_a die Rollenabwicklung für die zu bestimmende Fläche A ist, ergibt sich die Proportion

$$\frac{A}{n_a} = \frac{A_v}{n_v} \quad \text{und daraus} \quad A = \frac{n_a}{n_v} A_v$$

Beispiel. Eine unregelmäßige Fläche im Maßstab 1:1000 ist zu bestimmen. Als Vergleichsfläche dient ein Quadrat von 10 cm Seitenlänge. Dann ist

$$A_v = 10^2 \cdot \frac{1000^2}{10\,000} = 10\,000 \text{ m}^2.$$

Vergleichsfläche A_v und Fläche A werden in zwei Lagen je zweimal umfahren.

	Vergleichsfläche A_v					
	Lage 1			Lage 2		
Rollenablesung	Rollenabwicklung n_v	Mittel	Rollenablesung	Rollenabwicklung n_v	Mittel	
4216			7668			
	1112			1114		
5328		1111	8782		1113	
	1110			1112		
6438			9894			
	Mittel $n_v = 1112$					

	Fläche A					
	Lage 1			Lage 2		
Rollenablesung	Rollenabwicklung n_a	Mittel	Rollenablesung	Rollenabwicklung n_a	Mittel	
4024			7862			
	1598			1595		
5622		1597	9457		1595	
	1596			1595		
7218			1052			
	Mittel $n_a = 1596$		Fläche $A = \dfrac{1596}{1112} \cdot 10\,000 = 14\,353 \text{ m}^2 = 1{,}4353$ ha			

6.6.3 Digital-Planimeter

Als Nachfolgemodelle der Kompensations-Polarplanimeter sind elektronische Digital-Planimeter entwickelt worden. Beim mehrmaligen Umfahren eines geschlossenen Linienzuges wird an der Flüssigkeitskristallanzeige direkt die Fläche ausgewiesen. Entsprechend der gewählten Einheit werden Flächen im metrischen oder englischen System angezeigt. Die Drehbewegungen der Messrolle werden in elektrische Signale umgewandelt. Die Stromversorgung erfolgt über Akku (mit Ladegerät). Eine V24 Schnittstelle gestattet den Anschluss eines Rechners bzw. Druckers.

Bild 6.19 zeigt das elektronische Digital-Planimeter 330 E von Haff. Im Prinzip erfolgt das Umfahren der zu bestimmenden Fläche in gleicher Weise wie bei dem in Abschn. 6.6.2 behandelten mechanischen Polar-Planimeter. Dabei sollen Pol- und Fahrstab annähernd einen rechten Winkel zueinander bilden, wenn sich die Fahrlupe etwa im Schwerpunkt der zu messenden Fläche befindet. Den Anfangspunkt der Messung auf der Umfahrungslinie wählt man in dem Bereich, in dem die Messrolle nahezu keine Umdrehung ausführt. Zum Ausmessen von Flächen, die in einem bestimmten Maßstab gezeichnet sind, können feste oder frei programmierbare Maßstäbe gewählt werden. Bei älteren Digital-Planimetern erfolgt die Maßstabswahl über Eingabe eines Skalierfaktors. Tabellen mit Skalierfaktoren sind den jeweiligen Geräten beigegeben.

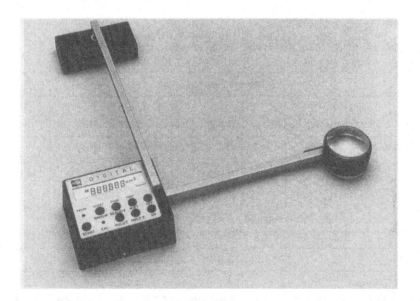

6.19 Digital-Planimeter 330 E (Haff)

Tafel 6.20 zeigt einen Auszug aus der Tabelle, deren Werte analog der in Tafel 6.14 aufgeführten Angaben sind. Nach Eingabe der Kommastelle erscheint nach Umfahren der Fläche der Flächeninhalt A in der entsprechenden Flächeneinheit in der Anzeige.

Für die Bestimmung langgestreckter Flächen eignet sich das Digital-Rollplanimeter (6.21), bei dem der Integriermechanismus auf einem Wagen mit zwei Rollen ruht. Durch

Tafel **6**.20 Skalierung

Maßstab	Skalierfaktor
1 : 1000	1,0
1 : 2000	4,0
1 : 2500	6,25
1 : 3000	9,0

diese Rollen kann sich der Wagen nur geradlinig bewegen. Auf der Geraden ist der Fahrbereich des Planimeters i. a. auf einem Meter, in seitlicher Ausdehnung durch die Länge des Fahrarms beschränkt.

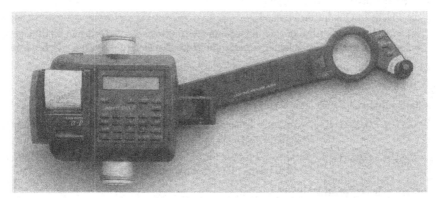

6.21 Längen-, Flächen-, Koordinatenmessgerät und Digitalisierer Super PLANIX (Riefler)

Die Informationen zur Berechnung der Flächen oder Strecken werden über zwei Impulsgeber gewonnen. Ein Impulsgeber ist in einer Rolle eingebaut. Bewegt sich die Rolle, werden die Impulse von einem Mikroprozessor in Entfernungen umgesetzt und daraus der Rechtswert in einem örtlichen Koordinatensystem berechnet. Der zweite Impulsgeber befindet sich in der Drehachse des Fahrarmes. Veränderungen des Fahrarmes bezüglich der durch die Rollenstellung vorgegebenen Bewegungsachse werden als Winkelveränderungen interpretiert. Bei konstanter Fahrarmlänge wird so der Hochwert in einem örtlichen Koordinatensystem berechnet. Damit sind die notwendigen Daten vorhanden, um neben Flächen auch Längen und Koordinaten bestimmen zu können.

Bei vielen Digital-Planimeterrn sind zwei verschiedene Messmethoden möglich: Punkt-Messmethode und Kurven-Messmethode.

Die Punkt-Messmethode wird gewählt, wenn die Flächenbegrenzung zwischen den Punkten geradlinig verläuft. Die Punkte werden mit Hilfe der Lupe angefahren, die Messwerte mittels einer Eingabetaste erfasst.

Die Kurven-Messmethode wird bei nicht geradlinigen Linienverläufen gewählt, dabei wird die Linie – wie bei den mechanischen Planimetern – mit Hilfe der Lupe möglichst genau abgefahren. Der Prozessor speichert die Kurvenpunkte und berechnet daraus die gewünschten Ergebnisse.

Es gibt Planimeter, die ein Umschalten zwischen den verschiedenen Methoden während der Bearbeitung zulassen.

Die Rollplanimeter können mit einem Drucker (Miniprinter) ausgestattet werden, der auf das Gehäuse aufgesteckt wird. Über die RS-232-Schnittstelle kann mit Hilfe eines Interface eine Verbindung zu einem Rechner hergestellt werden. So können die mit dem Planimeter ermittelten Daten direkt in entsprechende Software zur Weiterbearbeitung übertragen werden.

6.7 Zulässige Abweichungen für Flächenberechnungen

Wie bei den Längenmessungen sind auch die Flächenberechnungen zulässige Abweichungen festgelegt.

Zulässige Abweichungen für Flächenermittlungen

In den nachstehenden Formeln bedeuten

A die Fläche in Quadratmetern und

D_A die größte zulässige Abweichung in Quadratmetern zwischen zwei Flächenermittlungen, wenn beide nach derselben Berechnungsart ausgeführt worden sind (gleichartige Flächenermittlung).

Für Flächenermittlungen aus Feldmaßen und Koordinaten

$D_A = 0,2 \sqrt{A} + 0,0003\,A$

Für halbgraphische Flächenermittlung

$D_A = 0,3 \sqrt{A} + 0,0003\,A$, wenn zur Flächenermittlung eine Karte im Maßstab 1:500 oder größer benutzt worden ist

$D_A = 0,4 \sqrt{A} + 0,0003\,A$, wenn zur Flächenermittlung eine Karte im Maßstab 1:750, 1:1000, 1:1250 oder 1:1500 benutzt worden ist

Für graphische Flächenermittlung

$D_A = 0,3 \sqrt{A} + 0,0003\,A$, wenn zur Flächenermittlung eine Karte im Maßstab 1:500 oder größer benutzt worden ist

$D_A = 0,6 \sqrt{A} + 0,0003\,A$, wenn zur Flächenermittlung eine Karte im Maßstab 1:750, 1:1000, 1:1250 oder 1:1500 benutzt worden ist

$D_A = 1,2 \sqrt{A} + 0,0003\,A$, wenn zur Flächenermittlung eine Karte im Maßstab 1:2000 oder 1:2500 benutzt worden ist

Für zwei nach verschiedenen Berechnungsarten ausgeführte Flächenermittlungen (gemischte Flächenermittlung) gilt als größte zulässige Abweichung der Grenzwert der Formel für die ungenauere der beiden zu vergleichenden Berechnungen.

Ist eine Karte durch Vergrößerung entstanden, so gilt als Maßstab der Karte der Kartierungsmaßstab.

Die zulässigen Abweichungen für Flächen ergeben nach den genannten Formeln folgende Werte in Quadratmetern:

D_A \diagdown A	$0,2\sqrt{A}$ $+0,0003\,A$	$0,3\sqrt{A}$ $+0,0003\,A$	$0,4\sqrt{A}$ $+0,0003\,A$	$0,6\sqrt{A}$ $+0,0003\,A$	$1,2\sqrt{A}$ $+0,0003\,A$
100	2	3	4	6	12
500	5	7	9	14	27
1000	7	10	13	19	38
5000	16	23	30	44	88
10000	23	33	43	63	123

6.8 Praktische Hinweise zur Flächenberechnung

1. Die Anlage der örtlichen Messung sollte bereits die spätere Art der Flächenberechnung berücksichtigen.

2. Jede Flächenberechnung ist zu verproben. Diese Proben bilden zwei unabhängig voneinander und auf verschiedenen Wegen durchgeführte Flächenberechnungen. Bei gleichgewichtigen Berechnungen (z. B. beide aus Feldmaßen) ist das Mittel aus beiden Rechnungen einzuführen; bei Flächenberechnungen unterschiedlicher Genauigkeit (z. B. einmal aus Feldmaßen, einmal graphisch) hält man die genauere Rechnung an und wählt die ungenauere als Proberechnung.

3. Zweckmäßig ist die Flächenberechnung eines großen Blockes (Massenberechnung) aus gemessenen Maßen und die Flächenermittlung der Teilstücke halbgraphisch oder graphisch unter Abstimmung der Einzelflächen auf die Gesamtmasse.

4. Der Einsatz der Hilfsmittel richtet sich nach der Form der zu berechnenden Flächen. Langgestreckte Flächen lassen sich vorteilhaft halbgraphisch berechnen, wenn die kleine Seite der zu bildenden Dreiecke örtlich gemessen ist. Auch die Planimeterharfe leistet hier gute Dienste. Dagegen eignet sich das Polarplanimeter nicht zur Berechnung langgestreckter Figuren; mit ihm sollten Figuren umfahren werden, die ungefähr in allen Richtungen gleiche Ausdehnung haben. Für die Bestimmung langgestreckter Figuren leistet das Digital-Rollplanimeter gute Dienste.

5. Graphische Flächenbestimmungen hängen vom Maßstab des Planes und von der Maßhaltigkeit des Zeichenträgers ab. Je größer der Maßstab ist, um so genauer wird die graphische Flächenbestimmung sein. Bei genauen Flächenbestimmungen ist der Papiereingang über Vergleichswerte festzustellen und in Rechnung zu setzen.

6.9 Flächenteilungen, Flächenausgleich

Vielfach sind wegen Baumaßnahmen unter bestimmten Bedingungen Flächen zu teilen. Wenn dabei neue Eigentumsgrenzen entstehen, die einer Vermarkung und Sicherung im Kataster und Grundbuch bedürfen, fallen diese Vermessungen unter die Hoheitsaufgaben im Vermessungswesen.

Nach der Aufmessung einer Fläche kann ihre Teilung streng rechnerisch oder durch Näherung erfolgen. Die zweckmäßige Anlage der Messungslinien für die Aufmessung oder auch einige zusätzliche Maße können die Rechnung wesentlich vereinfachen. Man unterscheidet

 Teilungen von einem Punkt aus
 Parallelteilungen
 Senkrechtteilungen
 Verhältnisteilungen

Einige Beispiele sollen dies erläutern.

Beispiel. Von einem dreieckigen Grundstück ABC (6.22) mit einem Flächeninhalt $A = 709$ m² soll eine Fläche $A_1 = 400$ m² zur Lagerung von Baustoffen so abgetrennt werden, dass die Trennlinie durch Punkt D geht. Die einfachste Rechnung ergibt sich, wenn örtlich das Lot von D auf AB gefällt und die Höhe ($h_d = 15{,}83$ m) gemessen wird.

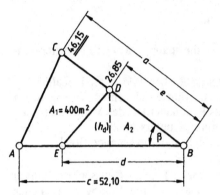

6.22 Teilung von einem Punkt aus

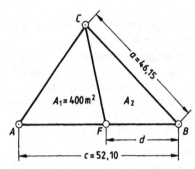

6.23 Teilung von einem Dreieckspunkt aus

Dann ist $A_2 = A - A_1 = 709 - 400 = 309\,\mathrm{m}^2$

Aus $A_2 = \dfrac{d \cdot h_d}{2}$ folgt $d = \dfrac{2A_2}{h_d} = \dfrac{618}{15,83} = 39,04\,\mathrm{m}$

Ist h_d nicht gemessen, findet man mit

$$A = \tfrac{1}{2}\,a \cdot c \cdot \sin\beta \qquad \text{und} \qquad A_2 = \tfrac{1}{2}\,d \cdot e \cdot \sin\beta \qquad d = \frac{A_2}{A} \cdot \frac{a \cdot c}{e}$$

Ein Sonderfall tritt ein, wenn die Flächen A und A_1 denselben Eckpunkt haben, also die Punkte C und D identisch sind (**6.23**). Es ist dann

$$a = e \qquad \text{und} \qquad d = \frac{A_2}{A} \cdot c$$

Beispiel. Bei $A = 709\,\mathrm{m}^2$ und $A_1 = 400\,\mathrm{m}^2$ ist in diesem Fall

$$d = \frac{309}{709} \cdot 52,10 = 22,71\,\mathrm{m}$$

Kontrolle:

$$h_c = \frac{2A}{c} = \frac{2 \cdot 709}{52,10} = 27,22\,\mathrm{m}$$

$$A_1 = \frac{1}{2}\,(c - d) \cdot h_c = \frac{1}{2} \cdot 29,39 \cdot 27,22 = 400\,\mathrm{m}^2$$

Beispiel. In einem dreieckigen Grundstück mit der Fläche A soll eine Fläche A_1 so abgeteilt werden, dass die neue Grenzlinie parallel zur Grundlinie des Dreiecks verläuft (**6.24**).

Es ist $A_2 = A - A_1$

$\qquad\qquad 2A = c \cdot h$ und $2A_2 = x \cdot h_2$

und daraus

$$\frac{A}{A_2} = \frac{c \cdot h}{x \cdot h_2}$$

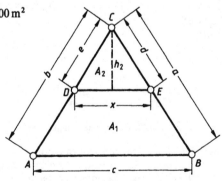

6.24 Teilung parallel zur Grundlinie

Mit $\quad x = \dfrac{c \cdot h_2}{h}\quad$ ist schließlich $\quad h_2 = h \cdot \sqrt{\dfrac{A_2}{A}}$

Entsprechend findet man

$$x = c\sqrt{\frac{A_2}{A}} \qquad d = a\sqrt{\frac{A_2}{A}} \qquad e = b\sqrt{\frac{A_2}{A}}$$

Gemessen wurden

$$a = 67{,}00\,\text{m}, \quad b = 71{,}34\,\text{m}, \quad c = 74{,}30\,\text{m}$$

Daraus ergibt sich die Fläche des Grundstücks mit

$$A = \sqrt{s(s-a)\,(s-b)\,(s-c)} \qquad s = \frac{a+b+c}{2} = 106{,}32$$

$$A = 2164\,\text{m}^2$$

Abzutrennen ist die Fläche $A_1 = 1300\,\text{m}^2$.

$$A_2 = A - A_1 = 2164 - 1300 = 864\,\text{m}^2$$

$$d = a\sqrt{\frac{A_2}{A}} = 67{,}00\sqrt{\frac{864}{2164}} = 42{,}34\,\text{m}$$

$$e = b\sqrt{\frac{A_2}{A}} = 71{,}34\sqrt{\frac{864}{2164}} = 45{,}08\,\text{m}$$

$$x = c\sqrt{\frac{A_2}{A}} = 74{,}30\sqrt{\frac{864}{2164}} = 46{,}95\,\text{m}$$

Zur Kontrolle:

$$h = \frac{2A}{c} = \frac{2 \cdot 2164}{74{,}30} = 58{,}25\,\text{m}$$

$$h_2 = h\sqrt{\frac{A_2}{A}} = 58{,}25\sqrt{\frac{864}{2164}} = 36{,}81\,\text{m}$$

$$A_1 = \frac{1}{2}\,(c+x)\,(h-h_2) = \frac{1}{2} \cdot 121{,}25 \cdot 21{,}44 = 1300\,\text{m}^2$$

Beispiel. Eine örtliche aufgemessene Fläche (6.25) soll durch eine Parallele MN zu AB in zwei flächengleiche Teile geteilt werden.

Die doppelte Gesamtfläche ist nach Abschn. 6.2

$$2A = (y_a - y_c)\,(x_b - x_d) + (y_d - y_b)\,(x_a - x_c)$$

$$2A = 40{,}17 \cdot 77{,}12 + (-46{,}20) \cdot (-78{,}62) = 6730\,\text{m}^2$$

Für die Teilfläche ist

$$2A_1 = \tfrac{1}{2} \cdot 2A = 3365\,\text{m}^2$$

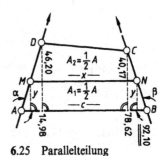

6.25 Parallelteilung

Die Fläche $AMNB$ wird als Differenz der Flächen zweier Dreiecke aufgefasst, deren gemeinsame Spitze durch den Schnitt der Verlängerungen der Strecken AD und BC gebildet wird.

$$2A_1 = \frac{c^2}{\cot\alpha + \cot\beta} - \frac{x^2}{\cot\alpha + \cot\beta} \quad ^1)\qquad \text{und daraus}\qquad x = \sqrt{c^2 - 2A_1\,(\cot\alpha + \cot\beta)}$$

$$\cot\alpha = \frac{14{,}98}{46{,}20} = 0{,}32424 \qquad \cot\beta = \frac{13{,}48}{40{,}17} = 0{,}33557$$

$$\cot\alpha + \cot\beta = 0{,}65981$$

$$x = \sqrt{92{,}10^2 - 3365 \cdot 0{,}65981} = 79{,}13\,\text{m}$$

Aus $\quad 2A_1 = (c + x)\,y\quad$ folgt $\quad y = \dfrac{2A_1}{c + x} = \dfrac{3365}{92{,}10 + 79{,}13} = 19{,}65\,\text{m}$

Die Absteckmaße (nach dem Pythagoras oder mittels Funktionen) sind dann $AM = 20{,}66\,\text{m}$, $BN = 20{,}73\,\text{m}$. Kontrolle für die Restfläche (die Maße im Bild 6.26 sind aus den gegebenen und errechneten Werten bestimmt)

$$2A_2 = 20{,}52 \cdot 70{,}52 + 26{,}55 \cdot 72{,}24 = 3365\,\text{m}^2$$

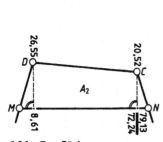

6.26 Restfläche

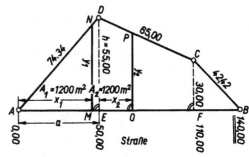

6.27 Senkrechtteilung

Beispiel. Von der örtlich aufgemessenen Fläche $ABCD$ (6.27) sind zwei Teilflächen von je 1200 m², ausgehend von Punkt A so abzutrennen, dass die neuen Begrenzungslinien senkrecht zu AB stehen. Aus Bild **6.27** entnimmt man

$$\frac{y_1}{x_1} = \frac{h}{a}\qquad y_1 = \frac{h}{a}x_1 \qquad y_1 \cdot x_1 = 2A_1 \qquad y_1 = \frac{2A_1}{x_1} \qquad \frac{h}{a}x_1 = \frac{2A_1}{x_1}$$

$$x_1 = \sqrt{\frac{2A_1 \cdot a}{h}} = \sqrt{\frac{2 \cdot 1200 \cdot 50}{55}} = 46{,}71\,\text{m}$$

$$y_1 = \frac{2A_1}{x_1} = \frac{2400}{46{,}71} = 51{,}38\,\text{m}$$

Probe: $\quad 2A_1 = x_1 \cdot y_1 = 46{,}71 \cdot 51{,}38 = 2400\,\text{m}^2$

Fläche $ADE = \dfrac{55{,}00 \cdot 50{,}00}{2} = 1375\,\text{m}^2\qquad$ Fläche $MNDE = 1375 - 1200 = 175\,\text{m}^2$

$^1)$ Entwicklung der Flächeninhaltsformel für das Dreieck:

$$2A_0 = c \cdot h \qquad \cot\alpha = \frac{q}{h} \qquad \cot\beta = \frac{p}{h} \qquad \cot\alpha + \cot\beta = \frac{p+q}{h} = \frac{c}{h}$$

$$h = \frac{c}{\cot\alpha + \cot\beta} \qquad 2A_0 = \frac{c^2}{\cot\alpha + \cot\beta}$$

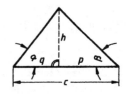

Somit ist von DE aus noch die Fläche $DPOE = 1200 - 175 = 1025\,\text{m}^2$ abzutrennen. Diese Fläche fassen wir als Differenz zweier Dreiecke auf, deren gemeinsame Spitze durch den Schnitt der Verlängerungen der Strecken DC und AB gebildet wird,

$$2A_{(DPOE)} = \frac{h^2}{\cot\alpha + \cot\beta} - \frac{y_2^2}{\cot\alpha + \cot\beta} \quad {}^1)$$

$$\alpha = \text{Winkel } EDC \text{ und somit } \cot\alpha = \frac{25,00}{60,00} = 0,41667$$

$$\beta = \text{Winkel } DEB = 100\,\text{gon und somit } \cot\beta = 0$$

Dann ist

$$y_2 = \sqrt{h^2 - 2A_{(DPOE)} \cdot \cot\alpha} = \sqrt{55^2 - 2050 \cdot 0,41667} = 46,59\,\text{m}$$

$$2A_{(DPOE)} = (h + y_2)x_2 \qquad x_2 = \frac{2A}{h + y_2} = \frac{2050}{55,00 + 46,59} = 20,18\,\text{m}$$

Absteckmaße: $AN = 69,44\,\text{m}$ \qquad $DP = 21,86\,\text{m}$

Geknickte Grenzen sind unwirtschaftlich und aus baulichen Gründen vielfach unerwünscht. Es ist anzustreben, anstelle eines geknickten Grenzzuges eine gerade Grenze zu legen, ohne die angrenzenden Flächen zu verändern.

Beispiel. Der im Bild 6.28 dargestellte Grenzzug $1-2-3-4-5$ soll unter Beibehaltung der Flächen der Flurstücke 38 und 39 so begradigt werden, dass die neue Grenze durch Punkt 1 geht.

6.28 Grenzbegradigung mit Flächenausgleich von einem Punkt aus

Zur Aufmessung des Linienzuges legt man eine Messungslinie durch Punkt 1, die bereits möglichst nahe der neuen Grenze liegt. Die durch diese Linie und den geknickten Grenzzug gebildete Fläche ist dann nach der Gaußschen Flächenformel

$$
\begin{aligned}
2\Delta A = y_2\,(x_3 - x_1) = \quad & 5,00 \cdot \quad 13,00 = \quad 65,00 \\
+ y_1\,(x_2 - x_6) = \quad & 0,00 \cdot -19,00 = \quad 0 \\
+ y_6\,(x_1 - x_5) = \quad & 0,00 \cdot -27,00 = \quad 0 \\
+ y_5\,(x_6 - x_4) = \quad & 7,00 \cdot \quad 11,00 = \quad 77,00 \\
+ y_4\,(x_5 - x_3) = -2,00 \cdot & \quad 14,00 = \quad\quad\quad -28,00 \\
+ y_3\,(x_4 - x_2) = -2,00 \cdot & \quad\ 8,00 = \quad\quad\quad -16,00 \\
\hline
& \quad\quad\quad\ 142,00 \quad -44,00 \\
& 2\Delta A \quad = 98,00 \\
& \Delta A \quad\ = 49\,\text{m}^2
\end{aligned}
$$

${}^1)$ S. Fußnote S. 95.

Die rechtsläufig umfahrenen Flächen sind demnach zu groß; deshalb ist Punkt 6 in Richtung Punkt 5 zu verschieben. Das Dreieck $1-6-7$ muß dabei $\Delta A = 49\,\text{m}^2$ groß werden.

$$2\Delta A = g \cdot y_7 \qquad y_7 = \frac{2\Delta A}{g} = \frac{98,00}{29,00} = 3,38\,\text{m} \qquad \Delta x_7 = \frac{2,00}{7,00} \cdot 3,38 = 0,97$$

Absteckmaß $6-7 = \sqrt{0,97^2 + 3,38^2} = 3,52\,\text{m}$

Mit der Geraden $1-7$ ist die Flächenausgleichslinie gefunden.

Beispiel. Eine gebrochene Grenzlinie (6.29) soll unter Ausgleich der Flächen so begradigt werden, dass die neue Grenze parallel AB verläuft.

6.29 Grenzbegradigung mit Flächenausgleich
parallel zu einer gegebenen Linie

Auf die örtlich abgesteckte Parallele zu AB (22,00 m) werden die Knickpunkte rechtwinklig aufgemessen und die Fläche, die der gebrochene Linienzug mit dieser Parallelen bildet, berechnet. Die Fläche $1-2-3-4-5-6-7-8-1$ ist nach der Gaußschen Flächenformel

$$2\Delta A = -1155,58 \qquad \Delta A = -578\,\text{m}^2$$

Die Probe aus Dreiecken und Trapezen ergibt ebenfalls $\Delta A = -578\,\text{m}^2$. Die negativen Flächen überwiegen, die Linie $1-2$ muß deshalb parallel um y nach oben verschoben werden (6.30).

6.30 Parallelverschiebung einer Grenzlinie

$$2\Delta A = (b+x)\,y = b \cdot y + x \cdot y \qquad (a-b):h = (b-x):y \qquad \text{und daraus} \qquad y = \frac{b-x}{a-b}\,h$$

$$2\Delta A = \frac{(b+x)\,(b-x)}{a-b}\,h = \frac{(b^2-x^2)}{a-b}\,h = \frac{b^2 \cdot h}{a-b} - \frac{x^2 \cdot h}{a-b}$$

$$x = \sqrt{b^2 - \frac{2\Delta A\,(a-b)}{h}} = \sqrt{87,64^2 - \frac{1155,58 \cdot 9,97}{22,00}} = 84,60\,\text{m}$$

$$y = \frac{2\Delta A}{b+x} = \frac{1155,58}{172,24} = 6,71\,\text{m}$$

Absteckmaße: $1-C = 6,85\,\text{m} \qquad 2-D = 6,92\,\text{m}$

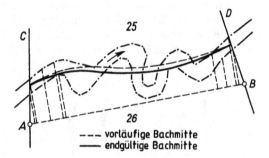

6.31 Flächenausgleich durch die Linie CD

Mit den errechneten Maßen x und y erhält man die in Bild 6.31 angegebenen Werte; der verschränkte Linienzug ergibt mit der neuen Linie CD die Fläche $\Delta A = 0$.

Beispiel. Eine im Wasserbau und Kulturbau vorkommende Aufgabe ist das Begradigen von Bachläufen. Zwischen den Flurstücken 25 und 26 soll der Bach (6.32) so reguliert werden, dass nach Abzug der für das neue Bachbett erforderlichen Grundfläche die beiden Eigentümer gleichmäßig an dem Landgewinn teilhaben. Man misst von einer Standlinie $A - B$ die beiden Uferlinien des Baches rechtwinklig auf, wie am Anfang und Ende der Linie dargestellt ist, und kartiert sie großmaßstäblich. Es werden dann die Fläche A_1 zwischen der Messungslinie und dem linken Ufer und die Fläche A_2 zwischen der Messungslinie und dem rechten Ufer berechnet. Die neue Bachmittellinie wird so angeordnet, dass die Fläche, die sie mit der Messungslinie einschließt $A_m = (A_1 + A_2)/2$ groß ist. Hierzu zeichnet man nach Augenmaß eine vorläufige Bachlinie in den maßstäblichen Plan (gestrichelt) und ermittelt mit dem Polarplanimeter oder der Planimeterharfe die Fläche bis zur Messungslinie, die gleich A_m sein sollte. Eine Abweichung von A_m bedingt eine kleine Verschiebung der vorläufigen Bachlinie.

6.32 Begradigung eines Baches

Die neue Bachmitte wird von der Messungslinie aus nach rechtwinkligen Koordinaten, die dem maßstäblichen Plan entnommen werden, abgesteckt; von dieser Linie aus sind die Uferbegrenzungslinien zu bestimmen, die sich nach dem Querschnitt richten, der nach den abzuführenden Wassermengen und sonstigen wasserbau- und kulturbautechnischen Gesichtspunkten zu entwerfen ist.

7 Hauptbestandteile der Vermessungsinstrumente

Die in diesem Buch behandelten Vermessungsinstrumente sind

> Nivellierinstrumente zur Höhenbestimmung und
> Theodolite zur Winkelmessung; und im Teil 2
> Tachymeter zur kombinierten Distanz-, Höhen- und Winkelmessung.

Allen gemeinsam sind das Zielfernrohr und Libellen.

7.1 Das Fernrohr

Hinsichtlich der geometrischen Anordnung und der optischen Gesetze gleichen sich im Prinzip die Fernrohre. Ein Fernrohr vergrößert den Gesichtswinkel, unter dem ferne Gegenstände dem Auge erscheinen. Es besteht in der Regel aus dem meist aus mehreren Linsen zusammengesetzten Objektiv (dem Gegenstand zugekehrt), dem Strichkreuz, dem meist aus mehreren Linsen bestehenden Okular (dem Betrachter zugewandt), das als Lupe wirkt und der Zwischenlinse (Fokussierlinse) zur Scharfstellung des Bildes.

7.1.1 Linsen und deren Gesetze

Eine Linse ist ein von zwei Kugelflächen oder einer Kugelfläche und einer Ebene begrenzter durchsichtiger Körper aus einer bestimmten Glassorte. Sammellinsen (7.1a bis c) sind in der Mitte dicker, Zerstreuungslinsen (7.1d bis f) dünner. Je nach der Form der Begrenzungsflächen kennt man bikonvexe (a), plankonvexe (b), konkav-konvexe (c), bikonkave (d), plankonkave (e) und konvex-konkave (f) Linsen.

a) b) c) d) e) f) 7.1 Linsenformen

Die gebräuchlichsten Linsen sind die bikonvexen und die bikonkaven. Jede dieser Linsen hat 2 Brennpunkte F_1 uns F_2 (7.2 und 7.4), die bei gleichen Krümmungsradien gleichweit vom Linsenmittelpunkt entfernt sind; diese Entfernung heißt Brennweite f. Die Hauptachse (optische Achse) der Linse geht durch die Mittelpunkte M_1 und M_2 ihrer Begrenzungskreise und steht auf der Mittelebene der Linse, die sie im optischen Mittelpunkt O schneidet, senkrecht. Auf ihr liegen die Brennpunkte F_1 und F_2. Bei einer bikonvexen Linse mit Kugelflächen gleicher Krümmung und aus Glas mit $n = 1,5$ fällt der Brennpunkt in den Krümmungsmittelpunkt.

Für die folgenden Betrachtungen gilt die Einschränkung, dass die Linsen dünn sind und es sich um achsnahe Strahlen handelt.

Alle Strahlen, die parallel zur Hauptachse laufen und die eine Sammellinse durchdringen, gehen auf der anderen Seite der Linse durch den Brennpunkt (7.2). Umgekehrt werden alle Strahlen, die vom Brennpunkt ausgehen (Brennstrahlen), von der Linse in der Richtung parallel zur Hauptachse gebrochen.

7.2 Bikonvexe Linse (Sammellinse)
 M_1, M_2 Krümmungsmittelpunkte
 F_1, F_2 Brennpunkte
 O Linsenmittelpunkt
 f Brennweite

Parallele Strahlen, die nicht parallel zur Hauptachse verlaufen, vereinigen sich nach Durchdringen der Linse in einem Punkt (7.3). Es ist der Schnittpunkt des Hauptstrahls, der die Linse in der Mitte trifft und daher unabgelenkt durchdringt, mit der Brennebene, die durch den Brennpunkt geht und rechtwinklig auf der Hauptachse steht.

7.3 Parallele Strahlen schräg zur Hauptachse
 (Strahlengang vereinfacht dargestellt, als
 ob die Brechung in Linsenmitte erfolgen
 würde)

Strahlen, die parallel zur Hauptachse durch eine Zerstreuungslinse gehen, werden zum dickeren Ende hin gebrochen (7.4) und scheinen von einem Punkt aus zu kommen, der negativer Brennpunkt (Zerstreuungspunkt) heißt.

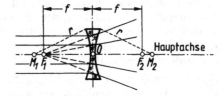

7.4 Bikonkave Linse (Zerstreuungslinse)

Das durch die Sammellinse erzeugte reelle, verkleinerte, umgekehrte Bild eines Gegenstandes, der sich außerhalb der doppelten Brennweite befindet, zeigt Bild 7.5. Wenn die Gegenstandsweite mit a und die Bildweite mit b bezeichnet werden, findet man

$$\frac{AB}{A_1 B_1} = \frac{a}{b} = \frac{a-f}{f}$$

und daraus die Linsengleichung (für dünne Linsen und achsnahe Strahlen)

$$\frac{1}{a} + \frac{1}{b} = \frac{1}{f} \text{ (Dioptrische Hauptformel)}$$

7.5 Konstruktion des von der Sammellinse entworfenen
 Bildes, $a > 2f$

7.6 Das virtuelle Bild des Gegen-
 standes, der innerhalb der ein-
 fachen Brennweite liegt, $a < f$

Liegt der Gegenstand innerhalb der einfachen Brennweite, so erhält man ein virtuelles, aufrechtes, vergrößertes Bild (7.6) mit der Proportion

$$\frac{AB}{A_1B_1} = \frac{a}{b} = \frac{f}{f+b}$$

und damit die Lupengleichung

$$\frac{1}{a} - \frac{1}{b} = \frac{1}{f}$$

Als Brechkraft der Linse, deren Einheit die Dioptrie ist, bezeichnet man den reziproken Wert der Linsenbrennweite in Metern. Eine Linse mit der Brennweite 0,25 m hat die Brechkraft $1/0,25 = 4$ Dioptrien. Dünne zusammengesetzte Linsen wirken wie eine einfache Linse, deren Brechkraft gleich der Summe der Brechkräfte der Einzellinsen ist.

7.1.2 Blenden, Objektiv, Okular

Die gemachte Einschränkung hinsichtlich der Dicke der Linse und der achsnahen Strahlen galt für die vorstehenden Betrachtungen. Bei dickeren Linsen und achsfernen Strahlen treten Abbildungsfehler [1]) der Linse auf. Man begegnet ihnen durch Anordnung von Blenden und Zusammensetzung des Objektivs und des Okulars aus Linsen mit verschiedener Brechkraft.

Als Öffnungsblende (Aperturblende) [2]) dient meistens die Objektivfassung, die die Öffnung der ankommenden Strahlen begrenzt; die Strichkreuzfassung als Gesichtsfeldblende begrenzt die Neigung der Strahlenbündel gegen die Hauptachse. So werden achsferne parallele Strahlen und stark gegen die Hauptachse geneigte Strahlen ausgeblendet. Die den Objektivkegel beschneidende Blende heißt Eintrittspupille, die das Bild der den Bildstrahlenkegel begrenzenden Blende Austrittspupille.

[1]) Die hauptsächlichsten Abbildungsfehler sind: Sphärische Aberration (Unschärfe durch achsferne Strahlen), Astigmatismus („Brennpunktlosigkeit" einfallender Strahlen von Punkten, die weit außerhalb der Achse liegen; die Punkte werden strichförmig verzerrt), chromatische Aberration (Fehler durch Farbzerstreuung des Lichtes).
[2]) Apertura (lat.) = Öffnung.

7.7 Zusammengesetztes
Objektiv

7.8 Okular mit zusammengesetzter
Kollektiv- und Augenlinse

Durch Zusammensetzen des Objektivs (7.7) aus einer Sammellinse aus Kronglas [1]) (Brechungskoeffizient $n = 1,52$) und einer Zerstreuungslinse aus Flintglas [2]) ($n = 1,62$) lässt sich die Farbzerstreuung wenigstens für zwei Farben, z. B. Grün und Rot, aufheben. Solche Linsensysteme heißen Achromate. Durch komplizierte Linsensysteme lassen sich auch drei und mehr Farben ausschalten (Apochromate).

Das im Bild 7.8 dargestellte Okular besteht aus zwei zusammengesetzten Linsen (Augen- und Kollektivlinse). Objektiv und Okular ergeben bei der Betrachtung des Gegenstandes ein umgekehrtes Bild. Man kann es durch Einschalten einer Sammellinse (Umkehrlinse) oder durch Einschalten von Prismen zwischen Objektiv und Okular aufrichten.

7.1.3 Das Strichkreuz

Um einen bestimmten Punkt in der Örtlichkeit anzielen zu können, haben die zu Messzwecken verwendeten Fernrohre ein Strichkreuz (DIN 18725). Es ist ein plangeschliffenes Glasplättchen, auf das zwei senkrecht zueinander stehende Striche eingeätzt oder eingeritzt sind (7.9). Bei Feinnivellieren ist die eine Hälfte des waagerechten Striches als Keil ausgebildet (7.10); dieser erleichtert bei Verwendung von Nivellierlatten mit Strichteilung das Koinzidieren mit einem Lattenstrich.

7.9 Einfaches Strichkreuz
mit Distanzstrichen

7.10 Strichkreuz mit Keil
und Distanzstrichen

7.11 Fernrohr-Strich-
platte

Bild 7.11 zeigt das gebräuchlichste, zur Hälfte als Doppelstrich ausgeführte Strichkreuz für Theodolite. Die Doppelstriche erleichtern das scharfe Anzielen des Punktes.

[1]) Kronglas = kalihaltiges Glas.
[2]) Flintglas = bleihaltiges Glas.

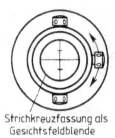

Strichkreuzfassung als
Gesichtsfeldblende

7.12 Strichkreuzplatte mit Justierschrauben

Die Strichkreuzfassung, die gleichzeitig als Gesichtsfeldblende dient, ist mit einem Ring oder Kegelstumpf verbunden, der durch drei oder vier Justierschrauben gehalten wird (7.12). Damit ist die Strichkreuzplatte um geringe Beträge zu verschieben. Die Strichkreuz-Justierschrauben werden meistens nach Abschrauben eines Schutzringes am Okularkopf zugänglich.

Mit den beiden kleinen waagerechten Strichen (Reichenbach'sche Distanzstriche), die im gleichen Abstand vom Querstrich angebracht sind, kann man optisch die Entfernung vom Instrument bis zum Ziel (Nivellierlatte) messen (7.13). Der zwischen diesen Strichen eingeschlossene Lattenabschnitt in Metern mal 100 ergibt die Entfernung (Näheres über optische Entfernungsmessung s. Teil 2).

Die Verbindungslinie zwischen optischem Mittelpunkt des Objektivs und Strichkreuz-schnittpunkt bezeichnet man mit Ziellinie[1]).

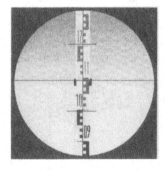

7.13 Strichkreuzablesung und optische Entfernungsmessung.
Ablesung: Querstrich 1,092
Entfernung: Strich oben $l_o = 1,105$
unten $l_u = 0,996$

$l = 0,109$
Entfernung = $0,109 \times 100 = 10,9$ m

7.1.4 Das einfache Meßfernrohr

Das einfache astronomische oder Keplersche Fernrohr besteht aus einer Objektivlinse mit großer (100 bis 700 mm) und einer Okularlinse mit kleiner Brennweite (6 bis 16 mm), die sich in zwei ineinander verschiebbaren Röhren befinden.

Es soll die Wirkung des Meßfernrohrs für die beiden Fälle besprochen werden, wenn sich der Gegenstand in endlicher und in unendlicher Entfernung vom Objektiv befindet.

[1]) Diese Definition ist nicht ganz korrekt, genügt aber für diese Betrachtungen. Nach Helmert ist die Ziellinie des geodätischen Fernrohrs der geometrische Ort aller Punkte, in denen der Strichkreuzschnittpunkt durch das Objektiv im Objektraum abgebildet wird.

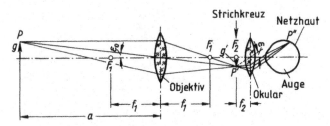

7.14 Strahlengang im astronomischen Fernrohr bei Einstellung auf einen nahen Zielpunkt

Die Objektivlinse bildet einen in endlicher Entfernung befindlichen Gegenstand g umgekehrt und verkleinert als reelles Bild g' ab (7.14). In dieser Bildebene muss das Strichkreuz angeordnet sein, das zusammen mit dem vom Objektiv entworfenen Bild durch das Okular (Lupe), dessen Brennpunkt F_2 ebenfalls in dieser Bildebene liegt, betrachtet wird.

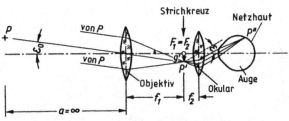

7.15 Strahlengang im astronomischen Fernrohr bei Einstellung auf einen fernen Zielpunkt

Von einem weit entfernt liegenden Punkt entsteht das Bild in der Brennebene. In dieser Ebene liegen wieder das Strichkreuz mit der Gesichtsfeldblende und der Brennpunkt F_2 des Okulars (7.15). Damit wird erreicht, dass die Lichtstrahlen aus dem Okular parallel austreten und durch die Augenlinse auf der Netzhaut des Auges zu einem Bild vereinigt werden.

Die Forderung, dass das vom Objektiv erzeugte Bild jeweils in der Strichkreuzebene liegt, wird meistens durch eine Zwischenlinse (Fokussierlinse) erfüllt.

7.1.5 Fernrohr mit innerer Einstellinse (Innenfokussierung)

Zwischen Objektiv und Okular ist eine Zwischenlinse als schwache Zerstreuungslinse angeordnet (7.16). Die Länge des Fernrohrs ist unveränderlich, das Strichkreuz fest eingebaut. Die über einen Triebknopf verschiebbare Zwischenlinse, auch Fokussierlinse genannt, bewirkt das Verlegen des vom Gegenstand erzeugten Bildes in die Strichkreuzebene. Zur Scharfeinstellung des Strichkreuzes ist das Okular durch ein Schraubengewinde um geringe Beträge zu verändern. Dabei kann ein Beobachter die auf dem Okularring befindliche Dioptrienzahl für sein Auge ablesen und bei künftigen Beobachtungen sofort einstellen.

Zum groben Einrichten des Fernrohrs auf das Ziel dient ein Diopter (Kimme und Korn). Die Leistung eines Fernrohrs ist abhängig von der Vergrößerung, der Helligkeit und dem Gesichtsfeld.

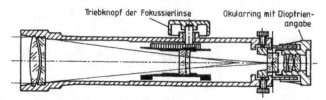

Triebknopf der Fokussierlinse Okularring mit Dioptrien-
angabe

7.16 Fernrohr mit Innenfokussierung (unveränderliche Länge)

Die Vergrößerung v eines Fernrohrs ist das Verhältnis des Sehwinkels ε (7.15), unter dem man einen Gegenstand (Nivellierlatte) im Fernrohr erblickt, zum Sehwinkel ε_0, unter dem man den Gegenstand ohne Fernrohr sieht.

$$v = \frac{\varepsilon}{\varepsilon_0}$$

Nach Bild 7.15 ist

$$g' = f_1 \cdot \varepsilon_0 = f_2 \cdot \varepsilon$$

und damit

$$v = \frac{\varepsilon}{\varepsilon_0} = \frac{f_1}{f_2} = \frac{\text{Brennweite Objektiv}}{\text{Brennweite Okular}}$$

Aus dem Sehwinkelverhältnis lässt sich näherungsweise die Fernrohrvergrößerung bestimmen, wenn man abwechselnd durch und neben das Fernrohr blickt und die Felder vergleicht (7.17).

$$v = \frac{\varepsilon}{\varepsilon_0} = \frac{\dfrac{L}{s}}{\dfrac{L_0}{s}} = \frac{L}{L_0}$$

Die dargestellte Vergrößerung ist fünffach.

$$v = \frac{L}{L_0} = \frac{10}{2} = 5$$

7.17 Bestimmen der Fernrohr-
vergrößerung

Man kann die Vergrößerung auch aus den Durchmessern der Eintritts- und Austrittspupille bestimmen. Den Durchmesser d der Austrittspupille erhält man, indem man in $\approx 25 \cdots 30\,\text{cm}$ Abstand vor das Okular ein Blatt Papier hält, auf dem sich die Austrittspupille als helle Kreisscheibe zeigt. Wird noch der Durchmesser D des Objektivs (Eintrittspupille) gemessen, so ist die Vergrößerung des Fernrohrs

$$v = \frac{D}{d}$$

Die Fernrohrvergrößerung der Vermessungsinstrumente ist 15 bis 50fach; sie ist in den Gebrauchsanleitungen jeweils angegeben.

Die Helligkeit eines Fernrohrs wird durch das Verhältnis der Lichtmengen H_1 und H_2 definiert, die ein Gegenstand auf die Einheit der Netzhaut des Auges über das Fernrohr und ohne Fernrohr wirft.

$$h = \frac{H_2}{H_1} = c \left(\frac{D}{v}\right)^2 \frac{1}{p^2} = c \cdot \frac{d^2}{p^2}$$

hierin bedeuten D = Eintrittspupille (Objektivdurchmesser), v = Vergrößerung, p = Durchmesser der Augenpupille ($\approx 2\,$mm am Tage), c = Konstante (bei vergüteter Optik $\approx 0,9$, bei nicht vergüteter Optik $\approx 0,6$), d = Durchmesser der Austrittspupille.

Bei jeder brechenden Fläche einer Linse verliert das Licht $\approx 5\%$ an Helligkeit, beim Durchgang durch ein Fernrohr also $30 \cdots 40\%$. Um diesem Lichtverlust entgegenzuwirken und den Kontrast des Bildes zu erhöhen, werden auf die Linsenflächen hauchdünne, durchsichtige Schichten aufgedampft, die reflexmindernd wirken. Man spricht vom Antireflex (AR)- oder Transparent (T)-Belag oder auch vom Vergüten der Linsen, die dann in der Draufsicht violett aussehen und den Lichtverlust eines Fernrohrs auf $\approx 10\%$ mindern.

Unter dem Gesichtsfeld versteht man den Öffnungswinkel γ des Kegelraumes, der im Fernrohr zu überblicken ist; er ist bei geodätischen Fernrohren $\approx 1 \cdots 2\,$gon. Um γ zu bestimmen, wird an einer Latte in der Entfernung s der durch das Gesichtsfeld erzeugte Lattenabschnitt l abgelesen. Dann ist

$$\gamma = \frac{l}{s}\,\text{rad}$$

7.2 Libellen

Zum Messen mit Vermessungsinstrumenten müssen Instrumentenachsen vertikal oder horizontal gestellt werden. Um dies zu erreichen, bedient man sich der Libellen, bei denen sich die Oberfläche der Flüssigkeit durch die Schwerkraft senkrecht zur Richtung des Lotes befindet.

Libellen werden in zwei Formen gefertigt: die Dosenlibelle zum Grobeinstellen und die Röhrenlibelle zum Feineinstellen.

Die Libellen reagieren äußerst empfindlich auf äußere Einflüsse wie Sonneneinstrahlung und Erschütterungen, z. B. aus Verkehrseinflüssen. Auch müssen die Libellen vor jeder Messung zum Einspielen gebracht werden. Das ist störend und zeitraubend. Man hat deshalb optisch-mechanische Bauteile entwickelt, die nach der Grobhorizontierung durch die Dosenlibelle die Feinhorizontierung automatisch vornehmen. Diese Bauteile werden als Kompensator bezeichnet. Bei den Nivellierinstrumenten mit Kompensator wird die Ziellinie innerhalb eines kleinen Bereiches waagerecht gestellt. Bei den Theodoliten mit automatischem Höhenindex wird die Vertikalkreisablesung automatisch auf die Lotrichtung bezogen. Die Kompensatoren werden bei der Behandlung der entsprechenden Vermessungsinstrumente erläutert.

7.2.1 Dosenlibelle

Es ist ein flaches, rundes, unten zugeschmolzenes und mit Äther oder Alkohol gefülltes Glasgefäß in einer Metallfassung (7.18). Der von der Flüssigkeit nicht ausgefüllte Raum bildet die Libellenblase als Dampf der Flüssigkeit. Auf der Oberfläche des Glaskörpers sind konzentrische Kreise eingeätzt, um das Einspielen der Libellenblase beobachten zu können. Die Libelle spielt ein, wenn der Mittelpunkt der Kreise mit dem Mittelpunkt der Libellenblase zusammenfällt. Die Tangentialebene an die Kugelfläche im Mittelpunkt der Kreise heißt Libellenachse.

Die Libellenfassung hat drei Justierschrauben, mit denen die Forderung Libellenachse senkrecht Stehachse zu erfüllen ist (s. Abschn. 9.4). Mit einer justierten Dosenlibelle wird beim Einspielen der Libellenachse die Stehachse eines Instrumentes grob senkrecht gestellt.

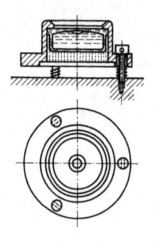

7.18 Dosenlibelle
(Schnitt und Draufsicht)

7.19 Röhrenlibelle
(Schnitt und Draufsicht)

7.2.2 Röhrenlibelle

Es ist eine zylindrische Glasröhre, deren obere Seite im Innern tonnenförmig ausgebildet ist (DIN 18722). Den tonnenförmigen Schliff kann man sich durch Drehen eines flachen Kreisbogens um eine parallel zu einer Sehne angeordneten Achse UU entstanden denken (7.19). Wendelibellen sind oben und unten tonnenförmig ausgebildet. Die Libelle ist bis auf die durch die Dämpfe der Flüssigkeit entstandenen Libellenblase mit Äther oder Alkohol gefüllt. Auf dem Glaskörper ist eine Teilung angebracht, deren Strichabstand 2 mm beträgt[1]) und mit pars bezeichnet wird.

[1]) ältere Teilung 2,26 mm

7.20 Röhrenlibelle (schematisch)
N Normalpunkt
S Spielpunkt
L Blasenmitte

Einige Grundbegriffe seien näher erläutert:

Als Normalpunkt N bezeichnet man den Nullpunkt oder Mittelpunkt der Teilung (7.20). Die Libellentangente ist im Längsschnitt eine beliebige Tangente an den inneren Schliffkreis. Liegt diese Tangente im Normalpunkt N, so heißt sie Libellenachse. Liegt sie in Blasenmitte L, so ist sie waagerecht, da die Blase immer im höchsten Punkt der Libelle steht. Der Punkt, in dem sich die Libellentangente senkrecht zur Stehachse befindet, heißt Spielpunkt S. Ist die Stehachse senkrecht, fallen S und L zusammen und ε_2 wird null. Der Spielpunkt S einer Libelle ist einfach zu bestimmen, indem das grob horizontierte Instrument mit Libelle um 200 gon gedreht und in beiden Richtungen die Stellung der Libelle abgelesen wird. Die Mitte ist der Spielpunkt S, auf den die Libelle mit den Fußschrauben einzustellen ist.

Eine Libelle justieren bedeutet, den Spielpunkt S mittels der Libellenjustierschrauben (7.21) in den Normalpunkt N zu legen (s. auch Abschn. 9.4).

7.21 Justierschraube einer Röhrenlibelle
1 Fernrohr
2 Federhülse
3 Lagerzapfen der Libelle
4 Justierschraube
Die Justiereinrichtung kann auch mit Zug- und Druck-
schraube ausgerüstet sein

Das Merkmal für die Güte einer Libelle ist die Libellenangabe. Es ist der Winkel α, um den die Libelle zu neigen ist, damit sie 1 pars weiterläuft. Meistens wird sie in Sekunden bestimmt. Grobe Libellen (Dosenlibellen) haben somit bei kleinem Schliffkreisradius eine große Angabe, feine Libellen bei großem Schliffkreisradius eine kleine Angabe. Sie beträgt bei Dosenlibellen $\approx 8'$ ($r = 0{,}9$ m), bei einfachen Röhrenlibellen $\approx 30''$ ($r = 14$ m), bei mittleren Libellen $\approx 20''$ ($r = 21$ m) und bei feinen Libellen $\approx 5''$ ($r = 83$ m).

Die Angaben für die Libellen der Vermessungsinstrumente sind in den zugehörigen Gebrauchsanleitungen vermerkt. Man kann sie jedoch für Fernrohr- und Nivellierlibellen auch einfach feststellen, indem man das Fernrohr über eine Fußschraube stellt, die beiden Enden links und rechts der Libellenblase abliest und an der in dieser Richtung aufgestellten Nivellierlatte, deren Entfernung s vom Instrument gemessen wird, die Ablesung O macht (7.22). Durch Bewegen der zur Nivellierlatte zeigenden Fußschraube lässt man die Libelle um einige Striche weiterlaufen, liest erneut beide Enden der Libellenblase und an der Latte U ab. Dann ist

$$\gamma = \frac{O - U}{s} \ \text{rad} \ ('')$$

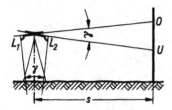

7.22 Bestimmen der Libellenangabe

und wenn $L_2 - L_1$ die Differenz aus dem Mittel beider Blasenablesungen ist, findet man die Angabe der Libelle mit

$$\alpha = 1\,\text{pars} = \frac{O - U}{(L_2 - L_1) \cdot s}\,\text{rad}\,('')$$

Beispiel. Entfernung $s = 50,0\,\text{m}$

Blasenablesung L_1:	links 3,2	rechts 12,6	Lattenablesung O = 1,778

Nach Veränderung der Libelle durch die Fußschraube

Blasenablesung L_2:	links 8,1	rechts 17,5	Lattenablesung U = 1,743
$L_2 - L_1$	links 4,9	rechts 4,9	$O - U = 0,035$

Mittel $L_2 - L_1 = 4,9$

$$\alpha = 1\,\text{pars} = \frac{0,035}{4,9 \cdot 50,0} \cdot 206265'' \approx 30''$$

7.2.2.1 Koinzidenzlibelle

Beim Einstellen der Röhrenlibelle wird die Libellenblase in Symmetrie zur Libellenteilung gebracht.

Um eine noch schärfere Libelleneinstellung zu finden und damit die Genauigkeit zu steigern, wird bei manchen Fein-Nivellieren über der Libelle ein Prismensystem angebracht, das die beiden Hälften der Blasenenden zusammenspiegelt (7.23). Das Gesichtsfeld der Libelle, das neben oder im Gesichtsfeld des Fernrohrs erscheint, besteht aus zwei halben Blasenenden (7.24), die beim Neigen der Libelle mittels Kippschraube um die gleichen

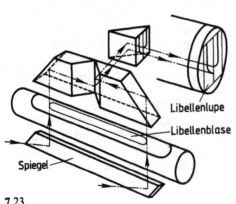

7.23
Koinzidenzlibelle, Prismensystem mit Libelle

7.24
Gesichtsfeld der Koinzidenzlibelle; links nicht einspielend, rechts einspielend. Die Pfeile deuten an, in welchem Sinn eine Drehung der Kippschraube auf die Libellenblase wirkt

Beträge in entgegengesetzter Richtung laufen. Die Libelle spielt ein, wenn beide Blasenenden koinzidieren [1]) (sich zu einem Halbkreis ergänzen).

Bild 7.25 zeigt ein Okulargesichtsfeld mit Latte und Libelle. Diese Anordnung hat den Vorteil, dass im Augenblick des Einspielens der Libelle an der Latte abgelesen werden kann, allerdings wird das Gesichtsfeld des Gegenstandes bei dieser Form verkleinert.

7.25 Fernrohrgesichtsfeld mit Koinzidenzlibelle

[1]) koinzidieren = zusammenfallen, einander decken.

8 Einfache Geräte zur Höhenmessung

Bei der Höhenmessung misst man jeweils zwischen zwei Punkten den Höhenunterschied, indem von einer kurzen waagerechten Ziellinie der senkrechte Abstand zu jedem Punkt ermittelt wird. In Bild **8.1** beträgt der Höhenunterschied zwischen A und B $2,10 - 0,58 = 1,52\,\text{m}$.

Die waagerechte Ziellinie erhält man bei einfachen Höhenmessungen mit der Schlauchwaage oder der Setzlatte, bei genaueren Höhenmessungen mit dem Nivellierinstrument.

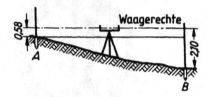

8.1 Höhenunterschied zwischen zwei Punkten von horizontaler Ziellinie aus bestimmt

8.1 Schlauchwaage

Sie beruht auf hydrostatischen[1]) Gesetzen und besteht aus einem $20 \cdots 30\,\text{m}$ langen Schlauch, an dessen Enden Glasröhren ($\varnothing\,25\,\text{mm}$) mit Millimeterteilung, die in einem Messingrohr mit verschließbarem Hahn ruhen, angebracht sind (**8.2**). Der Schlauch wird mit Wasser gefüllt. Der Flüssigkeitsspiegel in den beiden Röhren liegt in einer Horizontalebene und bildet in jedem Fall eine waagerechte Ziellinie.

In dem Schlauch dürfen sich keine Luftblasen bilden; man verhindert dies durch Bewegen des Schlauches. Mit der einfachen Schlauchwaage lassen sich Höhenübertragungen auf Baustellen des Hochbaus, Straßenbaus, Wasserbaus usw. leicht und mit ausreichender Genauigkeit ($\pm 2\,\text{mm}$) durchführen. Es sind nur die Glaszylinder an die Messpunkte zu bringen und die Flüssigkeitsspiegel zu markieren, die in gleicher Höhe liegen; damit ist die horizontale Ziellinie festgelegt.

8.2 Schlauchwaage

[1]) Hydrostatik (griech.): Lehre vom Gleichgewicht ruhender Flüssigkeiten.

Für genaue Höhenmessungen gibt es Präzisionsschlauchwaagen, mit denen Höhenunterschiede auf Bruchteile des Millimeters zu bestimmen sind. Bei Setzungsbeobachtungen an Bauwerken gestattet die Präzisionsschlauchwaage (Niveaumesser) unabhängig vom Wetter und der durch den Verkehr bedingten Vibration des Bauwerks zu messen. Durch sinnvolle Anordnung der Messstellen am Bauwerk können die Neigungsänderungen des Bauwerks über einen relativ weiten Messbereich mit hoher Genauigkeit registriert werden.

Das Prinzip der Schlauchwaage wird auch für Höhenübertragungen auf weite Entfernung angewandt (z. B. in Dänemark zum Höhenanschluss von Inseln); man nennt dies hydrostatisches Nivellement, das jedoch sehr kompliziert ist.

Es gibt auch Schlauchwaagen, die für den Einmann-Betrieb geeignet sind und eine Niveaudifferenz zwischen einer stationär gelagerten Schlauchtrommel und einem Druckmessmodul mit digitaler Anzeige, welches an einem Schlauchende montiert ist, über den Flüssigkeitsdruck ermitteln. An einem Punkt A wird ein Referenzdruck (z. B. den Wert Null) ermittelt. Wenn die digitale Anzeige an einem Punkt B den Wert Null anzeigt, ist dieser Druck wieder erreicht und beide Punkte haben die gleiche Höhe. Während des Messvorgangs darf sich die Temperatur der Flüssigkeit im Schlauch nicht wesentlich ändern, weil sich diese Veränderung auf den Druck auswirken würde, was zu einer Fehlinterpreation der Höhe durch das Messmodul zur Folge hätte.

8.2 Setzlatte

In unübersichtlichem und steilem Gelände verwendet man zur Höhenbestimmung – vornehmlich zur Aufnahme von Querprofilen – die Setzlatte. Es ist eine 3 bis 4 m lange, in Dezimeter geteilte Latte, die mit einer Röhrenlibelle zum Waagerechtstellen versehen ist und an einem Ende einen rechtwinklig angeordneten Arm besitzt (8.3). An diesem wird die in Dezimeter geteilte Messlatte bei einspielender Setzlattenlibelle angehalten und der Höhenunterschied abgelesen. Dies wiederholt sich laufend. Verläuft das Gelände nicht gleichmäßig, so werden Zwischenwerte (gestrichelte Messlatte) gemessen. Anstelle des rechtwinkligen Armes kann an der senkrechten Latte ein Schieber angebracht sein, in dessen Gabel die waagerechte Latte liegt.

Die Parallelität zwischen Unterkante Setzlatte und Libellenachse prüft man durch Umsetzen der Libelle. Beim Einstellen der Setzlatte auf den Mittelwert beider Ablesungen wird die Libelle zum Einspielen gebracht. Die Genauigkeit beträgt $\pm 1{,}0\sqrt{n}$ (in cm), wenn n die Anzahl Setzlattenlagen bedeutet. In einfachen Fällen genügt für diese Art

8.3 Messen mit der Setzlatte.
Ablesung 1,05 m

Höhenmessung eine Richtlatte mit parallelen Kanten, eine Wasserwaage und ein Meterstock.

8.3 Pentagonprisma und Schnurlot

Zur groben Bestimmung von Höhenunterschieden kann man das Pentagon verwenden. Man hält seinen Griff waagerecht, projiziert so das herabhängende Lot in die Waagerechte und zielt den nächsten Standpunkt an (8.4). Der Höhenunterschied ist $\Delta h = h - i$. Die Genauigkeit beträgt 0,1 m auf 100 m.

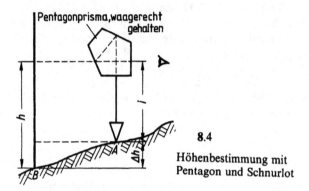

8.4

Höhenbestimmung mit
Pentagon und Schnurlot

9 Das Nivellierinstrument

Das Nivellierinstrument dient zum Messen von Höhenunterschieden; es ist das wichtigste Instrument für die Höhenmessung. Die Genauigkeit der Höhenbestimmung hängt von der Güte des Instrumentes, seiner Einrichtung für die Horizontierung der Ziellinie und den Messmethoden ab.

Es gibt verschiedene Merkmale, denen Nivellierinstrumente zugeordnet werden können. Grundsätzlich ist zwischen analogen und digitalen Instrumenten zu unterscheiden. Bei Analoginstrumenten wird der Messwert von einem Beobachter abgelesen und in einem Feldbuch aufgeschrieben oder in ein elektronisches Medium (z. B. elektronisches Feldbuch) eingegeben. Digitale Instrumente verfügen über einen Mikroprozessor, der einen Lattencode hochgenau interpretieren kann. Die Messwerte werden auf einem Display angezeigt. Der große Vorteil dieser Instrumente besteht in der Möglichkeit, die Messwerte auf einem Speichermedium automatisch zu speichern und so einen durchgängigen Datenfluß von der Aufnahme bis zur Auswertung zu ermöglichen. Den digitalen Instrumenten wird eine höhere Produktivität zugeschrieben. Da Ablese- und Übertragungsfehler ausgeschlossen werden können, ist die Sicherheit der Arbeit unter Verwendung digitaler Instrumente gegenüber analogen Instrumenten deutlich höher einzuschätzen.

Digitale Nivellierinstrumente können wie analoge Instrumente genutzt werden – z. B. bei Ausfall der Stromversorgung. Die nachfolgende Beschreibung der Bauteile der Nivellierinstrumente hat für beide Instrumententypen Gültigkeit.

9.1 Stativ, Befestigung des Nivellierinstrumentes auf dem Stativ

Die leichten, mittelschweren und schweren Stative, deren Beine starr oder einschiebbar sind, bestehen meistens aus Eschenholz oder Aluminium (DIN 18726). Die mit Stahlspitzen und Stativschuhen versehenen Stativbeine sind durch Kugelgelenke oder durch Walzengelenke mit dem Stativteller verbunden. Man verwendet Tellerstative und Kugelkopfstative.

Beim Tellerstativ (9.1) erfolgt die Befestigung des Instrumentes durch eine Anzugschraube, die von einer runden Öffnung in der Kopfplatte des Tellerstativs aufgenommen wird. Die Anzugschraube greift in die Federplatte des Instrumentes ein (9.2); die Spitzen der Fußschrauben stehen auf der Grundplatte. Diese Konstruktion gewährleistet einen stets leichten Gang der Fußschrauben. Wenn nur die Grundplatte vorhanden ist, wird diese von der Anzugschraube gehalten.

9.1 Tellerstativ

9.2 Befestigen des Nivellier-
 instrumentes mit Grund- und Feder-
 platte durch eine Anzugschraube

9.3 Kugelkopfstativ

Beim Kugelkopfstativ (**9.3**) oder Gelenkkopfstativ besteht der Instrumententeil aus einem zylindrischen Fuß mit konischer Auflagefläche, die auf der Kugelfläche des Stativkopfes steht. Die Grobhorizontierung ist damit schnell auszuführen.

9.2 Der Aufbau des Nivellierinstrumentes

Die Hauptbestandteile eines Nivellierinstrumentes sind das Messfernrohr und Einrichtungen zur waagerechten Einstellung der Zielachse. Das Fernrohr ist mit dem Unterteil durch Zapfen und Hülse verbunden und über diesem drehbar. Die Grobhorizontierung des Instrumentes erfolgt mittels Dosenlibelle, die Feinhorizontierung mittels einer Röhrenlibelle oder automatisch über einen Kompensator. Das um die Stehachse drehbare Fernrohr wird mit einer Horizontalklemme oder einer Rutschkupplung fixiert. Mit einem Seitenfeintrieb kann das Fernrohr nach dem Festlegen noch um geringe Beträge gedreht werden, um das Strichkreuz in das Ziel zu bringen. Instrumente mit Rutschkupplung sind mit endlosem Seitenfeintrieb ausgestattet.

Das Nivellierinstrument kann mit einem Horizontalkreis zum Messen von Horizontalwinkeln, einer Streckenmeßeinrichtung (Distanzstriche) und einer Ablotevorrichtung (Lothaken) ausgerüstet sein; man nennt es dann Nivellier-Tachymeter (s. Teil 2).

Je nach der Lagerung des Fernrohrs und nach der Möglichkeit der Ziellinien-Horizontjerung, die entweder durch eine Röhrenlibelle, die mit dem Fernrohr fest verbunden ist, oder durch einen Kompensator, der in den Strahlengang eingebaut ist, geschieht, unterscheidet man folgende Arten der Nivellierinstrumente:

1. Libellen-Nivelliere ohne Kippschraube (**9.4**), bei denen das Fernrohr fest mit der Fernrohrstütze verbunden ist (Norddeutsches Nivellier).

2. Libellen-Nivelliere mit Kippschraube (**9.5**), bei denen das Fernrohr und die damit verbundene Röhrenlibelle mit der Kippschraube feinfühlig um geringe Beträge gekippt werden können (Süddeutsches Nivellier).

3. Nivelliere mit automatischer Horizontierung (**9.6**), bei denen das Fernrohr fest mit der Fernrohrstütze verbunden ist und eine optisch-mechanische Einrichtung (Kompensator) die Ziellinie gegen kleine Instrumentenneigungen stabilisiert.

Digitale Nivellierinstrumente werden ausschließlich mit automatischer Horizontierung hergestellt.

Zu nennen sind noch Libellen-Nivelliere mit wälzbarem Fernrohr und Wendelibelle sowie mit umlegbarem Fernrohr und umsetzbarer Libelle. Sie werden nicht behandelt.

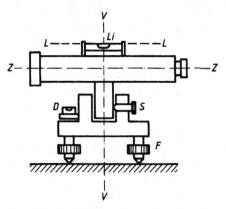

9.4 Libellen-Nivellier ohne Kippschraube
 (schematisch)

9.5 Libellen-Nivellier mit Kippschraube
 (schematisch)

F	Fußschrauben	S	Seitenklemme
D	Dosenlibelle	K	Kippschraube
Li	Röhrenlibelle		

LL	Libellenachse
ZZ	Zielachse
VV	Vertikalachse

9.6 Nivellier mit automatischer Horizontierung
 (schematisch)
 F Fußschrauben
 D Dosenlibelle
 SF Seitenfeintrieb
 ZZ Zielachse
 VV Vertikalachse

9.2.1 Kompensatoren (Ziellinienregler zur automatischen Horizontierung)

Man hat im Fernrohr von Nivellierinstrumenten optisch-mechanische Bauteile angeordnet, die innerhalb eines kleinen Bereichs die Ziellinie automatisch waagerecht stellen. Man bezeichnet dies als automatische Horizontierung. Wegen des begrenzten Anwendungsbereichs ist eine Vorhorizontierung mit einer Dosenlibelle erforderlich.

Wenn man ein Fernrohr um den Winkel α neigt, so treffen die von einem Punkt kommenden Strahlen im Abstand a vom Strichkreuzschnittpunkt auf den Vertikalstrich (**9**.7).

$$a = f \cdot \alpha, \quad \text{wenn } \alpha = \frac{\alpha \, (\text{gon})}{\text{rad} \, (\text{gon})} \text{ ist}$$

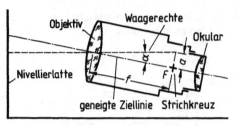

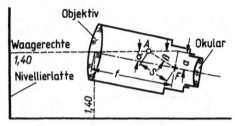

9.7 Zielstrahl bei um α geneigtem Fernrohr **9.8** Durch F abgelenkter Zielstrahl

Damit trotz der Fernrohrneigung die horizontale Ziellinie durch die Mitte des Strich-
kreuzes geht, muss sie entweder irgendwo zwischen Objektiv und Strichplatte durch eine
optische Einrichtung entsprechend abgelenkt werden oder das Objektiv bzw. Okular muss
entsprechend automatisch verschoben werden. Die Ablenkung kann z. B. über einen
Spiegel erfolgen, der im Abstand s von der Strichplatte wirksam wird (**9.8**).

$$a = s \cdot \beta = f \cdot \alpha \qquad \beta = \frac{f}{s}\,\alpha = n \cdot \alpha$$

β ist demnach der f/s-fache (n-fache) Betrag von α. Die Erfüllung dieser Forderung
übernimmt bei den automatischen Nivellieren im Einwägungsbereich der Dosenlibelle ein
optisch-mechanischer Bauteil, der mit dem Fernrohrkörper verbunden ist. Die Befesti-
gung des optisch-mechanischen Bauteiles (Spiegel, Prismen, Linsen) kann durch Aufhän-
gen an Drähten oder Bändern, an Kreuzfedergelenken oder an einem elastischen Stab
oder durch Lagerung in einer sich in Präzisions-Kugellagern drehenden Achse erfolgen.
Als Beispiele werden Kompensatoren von Zeiss, Leica und Breithaupt kurz behandelt.

Beim Kompensator des Nivellierinstrumentes Ni 2 von Zeiss ist am Fernrohrkörper ein
spiegelndes Prisma mit vier Drähten aus korrosionsbeständigem Material aufgehängt
(**9.9, 9.10**).

9.9 Aufhängen des Prismas **9.10** Wirkungsweise des aufge-
 an vier Drähten (Zeiss Ni 2) hängten Prismas

Die Schwerkraft lässt das Prisma stets mit einer Genauigkeit von 0,2″ einpendeln. Da der
Kompensator im Ni 2 in 1/7,4 der Objektivbrennweite sitzt, muss der Winkel α der
Fernrohrneigung mit dem Faktor 7,4 multipliziert werden, um ein richtiges β zu erhalten.
Dieser Faktor wird erreicht durch das Verhältnis des oberen Abstandes der Einspannstel-
len der Drähte zum unteren (1:2), durch Vergrößerung des Faktors 2 auf 3,7 durch
Höherlegung des Schwerpunktes des Pendelsystems und schließlich durch weitere
Vergrößerung des Faktors 3,7 auf 7,4 durch Spiegelwirkung des Prismas.

Durch die Höherlegung des Schwerpunktes wird gleichzeitig eine Vergrößerung der
effektiven Pendellänge von etwa 3 cm zu einer reduzierten Pendellänge von 13 cm erreicht,
wodurch das Pendelsystem wesentlich unanfälliger gegen Störschwingungen wird.

Der pendelnde Teil des Ni 2-Kompensators hat eine Gewichtskraft von 0,2 N (Masse des Kompensators = 20 g); die Belastungsgrenze eines jeden Drahtes liegt jedoch bei 20 N. Bild **9.11** zeigt den Schnitt durch das Fernrohr des Ni 2. Der Zielstrahl verläuft über das dreiteilige Objektiv (1, 2), die Fokussierlinse (3), die Prismen (4, 5, 6), das Strichkreuz (8) und das Okular in das Auge des Beobachters. Vor und hinter dem pendelnden Prisma (5) sind zwei mit dem Fernrohrkörper fest verbundene Prismen (4, 6) angeordnet, deren okularseitiges (6) als Dachprisma ausgebildet ist. Man erhält seitenrichtige, aufrechte Bilder. Für ein rasches Abklingen der Schwingungen des Kompensators sorgt ein Dämpfungszylinder (7).

Der Schwingungsbereich des pendelnden Prismas ist begrenzt (bis zur Fernrohrneigung ± 15′), eine Arretierung beim Transport somit nicht erforderlich. Der Kompensator richtet die Ziellinie innerhalb einer halben Sekunde mit einem mittleren Fehler ± 0,2″ zum Lot aus, sofern die Ziellinie vorher entsprechend justiert wurde.

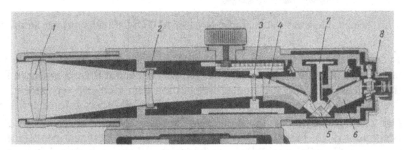

9.11 Schnitt durch das Fernrohr Ni 2 mit Strahlengang (Zeiss)

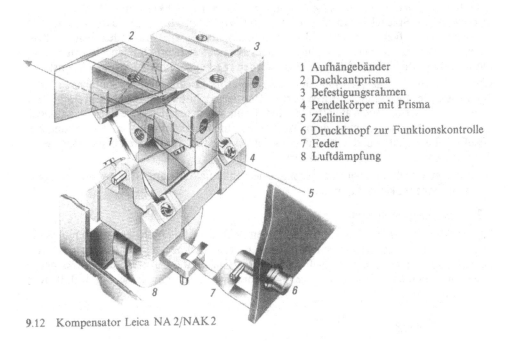

1 Aufhängebänder
2 Dachkantprisma
3 Befestigungsrahmen
4 Pendelkörper mit Prisma
5 Ziellinie
6 Druckknopf zur Funktionskontrolle
7 Feder
8 Luftdämpfung

9.12 Kompensator Leica NA 2/NAK 2

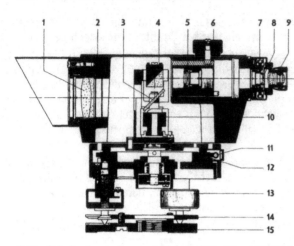

1 Objektiv
2 Fernrohrgehäuse
3 Kompensatorpendel mit Spiegel
4 Umlenkprisma
5 Fokussierlinse
6 Fokussierbetrieb
7 Justierschraube für Strichplatte
8 Strichplatte
9 Okular
10 Wirbelstrombremse
11 Triebschnecke für Seitenfeintrieb
12 Zahnkranz für Reibungsbremse
13 Fußschraube
14 Federplatte
15 Zentrierplatte

9.13 Schnitt durch das automatische Nivellier AUTOM (Breithaupt) mit Strahlengang

In den Nivellierinstrumenten Leica NA2/NAK2 ist ein an vier kreuzweise angeordneten, vorgespannten Aufhängebändern hängendes Pendel mit Prisma zwischen Fokussierlinse und Strichkreuzplatte vorhanden, welches mit dem Gehäuse verbunden ist (9.12). Eine Ziellinienschiefe führt zu einer Kippung des Pendelkörpers infolge der Schwerkraft.

Der Ziellinienregler des automatischen Ingenieur-Nivellierinstrumentes AUTOM von Breithaupt (9.13) besteht aus zwei optischen Elementen: einem pendelnden Spiegel (3), der unter 45° zur Horizontalen aufgehängt ist und einem darüber befestigtem Rechtwinkelprisma (4). Durch den Spiegel werden die einfallenden Lichtstrahlen nach oben reflektiert und weiter durch das Rechtwinkelprisma zum Strichkreuz und Okular gelenkt. Der pendelnde Spiegel ist an einem horizontal und quer zur Visierrichtung liegenden Torsionsband aufgehängt. Der Schwerpunkt des den Spiegel tragenden Pendels liegt unterhalb des Aufhängepunktes; das Pendel befindet sich im stabilen Gleichgewicht. Durch eine kräftige Wirbelstrombremse werden die Pendelschwingungen gebremst.

Um in der Praxis das Arbeiten des Kompensators zu überprüfen, sollte nach jeder Aufstellung des Instrumentes durch kurzes Klopfen am Stativ oder Instrument festgestellt werden, dass der Kompensator frei arbeitet. Beim automatischen Nivellier NA2 (Leica) gestattet ein Druckknopf unter dem Okular eine Funktionskontrolle. Bei der Zielung zur Nivellierlatte drückt man den Knopf und sieht, wie die Ziellinie ausweicht und rasch wieder in die horizontale Lage zurückkehrt.

Bei digitalen Nivellieren wird im Display eine Fehlermeldung angezeigt, wenn der Kompensator nicht funktionsfähig ist.

9.2.2 Planplattenmikrometer

Bei der Ablesung an der Nivellierlatte können an dem Mittelstrich des Strichkreuzes die Millimeter nur geschätzt werden. Um diese messen zu können, schaltet man vor das Objektiv eine genau planparallel geschliffene Glasplatte. Ein auf diese Glasplatte senkrecht auffallender Lichtstrahl geht ungebrochen hindurch; ein schräg auffallender Strahl wird parallel um

$$v = \frac{d}{\cos \beta} \sin (\alpha - \beta)$$

9.14 Wirkungsweise der planparallelen Platte

verschoben (**9**.14). Die Verschiebung v ist somit abhängig von der Dicke d der Glasplat-te, dem Einfallswinkel α und dem Brechungskoeffizienten des Glases $n = \sin\alpha/\sin\beta$. Man richtet es nun so ein, dass die Ziellinie beim Kippen der Planplatte um ein Teilungsinter-vall der Latte ($^1/_2$ cm bei Halbzentimeterlatten, 1 cm bei Zentimeterlatten) parallel zu sich selbst zu verschieben ist. Die Verschiebung der Ziellinie bis zum Lattenstrich (**9**.15) erfolgt durch Drehen eines Triebknopfes mit Skala (Mikrometertrommel), an der leicht $^1/_{100}$ des Lattenintervalls abgelesen (geschätzt) werden können. Bei Präzisionsinstrumenten mit eingebauter Planplatte sind $^1/_{1000}$ des Lattenintervalls zu schätzen; die Ablesung erfolgt über eine Glasteilung für die Planplatte.

Ablesung an der Latte nach Herstellen der Koinzidenz	2,54	
Ablesung an der Mikrometertrommel	92	
Gesamtablesung	2,5492	
Ablesung ohne Planplattenmikrometer	2,544	

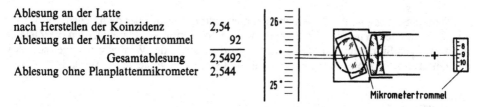

9.15 Vor dem Objektiv angebrachte Planplatte mit Mikrometertrommel (Planplattenmikrometer)

Die Planplatte und die Mikrometertrommel sind so abgestimmt, dass bei der Mittel-stellung des Mikrometers (Ablesung an der Trommel 50) die Planplatte senkrecht zum Zielstrahl steht und der Strahl nicht versetzt wird. Bei Nullstellung (0) und Maximalstel-lung (100) des Mikrometers wird der Zielstrahl um den gleichen Betrag in entgegengesetz-ter Richtung versetzt. So braucht die Trommelablesung nur als 4. und 5. Ziffer der Lattenablesung angefügt zu werden. Beim Vorschalten einer Planplatte vor ein Nivellier liest man somit jeweils 5 Einheiten des Teilungsintervalls mehr ab gegenüber der Ablesung ohne Planplatte. Dieser Wert ist bei jeder Ablesung konstant und damit auf das Nivellement ohne Einfluß, da er sich bei der Differenzbildung aufhebt.

Bilder **9**.16 und **9**.17 zeigen Planplattenmikrometer auf Nivellierinstrumenten.

9.2.3 Der Horizontalkreis beim Nivellierinstrument

Die Nivellierinstrumente können wahlweise mit einem Horizontalkreis ausgerüstet sein, der einfache Winkelmessungen im ebenen Gelände gestattet. Er besteht aus einem Metall- oder Glaskreis mit 360°- oder 400 gon-Teilung. Die Ablesung geschieht auf einfachste Art über eine Lupe an einem Indexstrich mit einer Schätzgenauigkeit von 0,1 gon (**9**.18) oder über ein neben dem Fernrohr befindliches Skalenmikroskop mit 1 cgon Schätzung. Bei

9.16 Planplattenmikrometer GPM 3
 auf Leica NA 2
 1 Mikrometerschraube
 2 Befestigungsschraube

9.17 Planplattenmikrometer auf
 Zeiss Ni 2
 1 Mikrometerschraube
 2 Befestigungsschraube

der Winkelmessung ist das Nivellierinstrument mit dem Lot über dem Scheitelpunkt des zu bestimmenden Winkels zu zentrieren und zu horizontieren. Dann werden die Ziele im rechtsläufigen Sinn nacheinander angezielt und jedesmal der Winkelwert abgelesen. Aus der Differenz der Ablesungen ergibt sich die Größe des gemessenen Winkels (9.19).

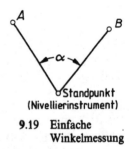

9.18 Kreisablesung am Indexstrich,
 Ablesung: 6,7 gon

Beispiel. (9.19): Ablesung Ziel A 106,2 gon
 Ziel B 162,9 gon
 ─────────────────────────
 $\alpha =$ 56,7 gon

9.19 Einfache
 Winkelmessung

Bei vielen Nivellierinstrumenten kann der Teilkreis verdreht und somit sein Nullpunkt in jede gewünschte Lage gebracht werden. Die Winkelmessung mit dem Nivellierinstrument erfolgt meistens im Zuge der Nivellier-Tachymetrie. Dabei wird zusätzlich zur Höhe und zum Winkel noch die Entfernung zwischen Stand- und Zielpunkt bestimmt, indem die Differenz der Ablesungen von Ober- und Unterstrich des Strichkreuzes an der Latte mit 100 multipliziert wird (s. Abschn. 7.1.3). Die Genauigkeit liegt im dm-Bereich.

Das digitale Nivellierinstrument DiNi 12 T (Trimble/Zeiss) ist mit einem elektronischen Horizontalkreis ausgerüstet, der eine Ablesegenauigkeit von 2 mgon ermöglicht. Die Distanzbestimmung erfolgt in cm-Genauigkeit. Die integrierten Anwendungsprogramme lassen den Einsatz dieses Instrumentes als digitales Nivelliertachymeter zu. Weiteres über Nivellier-Tachymetrie s. Teil 2.

9.2.4 Erweiterung des Einsatzbereiches der automatischen Nivelliere

Durch Aufsetzen eines Prismas auf das Objektiv lassen sich bestimmte automatische Nivellierinstrumente in ein automatisches Lot umwandeln. Es kann hiermit auf- und abgelotet werden. Der Einsatz ist im Hoch- und Tiefbau sinnvoll. Das aufgesetzte Prisma lenkt den Zielstrahl rechtwinklig ab.

Es kann im Bauwesen erforderlich sein, einen horizontalen Strahl oder eine horizontale Ebene sichtbar zu machen. Dies kann man mit einem Laserstrahl erreichen. Bei bestimmten automatischen Nivellieren kann man mittels eines Bajonettverschlusses das Fernrohrokular gegen das Laserokular austauschen. Es können mit dem automatisch horizontierten Laserstrahl auch auf größere Entfernungen Höhen übertragen oder Profile ausgemessen werden. Wird noch ein Prisma auf das Objektiv des automatischen Nivelliers gesetzt, kann man mit dem Laserstrahl auch loten.

9.2.5 Digitale Nivellierinstrumente

Die digitalen Nivellierinstrumente sind Kompensator-Instrumente. Mit ihnen wird elektronisch gemessen und gerechnet. Speichermedien und Übertragungsoptionen lassen einen elektronischen Datenfluss von der Aufnahme bis zur Auswertung zu. Ablesefehler, bedingt durch menschliche Unzulänglichkeiten, werden ausgeschaltet.

Die Instrumente sind mit Programmen für alle Aufgaben der Höhenmessung (s. Abschn. 10), also Aufnahme und Absteckung, ausgerüstet. Bei automatischer Speicherung der Messwerte muss der Ablauf der Vermessungsarbeiten exakt nach den Vorgaben des Programmdialoges erfolgen. Ergänzende Programme ermöglichen die Eingabe projektbezogener Daten. Parametereinstellungen und die Justierung der elektronischen Ziellinie (s. Abschn. 9.4.4). Die Daten können über eine im Instrument eingebaute Schnittstelle (Leica, Topcon, Trimble/Zeiss) zum Rechner oder vom Rechner zum Instrument übertragen werden.

Es gibt zwei Verfahren zur automatischen Höhenmessung:

– Ein Instrument sendet einen Laserstrahl, der von einem positionsempfindlichen Detektor empfangen wird. Da diese Instrumente nicht über einen optischen Teil verfügen, ist eine Lattenablesung nicht möglich. Allein der Detektor kann den empfangenen Strahl in Höheninformationen umsetzen. Ergebnisse können auf einem Display digital angezeigt und auch gespeichert werden. Lasernivelliere werden häufig auf Baustellen eingesetzt. Eine nähere Beschreibung erfolgt im Teil 2.

– Ein von einer Lichtquelle (z. B. Tageslicht) beleuchteter Code auf einer Nivellierlatte wird in der Bildebene des Nivellierinstrumentes empfangen und von einem Mikroprozessor ausgewertet. Ergebnisse werden digital angezeigt, sie können automatisch gespeichert werden. Das digitale Nivellierinstrument unterscheidet sich vom analogen Instrument durch zusätzliche elektronische Bauteile. Der optische Teil entspricht weitgehend dem der analogen Kompensatornivelliere. Mit einem digitalen Nivellierinstrument kann eine Nivellierlatte mit DIN – Teilung (s. Abschn. 9.5) optisch abgelesen werden.

Die derzeit angebotenen digitalen Nivellierinstrumente unterscheiden sich vorwiegend durch verschiedene Auswerteverfahren. Diese sind:

 Korrelationsverfahren (Leica)
 Phasenmessverfahren (Topcon)
 Geometrisches Positionsmessverfahren (Trimble/Zeiss).

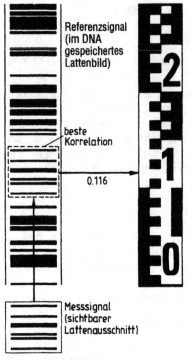

Referenzsignal
(im DNA
gespeichertes
Lattenbild)

beste
Korrelation

0.116

Messsignal
(sichtbarer
Lattenausschnitt)

9.20 Auswertung des Lattencodes nach
Korrelationsverfahren (Leica)

Beim Korrelationsverfahren ist der Latten-code in einem Mikroprozessor gespeichert. Dieser bekannte Code wird mit dem auf einem Sensor im Instrument über Spiegel abgebildeten Empfangssignal des Latten-ausschnittes korreliert (9.20).

Das Phasenmeßverfahren beruht auf drei Codemustern, die auf der Latte vorhanden sind. Ein Muster ist linear, die beiden ande-ren ergeben Sinussignale mit unterschied-licher Wellenlänge. Die Höhen- und Ent-fernungswerte werden aus der jeweiligen Kombination der drei Codeinformationen zueinander errechnet.

Beim geometrischen Positionsmessverfahren ist die Geometrie der Striche des Latten-codes untereinander bekannt und gespei-chert. Das Lattenbild wird nach der Lage der einzelnen Codestrichkanten zueinander ausgewertet. Bei einem Codegrundraster von 2 cm und die für die Auswertung not-wendigen 15 Kanten genügt ein abgebildeter Lattenausschnitt von 0,30 m, jeweils 0,15 m ober- und unterhalb des horizontalen Striches, für eine Ablesung.

Für die Messung wird die Ziellinie auf den Lattencode eingerichtet und der vertikale Strich des Strichkreuzes mit dem Seitenfeintrieb genau in die Mitte der Codeteilung gedreht. Mit dem Fokussierknopf wird das Lattenbild scharf eingestellt. Nur ein exakt scharf eingestelltes Bild des Codes kann eindeutig und fehlerfrei ausgewertet werden. Die Messung erfolgt nach Betätigung des Messknopfes, der an der rechten Seite des Gehäuses angebracht ist. Nach etwa 2 bis 4 Sekunden sind Mess-, Rechen- und Speichervorgang abgeschlossen.

9.3 Nivellierinstrument-Typen

Es gibt analoge und digitale Nivellierinstrumente. Voraussetzung für die elektronische Verarbeitung von Messdaten ist eine codierte Messlatte. Digitale Instrumente sind unter Verwendung von Nivellierlatten mit Dezimalteilung als analoge Nivellierinstrumente einsetzbar.

Die Genauigkeit eines Nivellements ist u. a. weitgehend von der Güte des eingesetzten Nivellierinstrumentes abhängig. Darunter versteht man die Fernrohrvergrößerung, die Größe der Objektiv-Öffnung, die Art der Horizontierung der Ziellinie, die Empfindlich-keit der Libelle, sofern eine solche vorhanden ist, sowie die eventuelle Anwendung einer planparallelen Platte.

Man unterscheidet hinsichtlich der Genauigkeit und des Einsatzes:

Bau-Nivelliere (für Nivellements niederer und mittlerer Genauigkeit)

Ingenieur-Nivelliere (für Nivellements hoher Genauigkeit)

Fein-Nivelliere (für Nivellements höchster Genauigkeit)

Die in den folgenden Abschnitten gezeigten verschiedenen Nivellierinstrumente gelten für die einzelnen Typen als Beispiele. Damit ist kein Werturteil über diese noch über die nicht genannten Instrumente abgegeben.

9.3.1 Bau-Nivelliere (für Nivellements niederer und mittlerer Genauigkeit)

Es sind einfache und robuste Nivellierinstrumente für die Baustelle, die mit und ohne Teilkreis geliefert werden. Unter ihnen findet man Libellen-Instrumente (Spiegelablesung) mit und ohne Kippschraube sowie Instrumente mit automatischer Horizontierung. Ihre Bedienung ist äußerst einfach. Man setzt sie bei Höhenmessungen ein, bei denen eine Genauigkeit von nicht mehr als 5 mm gefordert wird, also beim Festlegen von Festpunkthöhen auf der Baustelle, bei der Angabe von Bauhöhen im Hochbau, Tiefbau, Straßenbau, Wasserbau sowie im kulturtechnischen Bauwesen, bei einfachen Absteckungsarbeiten im Bauwesen, bei der Aufnahme von Längen- und Querprofilen für die Planung und Bearbeitung von Projekten sowie für Massenermittlungen, bei Flächennivellements und bei einfachen tachymetrischen Aufnahmen im ebenen Gelände.

Die Fernrohrvergrößerung ist 16 ⋯ 30fach, der Objektivdurchmesser beträgt 20 ⋯ 30 mm, die Angabe der Röhrenlibelle bei den Libelleninstrumenten ist 25″ ⋯ 60″, die Angabe der Dosenlibelle bei den automatischen Baunivellieren 8′ ⋯ 30′. Die Standardabweichung für 1 km Doppelnivellement ist 5 ⋯ 10 mm.

9.21 Baunivellier NA 700 Serie (Leica) mit automatischer Horizontierung

9.22 Baunivellier Ni 50 (Trimble/Zeiss) mit automatischer Horizontierung

9.3.2 Ingenieur-Nivelliere (für Nivellements hoher Genauigkeit)

Es sind analoge und digitale Nivellierinstrumente, die sich für alle Höhenmessungen auf Baustellen, in der Industrie und im Vermessungswesen eignen, die erhöhte Genauigkeit fordern. Die optischen Ingenieur-Nivelliere besitzen entweder Libellen-Horizontierung (Koinzidenzlibelle) und Kippschraube oder automatische Horizontierung und können wahlweise auch mit einem Teilkreis ausgerüstet sein. Für einige Ingenieur-Nivelliere gibt es als Zusatzeinrichtung eine aufsteckbare planparallele Platte mit Mikrometer, die es gestattet, mit dem Ingenieur-Nivellier Feinnivellements auszuführen (s. Abschn. 10.3.4). Die elektronisch messenden und automatisch registrierenden Instrumente besitzen einen Kompensator.

Ingenieur-Nivelliere werden verwendet für Festpunktnivellements, für Höhenbestimmungen und Höhenangaben bei der Projektierung und Ausführung von Straßen, Eisenbahnen, Wasserwegen, Brücken, Kraftwerken, für Industrievermessungen und Bauwerksüberwachungen sowie für die im Abschn. 9.3.1 genannten Arbeiten.

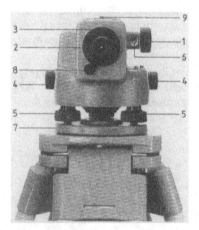

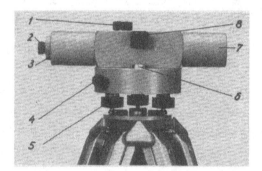

9.23 Ingenieur-Nivellier NA 2 (Leica) mit automatischer Horizontierung. Mit aufgesetztem Planplattenmikrometer für Präzisions-Höhenmessungen einsetzbar.

1 Fokussiertrieb
2 Okular
3 Schraubkappe für Strichplattenjustierung
4 Endloser Seitenfeintrieb
5 Fußschraube
6 Pentagonprisma zur Kontrolle der Dosenlibelle
7 Grundplatte
8 Druckknopf zur Funktionskontrolle des Kompensators
9 Visierleiste

9.24 Ingenieur-Nivellier Ni 2 (Zeiss) mit automatischer Horizontierung. Mit aufgesetztem Planplattenmikrometer für Präzisions-Höhenmessungen einzusetzen

1 Fokussierknopf
2 Okular
3 Schraubkappe für Strichplattenjustierung
4 Endloser Seitenfeintrieb
5 Fußschraube
6 Dosenlibelle
7 Objektiv
8 Pentagonprisma zur Kontrolle der Dosenlibelle

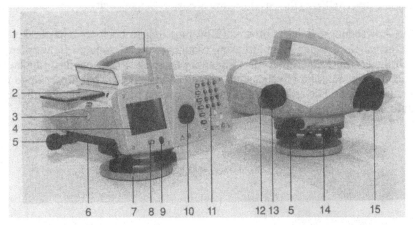

9.25 Digital Nivellier DNA 10 (Leica)

1 Handgriff mit Kimme und Korn
2 PCMCIA[1] Karte im Kartenfach
3 Entriegelungsknopf für
 Kartenfachdeckel
4 Display (s. Bild 9.27)
5 Endloser Seitentrieb (beidseitig)
6 Batteriefach
7 Dreifuß mit Fußschrauben

8 Ein-/Austaste
9 Dosenlibelle
10 Okular
11 Tastatur
12 Messtaste
13 Fokussiertrieb
14 Horizontalkreis
15 Objektiv

Die Fernrohrvergrößerung ist $20 \cdots 35$fach, der Objektivdurchmesser beträgt $30 \cdots 45$ mm. Die Angabe der Röhrenlibelle bei den Libelleninstrumenten ist $20'' \cdots 60''$, die der Dosenlibelle bei den automatischen Nivellieren $8' \cdots 12'$. Die Standardabweichung für 1 km Doppelnivellement ist $2 \cdots 4$ mm, bei vorgeschaltetem Planplattenmikrometer und Präzisionslatten $0,5 \cdots 1$ mm.

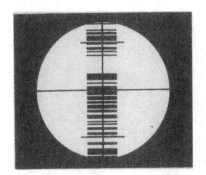

```
              ┌─── MESS & REG ───┐
     PtNr:    │              A1  │
     HO  :         0.00000 m
     Bem :         ------
     Rück:         1.23456 m
     Dist:           10.00 m
     HIns:         1.23456 m
                        <WEITER>
```

9.26 Gesichtsfeld der Kombinivellierlatte mit Strichcode

9.27 Anzeige des DNA 10 (Leica) mit Titelzeile, sechs Informationszeilen und Aktivfenster. Am rechten Anzeigenrand können Symbole eingeblendet werden z. B. Batterieladung, Zeichensatzaktivierung u.s.w.

[1]) Personal Computer Memory Card International Association.

9.3.3 Fein-Nivelliere (für Nivellements höchster Genauigkeit)

Ihr Anwendungsbereich umfasst Höhenmessungen höchster Genauigkeit, wie z.B. Deformationsmessungen an Brücken, Staumauern und anderen Bauwerken, Feinbeobachtungen von Fundament- und Bodenbewegungen, Präzisionsfluchtungen im Maschinenbau, Geodätische Nivellements höchster Genauigkeit. Es gibt analoge und digitale Fein-Nivelliere. Die analogen Instrumente werden mit Libellenhorizontierung oder mit automatischer Horizontierung hergestellt.

9.28 Präzisions-Nivellier „N 3" (Leica)
mit Kippschraube, Koinzidenz-
libelle und Planplattenmikrometer

Die Fernrohrvergrößerung ist 40 ··· 46fach, das Objektiv hat einen Durchmesser von 50 ··· 56 mm. Die Angabe der Röhrenlibelle bei den Libelleninstrumenten ist 8″ ··· 10″, die der Dosenlibelle bei den automatischen Nivellieren 5′ ··· 8′. Die Standardabweichung für 1 km Doppelnivellement ist mit 0,3 ··· 0,5 mm zu erwarten.

a) b)

9.29 a) Gesichtsfeld des Fernrohrs und Wirkung der planparallelen Platte („N 3" Leica)

b) Gesichtsfeld des Okulars für Koinzidenzlibelle und Skala des Planplattenmikrometers („N 3" Leica)

Das analoge Präzisions-Nivellier N 3 von Leica (**9.28**) ist mit einem panfokalen Fernrohr ausgestattet. Dieses verändert die Vergrößerung in Abhängigkeit von der Zielweite. Eine kurze Zielweite hat eine geringe Vergrößerung mit großem Sehfeldwinkel zur Folge. Durch Betätigen der Fokussierschraube wird ein Zoomeffekt ausgelöst. Bei einer Entfernung von 2 m ist die Vergrößerung 21fach, bei Einstellung auf unendlich jedoch 46fach. Das Planplattenmikrometer ist fest eingebaut. Die Kippung der Platte bewirkt eine vertikale Parallelversetzung der Ziellinie, bis der Lattenstrich mit Hilfe der Keilstrichplatte exakt anvisiert ist (**9.29**a). Mit einem zweiten Okular wird das Einspielen der Koinzidenzlibelle beobachtet (**9.29**b) und die Mikrometerskala abgelesen. Die Ablesung erfolgt digital auf 0,1 mm, geschätzt werden 0,01 mm.

Bild **9.30**a zeigt das Digital-Nivellier DINI 12 von Trimble/Zeiss mit dem zugehörigen Display (**9.30**b).

a) b)

9.30 a) Digital-Nivellier Trimble/Zeiss DINI 12

1 Visierkante	7 Tastatur
2 Okular	8 Objektiv
3 Einblick Dosenlibelle	9 Fokussierknopf
4 Abdeckung der Justierschraube	10 Auslösetaste
des Strichkreuzes	11 Seitenfeintrieb
5 Display	12 Horizontalkreis
6 Bedienung der Softkeys (s. Bild 9.30b)	13 Einschub der PCMCIA Karte

b) Display DINI 12/22. In der vierten Zeile des Displays werden die vom jeweilig aufgerufenen Programm abhängigen Softkeys angezeigt, die mit den fünf darunter angeordneten Tasten bedient werden.

Die Anwendungsbereiche verschiedener Ingenieur-Nivelliere können durch das Aufsetzen einer planparallelen Platte so erweitert werden, dass diese bei der Verwendung von Invar-Nivellierlatten ebenfalls für Höhenmessungen höherer Genauigkeit einzusetzen sind (s. Abschn. 9.2.2). Die mittlere Abweichung für 1 km Doppelnivellement ist dann 0,4 ... 1 mm. Im Anhang sind die Ingenieur-Nivelliere angegeben, die zusätzlich mit einer Planplatte auszurüsten sind.

9.4 Prüfen und Berichtigen des Nivellierinstrumentes

Bei einem messbereiten Nivellierinstrument sollen das Fernrohr und das Strichkreuz sowie die drei Achsen (**9.31**)

Vertikal-(Steh-)achse VV, Libellenachse LL (für Dosen- und Röhrenlibelle), Ziellinie ZZ, bestimmte Bedingungen erfüllen:

1. Im Fernrohr darf keine Parallaxe vorhanden sein,
2. die Stehachse soll lotrecht sein (Prüfung $L \perp V$, Libellenachse senkrecht zur Stehachse),
3. die Ziellinie soll waagerecht sein (Prüfung bei Libelleninstrumenten $L \parallel Z$, Libellen-achse parallel Ziellinie [1]); bei automatischen Nivellieren Überprüfen der waagerechten Ziellinie im Arbeitsbereich des Kompensators).
4. Bei digitalen Instrumenten muss die elektronische Ziellinie überprüft werden.

Um diese Forderungen zu erfüllen, sind die Libellen und die Strichkreuzplatte mit Berichtigungsschrauben (Justierschrauben) ausgerüstet. Je nach Art des Nivellierinstru-mentes (Nivellier ohne Kippschraube, Nivellier mit Kippschraube oder Nivellier mit automatischer Horizontierung) weicht die Untersuchung und Berichtigung in einigen Punkten ab. Bei der Überprüfung sollen die Instrumente im Schatten stehen.

9.31 Achsen des
Nivellierinstrumentes
(Baunivellier Theis N 4)
LL Libellenachse
ZZ Ziellinie
VV Vertikalachse
(Stehachse)

9.4.1 Beseitigen der Parallaxe

Das vom Objektiv erzeugte Bild soll in der Strichkreuzebene liegen. Beide, das Bild und das Strichkreuz, werden vom Beobachter durch das Okular, das wie eine Lupe wirkt, betrachtet. Liegen Bild und Strichkreuz nicht in einer Ebene – man sagt, die Bilder fallen auseinander – so liegt eine Parallaxe vor.

[1] Auf die Nebenforderung, dass die Vertikalebenen durch Libellenachse und Ziellinie parallel sein sollen (Kreuzungsfehler), wird nicht näher eingegangen.

Der Beobachter dreht zunächst am Okular von + nach – (nicht zu weit in negativer Richtung um das Auge nicht zu ermüden), bis es das Strichkreuz scharf und schwarz sieht. Als Hintergrund wählt man eine weiße Fläche; zum Aufhellen des Gesichtsfeldes hält man ein Blatt weißes Papier schräg nach oben vor das Objektiv. Mit dem Fokussierknopf wird nun das Ziel (Nivellierlatte) scharf eingestellt. Das Strichkreuz und das Lattenbild müssen gleich scharf erscheinen und dürfen sich beim Bewegen des Kopfes nicht gegeneinander verschieben; damit ist die geforderte parallaxenfreie Einstellung erfolgt. Verschieben sich die Bilder, so liegt eine Parallaxe vor und der Vorgang ist zu wiederholen.

9.4.2 Senkrechtstellen der Stehachse, Prüfen der Forderung $L \perp V$

Hier weicht die Untersuchung und Berichtigung für die drei Arten der Nivelliere voneinander ab.

Bei dem Nivellierinstrument ohne Kippschraube, bei dem das Fernrohr fest mit der Fernrohrstütze verbunden ist, wird die Forderung Libellenachse senkrecht zur Vertikalachse ($L \perp V$) durch Justieren der Röhrenlibelle erreicht. Zunächst wird beim aufgestellten Nivellierinstrument die Stehachse genähert senkrecht gestellt, indem man die Dosenlibelle einspielen lässt. Dann wird man die Röhrenlibelle, die parallel zu zwei Fußschrauben zu stellen ist, einspielen lassen. Die Libellenblase folgt dabei dem Zeigefinger der rechten Hand. Sodann wird das Fernrohr mit Libelle um 200 gon gedreht. Der sich jetzt zeigende Libellenausschlag ist gleich dem doppelten Stehachsfehler. Die eine Hälfte des Libellenausschlags beseitigt man mit den Fußschrauben und findet so den Spielpunkt der Libelle (s. Abschn. 7.2.2); die Stehachse steht jetzt in dieser Richtung senkrecht. Die zweite Hälfte des Libellenausschlags wird mit den Libellenjustierschrauben beseitigt; damit wird der Spielpunkt S in den Normalpunkt N der Libelle gelegt. Das Fernrohr mit der Libelle wird nun um 100 gon über die 3. Fußschraube gedreht. Ein sich jetzt evtl. zeigender Libellenausschlag wird mit der Fußschraube beseitigt. Nun steht die Stehachse (Vertikalachse) in jeder Richtung senkrecht. Wenn sich beim Drehen des Fernrohrs noch ein Libellenausschlag zeigt, ist der Vorgang zu wiederholen. Ein sich zeigender Ausschlag der Dosenlibelle ist nach Justieren der Röhrenlibelle ganz mit ihren Justierschrauben zu beseitigen.

Für die Nivelliere mit Kippschraube ist die Forderung $L \perp V$ nur in eingeschränktem Maße wichtig, weil das Fernrohr mit Libelle zur Stehachse in geringem Maße gekippt werden kann. Da die Stehachse mit Hilfe der Dosenlibelle des Nivellierinstrumentes genähert senkrecht gestellt wird, gilt die Forderung $L \perp V$ hier für die Dosenlibelle. Man bringt diese zum Einspielen und dreht das Fernrohr langsam um 200 gon. Hierbei beobachtet man die Blase der Dosenlibelle. An der Stelle des größten Ausschlags beseitigt man diesen zur Hälfte mit den Fußschrauben, womit der Spielpunkt der Dosenlibelle gefunden ist und die Stehachse im Einspielbereich der Dosenlibelle senkrecht steht. Die zweite Hälfte des Ausschlags wird mit den Justierschrauben der Dosenlibelle fortgeschafft. Jetzt fallen Spielpunkt und Normalpunkt der Dosenlibelle zusammen. Eventuell ist der Vorgang zu wiederholen.

Bei dem Nivellier mit automatischer Horizontierung ist wie bei dem Nivellier mit Kippschraube über die Dosenlibelle die eingeschränkte Forderung $L \perp V$ zu erfüllen.

9.4.3 Waagerechtstellen der Ziellinie (Nivellierprobe $L \parallel Z$)

Das Überprüfen der waagerechten Ziellinie erfolgt bei dem Nivellier ohne Kipp-schraube und bei dem Nivellier mit Kippschraube durch Erfüllen der Forderung Libellenachse parallel Ziellinie ($L \parallel Z$).

Bei dem automatischen Nivellier wird die waagerechte Ziellinie innerhalb der Einspielgenauigkeit der Dosenlibelle durch die Forderung erfüllt, dass ein durch die Objektivmitte gehender Strahl auch durch die Strichkreuzmitte verlaufen muss.

Die Prüfungsmethoden sind für die drei Instrumentenarten gleich; man bezeichnet sie auch als „Nivellierproben". Sie sind mit demselben Instrumentarium auszuführen, mit dem später nivelliert wird. Wenn also mit Planplatte und Halbzentimeterlatte gearbeitet werden soll, wird die „Nivellierprobe" auch damit vorgenommen.

Folgende drei Prüfungsmethoden seien genannt:

1. Methode

Zwischen den örtlich festgelegten, $40 \cdots 50$ m entfernten Punkten A und B (Pfahl, Kreuz auf Mauer) wird der Höhenunterschied durch „Nivellieren aus der Mitte" bestimmt (9.32).

Hierzu wird das Nivellierinstrument auf 0,5 m (bei Feinnivellieren auf 0,1 m) genau in die Mitte zwischen beiden Punkten aufgestellt. Der Instrumentenstandpunkt I braucht nicht in der Geraden AB zu liegen, es müssen nur die Entfernungen $A-I$ und $I-B$ gleich lang sein. Es wird bei einspielender Libelle (bei Libelleninstrumenten die Röhrenlibelle, bei automatischen Nivellieren die Dosenlibelle) abgelesen

$$\text{in } A: \quad m_1 = h_1 + d \qquad \text{in } B: \quad m_2 = h_2 + d$$

Damit ergibt sich der Höhenunterschied zwischen A und B mit

$$\Delta h = h_1 - h_2 = m_1 - d - (m_2 - d) = m_1 - m_2$$

Man erhält den Höhenunterschied zweier Punkte also auch mit schiefer Ziellinie, wenn die Zielweiten gleich sind. Das ist eine wichtige Feststellung.

Nun stellt man das Instrument nahe an den zuletzt abgelesenen Punkt B und liest bei einspielender Libelle an der Latte in B den Wert l_2 ab, den man wegen der kurzen Entfernung als fehlerfrei ansieht ($l_2 = k_2$). Die Reihenfolge der Ablesungen aus der Mitte (erst A, dann B) und Wechsel des Instruments zum Punkt B sollte man sich wegen der Vorzeichen und der leichteren Rechnung zu eigen machen.

Nach Bild **9.32** findet man

$$\Delta h = m_1 - m_2 = k_1 - k_2$$

und daraus die Sollablesung in A mit

$$k_1 = (m_1 - m_2) + k_2$$

9.32 Nivellierprobe

Beispiel. Nivellierprobe

steigendes Gelände

aus der Mitte: Ablesung in A $m_1 = 2{,}413$

 Ablesung in B $m_2 = 1{,}637$

$$\Delta h = m_1 - m_2 = 0{,}776$$

Stand bei B: Ablesung in B $k_2 = 1{,}468$

 Soll-Ablesung in A $k_1 = 2{,}244$

fallendes Gelände

aus der Mitte: Ablesung in A $m_1 = 0{,}965$

 Ablesung in B $m_2 = 2{,}143$

$$\Delta h = m_1 - m_2 = -1{,}178$$

Stand bei B: Ablesung in B $k_2 = 1{,}514$

 Soll-Ablesung in A $k_1 = 0{,}336$

Wenn an der Latte in A anstelle des errechneten Sollwertes k_1 der Wert l_1 abgelesen wird, ist die Ziellinie nicht waagerecht. Man erfüllt die Forderung der waagerechten Ziellinie indem man bei dem Nivellier ohne Kippschraube bei einspielender Röhrenlibelle das Strichkreuz mit den senkrecht wirkenden Justierschrauben verschiebt, bis der Sollwert k_1 abgelesen wird. Man merke sich, dass die während eines Prüfungsvorganges einmal benutzten Justiereinrichtungen nicht ein zweites Mal verwendet werden dürfen, da sonst der erste Justiervorgang hinfällig würde. Die Forderung $L \parallel Z$ kann also hier nur mit den Justierschrauben des Strichkreuzes erfolgen.

Die Forderung der waagerechten Ziellinie wird bei dem Nivellier mit Kippschraube erfüllt, indem man mittels der Kippschraube die Röhrenlibelle zum Einspielen bringt und das Strichkreuz mit den senkrecht wirkenden Justierschrauben verschiebt, bis der Sollwert k_1 abgelesen wird. Eine andere Möglichkeit besteht in der Einstellung des Sollwertes mit der Kippschraube und Beseitigen des sich jetzt zeigenden ganzen Ausschlages der Libelle mit ihren Justierschrauben. Bei einigen Instrumenten ist das Strichkreuz fest eingebaut und somit nur die letztgenannte Justiermöglichkeit über die Libelle gegeben.

Ähnlich wird bei dem Nivellier mit automatischer Horizontierung die Forderung erfüllt, dass ein durch Objektivmitte gehender Strahl auch durch Strichkreuzmitte verlaufen muss. Bei den meisten Instrumenten wird bei einspielender Dosenlibelle die Strichkreuzplatte mit den senkrecht wirkenden Justierschrauben verschoben, bis der Sollwert k_1 erreicht ist. Es gibt jedoch auch andere technische Lösungen. So wird der Sollwert k_1 z. B. bei dem NA 2 (Leica) durch eine auf der rechten Seite des Instrumentes befindliche Justierschraube eingestellt. Man beachte die den Instrumenten beigegebene Justieranweisung.

Bei der Justierung eines Nivelliers mit Planplatte [1]) kann für die Ablesung in B selbst auf die nahe Entfernung nicht mehr $l_2 = k_2$ gelten.

Man stellt deshalb das Instrument um 1/10 der Entfernung AB hinter B auf (9.32) und erhält die Ablesungen in A und B mit l_1 und l_2. Daraus errechnet sich der Sollwert mit

$$k_1 = m_1 - m_2 + l_2 + \frac{(m_1 - m_2) + (l_2 - l_1)}{10}$$

Beispiel. (Halbzentimeterlatte) $AB = 45{,}0$ m B-Instrument $= {}^1/_{10}\, AB = 4{,}50$ m

Aus der Mitte: Ablesung in A $m_1 = 2{,}8768$

 Ablesung in B $m_2 = 4{,}0586$

$$m_1 - m_2 = -1{,}1818$$
$$l_2 = 3{,}0742$$
$${}^1/_{10}\,[(m_1 - m_2) + (l_2 - l_1)] = -0{,}0009$$

Soll-Ablesung in A $k_1 = 1{,}8915$

Stand bei B: Ablesung in B $l_2 = 3{,}0742$

 Ablesung in A $l_1 = 1{,}9014$

$$l_2 - l_1 = 1{,}1728$$

[1]) Bei Feinnivellieren ist noch eine Korrektion für Erdkrümmung und Strahlenbrechung anzubringen, auf die hier nicht eingegangen wird.

9.33 Nivellierprobe nach Kukkamäki **9.34** Nivellierprobe mit zwei Zwischenpunkten

2. Methode[1])

Man stellt das Instrument in die Mitte zwischen zwei 20 m entfernte Punkte A und B (9.33) und liest m_1 und m_2 ab. Dann wird das Nivellierinstrument auf Punkt C gestellt, der 20 m von B entfernt ist und l_1 und l_2 werden bestimmt.
Es ist dann

$$\Delta h = h_1 - h_2 = m_1 - m_2 = k_1 - k_2$$

$$l_1 = k_1 + 4d \qquad\qquad k_1 = l_1 - 4d$$
$$l_2 = k_2 + 2d \qquad\qquad k_1 = l_1 - 2\left[(l_1 - l_2) - (m_1 - m_2)\right]$$
$$\overline{l_1 - l_2 = k_1 - k_2 + 2d} \qquad k_2 = l_2 - 2d$$
$$l_1 - l_2 = m_1 - m_2 + 2d \qquad k_2 = l_2 - \left[(l_1 - l_2) - (m_1 - m_2)\right]$$
$$2d = (l_1 - l_2) - (m_1 - m_2)$$

Beispiel.

Aus der Mitte: Ablesung in A $m_1 = 2{,}345$ Stand in C: Ablesung in A $l_1 = 3{,}161$
 Ablesung in B $m_2 = 1{,}104$ Ablesung in B $l_2 = 1{,}906$

$$m_1 - m_2 = 1{,}241 \qquad\qquad\qquad\qquad\qquad l_1 - l_2 = 1{,}255$$
$$2d = (l_1 - l_2) - (m_1 - m_2) = +\,0{,}014$$

Soll-Ablesung in A $k_1 = 3{,}161 - 2 \cdot 0{,}014 = 3{,}133$
Soll-Ablesung in B $k_2 = 1{,}906 - 0{,}014 \quad = 1{,}892$

Der Vorteil dieser Methode liegt in der geringen Änderung der Fokussierung während der Messung. Die Berichtigung erfolgt wie beschrieben.

3. Methode

Man teilt die Strecke von 45 m bis 60 m genau in drei gleiche Teile (9.34) und besetzt die Punkte B und C mit Nivellierlatten, die jeweils von A und D mit dem Nivellierinstrument angezielt werden[2]).

[1]) Nach Kukkamäki (Finnland).
[2]) Es würde genügen, wenn $BC = CD$ ist.

Aus Bild **9.**34 ist zu entnehmen

$$\Delta h = h_1 - h_2 = h_4 - h_3 \qquad h_4 = h_1 - h_2 + h_3 \qquad h_1 = l_1 - d$$
$$h_2 = l_2 - 2d \qquad h_3 = l_3 - d$$

und somit der Sollwert in *B*:

$$h_4 = l_1 - l_2 + l_3$$

Man merke sich als Gedächtnisstütze: Die abgelesenen Werte l_1, l_2, l_3 sind mit Vorzeichenwechsel zusammenzufassen.

Beispiel. Stand in *A*: Ablesung in *C* $\qquad l_1 = 1{,}847$
 Ablesung in *C* $\qquad l_2 = 0{,}725$
 $\overline{\qquad\qquad\quad l_1 - l_2 = 1{,}122}$
 Stand in *D*: Ablesung in *C* $\qquad l_3 = 1{,}643$
 Soll-Ablesung $\qquad h_4 = 2{,}765$

Die Berichtigung erfolgt wie beschrieben.

Nach der Justierung sollen die Justierschrauben mäßig fest angezogen sein. Die Nivellierprobe ist zu wiederholen.

Man kann die Nivellier-Probe auch in der Werkstatt mit Hilfe eines Kollimators durchführen. Ein Kollimator ist ein auf unendlich eingestelltes Fernrohr mit einem Objektiv größerer Brennweite ($f = 500$), größerem Objektivdurchmesser (60 mm) und beleuchtetem Strichkreuz, dessen Zielachse genau waagerecht gestellt werden kann (z. B. mittels umsetzbarer Libelle). Stellt man nun das zu justierende Instrument so vor den Kollimator, dass die Objektive einander zugewandt sind, so bildet sich das Strichkreuz des Kollimators bei Betrachtung durch das Instrument im Unendlichen ab. Das zu prüfende Nivellierinstrument wird auch auf unendlich eingestellt.

Die Justierung erfolgt, indem die Strichkreuze des Nivelliers und des Kollimators mit der Kippschraube des zu prüfenden Instrumentes zur Deckung gebracht werden und ein Ausschlag der Libelle mit den Libellenjustierschrauben beseitigt wird, oder man verschiebt bei einspielender Libelle die Strichkreuzplatte mit den senkrecht wirkenden Justierschrauben bis die Deckung mit dem Strichkreuz des Kollimators hergestellt ist.

Bei Nivellieren mit automatischer Horizontierung wird das Strichkreuz mit der Justierschraube bis zur Deckung mit dem Strichkreuz des Kollimators verschoben.

9.4.4 Ziellinien digitaler Nivelliere

Digitale Nivelliere haben neben der optischen Ziellinie eine Ziellinie des elektronischen Messsystems. Diese ist streng nach den Anweisungen des Herstellers zu überprüfen, da die jeweiligen Ablesungen von einem installierten Prüfprogramm verarbeitet werden.

Die Überprüfung kann nach den zuvor beschriebenen Methoden 2. oder 3. oder nach der Methode von Förstner erfolgen. An den Enden der 45 m langen Teststrecke sind die Latten A und B aufgestellt. Die Instrumentstandpunkte 1 und 2 befinden sich etwa in den Drittelpunkten der Teststrecke (**9.**35). Da mit digitalen Instrumenten auch Entfernungen

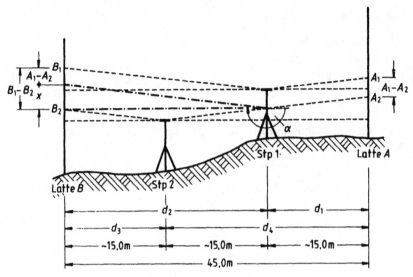

9.35 Prüfstrecke für digitale Ingenieurnivelliere

mit hinreichender Genauigkeit bestimmt werden können, wird an die Unterteilung der Prüfstrecke nicht die hohe Anforderung gestellt, wie sie bei analogen Instrumenten notwendig ist. Die Abfolge der Visuren wird im Display angezeigt.

Bei der Überprüfung digitaler Ingenieurnivelliere nach Förstner wird der Winkel α bestimmt und abgespeichert. Dieser Winkel ergibt sich nach Bild **9.35** zu:

$$\alpha = \arctan\left[(A_1 - B_1 + B_2 - A_2) : (d_1 - d_2 + d_3 - d_4)\right]$$

Aus Bild **9.35** ist weiter zu entnehmen:

$$x = B_1 - B_2 - (A_1 - A_2) \quad \text{oder} \quad -x = A_1 - B_1 + B_2 - A_2 \, .$$

Der Nenner $(d_1 - d_2 + d_3 - d_4)$ ist immer negativ, somit liegt der Winkel α (s. Bild 9.35) in Abhängigkeit vom Vorzeichen des Zählers im zweiten oder dritten Quadranten. Der Korrekturwert der Höhenablesung berechnet sich aus Winkel und Entfernung.

Wenn der elektronische Teil eines digitalen Nivellierinstrumentes geprüft und der Korrekturwert abgespeichert wurde, wird die Sollablesung des letzten Ziels im Display angezeigt. Die optische Ziellinie kann dann korrigiert werden, indem das Strichkreuz mit Hilfe der Justierschrauben in den angezeigten Sollwert einer Nivellierlatte mit DIN-Teilung verschoben wird.

Die während der Messung im Display des Instrumentes angezeigte bzw. abgespeicherte Lattenablesung ist ein korrigierter Wert.

9.5 Nivellierlatten und Zubehör

Die Nivellierlatte ist der Maßstab, mit dem die Abstände der einzuwägenden Punkte von der waagerechten Ziellinie des Instrumentes aus gemessen werden. Für analoge Nivelliere kennt man Latten mit Felderteilung und mit Strichteilung, für digitale Nivelliere Latten mit Codeteilung.

Nivellierlatten bestehen aus abgelagertem, trockenem Kiefern- oder Eschenholz; sie sind 6···9 cm breit und in der Regel 3 oder 4 m lang. Neben starren Latten gibt es zur Erleichterung des Transportes Klapplatten mit Schnellverschluss (zusammen-klappbar in der Regel auf 1 m, 1,5 m, 2 m) und Teleskoplatten. Der Anstrich besteht aus wetterfesten Farben, Lacken oder Leuchtfarben, die Enden sind mit Metallbeschlägen versehen.

Je nachdem, ob das Nivellierinstrument ein aufrechtes oder umgekehrtes Bild liefert, verwendet man Nivellierlatten mit aufrechten oder umgekehrten Zahlen.

Nach DIN 18703 unterscheidet man Nivellierlatten mit einfacher Felderteilung (9.36 a) und doppelter Felderteilung (9.36 b). Die Unterteilung erfolgt in Meter, Dezimeter, halbe Dezimeter und Zentimeter. Die arabischen Ziffern der Dezimeter-angabe stehen am Beginn des dazugehörigen Dezimeterfeldes. Bei einfacher Felder-teilung wechseln die Farben Schwarz und Rot je Meter auf weißem oder gelbem Grund; bei doppelter Felderteilung sind alle Angaben schwarz auf weißem oder gelbem Grund.

Die Latten werden an Handgriffen gehalten und mittels eines Lattenrichters oder einer angeschraubten Dosenlibelle mit 20'···30' Angabe senkrecht gestellt. Die bei einspielender Libelle senkrechte Stellung der Latte, von der in hohem Maße die Genauigkeit des Nivellements abhängt, ist vor Beginn des Nivellements mit einem Lot oder mit dem Nivellierinstrument in zwei senkrecht zueinander stehenden Richtungen zu prüfen. Ein sich zeigender Ausschlag an der Dosenlibelle ist ganz mit den Justierschrau-ben zu beseitigen. Für genauere Messungen unterstützt man die Latte mit zwei senkrecht zueinander stehenden Streben.

Außer den genannten Nivellierlatten gibt es noch solche mit digitalisierter Teilung, mit Doppelteilung, mit Halbzentimeterteilung sowie mit codierter Teilung.

Bei der Nivellierlatte mit digitalisierter Teilung (9.37) ist jeder Zentimeter beziffert. Damit entfällt weitgehend die Fehlerquelle beim Ablesen und Auszählen der Teilstriche.

Wendelatten haben eine Doppelteilung, je eine auf der Vorder- und Rückseite, die um einen unrunden Wert gegeneinander verschoben sind. Mit ihrem Einsatz schaltet man weitgehend Ablese- und Schätzfehler aus und erhöht die Genauigkeit. Die beiden Teilungen können auch auf einer Seite nebeneinander liegen.

Halbzentimeterlatten sind starre Holzlatten und haben anstelle der Zentime-terteilung eine solche in Halbzentimetern; dies dient der Erhöhung der Genauig-keit. Bei der Berechnung ist der Endwert des Höhenunterschiedes durch zwei zu dividieren.

Eine Nivellierlatte mit Codeteilung für digitale Nivellierinstrumente ist in (9.39) abgebildet. Für derartige Latten gibt es keine Norm.

9.36 Nivellierlatte
(aufrechtes Bild)
a) mit einfacher
Felderteilung
(DIN 18 703)
b) mit doppelter
Felderteilung
(DIN 18 703)

9.37 Digitalisierte
Nivellierlatte

9.38 Invarlatte
(Strichteilung)
aufrechtes
Bild, mit
Doppelteilung
in Zentimeter,
Lattenkon-
stante 3,015 m
(DIN 18 717)

9.39 Nivellierlatte
mit
Codeteilung
(Leica)

Diese Latten können aus drei zusammensteckbaren Segmenten von 1,35 m Länge beste-
hen (Leica) oder als Klapplatte ausgebildet sein (Zeiss). Sie können auch als Teleskoplatte
ausgebildet sein. Auf der Rückseite der Latte ist vielfach eine DIN-Teilung aufgebracht.

Für Präzisionsnivellements verwendet man 1,75 m oder 3 m lange Invarlatten mit zwei
nebeneinander liegenden Teilungen in Zentimeter (**9.38**) oder Halbzentimeter. Die Strich-
teilung ist auf dem unter 200 N Zugkraft gespannten Invarband aufgebracht, das in
einen Holzrahmen eingefügt ist, der die Bezifferung trägt. Die Teilungsdifferenz (Latten-
konstante) beträgt bei der abgebildeten Latte 3,015 m.

Für Präzisionsnivellemente mit Digitalnivellieren gibt es Invarlatten mit Codeteilung.

Die Nivellierlatte muss beim Streckennivellement während des Instrumentenwechsels
auf einem festen, scharf markierten Punkt stehen. Für Höhenmessungen in Stadtgebieten
kann man unter den Lattenfuß einen Stollen schrauben, so dass ein markierter Punkt auf
dem Pflaster aufzuhalten ist. Im lockeren Boden dienen eingeschlagene Pfähle mit Nagel
oder Rohre als Wechselpunkt. Am häufigsten jedoch verwendet man Lattenuntersätze
(Unterlagsplatten, Frösche, Kröten) aus Grauguss mit drei Fußspitzen aus Stahl und
einem Handgriff im Gewicht von 2,5 kg oder 5 kg mit einem oder zwei Aufsetzzapfen aus

a)

c)

b)

9.40
Lattenuntersatz
a) mit einem Aufsetzzapfen
b) mit zwei Aufsetzzapfen
c) mit praktischem Griff

gehärtetem Stahl (**9.40**). Der in Bild **9.40**b ersichtliche höhere Aufsetzzapfen ist herausschraubbar; er dient zur Ausführung von Nivellements mit doppelten Wechselpunkten (s. Abschn. 10.3.3). Die Lattenuntersätze sind fest in den Boden einzutreten.

Prüfen der Nivellierlatten

Die Genauigkeit des Nivellements hängt auch weitgehend von der Nivellierlatte ab. Abweichungen, die auf die Durchbiegung der Latte, schlechte Teilung und Bezifferung, nicht justierte Dosenlibelle, mangelhafte Verschlüsse bei Klapplatten, lockere Metallbeschläge an den Enden zurückzuführen sind, können durch Achtsamkeit vermieden werden.

Da die Nivellierlatten aus Holz ihre Länge besonders bei Änderung der Luftfeuchtigkeit ändern, ist die Lattenteilung in gewissen Zeitabständen (bei Festpunktnivellements täglich) zu untersuchen und das mittlere Lattenmeter zu bestimmen. Hierzu bedient man sich eines Prüfmeterstabes mit Strichteilung (**9.41**); die Überteilung von 1 mm nach jeder Seite ist dabei in 5 Teile zu je 0,2 mm geteilt. Die Gleichung des Prüfmeters muss bekannt sein.

9.41 Prüfmeter mit Strichteilung. Angabe der Überteilung 0,2 mm

Die Nivellierlatte wird in waagerechter Lage an jeweils zwei im Abstand von 1 m befindlichen Punkten an 5 Stellen geprüft, wobei jedes Mal der linke und rechte Rand des Teilstriches der Latte abgelesen wird.

Tafel 9.42 Vordruck und Beispiel zum Bestimmen des Lattenmeters einer Nivellierlatte

Normalmeter Nr.		Gleichung: $A = 1\,\text{m} + 0{,}003\,\text{mm} + 0{,}0115\,(t° - 20°)\,\text{mm}$						
Latte Nr. 3 m Holzlatte, starr, $^{1}/_{2}$ cm-Teilung		links ⊣⊢ + − ⊣⊢ + − rechts 0 1 m				Datum: Gemessen durch:		

Temp. rel. Luftfeuchtigkeit	Latte abgelesen in Lattenmeter		Ablesung am Normalmeter links 0,2 mm	rechts 0,2 mm	li−re 0,2 mm	Mittel mm	Verb. des Normalmeters mm	absolute Länge des Lattenmeters
1	2	3	4	5	6	7	8	9
24° 50%	02	22	+0,4 −0,7	+1,6 +0,6	−1,2 −1,3	−0,25		
	14	34	+2,6 +1,3	+3,6 +2,5	−1,0 −1,2	−0,22		
	27	47	−0,2 +2,2	+1,2 +3,3	−1,4 −1,1	−0,25		
	33	53	−4,8 −3,4	−3,5 −2,3	−1,3 −1,1	−0,24		
	39	59	+3,4 −1,6	+4,8 −0,2	−1,4 −1,4	−0,28		
						−1,24:5 = −0,248	+0,049	1 m −0,199 mm

Lattenmeter: 0,999801 m

Korrektion auf 100 m Höhenunterschied $c_{100} = -0{,}020\,\text{m}$

Rechengang: In den Sp. 2 und 3 wird das zu überprüfende Lattenintervall vermerkt. Die in 0,2 mm-Einheiten ermittelten Ablesungen links und rechts am Normalmeter werden mit den entsprechenden Vorzeichen (im Kopf des Vordrucks angegeben) in den Sp. 4 und 5, deren Differenz in Sp. 6 eingetragen. Das Mittel der Sp. 7 in mm findet man durch Addition der beiden Werte der Sp. 6 dividiert durch 10. Die Verbesserung des Normalmeters in Sp. 8 ist aus der angegebenen Gleichung zu berechnen. Weiter findet man die absolute Länge des Lattenmeters Sp. 9 = 1 m + (Sp. 7 + Sp. 8) und daraus die Korrektion für 100 m Höhenunterschied. Mit dieser Korrektion sind die gemessenen Höhenunterschiede zu verbessern.

10 Höhenmessung (Nivellement)

Bezugsfläche für Höhenmessungen ist der Meereshorizont [1]). Als Ausgangspunkt für die Höhenmessungen in Deutschland wurde 1879 der Normalhöhenpunkt an der alten Berliner Sternwarte mit $+ 37{,}000$ m ü. NN (über Normal-Null) festgelegt. Die Höhenausgangsfläche (Bezugsfläche) liegt also 37,000 m unter diesem Punkt; sie ist die Normal-Null-Fläche (NN) und fällt innerhalb eines Dezimeters mit dem Mittelwasser der Nordsee (Amsterdamer Pegel) zusammen. Auf diese Bezugsfläche bezieht man alle Höhenangaben und bezeichnet sie als Höhen über NN (Normal-Null). Die Höhe ü. NN eines Punktes ist somit sein Abstand von der Normalnullfläche längs der Lotlinie.

Nach Abbruch der Berliner Sternwarte wurde der Normalhöhenpunkt 1912 nach Hoppegarten bei Berlin verlegt; er ist durch einen Granitpfeiler unterirdisch vermarkt und durch unterirdische Festlegungen versichert. Normal-Null hat sich dadurch nicht geändert.

Von dem Normalhöhenpunkt ausgehend, ist über ganz Deutschland ein Nivellementpunktfeld (NivP-Feld) mit vielen tausend vermarkten Nivellementpunkten (NivP) geschaffen, deren Höhen durch Feinnivellements bestimmt sind.

Die Grundlage für das NivP-Feld ist das Deutsche Haupthöhennetz (DHHN), das möglichst unverändert erhalten bleiben soll. Das NivP-Feld ist in die Niv-Netze 1. bis 3. Ordnung gegliedert [2]). Zum Netz 1. Ordnung zählen die für die grundlegende Netzausgleichung verwendeten Niv-Linien des DHHN und die Niv-Linien des Zwischennetzes 1. Ordnung, die in der Regel nach ähnlichen Methoden wie die Niv-Linien des DHHN gemessen, jedoch in das DHHN nach dessen Ausgleichung eingerechnet werden.

Durch Netzverdichtung des Niv-Netzes 1. Ordnung entstehen Niv-Schleifen:
im Niv-Netz 2. Ordnung bis zu 70 km Länge, im Niv-Netz 3. Ordnung bis zu 35 km Länge.

Die Niv-Netze werden durch Niv-Linien bis zu 4 km Länge ausgefüllt.

Die Niv-Linien wiederum sind in Niv-Strecken (Nivellement zwischen zwei benachbarten Niv-Punkten) unterteilt.

Von 1913 ab wurden alle älteren und neueren Nivellements in einem neuen Netz zusammengefasst; die Höhe des Normalhöhenpunktes und die vermarkten Höhenpunkte wurden beibehalten. Die für diese Punkte neu berechneten Höhen, die die normale orthometrische Korrektion [3]) enthalten,

[1]) Für Meerestiefen gilt als Ausgangshöhe „Seekartennull", das in der Deutschen Bucht als örtliches, mittleres Springniedrigwasser definiert ist. Es ist keine Niveaufläche. Für die Ostsee (ohne Gezeiten) ist Seekarten-Null gleich Normal-Null.

[2]) Nach Richtlinien der Arbeitsgemeinschaft der Vermessungsverwaltungen (AdV) und NivP-Erlassen der Länder.

[3]) Normale orthometrische Korrektion NOK (mm) $= \pm 0{,}000825 \cdot M\,(\text{km}) \cdot H\,(\text{m})$. Hierin ist M die Differenz der geogr. Breiten zwischen den Endpunkten des Nivellements, umgerechnet in km, und H die mittlere Meereshöhe aus den Endpunkten des Nivellements in m.

bezeichnet man als „Höhen im neuen System" gegenüber den „Höhen im alten System", die diese Korrektion nicht enthalten. Der Unterschied zwischen beiden Systemen beträgt bis zu 10 cm, er ist im Süden Deutschlands am größten. Man achte darauf, dass man jeweils nur mit Höhen im gleichen System arbeitet.

Die Beschreibung der Höhenfestpunkte und deren Höhen sind in Karteien und Verzeichnissen niedergelegt, die bei den Landesvermessungsämtern, den staatlichen Vermessungs- und Katasterämtern sowie bei den Dienststellen des Sondervermessungs-dienstes (z. B. Kommunen) geführt und laufend gehalten werden. Sie bilden die Grundla-ge für alle Höhenmessungen. Auskunft über die Höhenfestpunkte geben die Vermes-sungsdienststellen.

Man wendet für die Höhenmessung je nach ihrem Zweck folgende Verfahren an, die in der Reihenfolge der Aufzählung hinsichtlich ihrer Genauigkeit abnehmen: das Nivellement (geometrische Höhenmessung), die trigonometrische Höhenmessung (s. Teil 2) und die barometrische Höhenmessung, die auf der Luftdruckbestimmung in verschiedenen Schichten der Atmosphäre beruht (sie wird nicht behandelt).

Die Höhen der Niv-Punkte werden durch Nivellement bestimmt.

10.1 Festlegen und Vermarken der Nivellementpunkte

Der Abstand der Niv-Punkte in einer Niv-Linie soll innerhalb von Wohnplätzen höch-stens 400 m betragen, in der Feldlage den Abstand von 800 m nicht überschreiten. Die Vermarkung geschieht durch Höhenbolzen aus Stahl, Temperguß, Aluminiumbronze oder einer Aluminiumlegierung (**10.1**), die vorwiegend in die Fundamente gut gegründeter Gebäude oder in Widerlager, Flügelmauern oder dgl. standfester Bauwerke waagerecht oder senkrecht eingelassen werden. Der waagerecht eingelassene Höhenbolzen (Mauer-bolzen MB) ragt mit dem Kopf aus der Mauerwand heraus, der senkrecht gesetzte Höhenbolzen (Vertikalbolzen) lässt nur die oberste Kuppe einige Millimeter sichtbar. Der höchste Punkt des Bolzens bezeichnet den Höhenpunkt, auf den die Nivellierlatte aufgesetzt wird. Beim Setzen eines Bolzens ist darauf zu achten, dass eine 4 m lange Nivellierlatte senkrecht aufzusetzen ist und vorspringende Ecken, Gesimse usw. dies nicht verhindern [1]). Wenn es im freien Gelände an standfesten Bauwerken mangelt, behilft man

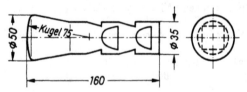

$\varnothing 50$ „Kugel 75 $\varnothing 35$

160

10.1 Höhenbolzen Form B nach DIN 18 708

[1]) An vielen neueren Häusern wäre unter der Voraussetzung der Verwendung von 4 m-Latten keine Möglichkeit, einen Höhenbolzen anzubringen. Man verwendet deshalb in bebauten Gebieten vielfach 2 m-Latten.

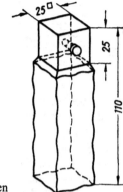

10.2 Granitpfeiler mit Höhenbolzen

sich mit Granitpfeilern (**10.**2), die an der Stirnseite einen Bolzen (Pfeilerbolzen PB) tragen und auf fest gewachsenem Boden in einem Betonmantel stehen.

Es werden auch Rammpfähle (RP) verwendet. Der Rammpfahl ist ein vorgefertigter eisenarmierter Schleuderbetonpfahl von 1,0 ··· 1,5 m Länge mit einer massiven Eisenspitze. Er wird etwa bodengleich eingerammt und danach ein Tellerbolzen (Vertikalbolzen) in seine Kopffläche einzementiert.

In Marschgebieten an der Küste müssen wegen der Setzung des Geländes Rohrfestpunkte bis zu einer Tiefe von 20 m gegründet werden. Das aus Stücken von 2 ··· 4 m Länge bestehende Stahlrohr trägt oben eine aufgeschraubte, verzinkte Halbkugel zum Aufsetzen der Latte. An Bahnhofsgebäuden, Kirchen usw. findet man zuweilen noch kreisrunde Höhenmarken (Höhentafeln), deren oberster Punkt oder deren zentrisches Loch die Höhe über NN angibt.

Das Festlegen, Vermarken und Überwachen der genannten Höhenfestpunkte ist Sache des staatlichen Vermessungsdienstes. Ein Höhenbolzen darf deshalb von Dritten weder entfernt noch verändert werden. Macht eine Baumaßnahme dies erforderlich, so ist das zuständige Vermessungsamt zu benachrichtigen, das den Punkt verlegt.

Für größere Ingenieurarbeiten sind vielfach zusätzliche Höhenfestpunkte zu schaffen, die nicht in das staatliche Höhenfestpunktnetz übernommen werden. Die Auswahl und Vermarkung der Punkte geschieht nach den behandelten Gesichtspunkten. Für zeitlich begrenzte Arbeiten genügen evtl. vorhandene markante Punkte wie Mauervorsprünge, Treppenstufen, Fundamentsockel usw.

10.2 Die Ausführung des Nivellements

Die Höhenmessung dient zur Bestimmung von Höhenfestpunkten, zum Festlegen von Höhen für Hochbauten und Ingenieurbauten aller Art, zur Aufnahme der Formen der Erdoberfläche usw. Sie erfolgt durch Bestimmen von Höhenunterschieden.

Der Höhenunterschied Δh zweier Punkte (**10.**3) ist die Differenz der Ablesungen h_r und h_v, die von der waagerechten Ziellinie aus bestimmt sind. Dabei bezeichnet man im Sinne der fortschreitenden Messung die rückwärtige Ablesung als „Rückblick", die nach vorn gerichtete als „Vorblick". Der Höhenunterschied zwischen A und B ist somit die Differenz zwischen Rückblick und Vorblick; er ergibt sich vorzeichentreu, bei steigendem Gelände

10.3 Bestimmen des Höhenunterschiedes zwischen A und B
$\Delta h = h_r - h_v$

positiv, bei fallendem Gelände negativ. Um restliche Instrumentenfehler auszuschalten, wird das Nivellierinstrument in die Mitte von A und B aufgestellt (Rückblick und Vorblick gleich lang).

Durch Summieren einzelner Höhenunterschiede bestimmt man die Höhen der Nivellementsfestpunkte, die wiederum als Ausgangspunkt für weitere Nivellements dienen. Bei diesem fortschreitenden Nivellement nennt man den Punkt, auf dem die Latte stehenbleibt, während das Instrument den Standpunkt wechselt, den ,,Wechselpunkt''. Durch örtliche Verhältnisse bedingt, kann es vorkommen, dass ein Neupunkt nicht gleichzeitig Wechselpunkt ist; dann wird dieser als ,,Zwischenpunkt'' abgelesen. Diese Zwischenablesung ist von der Entfernung unabhängig. Sie ist sorgfältig vorzunehmen, da hierfür keinerlei Kontrolle vorliegt.

Der Instrumentenstandpunkt beim Nivellieren ist willkürlich. Die Grobaufstellung geschieht mit dem Stativ nach Augenmaß, die Grobhorizontierung mit der Dosenlibelle.

Die Feinhorizontierung erfolgt

a) bei dem Nivellier ohne Kippschraube, indem man mit den Fußschrauben die Röhrenlibelle in allen Lagen einspielen läßt. Hierzu bringt man die Libelle zunächst parallel zu zwei Fußschrauben und dann über der dritten Fußschraube zum Einspielen. Dabei folgt die Libelle dem Zeigefinger der rechten Hand. Beim Nivellieren kann man in beschränktem Maß eine Fußschraube wie eine Kippschraube betätigen.

b) bei dem Nivellier mit Kippschraube, indem man mit der Kippschraube vor jeder Ablesung die Röhrenlibelle einspielen lässt,

c) bei dem Nivellier mit automatischer Horizontierung selbsttätig.

Das Luftflimmern beeinträchtigt das Nivellement erheblich. Genaue Nivellements führt man deshalb im Sommer in den frühen Morgen- und späten Abendstunden durch. Libelleninstrumente sind vor der Sonneneinstrahlung besonders zu schützen. Windstille Tage mit bedecktem Himmel sind zum Nivellieren am günstigsten.

Die Nivellements werden in der Regel an vorhandene und der Höhe nach bekannte Höhenfestpunkte an- und abgeschlossen. Die unveränderte Höhenlage der Anschlusspunkte ist von benachbarten Höhenfestpunkten zu überprüfen. Damit sind sämtliche Höhenangaben auf Normal-Null (NN) bezogen.

Nur in Ausnahmefällen, wenn der Aufwand eines Höhenanschlusses an vorhandene Punkte in keinem Verhältnis zur Aufgabe steht und es sich um eine relative Höhenbestimmung zwischen Einzelpunkten handelt, wählt man einen Horizont. Dieser sollte dann so angenommen werden (mehrere hundert Meter über oder unter der NN-Höhe) des Geländes), dass Verwechslungen mit NN-Höhen ausgeschlossen sind.

Die örtlich gemessenen Werte werden zweckmäßig in einen Vordruck eingetragen (Tafel **10.5**) und mögliche Kontrollen direkt an Ort und Stelle gerechnet. Dieser Aufschrieb wird für die meisten bautechnischen Zwecke ausreichend sein. Für umfangreiche Nivellements stehen Datenerfassungsgeräte zur Verfügung, in die die gemessenen

Werte, Punktnummern und sonstige Informationen manuell eingegeben und registriert werden, die später in einer Rechenanlage auszuwerten sind.

Beim Einsatz eines digitalen Nivellierinstruments mit Datenspeicher entfallen Ablesung und Protokollierung der Messergebnisse.

Man unterscheidet

Strecken-Nivellements zum Festlegen von Höhen einzelner Punkte (einfaches Nivellement; Nivellement im Hin- und Rückweg, mit Wendelatte (2 Teilungen), mit doppelten Wechselpunkten, mit codierter Nivellierlatte und automatischer Berechnung der Höhen; Feinnivellement mit Präzisionslatten)

Nivellements zur Aufnahme von Längs- und Querprofilen

Flächennivellements.

10.2.1 Messen mit digitalen Nivellieren

Die mit Kompensator ausgerüsteten digitalen Nivelliere werden wie jedes andere Nivellierinstrument mit Ziellinienkompensator aufgestellt. Dann wird die Dosenlibelle mit den drei Fußschrauben eingespielt, die codierte Nivellierlatte mit dem Vertikalstrich des Strichkreuzes etwa mittig anvisiert und das Lattenbild mit der Fokussierung scharfgestellt.

Für den Messvorgang stehen verschiedene Programme zur Verfügung. Diese ermöglichen Einzelmessungen, bei denen von jeder Messung die Lattenablesung und die Distanz zwischen Instrument und Latte berechnet und im Display angezeigt werden oder Streckennivellements, bei denen nach Eingabe der Höhe des Ausgangspunktes im Fortgang des Nivellements jeweils die Höhen der Wechselpunkte angegeben werden. Zwischenblicke und Höhenübertragungen können mit diesem Programm ebenfalls bearbeitet werden. Auch gibt es Programme, die das Prüfen und Justieren der Instrumente stützen, wie in Abschn. 9.4.4 beschrieben.

Sollen die Messdaten gespeichert werden, so erfolgt dies automatisch mit dem manuellen Auslösen der Messung. Speichermedien sind einsteckbare Datenspeicher, elektronische Feldbücher oder, bei on-line Verarbeitung, der Rechner. Wie bei der manuellen Feldbuchführung ist auch bei automatischer Speicherung eine exakte Zuordnung der Messdaten zu Punktbezeichnungen von großer Bedeutung. Die Punkte können fortlaufend oder individuell benannt werden.

Es ist ein Vorteil digitaler Instrumente, dass man in der Regel viele Geräteparameter den Anforderungen der zu bearbeitenden Aufgabe leicht anpassen kann.

10.3 Streckennivellements

Für ein größeres Bauvorhaben sind vielfach neue, in der Nähe der Baustelle befindliche Höhenfestpunkte zu bestimmen. Man beobachtet dann ein Streckennivellement, das von einem bekannten Höhenfestpunkt über die zu bestimmenden Punkte zu einem zweiten bekannten Höhenfestpunkt führt. Die verwendeten Höhenfestpunkte sollten von weiteren, bekannten Festpunkten überprüft sein. Zweckmäßig führt man zur Kontrolle das

Nivellement vom Endpunkt über die Neupunkte wieder zum Ausgangspunkt zurück und bestimmt so jeden Neupunkt zweimal unabhängig voneinander. Man findet auch beschränkte Kontrollen beim Einsatz der Wendelatte (2 Teilungen) und beim Nivellement mit doppelten Wechselpunkten. Die Zielweite ist maximal 50 m, da Millimeter abgelesen werden sollen. Rück- und Vorblick sind gleich lang zu wählen; das bedeutet im steileren Gelände kürzere Zielweiten. Sind gleiche Zielweiten nicht zu erreichen, sollen wenigstens die Summe aller Vor- und Rückblicke gleich sein.

10.3.1 Das einfache Nivellement

In Bild **10**.4 sind die ersten vier Instrumentenstandpunkte eines Streckennivellements zwischen FPA und FPE (nicht dargestellt) zur Bestimmung der Höhen der Punkte B und C (Tafel **10**.5) angegeben. Das Nivellement geht in folgenden Schritten vor sich, nachdem die Dosenlibelle der Latte und das Nivellierinstrument überprüft sind:

Latte in FPA senkrecht halten; Nivellierinstrument in S_1 aufstellen, Dosenlibelle einspielen lassen (beim Nivellier ohne Kippschraube auch Röhrenlibelle zum Einspielen bringen), Fernrohr auf Latte einrichten (beim Nivellier mit Kippschraube mit dieser die Röhrenlibelle einspielen lassen), an der Latte r_1 und die Entfernung (Metergenauigkeit) ablesen und aufschreiben. Auf Zeichen des Beobachters geht der Lattenträger zum Wechselpunkt WP_1. Dabei zählt er seine Schritte bis zum Instrument und schreitet die gleiche Zahl bis zum Wechselpunkt ab, den er mit der fest eingetretenen Unterlagsplatte markiert. Das Instrument wird nun auf WP_1 ausgerichtet, bei Libelleninstrumenten die Röhrenlibelle kontrolliert bzw. zum Einspielen gebracht und v_1 sowie die Entfernung in Metern abgelesen und notiert. Beim Einsatz eines Schreibers sind die abgelesenen Werte zu nennen und vom Schreiber laut zu wiederholen, um Hörfehler zu vermeiden. Der Höhenunterschied zwischen FPA und WP_1 ist dann $\Delta h_1 = r_1 - v_1$. Nun wird das Nivellierinstrument zum Punkt S_2 getragen, während die Latte auf WP_1 bleibt und vorsichtig gewendet wird. Jetzt liest man bei WP_1 rückwärts r_2 und nach Aufsetzen der Latte bei WP_2 vorwärts v_2 ab und erhält $\Delta h_2 = r_2 - v_2$. So wird fortgefahren, bis man Punkt B erreicht hat und findet

$$\Delta H = \Delta h_1 + \Delta h_2 + \ldots \Delta h_n = \sum_1^n \Delta h = \sum_1^n r - \sum_1^n v$$

Das Gelände ist entsprechend dem Vorzeichen des Höhenunterschiedes: plus = steigend, minus = fallend.

10.4 Schematische Darstellung eines Streckennivellements

In Beispiel Tafel 10.5 ist das Nivellement bis zum Punkt FPE fortgesetzt. Dann muss sein

$$H_e - H_a = \sum \Delta h = \sum r - \sum v$$

Die sich zeigende Differenz wird, sofern sie innerhalb der erlaubten Fehlergrenze liegt, gleichmäßig auf die Wechselpunkte verteilt.

Beispiel. Die Höhen der Punkte B und C sind zwischen den gegebenen Höhenfestpunkten A und E zu bestimmen. Es wurde mit einem Ingenieur-Nivellier und einer Latte mit einfacher Felderteilung von A über B und C nach E nivelliert. Punkt B konnte gleichzeitig als Wechselpunkt gewählt werden, während Punkt C mit einer Zwischenablesung erfasst wurde.

Tafel **10.5** Vordruck und Beispiel für ein Streckennivellement
(Berechnung mit Höhenunterschieden)

Instrument:	Ingenieur-Nivellier			Wetter:		Beobachter:

Latte:				Datum:		Lattenträger:

Punkt	Ziel-weite	Lattenablesung			Δh $=r-v$	Höhe ü. NN	Bemerkungen
		rück-wärts	zwischen	vor-wärts			
		r	z	v			
1	2	3	4	5	6	7	8
FPA	48	3,005				101,235	
WP_1	47			1,898	1,107	102,342	
WP_1	41	2,235					
					+1		
WP_2	40			2,000	0,235	102,578	
WP_2	45	3,010					
WP_3	45			2,275	0,735	103,313	
WP_3	31	1,885					
					+1		
B	30			2,725	−0,840	102,474	Pfahl mit Nagel
B	50	1,134					
C			2,843		−1,709	100,765	OK Schwelle
WP_4	50			0,833	2,010	102,775	
WP_4	39	0,657					
					+1		
FPE	38			0,734	−0,077	102,699	
	504	11,926 −10,465		10,465	1,461 +3	1,464 1,461	$= H_e - H_a =$ Soll $=$ Ist
		1,461				+0,003	$= d =$ Soll − Ist

zulässige Differenz: $2,0 + 5 \sqrt{0,5} = 6\,\text{mm}$

In Sp. 1 sind die Punktnummern vermerkt; die Angabe der Wechselpunkte entfällt in der Praxis, sie ist hier der Übersichtlichkeit wegen erfolgt. Die Zielweite der Sp. 2 wird in Metern oder in Schritten angegeben. Die Ablesungen rückwärts und vorwärts stehen in den Sp. 3 und 5. In Sp. 4 (Zwischenablesung) wurde der gemessene Wert für Punkt C eingetragen; er ist ohne jede Kontrolle.

Nach Abschluss des Nivellements addiert man die Sp. 3 und 5 und rechnet $\Sigma r - \Sigma v$ (Σ Sp. 3 – Σ Sp. 5). Bis auf die Messungenauigkeiten soll diese Differenz gleich ($H_e - H_a$) sein. Nun bildet man (zweckmäßig mit einem Taschenrechner) die einzelnen Höhenunterschiede $\Delta h = r - v$ in Sp. 6, deren Summe gleich ($\Sigma r - \Sigma v$) sein muss. Auf die negativen Δh bei fallendem Gelände ist besonders zu achten; während bei den positiven Werten das Vorzeichen entfällt, ist das negative Vorzeichen einzutragen. Die Zwischenablesung bei dem Punkt C denkt man sich zunächst als Vorwärts-, dann als Rückwärtsablesung geschrieben und bildet mit diesen Werten fortlaufend die Δh.

Die Differenz ($H_e - H_a$) – $\Sigma \Delta h$ ist auf die Δh gleichmäßig zu verteilen. Mit diesen verbesserten Werten sind die Höhen ü. NN durch laufende Addition zu finden (Sp. 7), deren Endwert die Höhe von FPE ist.

Die Berechnung kann auch über den „Instrumentenhorizont" erfolgen, die aber für Zwischenablesungen keine Rechenkontrolle ergibt. Eine solche Berechnung zeigt Tafel **10.14**.

Tafel **10.6** Rohdaten eines Streckennivellements mit Zwischenblicken von FP 147 bis FP 1791, durchgeführt mit DNA 10 (Leica)

```
110002 + 00000147 83...0 + 00304575
110003 + 00000147 32...0 + 00019449 331.00 + 00000951
110004 + 00000001 32...0 + 00020520 332.00 + 00001729
110005 + 00000001 573 .0 − 00001071 574..0 + 00039969 83..00 + 00303797
110006 + 00000001 32...0 + 00039970 331.00 + 00000862
110007 + 00000002 32...0 + 00039507 332.00 + 00001811
110008 + 00000002 573 .0 − 00000607 574..0 + 00119446 83..00 + 00302848
110009 + 00000002 32...0 + 00038399 331.00 + 00001329
110010 + 00000003 32...0 + 00039490 332.00 + 00002335
110011 + 00000003 573 .0 − 00001698 574..0 + 00197335 83..00 + 00301841
110012 + 00000003 32...0 + 00033858 331.00 + 00000958
110013 + 00001001 32...0 + 00011274 333.00 + 00000693
110014 + 00001001 83 .00 + 00302106
110015 + 00001002 32...0 + 00011015 333.00 + 00000847
110016 + 00001002 83 .00 + 00301952
110017 + 00001003 32...0 + 00010650 333.00 + 00000997
110018 + 00001003 83 .00 + 00301802
110019 + 00000004 32...0 + 00033782 332.00 + 00002125
110020 + 00000004 573 .0 − 00001622 574..0 + 00264976 83..00 + 00300674
110021 + 00000004 32...0 + 00030242 331.00 + 00001430
110022 + 00001791 32...0 + 00023339 332.00 + 00001338
110023 + 00001791 573 .0 + 00005280 574..0 + 00318557 83..00 + 00300766
```

1. Wort mit Identifikation 11 = Punktnummer. Endziffer = Blocknummer. Nach Pluszeichen ist die individuell eingegebene Punktnummer oder die Wechselpunktnummer angegeben. Diese kann auch Eingabe eines Inkrementalschritts automatisch erhöht werden. Weitere Identifikationen: 32 = Entfernung zur Latte, 83 = Höhe ü. NN eines Punktes (als Ausgangshöhe über Tastatur eingegeben oder aus Differenzen der Lattenablesungen gerechnet), 331 = Lattenablesung bei Rückblick, 332 bei Vorblick und 333 bei Zwischenblick. Weitere Identifikationen gibt es für Ablesungen bei Einzelmessungen und Absteckungen. 573 = Zielweitenunterschied aus Rückblick und Vorblick, 574 = Streckensumme (notwendig zur Berechnung der zulässigen Abweichung. Abschn. 10.3.5).

Bei digitalen Nivellierinstrumenten können Daten eingegeben und Messwerte automatisch registriert werden. Die Daten werden numerisch in Blöcken registriert. Die Datenblöcke sind in Worte gegliedert, die aus einer Ziffernfolge bestehen. Eine Kennung der Worte wird durch vorgegebene Identifikationsmerkmale ermöglicht, die am Anfang eines Wortes stehen und 2 bis 3 Zeichen lang sind. Der Ausdruck des Feldbuches kann aus Buchstaben bestehende Worte enthalten (Trimble/Zeiss) die entstehen, indem ein Zifferncode beim Ausdruck in Worte übersetzt wird.

Mit den Programmen, die in den digitalen Nivellieren installiert sind, ist eine Wortfolge festgelegt unter denen die Messwerte abgelegt werden. Deshalb ist es zwingend, die Vermessungsarbeiten genau nach den im Display sichtbaren Aufforderungen des Dialogs durchzuführen.

Mit Hilfe eines weiteren Programms kann der Speicherinhalt in Form eines Feldbuches dargestellt werden. Die Datenblöcke der Tafel **10**.6 sind in Tafel **10**.7 als Feldbuch ausgedruckt. Es sind nur die aufgenommenen Daten dargestellt; Kontrollen sind nicht gerechnet und Abweichungen nicht ausgeglichen. Es gibt Programme, die auch diese Arbeitsschritte ausführen.

Tafel **10**.7 Feldbuchausdruck eines Streckennivellements mit Zwischenblicken von FP 147 bis FP 1791 durchgeführt mit DNA 10 (Leica)

Leica Geosystems AG __-Digitalnivellier Messprotokoll
Jobname : TEST
Beobachter : Faltermeier/Vollweiler
DNA 10 : Instr.Nr.: 330832
Bemerkung : _____ / _____
Datum/Zeit : 08.01.2003 / 14:13:11
Liniennivellement von HP 147 bis HP 1792
Linie : V F Methode: RV
Datum : 08.01.2003 Zeit: 14:14:12

PtNr.	Typ	Latte	Distanz	PtHoehe	Bemerkung
147				304.5750	gegeben
147	Rück	0.9510	19.45		_____
1	Vor	1.7290	20.52	303.7970	_____
1	Rück	0.8617	39.97		_____
2	Vor	1.8112	39.51	302.8475	_____
2	Rück	1.3286	38.40		_____
3	Vor	2.3351	39.49	301.8410	_____
3	Rück	0.9581	33.86		_____
1001	Zw	0.6934	11.27	302.1057	
1002	Zw	0.8471	11.02	301.9521	
1003	Zw	0.9967	10.65	301.8025	
4	Vor	2.1255	33.78	300.6737	
4	Rück	1.4300	30.24		_____
1791	Vor	1.3378	23.34	300.7659	_____

Es bedeuten: PtNr. = benutzerdefiniert eingegebene Festpunkte oder Wechselpunkte (linksbündig) oder benutzerdefinierte Zwischenpunkte (rechtsbündig), Typ = **Rück**blick, **Vor**blick, **Zw**ischenablesung, Latte = dekodierte Lattenablesung, Distanz = Entfernung zwischen Instrument und Latte, PtHoehe = für Punkt 147 benutzerdefiniert eingegeben, danach: Höhe des vorherigen Punktes + Latte Rück – Latte Vor.

10.3.2 Nivellement mit Wendelatten (Latten mit 2 Teilungen)

Die auf der Vorder- und Rückseite oder auf einer Seite nebeneinander befindlichen Lattenteilungen sind um ein unrundes Maß gegeneinander versetzt, z. B. 3,335 m. Somit wird das Nivellement doppelt ausgeführt und damit die Lattenablesung und die Rechnung durchgreifend kontrolliert und die Genauigkeit gesteigert (Beispiel Tafel **10.9**). Unkontrolliert bleibt jedoch jede Veränderung des Lattenstandpunktes in dem Zeitraum, in dem das Nivellierinstrument umgesetzt wird.

Beim Einsatz von zwei Latten lässt sich der sichere Stand des Instrumentes während der Messung überprüfen, indem man in der Reihenfolge Teilung I rückwärts, Teilung I vorwärts, Teilung II vorwärts, Teilung II rückwärts abliest.

10.3.3 Nivellement mit doppelten Wechselpunkten

Mit dieser Anordnung werden ebenfalls zwei Nivellements zur gleichen Zeit ausgeführt, wobei die Ablesungen an den Wechselpunkten laufend zu überprüfen sind. Nicht kontrollierbar sind die Ablesungen am Anfangs- und Endpunkt, auf die für jedes Nivellement die gleiche Latte aufgehalten wird.

Bild **10.8** zeigt das Prinzip dieses Nivellements. Anstelle von einem sind jeweils zwei Wechselpunkte, im geringen Abstand voneinander liegend, angeordnet, auf die die Nivellierlatte aufzuhalten ist. Die Nivellements werden in Tafel **10.9** getrennt aufgeschrieben und berechnet. Eine Messprobe findet man in der Differenz der zu einem Wechselpunkt gehörenden Vorwärts- und Rückwärtsablesungen, die gleich sein müssen, z. B. in Bild **10.8** $v_1 - v_1' = r_2 - r_2'$. Da sich die Probe auf die Ablesungen von zwei Instrumentenaufstellungen bezieht, ist die erste Ablesung erst beim zweiten Standpunkt zu prüfen. Anders ist es beim Gebrauch eines Lattenuntersatzes mit zwei Aufsatzzapfen (9.40). Hier muss die Differenz beider Lattenablesungen von einem Instrumentenstandpunkt aus immer gleich sein. Eine Veränderung des Lattenuntersatzes im Zeitraum des Umsetzens des Instrumentes bleibt unkontrolliert.

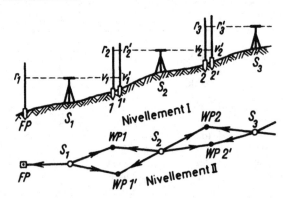

10.8 Schematische Darstellung eines Nivellements mit doppelten Wechselpunkten

Beispiel. (Tafel **10.9**) Die Höhe des Punktes 1 ist mit An- und Abschluss in A und E durch ein Streckennivellement mit einem Ingenieur-Nivellier und Wendelatte zu bestimmen.

Der Vordruck ist für zwei Nivellements eingerichtet. Bei der Ausführung des Nivellements werden die Werte der Sp. 3 ··· 6 an der Latte abgelesen und hieraus die Höhenunterschiede Δh (Sp. 3 minus Sp. 4 und Sp. 5 minus Sp. 6) in Sp. 7 errechnet, die bis auf die unvermeidlichen Meßungenauigkeiten für beide Nivellements gleich sein müssen. Als Rechenproben findet man: (Σ Sp. 3 − Σ Sp. 4) + (Σ Sp. 5 − Σ Sp. 6) = Σ Sp. 7 und $^1/_2$ Σ Sp. 7 = Σ Sp. 8.

Tafel 10.9 Vordruck und Beispiel für ein Nivellement mit Wendelatte (doppeltes Streckennivellement)

Instrument:	Ing.-Nivellier mit autom. Horizont.	Wetter:	Beobachter:
Latte:	Wendelatte	Datum:	Lattenträger:

Punkt	Ziel-weite	Lattenablesung Nivellement I (Vorderseite der Latte)		Nivellement II (Rückseite der Latte)		Δh_I Δh_{II}	Mittel Δh	Höhe ü. NN
		r	v	r	v			
1	2	3	4	5	6	7	8	9
A	42	1,874		5,208		0,936		234,478
							-1	
WP_1	41		0,938		4,273	0.935	0,9355	235,413
WP_1	28	0,865		4,201		$-0,522$		
1	28		1,387		4,722	$-0,521$	$-0,5215$	234,891
1	50	0,931		4,266		$-1,555$		
							-1	
WP_2	50		2,486		5,820	$-1,554$	$-1,5545$	233,336
WP_2	42	1,653		4,988		0.410		
E	43		1,243		4,577	0,411	0,4105	233,746
	324	5,323 −6,054	6,054	18,663 −19,392	19,392	$-1,460$	$-0,730$ -2	$-0,732 = (H_e - H_a)$ $-(-0,730) = $ Ist
		$-0,731$ $+(-0,729)$ $-1,460$		$-0,729$		$\frac{1}{2} = -0,730$		$-0,002 = d$ (-2)

zulässige Differenz: $2,0 + 5\sqrt{0,3} = 5\,$mm

Die Differenz $d = (H_e - H_a) - \Sigma$ Sp. 8 ist gleichmäßig auf die Δh Werte zu verteilen. Die fortlaufende Addition der verbesserten Höhenunterschiede zur gegebenen Anfangshöhe ergibt die gesuchte Höhe des Punktes 1 und als Endkontrolle die Höhe von E.

10.3.4 Feinnivellement

Bei vielen ingenieurmäßigen Höhenmessungen an Bauwerken und bei geodätischen Präzisions-Nivellements kommen Nivelliere mit Planplatte und Präzisionslatten mit Invarbandteilungen zum Einsatz. Die Latten tragen nebeneinander zwei versetzte Teilungen (9.38). Grundsätzlich wird mit zwei Latten gearbeitet und im Hin- und Rückweg nivelliert. Die Zielweite soll 40 m nicht überschreiten; der Zielstrahl soll mindestens 0,5 m über dem Boden verlaufen. Zur Ausschaltung der Nullpunktsfehler der Latten hält man beim Hinweg stets die A-Latte, beim Rückweg stets die B-Latte auf die Festpunkte und auf die einzuwägenden Punkte auf. Es ergibt sich somit immer eine gerade Anzahl Aufstellungen zwischen den einzelnen Punkten. Die Dosenlibellen der Latten und das Instrument überprüft man vor jeder Messung.

Tafel **10.10** Vordruck und Beispiel für ein Feinnivellement

Instrument:	Automatisches Nivellier mit Planplatte	Wetter:		Beobachter:
Latten:	Invarlatten mit Zentimeterteilung A und B Lattenkonstante 3,0150	Datum:		Lattenträger:

Punkt	Latte	Ziel- weite	Lattenablesung Nivellement I linke Teilung Rückblick r_1 Vorblick v_1 $\Delta h_1 = r_1 - v_1$	Nivellement II rechte Teilung Rückblick r_2 Vorblick v_2 $\Delta h_2 = r_2 - v_2$	Probe f_r f_v d	$\Delta h = \frac{1}{2}(\Delta h_1 + \Delta h_2)$
1	2		3	4	5	6
12	A	38,5	4,7492	1,7341	51	
	B	38,4	4,4938	1,4789	49	
			0,2554	0,2552	+ 2	+0,2553
	B	26,6	4,4476	1,4326	50	
	A	26,5	5,0822	2,0672	50	
			−0,6346	−0,6346	0	−0,6346
	A	39,0	3,9972	0,9824	48	
	B	39,0	4,9358	1,9209	49	
			−0,9386	−0,9385	− 1	−0,9386
	B	31,0	4,6060	1,5910	50	
	A	31,0	4,0408	1,0259	49	
NP			0,5652	0,5651	+ 1	+0,5651
						−0,7528 = ΔH

Beispiel. Für die Setzungsuntersuchung eines Bauwerks ist der Höhenunterschied zwischen den Punkten 12 und NP durch ein Feinnivellement zu bestimmen.

Nach Aufstellen des Instrumentes dreht man das Fernrohr mit Blickrichtung auf Latte A (rückwärts) und lässt die Dosenlibelle einspielen. Dann liest man an der Latte rückwärts nach Einstellen der Koinzidenz an der linken Teilung 4,74 und an der Trommel 92 ab (Tafel **10.**10, Sp. 3). Das Fernrohr wird gedreht und im Vorblick an der Latte B die Teilung links abgelesen (4,4938 in Sp. 3) und sodann Teilung rechts (1,4798 in Sp. 4). Nun dreht man das Fernrohr zurück und liest im Rückblick an Latte A Teilung rechts ab (1,7341 in Sp. 4). In Sp. 5 sind die Proben $f_r = r_1 - r_2$ und $f_v = v_1 - v_2$ (die Differenzen müssten jeweils die Teilungsdifferenz (Lattenkonstante = 3,0150) ergeben, von denen nur die letzten beiden Stellen vermerkt werden) sowie $d = \Delta h_1 - \Delta h_2 = f_r - f_v$ angegeben. Nach der Kontrollrechnung gehen Latte A und Instrument weiter, Latte B bleibt stehen. Beim nächsten Standpunkt zeigt das Fernrohr beim Einspielen der Dosenlibelle wieder auf Latte A (jetzt vorwärts). Dann wird es auf Latte B gerichtet und die erste Ablesung an der linken Teilung (4,4476) vorgenommen. Die weitere Messung geht so vor sich wie vorher beschrieben.

Die Summe der Δh ergibt den gesuchten Höhenunterschied. Zur Ausschaltung systematischer Fehler ist ein Nivellement in entgegengesetzter Richtung, beginnend mit Latte B, auszuführen. Die Ergebnisse werden gemittelt.

Die Latten werden immer an derselben Stelle auf die festgelegten Unterlagsplatten gestellt, um eine eventuelle Schiefe der Aufsatzfläche auszugleichen; sie sind durch zwei senkrecht zueinander stehende Streben zu unterstützen und beim Wenden nicht von der Unterlagsplatte zu nehmen. Ein unter die Aufsatzfläche geschraubter Ring verhindert ein Abrutschen der Latte vom Aufsatzzapfen der Bodenplatte.

Beim Ablesen wird das optische Mikrometer soweit gedreht, bis die einen Keil bildenden Striche des Strichkreuzes einen Lattenstrich einschließen (9.29a). Dieser eingeschlossene Strich gibt die Zentimeter an; die weiteren Dezimalen sind an der Trommel oder der Glasteilung für die Planplatte abzulesen. Die Koinzidenz des Keilstriches mit dem Lattenstrich ist zügig, nicht pendelnd vorzunehmen.

Die Zielweiten von maximal 40 m werden auf 0,1 m genau bestimmt. Während der Messung und während des Vortragens von einem Instrumentenstandpunkt zum anderen schützt man Libelleninstrumente durch einen Schirm vor Sonnenbestrahlung.

Bei Instrumenten mit automatischer Horizontierung kann als Restfehler der Horizontierung eine Schiefe des Instrumentenhorizontes eintreten, der einen konstanten Fehler zur Folge hätte. Man schaltet ihn aus, indem man bei der Grobhorizontierung durch die Dosenlibelle das Fernrohr stets zu demselben Lattenträger z.B. Latte A) zeigen lässt, also beim ersten Standpunkt rückwärts, beim zweiten vorwärts usw.

Die Lattenablesungen erfolgen in der Reihenfolge

rückwärts an Teilung links (r_1)

vorwärts an Teilung links (v_1), vorwärts an Teilung rechts (v_2)

rückwärts an Teilung rechts (r_2).

10.3.5 Standardabweichung für Nivellements, zulässige Abweichungen

Wie in Abschn. 1.4 gesagt, sind Messungen – also auch Nivellements – nicht frei von Abweichungen. Die systematischen Abweichungen wird man durch Eichen und Justieren der Messgeräte und Messinstrumente sowie durch messtechnische und rechnerische Anordnungen ausscheiden. Die verbleibenden zufälligen Abweichungen können positiv und negativ sein. Um eine Aussage über die Genauigkeit zu machen, ermittelt man die Standardabweichung einer 1 km langen Nivellementstrecke.

Die Standardabweichung eines durch Nivellement ermittelten Höhenunterschiedes wächst mit der Wurzel aus der Länge der Nivellementlinie [1])

$$s_L = s_{1\,km} \cdot \sqrt{L}$$

s_L = Standardabweichung einer Nivellementlinie

$s_{1\,km}$ = Standardabweichung einer Strecke von 1 km Länge

L = Länge der Nivellementlinie in km

[1]) Näheres s. Großmann, W.: Grundzüge der Ausgleichsrechnung. 3. Aufl. Berlin 1969.

Die Nivellementlinie L kann aus mehreren Nivellementstrecken R (Strecke zwischen zwei benachbarten Niv-Punkten) bestehen. Aus den im Hin- und Rückweg gemessenen Nivellementstrecken findet man die Standardabweichung einer 1 km langen einfach gemessenen Strecke mit

$$s_{1\,km} = \sqrt{\frac{1}{2n}\left[\frac{dd}{R}\right]} = \sqrt{\frac{[ddp]}{2n}}$$

n = Anzahl der Nivellementstrecken [] = Summenzeichen

dd = Quadrat der Differenz d zwischen Hin- und Rückweg einer Strecke

R = Länge der jeweiligen Nivellementstrecke in km

p $= \dfrac{1}{R}$ = Gewicht der einzelnen Nivellementstrecke (reziproker Wert der Länge R)

Die Standardabweichung einer 1 km langen aus Hin- und Rückweg gemittelten Strecke ist

$$s_{x\,1\,km} = \frac{s_{1\,km}}{\sqrt{2}}$$

Beispiel. Im Hin- und Rückweg wurden 4 Nivellementstrecken gemessen, deren Standardabweichung für 1 km der einfach und doppelt nivellierten Strecke zu berechnen ist.

Nivellement-strecke	Länge R km	Höhenunterschied		Mittel	d mm	p $=1/R$	ddp $=dd/R$
		Hinweg	Rückweg				
1	2	3	4	5	6	7	8
1	0,7	−6,347	+6,345	−6,346	2	1,4	6
2	1,2	+2,073	−2,077	+2,075	4	0,8	13
3	0,6	−3.740	+3,742	−3,741	2	1,7	7
4	0,9	−8,142	+8,136	−8,139	6	1,1	40
							66

$$s_{1\,km} = \sqrt{\frac{[ddp]}{2n}} = \sqrt{\frac{66}{2\cdot 4}} = 2,9 \text{ mm (Standardabweichung für 1 km der einfach nivellierten Strecke)}$$

$$s_{x\,1\,km} = \frac{s_{1\,km}}{\sqrt{2}} = \frac{2,9}{\sqrt{2}} = 2,1 \text{ mm (Standardabweichung für 1 km der doppelt nivellierten Strecke).}$$

Die Vermessungsverwaltungen haben für die Abweichungen d aus dem Hin- und Rückweg eines Nivellements Grenzen festgelegt, die rund den 3fachen Betrag der Standardabweichung ausmachen und nicht überschritten werden dürfen.

Abweichung d_1 des Hin- und Rücknivellements zwischen zwei benachbarten NivP

im Niv-Netz 1. Ordnung: $d_1 = 2\sqrt{S}$ mm,

im Niv-Netz 2. Ordnung: $d_1 = 3\sqrt{S}$ mm,

im Niv-Netz 3. Ordnung: $d_1 = 5\sqrt{S}$ mm,

Abweichung d_2 aus neuer Messung und dem veröffentlichten Höhenunterschied zweier NivP

im Niv-Netz 1. Ordnung: $d_2 = (2 + 2\sqrt{S})$ mm,

im Niv-Netz 2. Ordnung: $d_2 = (2 + 3\sqrt{S})$ mm,

im Niv-Netz 3. Ordnung: $d_2 = (2 + 5\sqrt{S})$ mm.

Für ein Nivellement, das Bauzwecken dient, gilt $d_{Bau} = 10\sqrt{S}$.

Hierin ist S die Länge der Niv-Strecke (einfacher Messweg) in Kilometern. Die Werte von d sind Absolutwerte.

Dagegen können für Nivellements, die technischen Zwecken dienen, keine Grenzen der Abweichungen festgelegt werden; sie müssen sich nach den geforderten Genauigkeiten richten. Jedoch können die vorgenannten Grenzen einen Anhalt bieten. Hier muss das geeignete Instrumentarium eingesetzt und das zweckmäßigste Verfahren angewandt werden. Die errechnete Standardabweichung gibt dann Aufschluss über die Genauigkeit.

10.4 Längs- und Querprofile

Der Absteckung der Achse eines Verkehrsweges [1]) (Straße, Eisenbahn, Wasserstraße) geht die Entwurfsbearbeitung voraus. In einem Plan mit Höhenlinien wird die künftige Straßenachse projektiert. Es wird dabei angestrebt, die günstigste Linienführung auf möglichst kurzem Wege unter Umgehung der Geländehindernisse mit großen Radien, geringen Steigungen und wenig Erdbewegungen zu finden.

Soll dabei ein Verkehrsweg auf eine Strecke mit gleicher Steigung geführt werden, so greift man die Länge l der Strecke aus dem Plan ab, entnimmt diesem auch den Höhenunterschied ΔH zwischen den Endpunkten der Strecke und findet die Neigung s in % mit

$$s = \frac{\Delta H}{l} \cdot 100$$

Man legt sodann eine Steigung fest und rechnet mit dieser die Länge a von Höhenlinie zu Höhenlinie (10.11)

$$a = \frac{\Delta h \cdot 100}{s} \qquad \Delta h = \text{Abstand der Höhenlinien}$$

Den Wert a nimmt man in den Zirkel und findet durch Bogenschlag von einer Höhenlinie zur anderen die Leitlinie, die durch Gerade, Kreisbogen und Übergangsbogen ausgeglichen wird. Diese in dem Plan festgelegte Achse (Trasse) ist in die Örtlichkeit zu übertragen. Linien gleicher Steigung sind auch örtlich mit einem Gefällmesser oder dem Nivellierinstrument aufzusuchen.

[1]) Über Absteckungsarbeiten, Ingenieurvermessungen, Abstecken von Verkehrswegen s. Teil 2.

10.11 Bestimmen der Leitlinie

10.12 Stationierung: Achsfeld (boden-
gleich) und Nummernpfahl

Die Orientierung bildet die Stationierung, die über die Achse gezogen wird. Dies kann in einfachen Fällen entlang des Tangentenpolygons geschehen, wenn die Kurven noch nicht abgesteckt sind, oder, wie es in der Regel der Fall ist, entlang der abgesteckten Achse. Die Stationierung ist also die Längenmessung in der Achse, die in Abständen von 25 oder 50 m mit einem bodengleich geschlagenen Pfahl und einem Nummernpfahl sichtbar gemacht wird (**10.12**). Weiter sind alle Geländebrechpunkte, kreuzende Gräben, Wege, Böschungen und Punkte, in denen Querprofile aufgenommen werden sollen, zu verpfählen und einzumessen. Die Stationierung erfolgt bei Straßen, Eisenbahnen und Wasserläufen nach Kilometern, z. B. 2,5 + 14,2 oder 2 + 514,2 (= 2514,2 m vom Nullpunkt), bei ländlichen Wegen und kleinen Wasserläufen nach Hektometern, z. B. 4 + 17,8 (= 417,8 m vom Nullpunkt). Die Stationierung ist in einem Feldbuch festzulegen.

Für die Aufnahme und das Auftragen von Längs- und Querprofilen sind Gerätekonfigurationen, die einen durchgängigen Datenfluss von der Geländeaufnahme bis zur Ausgabe der Profile ermöglichen, besonders wirtschaftlich einzusetzen. Das rechnergestützte Konstruieren ist bei der Planung von Verkehrswegen üblich, aber nur wirtschaftlich, wenn der Arbeitsumfang den Einsatz entsprechender Hard- und Software rechtfertigt.

10.4.1 Aufnahme von Längsprofilen

Über die Bodenpfähle der Stationierungspunkte wird ein Nivellement gezogen, das an bekannte Höhenfestpunkte an- und abzuschließen ist. Bei Angabe der Höhen auf mm wählt man Zielweiten bis 50 m; genügt die Angabe auf cm, so können die Zielweiten auf 100 m ausgedehnt werden. Zweckmäßig nimmt man 50 m-Sichten und liest die Wechselpunkte auf mm, die Zwischenpunkte auf cm ab. Damit erhält man einen Vertikalschnitt der Erdoberfläche längs der abgesteckten Achse. Rückblick und Vorblick sind dabei stets auf einen Wechselpunkt gerichtet, der zweckmäßig auf einem Stationspunkt liegt. Alle anderen Zielungen sind Zwischenablesungen. Zur Kontrolle kann das Nivellement über alle Punkte wiederholt werden. Die Berechnung der Höhen geschieht über „Höhenunterschiede" oder über den „Instrumentenhorizont" (**10.13**).

10.13 Berechnen des Instrumentenhorizontes

Längsprofile von Wasserläufen werden aus Querprofilen, die an den Ufern festgelegt sind, entwickelt.

Beispiel. Über die örtlich vermarkten Stationspunkte der abgesteckten Achse eines Verkehrsweges ist ein Nivellement aufzunehmen (Tafel 10.14 und Bild 10.15).

Die Berechnung erfolgt über den Instrumentenhorizont, den man für die erste Instrumentenaufstellung durch Addition der Rückwärtsablesung zur Ausgangshöhe des Punktes $NP\,25$ findet (10.13).

Tafel 10.14 Vordruck und Beispiel für die Aufnahme des Längsprofils einer abgesteckten Straße (10.15). (Berechnung mit Instrumentenhorizont)

Instrument:	Ing.-Niv. mit autom. Horizont.				Wetter:		Beobachter:
Latte:					Datum:		Lattenträger:

Punkt	Ziel-weite	Ablesungen			Instr.-horizont	Höhe ü. NN	Bemerkungen
		r	z	v			
1	2	3	4	5	6	7	8
$NP\,25$	42	-1 1,415			66,090	64,676	
WP_1	42			1,290		64,800	
WP_1	38	-1 0,420			65,219		
0,3+0	37			1,655		63,564	
0,3+0	30	-1 2,482			66,045 (66,05)		
+11			2,09			63,96	
+16			2,16			63,89	
+50	35			0,343		65,702	
+50	35	-1 2,507			68,208 (68,21)		
+85			1,36			66,85	
0,4+0			0,78			67,43	
+16	30			0,527		67,681	
+16	40	-2 1,290			69,969		
WP_5	40			1,821		67,148	
WP_5	36	-2 1,540			68,686		
$NP\,26$	36			1,220		67,466	
		9,654 $-6,856$		6,856		$2,790 = H_{26} - H_{25} = $ Soll	
						$2,798 = \Sigma r - \Sigma v = $ Ist	
		2,798 -8				$-0,008 = d = $ Soll $-$ Ist	

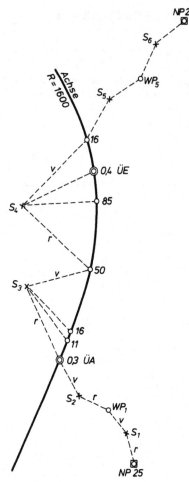

10.15 Aufnahme eines Längsprofils

Von dieser Höhe subtrahiert man die Vorwärtsablesung bzw. die Zwischenablesungen. Für die letzteren rundet man die Höhe des Instrumentenhorizontes auf cm [1]) (in Klammern angegeben). Die Berechnung der durch Zwischenablesungen gewonnenen Höhen sind nicht kontrolliert. Deshalb ist die Berechnung nach Tafel **10.5** über Höhenunterschiede vorzuziehen.

Die Differenz $d = (H_{26} - H_{25}) - (\Sigma r - \Sigma v) = -8$ mm wird auf die einzelnen Standpunkte in Sp. 3 gleichmäßig verteilt. Als Endhöhe muss bei der Berechnung die gegebene Höhe des $NP\,26$ herauskommen.

10.4.2 Aufnahme von Querprofilen

Die Querprofile dienen der Entwurfsbearbeitung, der Erdmassenberechnung und der Abrechnung. Je nach Geländeneigung und Ausdehnung des Baukörpers werden sie auf $20 \cdots 50$ m links und rechts der Achse aufgenommen. Querprofile stehen senkrecht zur Achse, in Kreisbogen und Übergangsbogen also rechtwinklig zur Tangente im Aufnahmepunkt (radial). Wenn nur das Tangentenpolygon abgesteckt ist, nimmt man die Querprofile senkrecht zu den Polygonseiten, im Knickpunkt in der Winkelhalbierenden auf und rechnet später die Achspunkte im Bogen ein. Im gleichmäßig steigenden Gelände wird der Abstand der Querprofile 25 oder 50 m betragen, im bewegten Gelände sich nach den Geländebrechpunkten richten. Je steiler das Gelände ist, um so kleiner werden die Abstände gewählt.

Bei umfangreichen Querprofilaufnahmen mittels Nivellierinstrument setzt man zweckmäßig einen Messtrupp ein, der aus 1 Beobachter, 1 Schreiber, 2 Mann für die Längenmessung und 1 Lattenträger besteht. Die Richtung des Profils wird mit dem Pentagonprisma nach einer Seite angegeben und mit einem Fluchtstab bezeichnet. Die Längenmessung und Höhenmessung geschieht in einem Arbeitsgang, wobei die aufzunehmenden Punkte nur mit der Nivellierlatte im Augenblick der Ablesung (Länge und Höhe) aufgehalten werden.

[1]) Nach DIN 1333 gelten für das Runden von Zahlen folgende Regeln:

Abrunden: Die zu rundende Stelle bleibt unverändert, wenn eine 0 bis 4 folgt: z. B. $8,2734 \approx 8,273 \approx 8,27$

Aufrunden: Die zu rundende Stelle wird um 1 erhöht, wenn eine 5 bis 9 folgt: z. B. $3,4265 \approx 3,427 \approx 3,43$.

Die Längenmessung rechnet grundsätzlich von der Achse aus nach links und rechts. Für die Aufnahme ist eine Reihenfolge festzulegen und einzuhalten, also z. B. immer erst die linke und dann die rechte Seite des Profils aufzunehmen. Ein Lage-Feldbuch braucht nicht geführt zu werden, da im Nivellement-Vordruck alle Längen und Höhen eindeutig eingetragen sind. Die Höhenaufnahme mit Ablesungen in cm beginnt auf einem Bodenpfahl und endet (zur Kontrolle) auf einem anderen Bodenpfahl. Bei mäßig geneigtem Gelände kann man mehrere Querprofile von einem Standpunkt aus erfassen, bei steilerem Gelände können einige Instrumentenstandpunkte mit entsprechenden Wechselpunkten erforderlich werden. Ist eine Kontrolle erwünscht, so wird die Aufnahme mit verändertem Horizont wiederholt. In der Regel wird hierauf verzichtet, da im aufgezeichneten Profil grobe Fehler ohne weiteres sichtbar werden.

Tafel **10.16** Vordruck und Beispiel für die Aufnahme von Querprofilen

Instrument:	Bau-Niv. mit autom. Horizontierung	Wetter:		Beobachter:
Latte:		Datum:		Lattenträger:

Profil	Punkt	Ablesung			Δh $= r - v$	Höhe ü. NN	Bemerkungen
		r	z	v			
0,4+0	Pf 0	1,83				67,43	Die Querprofile
					+ 2		werden nach bei-
	li 5,0		1,68		0,15	67,60	den Seiten nach
	10,0		0,38		1,30	68,90	Bedarf weiter
	15,0		0,33		0,05	68,95	ausgedehnt
	20,0		0,18		0,15	69,10	
	re 2,0		1,93		−1,75	67,35	
	4,0			2,98	−1,05	66,30	
		0,51					
					+ 2		
	9,0		2,93		−2,42	63,90	
	13,0		3,43		−0,50	63,40	
	20,0		3,48		−0,05	63,35	
	Pf 0,3+50			1,13	2,35	65,70	
		2,34		4,11	−1,77	− 1,73	$(H_e - H_a) =$ Soll
					+4		
		4,11				− 1,77	Ist
		−1,77				+ 0,04	Soll − Ist

Die Berechnung ist wie in Tafel **10.5** ausgeführt.

10.17 Feldbuch einer Querprofilaufnahme mittels Setzlatte

In steilem Gelände und in Waldgebieten empfiehlt sich die Aufnahme der Querprofile mittels Tachymeter (s. Teil 2). In einfachen Fällen genügt die Setzlatte (s. Abschn. 8.2). Hier ist das Führen eines Feldbuches angezeigt (10.17). Für grobe Querprofil-Aufnahmen kann auch ein Gefällmesser Verwendung finden.

Wenn Fluss-Querprofile aufgenommen werden, spricht man vom Peilen. Die Querprofile legt man in Linien an den Ufern fest. Entlang einer gespannten Leine, der Peilleine, die durch Metallmarken je Meter markiert ist, misst man mit einer Peilstange die Tiefe von der Wasseroberfläche bis zur Flusssohle. Die Höhe des Wasserspiegels wird von Pfählen aus bestimmt, deren Höhen ü. NN durch ein Nivellement festgelegt sind. Bei jeder Messung, in die die Höhe eines veränderlichen Wasserspiegels einbezogen ist, sollte das Datum und die Zeit der Aufnahme vermerkt sein.

10.4.3 Auftragen von Längs- und Querprofilen

Wenn die Aufnahme mit digitalen Instrumenten durchgeführt wurde, sollten die Profile mit Hilfe der EDV erstellt werden. Dies ist auch möglich, wenn analoge Instrumente eingesetzt wurden und die Daten „per Hand" in den Rechner eingegeben werden. Es wird grundsätzlich zum Einsatz digitaler Tachymeter geraten (s. Teil 2).

Wenn das Auftragen der Profile ohne den Einsatz der EDV erfolgen soll, werden die örtlich aufgenommenen Längs- und Querprofile auf Grund der Messungsunterlagen auf pausfähiges Millimeterpapier [1] maßstäblich aufgetragen. Man bezeichnet das lichtdurchlässige Millimeterpapier auf der Rückseite, um beim eventuellen Radieren in der Zeichnung die Millimeterteilung nicht zu verletzen.

Das Längenprofil wird verzerrt gezeichnet, man unterscheidet den Maßstab für die Längen (MdL) und den für die Höhen (MdH). Den Maßstab für die Längen wählt man im Maßstab des Lageplanes (1 : 500 ··· 1 : 5000, der üblichste ist 1 : 1000), den Maßstab für die Höhen jedoch 10mal größer (1 : 50 ··· 1 : 500), um die Höhenunterschiede besser hervortreten zu lassen.

Die unterste Linie des Längenprofils heißt der Horizont (die Bezugslinie); man legt ihn höhenmäßig in vollen Zehnmetern fest (10.18). Unter dieser Linie stehen die Längenangaben (Stationierung) für die einzelnen Punkte, über der Linie befinden sich die Angaben der Geländehöhen und der Entwurfshöhen. Unter der Horizontlinie ist genügend Platz vorzusehen für das Krümmungsbild sowie für das Querneigungsbild (im Straßenbau) bzw. das Rampenbild (im Eisenbahnbau). Für das Krümmungsbild wählt man zweckmäßig den Maßstab 1000/r oder 500/r, wobei Rechtsbogen nach oben und Linksbogen nach unten aufzutragen sind.

Alle Längen- und Höhenangaben werden sofort in schwarzer Tusche (nicht erst in Blei) in den Plan eingetragen. Dann erfolgt die maßstäbliche Kartierung des Geländes, dessen Darstellung in schwarz erfolgt. Nun ist der Entwurf unter Einhalten der bestehenden Vorschriften und Berücksichtigung eines möglichen Erdmassenausgleichs einzutragen.

[1] Dies gibt es in Millimeter- und Doppelmillimeter-Teilung in Blau, Grün, Rot, Sepia und Gelb. Die Farbe ist für die später zu fertigenden Lichtpausen wichtig, je nachdem, ob die Millimeterteilung schwach oder stark erscheinen soll. Ein gelber Strich ist lichtundurchlässig und erscheint auf der Lichtpause schwarz. Somit kommt die Millimeterteilung in blau schwach, grün stärker, sepia noch stärker und gelb am stärksten in der Lichtpause. Für das Auge am wenigsten ermüdend ist die grüne Millimeterteilung.

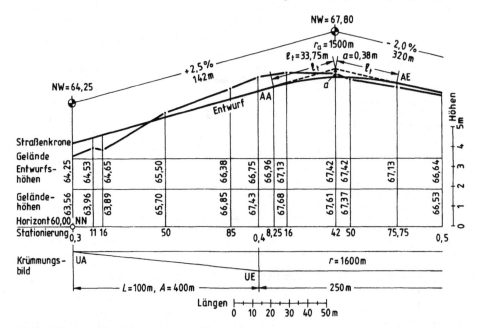

10.18 Längsprofil mit eingetragenem Entwurf

Man beachte, dass nicht die Linie der Straßenkrone, sondern die ≈ 0,50 m tiefer liegende Linie der Planumsoberkante den Massenausgleich herbeizuführen hat.

Die Entwurfslinie im Höhenplan nennt man Gradiente; ihre Steigung wird im Straßenbau in ± % (Prozent), im Eisenbahnbau in ± ‰ (Promille) und im Sinne der Kilometrierung als $+I$ (Steigung) oder $-I$ (Gefälle) angegeben. Die Neigungswechsel sind durch Ausrundungsbogen, deren Halbmesser r_a den jeweiligen Vorschriften entsprechen müssen, auszurunden.

Im Bild **10.**18 ist der Ausrundungshalbmesser $r_a = 1500$ m. Seine Tangenten errechnen sich mit

$$l_t = \frac{r_a}{2} \cdot \frac{I_1 - I_2}{100} = \frac{1500}{2} \cdot \frac{2,50 - (-2,00)}{100} = 33,75 \, \text{m}$$

und der Scheitelabstand mit

$$a \approx \frac{l_t^2}{2r_a} = \frac{33,75^2}{2 \cdot 1500} = 0,38 \, \text{m}$$

Damit ist die Höhe der Straßenkrone in km 0,4 + 42: $67,80 - 0,38 = 67,42$ m
Die Höhen der einzelnen Punkte sind

allgemein

$$H_p = H_a + \frac{I}{100} \cdot \Delta l$$

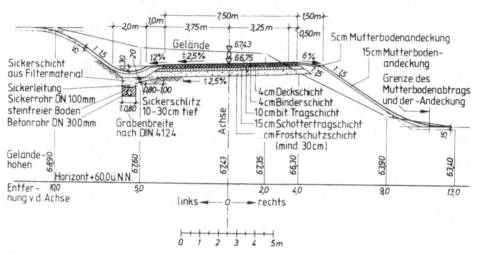

10.19 Querprofil mit eingetragenem Straßenquerschnitt

für Punkt

$$0,3 + 11 \quad H_{311} = 64,25 + \frac{2,50}{100} \cdot 11 = 64,53\,\text{m}$$

$$0,3 + 16 \quad H_{316} = 64,25 + \frac{2,50}{100} \cdot 16 = 64,65\ \text{usw.}$$

Die Höhe der Straßenkrone in km $0,4 + 16$ findet man aus $64,25 + \dfrac{2,50}{100} \cdot 116 = 67,15\,\text{m}$.

Von dieser Höhe ist noch der Wert zu subtrahieren, um den sich der Ausrundungsbogen von der Geraden mit der Steigung $+2,50\%$ gelöst hat.

$$y = \frac{x^2}{2r_a} = \frac{7,75^2}{2 \cdot 1500} = 0,02 \qquad (x = 116,0 - 108,25 = 7,75\,\text{m})$$

Gesuchte Höhe $67,15 - 0,02 = 67,13\,\text{m}$

Querprofile werden zweckmäßig im Maßstab 1:100 oder im Maßstab der Höhen des Längenprofils unverzerrt aufgetragen, weil man die Querschnittsflächen zum Teil auch graphisch berechnet. Das Auftragen erfolgt entweder nach den errechneten Höhen der Einzelpunkte oder, wenn man sich das Ausrechnen der Höhen ü. NN ersparen will, vom gezeichneten Instrumentenhorizont aus.

Bild **10.19** zeigt das Querprofil in km $0,4 + 0$ des Längsprofils, dessen örtliche Aufnahmewerte in Tafel **10.16** wiedergegeben sind. Es sind dargestellt: die Horizontlinie, die Geländelinie, der Achspfahl mit Höhenangabe sowie die projektierte Straße mit ihren Böschungen und allen dazugehörigen Angaben. Die eingetragenen Geländehöhen der Aufnahmepunkte und deren Abstandsmaße von der Achse entfallen vielfach in der Praxis.

Auch werden die Angaben des Straßenquerschnittes in einem Regelquerschnitt festgehalten. Wichtig ist jedoch, dass bei der Berechnung der Querschnittsfläche die Konstruktionshöhe der Straße berücksichtigt wird.

Für die spätere Erdmassenberechnung gilt es nun, die Querschnittsfläche zwischen der Geländelinie und der Konstruktionsunterkante (Planum des Verkehrsweges) zu bestimmen. Es kann auf verschiedenen Wegen geschehen. Für die auf Millimeterpapier im Maßstab 1:100 aufgetragenen Querschnitte kann dies mit einem Planimeter erfolgen, durch Auszählen der in der Fläche befindlichen Quadrate des Millimeterpapiers oder durch graphisches Aufsummieren der Mittellinien der durch die Zentimetereinteilung entstandenen Streifen. Das letzte Verfahren ist schnell und relativ genau. Die hervorgehobenen Zentimeterlinien teilen die Gesamtfläche in Streifen von 1 Meter. Die Mittellinien dieser Streifen – also jeweils die 5 mm-Linien – werden abgegriffen und graphisch addiert. Beim Maßstab 1:100 ist der Endwert in cm sogleich die Fläche in m². Dabei wird auch die Neigung des Planums (Einseit- oder Dachformneigung) mit in die Fläche und damit in das Volumen einbezogen.

Die Querschnittsfläche kann auch nach der Gauß'schen Flächenformel berechnet werden. Die einzelnen Punkte des Verkehrsweges sind dann in Raumkoordinaten erfasst, wobei in der Längsachse die Maße als x-Werte, senkrecht dazu die Abstandsmaße von der Achse als y-Werte und die Höhen als z-Werte gewählt werden.

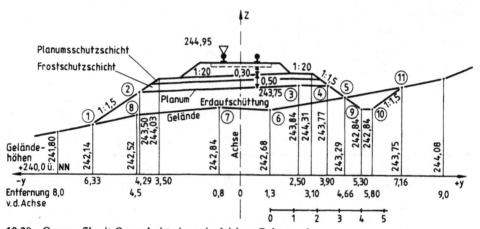

10.20 Querprofil mit Querschnitt einer eingleisigen Bahnstrecke

Beispiel. Für die Ermittlung der Erdmassen einer eingleisigen Bahnstrecke sind das Längsprofil und die Querprofile aufgenommen. Die Gradiente im Längsprofil – das ist Schienenoberkante – errechnet sich in dem im Bild 10.20 dargestellten Querprofil mit 244,95 m ü. NN. Für die Berechnung der Querschnittsfläche ist die Höhe des Planums unter der rechten Schiene maßgebend. Sie ergibt sich unter Berücksichtigung der Oberbauhöhe [1]) im Punkt unter der rechten Schiene mit 243,75 m ü. NN. Mit dieser Höhe errechnen sich die Höhen der Knickpunkte des Dammquerschnittes und die der Schnittpunkte der Böschungen mit dem Gelände.

Die Querschnittsfläche wird nach der Gauß'schen Flächenformel

$$2A = \sum y_i (z_{i-1} - z_{i+1})$$

ermittelt. Dabei wird die Auftragsfläche rechtsläufig, die Abtragsfläche linksläufig umfahren.

[1]) Näheres s. Matthews: Bahnbau 2002.

Tafel 10.21 Querschnittsfläche aus rechtwinkligen Koordinaten

Punkt Nr.	y_i	z_i	$z_{i-1} - z_{i+1}$ +	$z_{i-1} - z_{i+1}$ −	$y_i(z_{i-1} - z_{i+1})$ +	$y_i(z_{i-1} - z_{i+1})$ −
1	2	3	4		5	
Auftragsfläche						
1	−6,33	242,14				
2	−4,29	243,50		1,70	7,29	
3	2,50	243,84		0,27		0,68
4	3,90	243,77	0,55		2,15	
5	4,66	243,29	1,09		5,08	
6	1,30	242,68	0,45		0,59	
7	−0,80	242,84	0,16			0,13
8	−4,50	242,52	0,70			3,15
1	−6,33	242,14		0,98	6,20	
2	−4,29	243,50				
			2,95	2,95	21,31	3,96

$$2A = 17,35$$
$$A = 8,7 \ \text{m}^2$$

Punkt Nr.	y_i	z_i	+	−	+	−
Abtragsfläche						
5	4,66	243,29				
9	5,30	242,84	0,45		2,39	
10	5,80	242,84		0,91		5,28
11	7,16	243,75		0,45		3,22
5	4,66	243,29	0,91		4,24	
9	5,30	242,84				
			1,36	1,36	6,63	8,50

$$2A = -1,87$$
$$A = -0,9 \ \text{m}^2$$

Der besseren Übersicht wegen wurden die Höhenangaben der Punkte als z-Werte übernommen. Die Angaben vereinfachen sich, wenn alle Höhen um 240,00 m vermindert werden.

10.5 Flächennivellement

Längs- und Querprofile geben die Geländegestalt eines schmalen Streifens wieder. Für viele Bauvorhaben z. B. Anlage von Industriebauten, Flugplätzen, Sportplätzen, Aufstellung von Bebauungsplänen, Bearbeitung von Be- und Entwässerungsanlagen usw. braucht man jedoch die Geländedarstellung größerer Flächen. Man fertigt hierzu einen Lageplan mit Höhenlinien, die auf Grund von lagemäßig bekannten und höhenmäßig bestimmten Punkten konstruiert werden. Je nach Art und Umfang des vorhandenen Plan- und Kartenmaterials sowie der Geländeformen sind verschiedene Aufnahmeverfahren möglich. Bei der Höhenbestimmung mit dem Nivellierinstrument kann es sich wegen der waagerechten Ziellinie nur um mäßig geneigtes Gelände handeln; bei bewegtem Gelände erfolgt die Aufnahme mit Tachymetern (s. Teil 2).

10.5.1 Aufnahmeverfahren

Da von einem Instrumentenstandpunkt aus viele Punkte höhenmäßig erfasst werden, ist der Einsatz eines Nivelliers ohne Kippschraube oder mit automatischer Horizontierung angebracht. Um die Höhenaufnahme zu erleichtern, legt man außerhalb des aufzunehmenden Gebietes und in diesem einige Punkte fest, deren Höhen zwischen zwei bekannten Höhenfestpunkten im Zuge eines Streckennivellements zu bestimmen sind.

Neben dem Nivellementfeldbuch (Vordrucke Tafel 10.5 und 10.14) ist ein Lagefeldbuch zu führen, in das die Nummern der Punkte aufzunehmen sind. Da diese Aufzeichnungen getrennt vorgenommen werden, kontrolliert man bei jedem 10. Punkt durch Zuruf die Richtigkeit der Punktnummer. Der das Lagefeldbuch führende Ingenieur wählt die aufzunehmenden Punkte aus, zwischen denen das Gelände geradlinig steigt, so dass die Höhenlinien geradlinig interpoliert werden können. Alle topographischen Einzelheiten wie Böschungen, Rampen usw. sind ebenfalls mit aufzunehmen. Der ungefähre Verlauf der Höhenlinien und die Richtung des stärksten Gefälles werden im Feldbuch vermerkt.

Nach den vorhandenen Unterlagen richtet sich die anzuwendende Aufnahmemethode.

1. Ein Lageplan (Flurkarte) mit einer ausreichenden Anzahl Punkten ist vorhanden.

Von den örtlich einwandfrei zu identifizierenden Punkten des Planes (Grenzstein, Zaunecke, Mauerecke, Kulturartsgrenze usw.) wählt man die zur Höhenbestimmung erforderlichen aus. Weiter notwendige Punkte werden auf einfache Art eingemessen. Der jeweilige Instrumentenstandpunkt sollte so gewählt sein, dass möglichst viele Punkte zu erfassen sind. Die Ablesung geschieht auf cm oder 5 cm mit Zielweiten bis zu 200 m.

2. Ein Lageplan mit den Umgrenzungslinien der aufzunehmenden Fläche ist vorhanden.

In die Umringsgrenzen eingebundene Profil-Linien (10.22) bilden die Grundlage der Aufnahme. Innerhalb der Profile werden die Punkte durch eine Längenmessung festgelegt und durch das Nivellement höhenmäßig bestimmt. Lage- und Höhenmessung sind zweckmäßig in einem Arbeitsgang auszuführen. Der Personalaufwand ist wie bei der Aufnahme von Querprofilen.

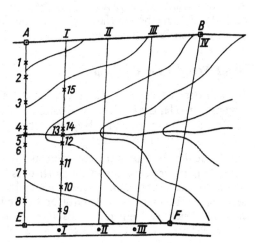

10.22 Flächennivellement durch Profilaufnahmen

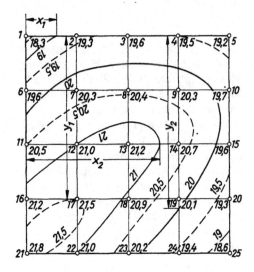

10.23 Aufnahme eines Flächennivellements
mittels Quadratrost und Konstruktion
der Höhenlinien

3. Es sind keine Planunterlagen vorhanden.

In diesem Fall legt man auf die aufzunehmenden Flächen einen quadratischen oder
rechteckigen Rost aus sich schneidenen und parallelen Geraden im Abstand von
10 ··· 50 m je nach Geländebeschaffenheit. Nach Abstecken der Außenlinien bestimmt
man die inneren Punkte durch Schnittbildung. Die Punktnumerierung geschieht bei
kleineren Aufnahmen fortlaufend (10.23), bei größeren Aufnahmen, indem eine Seite mit
Buchstaben und die senkrecht dazu stehende mit Ziffern bezeichnet wird. Der Schnitt
beider Linien ergibt dann die Punktbezeichnung, z. B. $A2$, $D4$ usw.

Einige Punkte oder Linien sind mit bekannten Kartenpunkten in Verbindung zu bringen,
damit die Höhenaufnahme in das vorhandene Kartenmaterial eingefügt werden kann.

**4. Die aufzunehmenden Punkte sind unregelmäßig über das Gelände ver-
streut.**

Die Lage- und Höhenmessung erfolgt mit einem Nivelliertachymeter (Nivellierinstrument
mit Horizontalkreis, Entfernungsstrichen und Ablotevorrichtung), mit dem die Punkte
nach der Polarmethode erfasst werden. Die Geländeaufnahme mit dem Nivelliertachy-
meter wird im Teil 2 behandelt.

10.5.2 Fertigen von Höhenplänen

Je nach der Art der Aufnahme werden die aufgenommenen Punkte in die Lagepläne
eingetragen oder die Punkte des Rostes kartiert und die entsprechende Höhe (Kote) auf
0,5 dm oder 1 dm gerundet beigeschrieben. Hiernach sind die Höhenlinien zwischen
diesen Punkten zu konstruieren.

Die Höhenlinien (Höhenschichtlinien, Isohypsen) verbinden Punkte gleicher Höhe; sie
vermitteln in ihrer Gesamtheit ein plastisches Bild des Geländes. Ihr senkrechter Abstand
(Äquidistanz, Schichthöhe) richtet sich nach dem Maßstab des Planes und der Gelände-
neigung, er beträgt 1 m bei mäßiger Geländeneigung für den Maßstab 1:1000 und
vergrößert sich bei kleineren Maßstäben. Geringe Geländeneigung erfordert eine kleine
(0,1 m, 0,5 m), steiles Gelände eine große Schichthöhe (5 m, 10 m). Die Höhenlinien

werden in Sepia oder gebrannter Siena ausgezogen. Die 5 m- und 10 m-Höhenlinien hebt man durch dickere Strichstärken (0,3 mm) hervor. Die künstlichen Böschungen, Rampen, Wasserläufe usw. stellt man durch Böschungssignaturen dar. Die Bezifferung der Höhenlinien erfolgt so, dass der Betrachter bei aufrechter Zahl gegen den Berg sieht.

Die Lage der Höhenlinien gewinnt man durch Interpolation in Richtung des stärksten Gefälles zwischen den kotierten Punkten. Die so gewonnenen Punkte gleicher Höhe werden durch eine mehr oder weniger gekrümmte Linie verbunden; damit ist die Höhenlinie konstruiert. Die Interpolation kann auf verschiedenen Wegen erfolgen:

1. Rechnerisch

Auf der Verbindungslinie der Geländepunkte A und B (10.24) mit ihren Höhen 176,8 und 174,3 sind die Punkte mit den Höhen 176,0 und 175,0 gesucht. Die Entfernung $AB = 40,5$ mm wird dem Plan entnommen. Dann findet man

$$x_1 = \frac{40,5 \cdot 0,8}{2,5} = 13 \text{ mm} \quad \text{und} \quad x_2 = \frac{40,5 \cdot 1,8}{2,5} = 29 \text{ mm}$$

Beide Werte sind im Plan von A aus in Richtung B abzusetzen. Die Rechnung kann auch von B in Richtung A erfolgen.

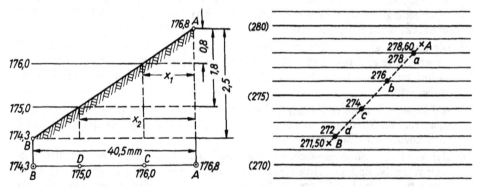

10.24 Rechnerisches Verfahren zur Konstruktion der Höhenlinien

10.25 Zeichnerisches Verfahren zur Konstruktion der Höhenlinien

2. Zeichnerisch

Man zeichnet auf Pauspapier eine Anzahl gleichabständiger, paralleler Linien (Abstand z.B. 0,5 cm), beziffert diese (10.25) und legt das Blatt so auf die Zeichnung, dass die Punkthöhen von A und B sowie die Parallelenbezifferung übereinstimmen. Um dies zu erreichen, hält man Punkt A mit einer Punktiernadel (Zirkelspitze) fest und dreht die Parallelenschar, bis Punkt B die richtige Höhenlage hat. Längs der Linie AB werden dann die gesuchten Punkte a (278 m), b (276 m), c (274 m), d (272 m) als Schnittpunkte mit den entsprechenden Parallelen markiert. Die Parallelen sollen die Geländelinien möglichst rechtwinklig schneiden. Um dies zu erreichen, legt man sich verschiedene Pausen mit engeren und weiteren Abständen der Parallelen an. Auch transparentes Millimeterpapier kann hierzu verwendet werden.

Künstliche Bauwerke unterbrechen die Höhenlinien gewöhnlich; an Kanten (Böschungen) knicken die Höhenlinien scharf ab.

10.6 Praktische Hinweise zur Höhenmessung

1. Die Gängigkeit der Stativbeine ist zu überprüfen. Ein Stativbein sollte so fest sein, dass es beim Heben durch sein Eigengewicht nicht zurücksinkt. Lockere Stativbeine verursachen erhebliche Fehler. Verbindungen zwischen Holz und Metall sind eventuell nachzustellen.

2. Beim Aufsetzen des Instrumentes auf das Stativ hält die linke Hand das Instrument so lange fest, bis mit der rechten die Anzugschraube festgedreht worden ist.

3. Die Dosenlibelle der Nivellierlatte und das Nivellierinstrument sind von Zeit zu Zeit zu überprüfen; dabei sollen Libelleninstrumente im Schatten stehen. Es soll jedoch nur dann justiert werden, wenn ein Fehler mit Sicherheit nachgewiesen ist. Die Justierschrauben dürfen nicht zu fest angezogen werden; sie sind nur soweit anzuziehen, dass sicher kein Spiel entsteht.

4. Die Fußschrauben des Nivellierinstrumentes sollen einen satten Gang haben; sie sind eventuell zu regulieren.

5. Vor Regen, Schnee, Staub und starker Sonneneinstrahlung ist das Nivellierinstrument durch Haube oder Schirm zu schützen. Bei starkem Luftflimmern sollten keine Höhenmessungen ausgeführt werden. Nass gewordene Instrumente sind nicht länger als unbedingt nötig im geschlossenen Behälter zu belassen. Der Behälter ist erst zu schließen, wenn das Instrument vollkommen trocken ist.

6. Die Latte ist gut senkrecht zu halten und eventuell durch Streben zu stützen. Eine Lattenschiefe geht voll in die Messung ein. Der Lattenuntersatz ist fest in den Boden einzutreten. Der Lattenfuß ist nicht auf den Erdboden aufzusetzen, damit er stets sauber ist.

7. Auf sicheren Instrumentenstandpunkt mit guter Sicht für den Rück- und Vorblick ist zu achten. Bei Streckennivellements wählt man gleiche Zielweiten, um Restfehler des Instrumentes zu eliminieren.

8. Bei Nivellieren ohne Kippschraube lässt man die Röhrenlibelle, bei Nivellieren mit Kippschraube und bei Nivellieren mit automatischer Horizontierung die Dosenlibelle einspielen. Die Röhrenlibelle des Nivelliers mit Kippschraube ist vor jeder Ablesung einzuspielen.

9. Nach dem Ausrichten des Fernrohrs auf die Latte wird das Lattenbild scharf und parallaxenfrei eingestellt und dann an der Latte abgelesen.

10. Die beste Kontrolle bei Streckennivellements ist die des Rücknivellements. An- und Abschlusspunkte sind zu überprüfen. Die Latte mit doppelter Teilung und das Nivellement mit doppelten Wechselpunkten verproben die Ablesungen.

11. Die Zielstrahlen sollten sich nicht mehr als 50 cm dem Erdboden nähern, um Refraktionsstörungen auszuschalten.

12. Die Berechnung der Höhen erfolgt zweckmäßig über die Höhenunterschiede, da diese Methode eine durchgreifende Rechenprobe einschließt.

11 Der Theodolit

Der Theodolit dient zum Messen und Abstecken beliebig großer Horizontal- und Vertikalwinkel. Seine Hauptbestandteile sind Einrichtungen zum Senkrechtstellen der Stehachse, ein um die Stehachse und Kippachse drehbares Fernrohr, ein horizontaler und ein vertikaler Teilkreis und Einrichtungen zum Ablesen oder Abtasten dieser Kreisteilungen. Die Genauigkeit der Messung hängt von der Güte des Instrumentes, seiner Ablesemöglichkeit und den Meßmethoden ab.

Es gibt analoge und digitale Theodolite. Der Aufbau beider Instrumentengruppen ist gleich, jedoch müssen bei analogen Instrumenten instrumentelle Fehler und Abweichungen durch geeignete Messverfahren ermittelt und rechnerisch berücksichtigt werden, während diese bei digitalen Theodoliten nach der Bestimmung in digitaler Form angegeben, gespeichert und nachfolgend automatisch in das Messergebnis eingehen.

Viele Theodolite sind mit einem elektro-optischen Distanzmesser als Aufsatz- oder Aufsteckgerät auszurüsten (s. Teil 2).

11.1 Horizontalwinkel, Vertikalwinkel, Richtungen

Man unterscheidet zwei Ebenen: die Horizontal- und die Vertikalebene. In jeder dieser Ebenen kann man Winkel bestimmen, nämlich Horizontal- und Vertikalwinkel.

Mit einem justierten und fehlerfrei aufgestellten Theodolit werden unabhängig von der Neigung des jeweiligen Zielstrahles Richtungen (Ablesung am Horizontalkreis) zu den einzelnen Punkten in der Horizontalebene gemessen. Die Richtungen werden später vielfach rechnerisch auf die x-Achse des Koordinatensystems bezogen (orientiert). Die Differenz zweier im Uhrzeigersinn gemessenen Richtungen r_1 und r_2 (Bild 11.1) ergibt den Horizontalwinkel

$$\beta = r_2 - r_1.$$

P_1 und P_2 liegen in der Horizontalebene durch S.

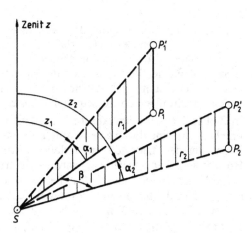

11.1 Horizontalwinkel, Zenitwinkel, Richtungen

Der Vertikalwinkel kann als Zenitwinkel z (Nullrichtung zeigt zum Zenit) oder als Höhenwinkel α (Nullrichtung liegt waagerecht) angegeben werden. Es ist

$$z = 100\,\text{gon} - \alpha$$

In der Regel wird bei der Ablesung am Höhenkreis der Zenitwinkel z angegeben. Der Zenitwinkel ist zu jedem Ziel einzeln zu bestimmen; er ist für Punkte unterhalb der Horizontalebene größer als 100 gon, der entsprechende Höhenwinkel damit negativ.

Den Winkel $P_1' - S - P_2'$ nennt man Positionswinkel; er kann in jeder beliebigen Ebene liegen. Im Vermessungswesen spielen diese Winkel keine Rolle.

11.2 Stativ, Befestigen des Theodolits auf dem Stativ

Die Theodolite gleichen i. allg. den im Abschn. 9.1 beschriebenen Nivellierstativen. Das Stativ muss spannungsfrei aufzustellen sein, damit sich der Standpunkt des Theodolits während der Messung nicht verändert.

Die Anzugschraube, die den Theodolit mit dem Stativ verbindet, ist hohl, um das optische Lot anwenden zu können. Meistens ist in der hohlen Anzugschraube eine Hülse mit Lothaken befestigt.

Das Gelenkkopfstativ ist vielfach mit einem Zentrierstock mit Dosenlibelle als Zentriereinrichtung ausgerüstet.

11.3 Der Aufbau des Theodolits

Der Theodolit besteht aus dem feststehenden Unterteil und dem Horizontalkreis (Limbus)[1], dem drehbaren Oberteil mit Alhidade[2] und Stützen sowie dem Fernrohr. In den Stützen sind die Funktionselemente der elektronischen Theodolite untergebracht. Hinzu kommt der Vertikalkreis zum Messen von Vertikalwinkeln. Der Theodolit soll geringes Gewicht, möglichst kleine Ausmaße, gute Optik, einwandfreie Achssysteme und Ableseeinrichtungen sowie bequeme Ablesemöglichkeiten haben.

In Bild 11.2 ist der schematische Schnitt eines einfachen Theodolits dargestellt. Oberteil und Unterteil sind durch einen Zapfen verbunden. Damit dreht sich die Alhidade in einer Ebene um den Unterteil und erlaubt, Winkel in dieser Ebene zu messen. Mit der Horizontierlibelle (Querlibelle) wird das Instrument über dem Aufnahmepunkt horizontiert. Mit der Horizontierung des Theodolits wird seine Stehachse lotrecht gestellt. Bei den meisten Theodoliten erfolgt dies mit Hilfe der drei Fußschrauben des Dreifußes (11.3). Dabei drehen sich die Fußschrauben auf besonders gehärteten Stellen der Grundplatte.

Bild 11.4 zeigt einen Dreifuß mit Grundplatte für Klauensysteme.

[1]) Limbus (lat.) = Saum in bezug auf den Teilkreis.
[2]) Alhidade (arab.) = Arm in bezug auf die Abkesemarke.

11.2 Einfacher Theodolit (schematisch)
1 Fußschraube
2 Dreifuß
3 Limbus (Horizontalkreis)
4 Alhidade (Ablesemarke)
5 Stütze (Fernrohrträger)
6 Fernrohr
7 Vertikalkreis (Höhenkreis)
8 Horizontierlibelle
VV Vertikalachse (Stehachse)
KK Kippachse
ZZ Ziellinie

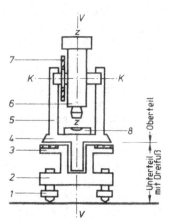

11.3 Dreifuß mit Grundplatte.
Aufnahme des Steckzapfens
nach DIN 18719

11.4 Dreifuß mit Grundplatte
für Klauensysteme
(Leica)

Der Horizontalkreis der analogen Theodolite besteht in der Regel aus Glas. Die Kreisteilungen werden in Grad oder Gon hergestellt und mit einer Bezifferung, die meistens im Sinne des Uhrzeigers verläuft, versehen. Von der Größe des Teilkreises ($\varnothing\,5\cdots10$ cm) und der Güte der Kreisteilung hängt u. a. die Leistung des Theodolits ab. Die Teilung der Kreise beträgt gewöhnlich 1, $^1/_2$, $^1/_5$ Gon bzw. 1, $^1/_2$, $^1/_3$, $^1/_6$ Grad.

Bei den Glaskreisen wird die Teilung mit einer Kreisteilmaschine auf eine aufgebrachte wachsähnliche Schicht eingerissen. Man bedampft die vom Wachs freien Stellen mit Chrom, wäscht das Wachs ab und prüft den so entstandenen Teilkreis elektronisch. Von ihm werden mit einem fotografischen Verfahren Kopien gezogen.

Der Horizontalkreis der digitalen Theodolite ist nicht beziffert. Für die elektronische oder inkrementale[1]) Kreisabtastung ist der Teilkreis aus Glas codiert oder mit einem radialen Strichraster versehen (siehe auch Abschn. 11.5.7).

[1]) Inkrement (lat.) = kleiner Zuwachs einer Größe.

Die Alhidade ist eine zum Teilkreis konzentrische Kreisscheibe. Bei einfachen Instrumenten trägt sie an einer oder an zwei gegenüberliegenden Stellen Ableseeinrichtungen. Im allgemeinen liegt die Ablesemarke nicht in der Ebene des Teilkreises. Fest verbunden mit der Alhidade sind die Fernrohrträger (Stützen), an deren oberen Enden das kippbare Fernrohr angeordnet ist.

In den Fernrohrträgern ist das Fernrohr fest und verdeckt gelagert. Das Fernrohr ist um die Kippachse drehbar. Auf eine Berichtigungsmöglichkeit der Kippachse wird verzichtet, da die gute feinmechanische Fertigung eine einwandfreie Lagerung gewährleistet.

Der Vertikalkreis (Höhenkreis) der analogen Theodolite besteht wie der Horizontalkreis in der Regel aus Glas und ist ähnlich wie dieser geteilt. Er sitzt auf der Kippachse fest und nimmt so an den Bewegungen des Fernrohrs teil. Die Ablesung erfolgt meistens über das neben dem Fernrohr liegende Ablesemikroskop, wobei die Ablesestellen des Horizontal- und Vertikal-(Zenit-)Winkels zusammen oder nach Betätigen eines Umschaltprismas nacheinander zu sehen sind. Wenn Zenitwinkel gemessen werden, zeigt bei der Zielung zum Zenit die Vertikalkreisablesung Null an; die Kreisablesung nimmt beim Neigen des Fernrohrs in Fernrohrlage I zu. Mit Rücksicht auf die geforderte Normung sind Vertikalkreise durchlaufend beziffert.

Der Vertikalkreis digitaler Theodolite ist nicht beziffert. Wie bei dem Horizontalkreis ist dieser für die elektronische oder inkrementale Kreisabtastung codiert oder mit einem Strichraster versehen.

11.3.1 Vertikalachssysteme

Die Vertikalachse (Stehachse) eines Theodolits, die Oberteil und Unterteil verbindet, kann verschieden ausgebildet sein. In den Anfängen wurden die Achsen konisch geschliffen, heute werden die Achsen zylindrisch oder scheibenförmig hergestellt.

Je nach Ausbildung des Vertikalachssystemes unterscheidet man

den einfachen Theodolit mit festem Teilkreis,
den Repetitions-Theodolit,
den Theodolit mit verstellbarem Teilkreis.

Der einfache Theodolit mit festem Teilkreis (11.2) ist ein Einachstheodolit, bei dem nur die Alhidadenachse vorhanden ist. Der Teilkreis liegt auf dem fest mit dem Dreifuß verbundenen Unterteil und ist nicht drehbar. Dreifuß mit Unterteil sind mit dem Oberteil durch Hülse und Achszapfen verbunden. Diese Anordnung ist bei einfachen Instrumenten zu finden.

Der Repetitionstheodolit ist ein Zweiachstheodolit mit zwei getrennten Achsen. Man kann mit ihm einfache und satzweise Winkelmessungen sowie Repetitionswinkelmessungen ausführen. Bei diesem Theodolit wird die Limbushülse auf die Hülse des Dreifußes gesteckt, die ihrerseits den Alhidadenzapfen aufnimmt. Alhidadenachse und Limbusachse berühren sich nicht (11.5).

Damit wird erreicht, dass der Oberteil für sich allein oder bei festgeklemmtem Limbus mit diesem zusammen drehbar ist. Man findet diese Anordnung bei vielen Bau- und Ingenieur-Theodoliten.

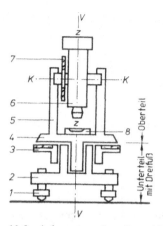

1 Fußschraube
2 Dreifuß
3 Limbus
 (Horizontalkreis)
4 Alhidade
 (Ablesemarke)
5 Stütze
 (Fernrohrträger)
6 Fernrohr
7 Vertikalkreis
 (Höhenkreis)
8 Horizontierlibelle
VV Vertikalachse
 (Stehachse)
KK Kippachse
ZZ Ziellinie

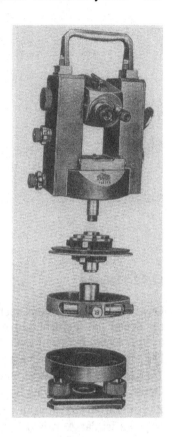

11.5 Achssystem eines Repetitionstheodolits
(schematisch)

11.7 Schematischer Schnitt durch
ein Vertikalachssystem (Leica)

11.6 Achssystem eines Repetitionstheodolits
mit Steckzapfen nach DIN 18719
(Breithaupt)

Bild **11.**6 zeigt das doppelte zylindrische Achssystem eines Repetitionstheodolits mit Steckzapfen. Der Unterteil mit dem Teilkreis und der Oberteil werden zusammengefügt. Beide Teile sind durch den Steckzapfen und die Steckhülse mit dem Dreifuß verbunden.

Bei dem im Bild **11.**7 dargestellten Achssystem ruht die plangeschliffene Unterseite der Alhidade auf einem Kugellager. Die Verengung am Ende der Achshülse dient zur Führung der Alhidadenachse. Der den Teilkreis tragende Limbus umfasst die Achsenhülse. Der Zentrierflansch wird mit drei Haltezapfen (**11.**8), die durch den Dreifußteller hindurchgehen, im Dreifuß verriegelt.

Bei einem Theodolit mit verstellbarem Teilkreis wird dieser durch Reibung festgehalten. Das Verstellen des Teilkreises geschieht durch Drehen eines Knopfes mit Kreistrieb. Feinmesstheodolite haben meistens diese Anordnung.

Digitale Theodolite gestatten durch Tastendruck den Winkelwert auf Null zu setzen. Die mechanische Verstellung des Teilkreises wird hier durch elektronische Vorgänge ersetzt.

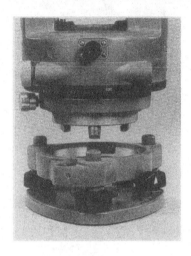

11.8 Abnehmbarer Dreifuß mit Drehkopfverriegelung
 (Leica)

11.3.2 Fernrohr

Das Fernrohr ist meistens nach beiden Seiten durchschlagbar. Es gibt auch Theodolite, bei denen das Fernrohr in den Achslagern umgelegt werden kann und solche mit exzentrischem Fernrohr außerhalb der Kippachsenlager.

Die geometrische Anordnung und die optischen Gesetze sind im Abschn. 7.1 besprochen.

Theodolite haben Fernrohre mit konstanter Länge, Innenfokussierung und vergüteter Optik. Bild 11.9 zeigt den Schnitt durch ein Theodolitfernrohr.

Zwei Fernrohrbewegungen seien besonders hervorgehoben:

Kippen ist das Auf- und Niederbewegen des Fernrohrs um die Kippachse.

Durchschlagen ist das Drehen des Fernrohrs um die Kippachse um 200 gon, so dass Objektiv und Okular in ihrer Lage vertauscht werden. Das Durchschlagen spielt beim Winkelmessen sowie beim Prüfen und Berichtigen des Theodolits eine wichtige Rolle.

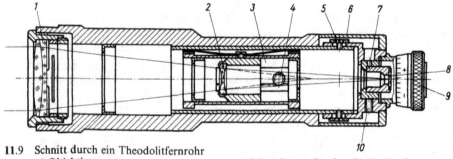

11.9 Schnitt durch ein Theodolitfernrohr
 1 Objektiv 6 Schutzkappe für den Okularkopf
 2 Fokussierlinse 7 Justieröffnung
 3 Zugrohr für 2 8 Strichkreuzplatte
 4 Fokussiertrieb 9 Okular
 5 Anzugschrauben am Okularkopf 10 Schraube für die Strichkreuzblende

11.3.3 Klemmvorrichtungen

Um Horizontalwinkel zu messen, müssen einzelne Punkte nacheinander angezielt werden. Hierzu muss das Fernrohr jeweils in Richtung auf das Ziel festzulegen sein. Dies geschieht mittels Klemmvorrichtungen, die aus Seitenklemme und Seitenfeintrieb bestehen. Mit der Seitenklemme wird der um die Stehachse drehbare Oberteil festgelegt, mit dem Seitenfeintrieb kann der Oberteil um geringe Beträge nach dem Feststellen der Seitenklemme gedreht werden, um das Strichkreuz scharf mit dem Ziel zur Deckung zu bringen. Der einfache Theodolit mit festem Teilkreis (Einachstheodolit) besitzt eine Klemmvorrichtung, um Alhidade und Teilkreis gegeneinander festzulegen; man bezeichnet sie mit Alhidadenklemme. Der Repetitionstheodolit (Zweiachstheodolit) hat noch eine weitere Klemmvorrichtung zum Festlegen des Limbus mit Teilkreis gegen den Dreifuß; diese nennt man Limbusklemme.

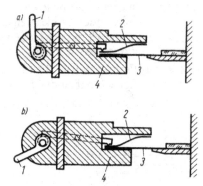

11.10 Kreisklemme
 a) Blattfeder entlastet
 b) Blattfeder gespannt

Viele Ingenieur-Theodolite haben anstelle der Limbus-Klemmvorrichtung eine Kreisklemme (11.10). Mit ihr kann der Horizontalkreis mit dem Oberteil verbunden werden. Die Kreisklemme dient der Kreisorientierung und der additiven Messung vorwiegend kleiner Winkel (s. Abschn. 12.3.2).

In Bild 11.10a steht der Klemmhebel nach oben; die ≈ 5 mm breite Blattfeder (2), die Membran (3) und die Alhidade (4) sind getrennt. Wenn die Blattfeder (2) durch Herunterdrücken des Klemmhebels (1) gespannt wird (11.10b), presst sie die Membran (3) nach unten an die Alhidade an. Durch Schließen und Öffnen der Kreisklemme, was durch Umlegen des Klemmhebels (1) geschieht, wird der Teilkreis fest mit der Alhidade verbunden oder von ihr gelöst. Bei geklemmtem Teilkreis übernimmt die Klemmvorrichtung die Funktion der Limbus-Klemmvorrichtung. Bei geöffneter Kreisklemme sitzt der Teilkreis durch sein Eigengewicht fest auf dem Unterteil; die Klemmvorrichtung hat jetzt die Funktion der Alhidaden-Klemmvorrichtung wie bei dem Einachstheodolit.

Anstelle des Klemmhebels kann auch ein Schaltknopf angeordnet sein, der jeweils um ein Viertel der Schaltstellung gedreht wird. Vorteilhaft gegenüber dem Theodolit mit zwei Klemmvorrichtungen ist, dass während der Winkelmessung die Klemmvorrichtungen nicht verwechselt werden können und der Schaltknopf zum Fernsehokular und damit auch zum Beobachter immer in der gleichen Lage bleibt.

11.3.4 Libellen

Mit den Fußschrauben wird die Vertikalachse (Stehachse) des Theodolits lotrecht gestellt. Um diese wichtige Forderung erfüllen zu können, sind Libellen erforderlich. Bei den gebräuchlichsten Theodoliten ist zwischen den Fernrohrträgern auf der Alhidade eine Horizontierlibelle (Querlibelle) als Röhrenlibelle parallel zur Kippachse angebracht. Zum Teil haben die Theodolite zur genäherten Horizontierung noch eine Dosenlibelle.

Ist senkrecht zur Horizontierlibelle eine weitere Röhrenlibelle vorhanden, so bezeichnet man diese beiden als Kreuzlibellen. Sie erleichtern das Horizontieren des Instrumentes.

An dem Fernrohr kann eine Röhrenlibelle als Nivellierlibelle angebracht sein. Sie ist meistens als Wendelibelle ausgebildet. Eine Reiterlibelle, die auf die Kippachse aufzusetzen ist, dient dem genauen Senkrechtstellen der Stehachse.

Für die Vertikalwinkelmessung ist eine besondere Höhenindexlibelle erforderlich, die vor jeder Messung zum Einspielen gebracht werden muss. Die Höhenindexlibelle (11.11) ist mit dem Höhenindex (Ablesezeiger) verbunden. Mit der Feinbewegungsschraube F (Höhenindextrieb) kann der Höhenindex samt Höhenindexlibelle gekippt und gegen die Lotrichtung orientiert werden.

Wenn eine Fernrohrlibelle (11.12) vorhanden ist, soll die Libellenachse parallel der Ziellinie sein. Vielfach haben die Theodolite eine Höhenindex- und eine Fernrohrlibelle.

11.11 Höhenindexlibelle

11.12 Fernrohrlibelle

11.3.5 Automatischer Höhenindex

Bequemer ist die Vertikalwinkelmessung mit Theodoliten auszuführen, die anstelle der Höhenindexlibelle mit einem automatischen Höhenindex ausgerüstet sind. Es ist eine optisch-mechanische Einrichtung, die die Vertilalkreisanzeige gegen kleine Neigungen des Instrumentes stabilisiert. Nachdem das Instrument genähert horizontiert ist, wird die Ablesung am Vertikalkreis automatisch auf die Lotrichtung bezogen.

Viele optisch-mechanische und elektronische Theodolite sowie Reduktions- und elektronische Tachymeter haben anstelle der Indexlibelle einen Pendel- oder Flüssigkeitskompensator.

Beim Pendelkompensator (11.13) erfolgt die Kompensation durch das pendelnd aufgehängte Glied 1a des Doppelobjektivs 1a/1b. Die Länge des Pendels ist gleich dem Teilungsradius r des Vertikalkreises. Die Ablesestelle 2 am Höhenkreis, der fest mit dem

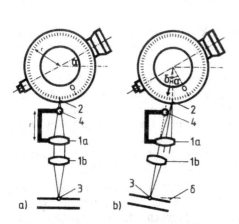

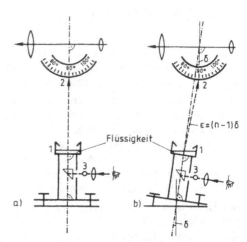

11.13 Wirkungsweise des automatischen
 Höhenindex-Pendelkompensator
 a) Theodolit fehlerfrei horizontiert
 b) Horizontierung gestört

11.14 Flüssigkeitskompensator
 a) Theodolit fehlerfrei horizontiert
 b) Horizontierung gestört

Fernrohr verbunden ist, wird auf dem Ableseindex 3 abgebildet; die Ablesung entspricht dem wirklichen Höhenwinkel α. Bei schlecht horizontiertem Instrument steht die Vertikalachse um den Winkel δ schief zum Lot. Durch das pendelnde Objektivglied 1a, dessen Mittelpunkt senkrecht unter der Pendellagerung 4 einspielt, und weil der Strahlengang zwischen den Gliedern 1a und 1b parallel verläuft, wird die Kreisstelle 2 wieder auf den Ableseindex 3 projiziert. Der Winkel δ, um den die Vertikalachse geneigt ist, wird somit eliminiert und der richtige Höhenwinkel α abgelesen.

Bei dem wartungsfreien Flüssigkeitskompensator (11.14) wirkt das Gefäß 1 mit Silikonöl bei genau senkrechter Stehachse wie eine planparallele Platte. Der von der Ablesemarke 2 kommende Lichtstrahl geht ungebrochen hindurch zum Ableseindex 3. Wenn die Stehachse jedoch um den kleinen Winkel δ zum Lot geneigt ist, wird durch die Flüssigkeitsoberfläche ein Keil mit demselben Winkel gebildet. Für den Brechungsindex n der Flüssigkeit wird der Lichtstrahl um den Winkel $\varepsilon = (n-1)\delta$ abgelenkt und somit die Ablesestelle 2 wieder auf den Ableseindex 3 projiziert.

Bei digitalen Feinmesstheodoliten wird die Auswirkung einer Stehachsneigung bei der Vertikalkreis- wie bei der Horizontalkreisablesung automatisch berücksichtigt. Der Kompensator ist meistens nicht, wie bei den analogen Theodoliten, im Ablesestrahlengang der Teilkreise untergebracht, sondern er ist ein besonderes Element. Somit können die Kompensationswerte getrennt von den Teilkreisablesungen angegeben werden.

11.4 Ablotevorrichtungen

Um den Theodolit über einen gegebenen Bodenpunkt aufstellen zu können, braucht man eine Ablote- oder Zentriervorrichtung. Hierzu dienen das Schnurlot, das starre Lot (Zentrierstock) und das optische Lot.

Das Schnurlot wird mit einem Laufknoten am Lothaken aufgehängt. Der wirksame Aufhängepunkt des Lotes soll bei aufgeschraubtem Instrument $\approx 5\,\mathrm{mm}$ über der Aufsatzfläche des Instrumentes liegen, um eine Verlagerung des Aufhängepunktes beim Horizontieren des Theodolits zu vermeiden. Das Schnurlot hat verschiedene Nachteile: es treibt bei Wind ab, es erschwert die Zentrierung bei Bodenbewuchs, es erfordert die Betrachtung in zwei senkrecht zueinander stehenden Richtungen, es muss beim Transport des Theodolits abgenommen werden. Die Zentriergenauigkeit beträgt ± 3 mm.

Bei Gruben- und Tunnelvermessungen muss der Theodolit vielfach unter einem Firstpunkt zentrisch aufgestellt werden. Zu diesem Zweck ist auf dem Fernrohrmantel der Körnerpunkt (kleines Loch oder kleine Spitze) angegeben, der bei waagerechtem Fernrohr in der Stehachse liegt. Das Lot wird an dem Firstpunkt befestigt und der Theodolit darunter zentriert.

Das starre Lot (Zentrierstock, Lotstab) besteht aus zwei ineinander verschiebbaren hohlen Metallstangen mit Lotspitze und einer justierbaren Dosenlibelle (11.15). Der Zentrierstock wird durch eine Feder, die in eine muldenförmige Vertiefung der Anzugschraube einrastet, gehalten. Vielfach ist an dem Rohr eine Zentimeterteilung angebracht, die die Höhe der Kippachse über Boden anzeigt. Die Zentriergenauigkeit ist ± 1 mm.

Das optische Lot besteht aus einem kleinen gebrochenen Fernrohr mit $2\cdots 5$facher Vergrößerung. Ein Prisma lenkt den Strahl rechtwinklig ab. Das optische Lot kann fest an den Dreifuß angebaut oder in der Alhidade eingebaut sein (11.16) oder es kann als selbständiges kleines Instrument anstelle des Theodolits mit seinem Steckzapfen in den Dreifuß oder Kugelfuß eingesetzt werden (11.17). Bei dem letztgenannten optischen Lot ist das Prisma vielfach umschaltbar, so dass über Bodenpunkten und unter Firstpunkten zentriert werden kann. Die Zentriergenauigkeit ist $\pm 0,4\cdots 1$ mm.

11.15 Ausziehbarer Zentrierstock
mit justierbarer Dosenlibelle

11.16 Optisches Lot in der Alhidade
 des Theodolits (Leica)

11.17 Auswechselbares optisches Lot
 auf Theodolit-Kugelfuß (Zeiss)

11.5 Ableseeinrichtungen

Zur Winkelmessung mit dem Theodolit ist die jeweilige Stellung der Ablesemarke (Index) zur Kreisteilung festzustellen. Die Ablesemarke wird sich selten mit einem Strich der Kreisteilung decken, sondern zwischen zwei Teilstrichen stehen (**11.18**). Es reicht für die genaue Winkelmessung jedoch nicht aus, diese Teilbeträge vom Teilstrich bis zur Ablesemarke zu schätzen. Zur Bestimmung von Dezimalstellen der Hauptteilung sind Hilfsmittel entwickelt worden; das einfachste ist der Nonius, der durch eine Lupe betrachtet wird.

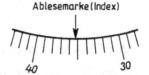

11.18 Teilkreis mit Ablesemarke (Index)
 Ablesung: 36,2 (Zehntel geschätzt)

Nonius und Lupe sind weitgehend durch das Ablesemikroskop ersetzt worden, das bei den meisten Theodoliten in eine besondere, neben dem Fernrohr liegende Mikroskopröhre eingebaut ist und die Ablesung des Horizontalkreises (Hz oder Az, Azimutalkreis) und des Vertikalkreises (V) in einem Blickfeld ermöglicht. Um die Genauigkeit zu steigern, können Mikroskope mit einem optischen Mikrometer versehen sein. Je nach Art der Ableseeinrichtung sind die Ablesemöglichkeiten verschieden.

Es gibt für analoge Theodolite bei Ablesung an nur einer Kreisstelle

das Strichmikroskop (ein Strich [Doppelstrich] ist Ableseindex)
das Strichmikroskop mit optischem Mikrometer
das Skalenmikroskop (eine Skala dient zur Ablesung)

und bei Ablesung an zwei diametralen Kreisstellen mit automatischer Mittelung

das Koinzidenzmikroskop mit optischem Mikrometer.

Bei den **digitalen Theodoliten** ersetzt die elektronische Kreisabtastung und die digitale Anzeige der Ergebnisse die Ablesung über das Mikroskop.

11.5.1 Ablesemikroskop

Die Ablesemarke (Nullstrich) liegt bei Anwendung eines Ablesemikroskops nicht in der örtlichen Ebene, sondern in der Bildebene des Teilkreises. An die Stelle der Lupe tritt ein kleines Fernrohr mit Objektiv- und Okularlinse.

Der Abstand g (11.19) vom Teilkreis G bis zum Objektiv O wird so gewählt, dass er zwischen einfacher und zweifacher Brennweite des Objektivs liegt. So erhält man vom Teilkreis ein etwas vergrößertes, reelles Bild B. In dieser Ebene, in der das durch das Objektiv erzeugte Bild B entsteht, liegt die Ablesemarke. Das Bild des Teilkreises und die Ablesemarke werden durch das Okular R (Lupe) betrachtet.

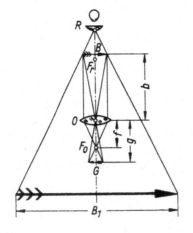

11.19 Strahlengang im Ablesemikroskop
R Okular
O Objektiv
G Gegenstand
g Gegenstandsweite
f Brennweite des Objektivs
F_0 Brennpunkt des Objektivs
F_r Brennpunkt des Okulars
b Bildweite
B wirkliches, vergrößertes Bild
B_1 scheinbares, stark vergrößertes Bild

11.5.2 Optisches Mikrometer

Um den Teilbetrag vom Teilkreisstrich bis zur Ablesemarke nicht schätzen zu müssen, sondern messen zu können, verwendet man ein optisches Mikrometer, das meistens aus einer Planplatte besteht. Der schräg unter dem Winkel α auf die planparallele Glasplatte auftreffende Lichtstrahl (11.20) wird parallel um

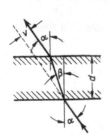

$$v = \frac{d}{\cos \beta} \sin (\alpha - \beta)$$

verschoben.

11.20 Strahlengang durch eine planparallele Glasplatte

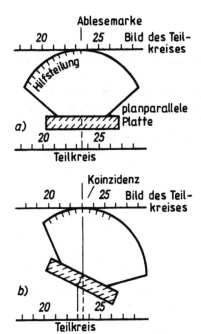

11.21 Schema der Anwendung
der planparallelen Platte
a) in Nullstellung
b) nach Koinzidenz

11.22 Schema der Anwendung
von zwei kippbaren
planparallelen Platten

Das Prinzip zeigt Bild **11**.21. Eine Skala (Hilfsteilung) ist mit der planparallelen Platte gekoppelt und mit der Hauptteilung so abgestimmt, dass sie einem Intervall der Hauptteilung entspricht. Die planparallele Platte wird für die Winkelablesung gekippt und damit das Bild des Teilkreises so weit verschoben, bis die Ablesemarke mit dem vorhergehenden Strich der Teilung koinzidiert.

Das optische Mikrometer gilt meistens gleichzeitig für die Ablesung am Horizontalkreis und am Vertikalkreis.

Das optische Mikrometer mit automatischer Mittelbildung besteht vielfach aus zwei kippbaren planparallelen Platten (**11**.22). Von den beiden gegenüberliegenden Ablesestellen wird jeweils der Lichtstrahl durch eine der planparallelen Platten gelenkt, die sich beide gegeneinander durch einen Knopf drehen lassen. Hierdurch verschieben sich auch die Bilder der Ablesestellen der Kreisteilung gegeneinander. Die Koinzidenz zweier Teilkreisstriche ergibt die Ablesestellung der Mikrometerskala, die im Mikroskopokular sichtbar ist.

Anstelle der planparallelen Platten können zwei Schiebekeile angeordnet sein, deren Wirkungsweise ähnlich ist. Durch Verschieben der Keile werden auch hier Teilkreisstriche der gegenüberliegenden Ablesestellen zur Koinzidenz gebracht.

11.5.3 Strichmikroskop

Die Achsen der Theodolite sind werksmäßig so genau gefertigt, dass sich für die Theodolite niederer und mittlerer Genauigkeit die Ablesung an zwei gegenüberliegenden Stellen erübrigt und man mit einer Ablesestelle auskommt.

Beim Strichmikroskop (**11.23**) geschieht die Ablesung in einfacher Weise an einem Strich als Ablesemarke, der auf einer Glasplatte aufgebracht ist. Strich und Teilung werden scharf eingestellt, so dass keine Parallaxe vorhanden ist. Eine Abstimmung ist nicht erforderlich; es soll nur der Ablesestrich parallel zu den Teilstrichen stehen. Der Teilbetrag von der Ablesemarke bis zum Teilkreisstrich wird geschätzt. Die Ablesegenauigkeit ist 1 dgon, die Schätzgenauigkeit 1 cgon.

11.23 Gesichtsfeld eines Strichmikroskopes
Ablesung: *Hz* 371,85 gon,
V 114,15 gon

11.5.4 Strichmikroskop mit optischem Mikrometer

Wenn die Ablesemarke bei der Ablesung zwischen zwei Strichen des Teilkreises steht, wird mit der planparallelen Platte die Koinzidenz zwischen der Ablesemarke (Doppelstrich) und dem nächsten Teilkreisstrich hergestellt. An der Mikrometerskala ist nun der Teilbetrag, der bei dem einfachen Strichmikroskop geschätzt werden müsste, abzulesen. Das Strichmikroskop mit optischem Mikrometer muss abgestimmt werden, es geschieht durch die Herstellerfirma.

In Bild **11.24** ist der Schnitt durch den Mikrometer-Theodolit T 1 (Leica) mit Strahlengang wiedergegeben. Für die Ablesung tritt das Licht über den Beleuchtungsspiegel durch ein Fenster und trifft nach Ausleuchten des Vertikalkreises über mehrere Prismen auf den Horizontalkreis. Nach Ausleuchten der Kreisstelle gelangt das Licht über weitere Prismen in das Ablesemikroskop, in dem der Beobachter die Kreisstellen des Vertikal- und Horizontalkreises sowie die digitale Mikrometer-Ablesung erblickt. Die Ablesung erfolgt hier durch Herstellen der Koinzidenz der jeweiligen Teilung mit der als Doppelstrich dargestellten Ablesemarke über ein Mikrometer.

Bild **11.25** zeigt das Gesichtsfeld des Strichmikroskops (Horizontal- und Vertikalkreis) mit optischem Mikrometer in Gon nach Koinzidenzeinstellung des Horizontalkreises. Teilkreis und Mikrometer sind voll beziffert.

11.24 Schnitt durch den Mikrometer-Theodolit T1 (Leica) mit Strahlengang der Kreisablesung

11.25 Gesichtsfeld des Strich-mikroskopes mit opti-schem Mikrometer (Leica T1) Digitale Ablesung: Hz 134,318 gon

11.5.5 Skalenmikroskop

Es hat für den Horizontalkreis und für den Vertikalkreis getrennte Skalen (**11.**26). Die Ablesemarke ist der jeweilige Strich der Hauptteilung, die in volle Gon geteilt ist. Die Skala weist 100 Teile auf (Grad 60 Teile). Die Ablesegenauigkeit ist 1 cgon, die Schätzgenauigkeit 2 mgon.

Das schnelle, äußerst einfache und übersichtliche Ablesen und die Sicherheit gegen grobe Fehler sind Vorzüge dieser Ableseart. Zu den ganzen Werten der Hauptteilung ist der Skalenwert zu addieren. Horizontalkreis (Hz bzw. Az, Azimutalkreis) und Vertikalkreis (V) liegen in einem Gesichtsfeld. Es ist deshalb achtzuge-ben, dass am richtigen Teilkreis abgelesen wird; vor allem, da es auch Theodolite gibt, bei denen der Horizontalkreis oben und der Vertikalkreis unten im Gesichtsfeld er-scheinen.

11.26 Gesichtsfeld eines Skalenmikroskopes
Ablesung: V 107,760 gon, Hz 0,175 gon

Bei der Skalenablesung muss die Länge der Skala mit dem scheinbaren Abstand zweier Teilkreisstriche übereinstimmen. Ist dies nicht der Fall, so liegt ein Fehler vor, der R u n genannt wird (**11.27**). Er wird beseitigt, indem bei scharf eingestellter Skala und scharfem Bild der Kreisteilung das Objektiv verschoben wird, bis die Skala und das Bild des Teilungsintervalls sich decken.

11.27 Runbeseitigung durch Skalenabstimmung
 T Teilkreiseinheit
 M Stellung des Mikroskops bei abgestimmter Skala
 M′ Stellung des Mikroskops bei nicht abgestimmter Skala
 S Skala
 B Bild der Teilkreiseinheit
 R Run

11.5.6 Koinzidenzmikroskop mit optischem Mikrometer

Viele Theodolite – vor allem Feinmesstheodolite – haben zwei diametral gelegene Ablesestellen, deren Bilder über Prismen in das Gesichtsfeld des Mikroskops gebracht und koinzidiert werden. Die Bilder, die sich entgegengesetzt bewegen, können sich gegenüberstehen, wobei eines der Übertragungsprismen als Dachprisma ausgebildet ist oder sie können nebeneinanderstehen, was durch das Übertragungssystem und zwei Ablenkprismen bewirkt wird. Gegenüberstehende Bilder erscheinen durch eine Kante getrennt.

11.28 Mittelbildung aus zwei Ablese-
 stellen

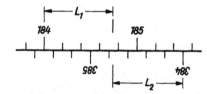

11.29 Auf optischem Wege untereinander
 gebrachte Ablesestellen

Stellen wir uns zunächst vor, dass beide Ablesestellen leserichtig untereinanderliegen würden (11.28). Das Mittel aus beiden Ablesungen wäre dann

$$184 + \frac{L_1 + L_2}{2}$$

So wird auch bei jedem Theodolit mit zwei Ablesestellen gerechnet. Damit diese Rechnung fortfällt, bringt man die zweite Ablesestelle auf dem Kopf stehend in das Gesichtsfeld (11.29). Um den Teilbetrag zwischen der Ablesemarke und dem letzten Teilstrich messen zu können, sind zwei kippbare planparallele Platten oder Schiebekeile als Mikrometer vorgesehen, mit deren Hilfe die in der Mitte des Gesichtsfeldes liegenden Striche beider Teilungen zur Koinzidenz gebracht werden (11.30). Die Kreisteilung beträgt in Bild 11.30 2 dgon.

Der gesuchte Wert $\dfrac{L_1 + L_2}{2}$ ist dann gleich

$$\frac{7 \text{ (Teilungsintervalle zwischen 184 und 384)} \times 2 \text{ dgon (Kreisteilung)}}{2}$$

plus Mikrometerablesung (diese ist bereits gemittelt). Das ergibt 7 (Teilungsintervalle) × 1 dgon plus Mikrometerablesung. Für die Dezigon braucht man somit nur die Anzahl Teilungsintervalle zwischen den um 200 gon verschiedenen Werten beider Teilungen zu bestimmen. Die Ablesemarke ist damit überflüssig und vielfach auch nicht mehr vorhanden. Es ist darauf zu achten, dass die um 200 gon unterschiedliche, auf dem Kopf stehende Zahl nur unter bzw. über oder rechts von der abzulesenden Zahl, aber nie links von ihr stehen darf. Die Zenti- und Milligon zeigt die Hilfsskala an; diese sind bereits Mittelwerte.

Im Beispiel Bild **11.30** wird abgelesen:

an der Hauptteilung	184,7
an der Hilfsskala	483
(opt. Mikrometer)	
	184,7483 gon

11.30 Automatische Mittelbildung

Bei einigen Theodoliten ist die Ablesung der Teilkreise teildigitalisiert.

Der Dezimalwert wird bis zum Milligon in Ziffern abgelesen und nur die letzte Stelle in $^1/_{10}$ mgon der Skala entnommen. In den gegenläufigen und gegenüberstehenden Bildern der beiden diametral zueinander gelegenen Kreisteilstellen entfallen hierbei die Ziffernangaben.

In Bild **11.31** ist das Gesichtsfeld eines Koinzidenzmikroskops mit teildigitaler Ablesung nach Herstellen der Koinzidenz dargestellt.

Die Genauigkeit der Koinzidenz ist für die Messgenauigkeit entscheidend. Deshalb sollen die Bilder gut beleuchtet und ohne Parallaxe sein. Das Koinzidieren ist immer nur in einer Richtung vorzunehmen (Knopf nicht hin und her drehen). Die Ablesegenauigkeit beträgt $^1/_{10}$ bis $^2/_{10}$ mgon.

11.31 Gesichtsfeld eines Koinzidenzmikroskopes mit optischem Mikrometer und teildigitaler Ablesung
Ablesung: 105,8224 gon

11.5.7 Elektronische Kreisabtastung und digitale Anzeige bei digitalen Theodoliten

An die Stelle des Ablesemikroskops beim analogen Theodolit und der notwendigen Ablesung am Mikroskop mit Koinzidenzeinstellung oder Intervallschätzung am Teilkreis tritt hier das Prinzip der Kreisabtastung und der digitalen Anzeige der Winkelwerte. Ein Mikroprozessor steuert die Messabläufe.

11.32 Ausschnitt eines codierten Teilkreises (Zeiss Elta 2)

Das elektronische Abtasten des Teilkreises erfolgt automatisch nach dem Codeverfahren, dem Inkrementalverfahren oder dem dynamischen Verfahren. Bei den ersten beiden Verfahren steht der Teilkreis fest, bei dem letzten Verfahren rotiert dieser. Die Richtungsmessung besteht aus der Grob- und der Feinmessung, die von den Instrumentenherstellern auf verschiedene Weise gelöst wird.

Bei dem Codeverfahren ist auf der Kreisscheibe eine Codeteilung aufgebracht, die aus konzentrisch angeordneten Spuren besteht. Dabei greift man auf das Dual-System zurück, indem die gröbste Spur zur Hälfte des Teilkreises lichtdurchlässig, zur anderen Hälfte lichtundurchlässig ist. Die nächste Spur ist in vier Teile (2 lichtdurchlässige, 2 lichtundurchlässige) die folgende Spur in acht Teile (4 lichtdurchlässige, 4 lichtundurchlässige), die weitere Spur in sechzehn Teile (8 lichtdurchlässige, 8 lichtundurchlässige) usw. geteilt (**11.32**). Der Intervallschritt ist durch die feinste Spur gegeben. Auf einer Seite des Teilkreises sind Leuchtdioden (Lumineszenzdioden), auf der anderen Seite Photodioden angebracht, durch die beim Abtasten der Codespuren ein helles (lichtdurchlässiges) oder dunkles (lichtundurchlässiges) Signal erzeugt wird, das in ein elektrisches Signal umgewandelt eine Spannung oder ein Nullsignal ergibt, das der 0 oder 1 im Dualsystem entspricht. Die nach der Dualcodierung erhaltenen Signale werden in die Dezimalanzeige umgewandelt.

Der Durchmesser des Teilkreises erlaubt nur eine beschränkte Anzahl von Code-Spuren, deren feinste Spur ein Intervall von 0,5 gon aufweist. Deshalb werden diese für die Grobabtastung verwendet. Für die Ermittlung des Feinwertes dienen die beiden dargestellten Strichteilungen, wobei die innere auf die äußere abgebildet und der Abstand

Leuchtdiode

Photodiode

11.33 Ausschnitt einer inkrementellen
Kreisabtastung (schematisch)

zwischen den diametralen und abgebildeten Strichen nach Koinzidenz mittels eines elektronischen Mikrometers gemessen wird. Damit wird eine Messgenauigkeit von 0,2 mgon erreicht.

Bei dem Inkrementalverfahren [1]) befinden sich auf dem Teilkreis keine Codezeichen sondern ein Strichraster (**11.33**). Strichdicke und Strichabstand sind gleich und stellen somit eine Hell-Dunkel-Folge dar. Eine aus einer Leuchtdiode und einer Photodiode bestehende Lichtschranke tastet die Hell-Dunkel-Felder ab, wobei die Richtungsänderung gegenüber der Anfangsrichtung bestimmt wird. Beim Abtasten des Teilkreises wird durch jedes Hell-Dunkel-Feld in der Photodiode eine Periode eines elektrischen Sinussignals hervorgerufen, das in ein Rechteck-Signal umgewandelt wird. Die bei der Drehung des Theodolitoberteiles erzeugten Perioden werden elektronisch gezählt, umgewandelt und digital angezeigt. Hierdurch wird der Grobwert ermittelt. Die Feinmessung wird durch Interpolation vorgenommen, die mit einem elektronischen Planplattenmikrometer erfolgen kann.

Eine weitere Möglichkeit gibt das Moiré-Streifen-System. Hierbei sind auf dem Glaskreis 20000 Striche von 5,5 μm Dicke radial angeordnet, deren Abstand gleich der Strichdicke ist. Strichdicke und Strichabstand bilden jeweils eine Gitterkonstante, deren Größe im Winkelmaß 0,02 gon beträgt. Man nimmt nun einen Ausschnitt von 200 Strichen und bildet diesen auf die diametral gegenüberliegende Kreisstelle ab, wobei der Ausschnitt geringfügig um 1,005 vergrößert wird und so ein Moiré-Muster entsteht

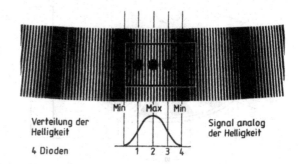

Min Max Min

Verteilung der
Helligkeit

Signal analog
der Helligkeit

4 Dioden 1 2 3 4

11.34 Inkrementelle Kreisabtastung
(Moiré-Streifen-Muster)

[1]) Inkrement = Zunahme einer Größe = wachsende Folge der Hell-Dunkel-Felder.

(11.34). Die diametralen Kreisbilder bewegen sich beim Verdrehen des Teilkreises gegenläufig. Durch die Überlagerung beider Teilungen durchläuft die Helligkeit einen Größt- und Kleinstwert beim Drehen der Alhidade. Das Zählintervall wird durch das Moiré-Muster auf 11 µm oder 0,01 gon erweitert. Zur Steigerung der Genauigkeit auf 0,1 mgon löst man die Moiré-Periode auf, indem man über diese vier Dioden gleichmäßig verteilt anordnet, die die Lage des Moiré-Musters gegenüber der Ablesestelle festlegen. Die Hell-Dunkel-Perioden werden als Grobmessung gezählt und die Lichtstärken innerhalb dieser Periode als Feinmessung ausgewertet. Der endgültige Wert der Horizontalkreisablesung wird von einem Mikroprozessor, dessen Elektronik in den Theodolit-Stützen untergebracht ist, durch Zusammensetzen der Grob- und Feinmessung berechnet und ist digital an einer Flüssigkeitskristallanzeige für Horizontal- und Vertikalwinkel abzulesen.

Mit einem Druckknopf (Null-Taste) kann die Ablesung des Horizontalkreises auf Null gebracht werden, auch lässt sich jede andere Ablesung durch Drehen des Kreistriebes erzeugen. Bei der Vertikalwinkelmessung kann die Angabe als Zenitwinkel, Höhenwinkel oder Neigung in Prozent erscheinen, wobei die vorher bestimmten Instrumentenfehler gespeichert und dann automatisch als Korrektur angebracht werden.

Das dynamische Verfahren hat den Vorteil, dass bei einer Messung alle Striche des Teilkreises abgetastet werden. Auf dem Teilkreis sind Striche im gleichen Abstand (Teilungsintervall φ_0) aufgebracht **(11.35)**. Der zu bestimmende Winkel ist durch je zwei diametral festgelegte Lichtschranken, die jeweils wieder aus Sende- und Empfangsdioden bestehen, gegeben. Dabei stellen die fest mit dem Unterteil des Theodolits verbundenen Lichtschranken L_S die Nullrichtung und die mit der Alhidade drehbaren Lichtschranken L_R die Ablesestelle am Teilkreis dar. Bild **11.35** zeigt jeweils nur eine Lichtschranke.

Die Winkelmessung erfolgt durch eine Phasenvergleichsmessung, die sich aus der Grob- und Feinmessung zusammensetzt:

$$\varphi = n \cdot \varphi_0 + \Delta\varphi$$

Mit der Grobmessung wird die ganze Anzahl n der Signal-Perioden bestimmt, zu der das Restintervall hinzukommt. Durch den rotierenden Teilkreis mit der Hell-Dunkel-Teilung wird das Licht der Sendediode sinusförmig umgewandelt. Das in der Empfangsdiode

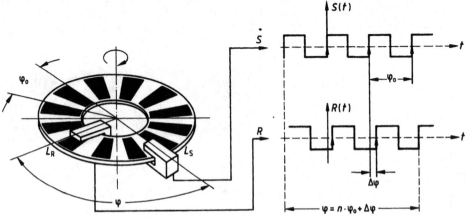

11.35 Dynamisches Verfahren der Kreisabtastung (Leica)

entstehende elektrische Signal wird weiter in ein Rechtecksignal verwandelt. Der Winkel ergibt sich dann aus dem n-fachen der Signalperioden φ und dem Phasenunterschied $\Delta\varphi$. Ein Prozessor setzt den Teilkreis in Rotation und lenkt den Ablauf der Grob- und Feinmessung. Referenzmarken der Teilung dienen der Grobmessung. Die Signalperioden werden vom Durchlaufen der Referenzmarke der ersten Lichtschranke bis zum Durchlaufen der zweiten Lichtschranke gezählt. Die Feinmessung zur Bestimmung von $\Delta\varphi$ ist das arithmetische Mittel aus 512 Phasenvergleichsmessungen. Die Messgenauigkeit liegt bei 0,1 mgon.

Grob- und Feinmessung erscheinen als Richtung im Display.

11.6 Theodolit-Typen (analoge und digitale)

Die Güte eines Theodolits ist abhängig von der Fernrohrvergrößerung, der Angabe der Libelle, dem Teilkreisdurchmesser und der Ablesegenauigkeit. Meistens ist das Kriterium die Ablesegenauigkeit, und man unterscheidet dann Theodolite mit

niederer Ablesegenauigkeit	$(1 \cdots 2\,\text{cgon})$
mittlerer Ablesegenauigkeit	$(1 \cdots 5\,\text{mgon})$
hoher Ablesegenauigkeit	$(^1/_{10} \cdots {}^2/_{10}\,\text{mgon})$
höchster Ablesegenauigkeit	$(^1/_{100} \cdots {}^2/_{100}\,\text{mgon})$ [1]

Diese Unterteilung findet auch in der Anwendung ihren Niederschlag. Deshalb spricht man in der Reihenfolge der vorangegangenen Aufzählung von Bau-, Ingenieur, Feinmess- und Präzisionstheodoliten, die als analoge oder als digitale Instrumente ausgebildet sind. Eine scharfe Abgrenzung lässt sich bei der Einteilung nicht vornehmen, so dass ein Übergreifen zur einen oder anderen Seite möglich ist.

Bei der Vielzahl der zur Verfügung stehenden Modelle ist es zweckmäßig, sich vor der Anschaffung eines Theodolits über dessen Einsatz Klarheit zu verschaffen. In den folgenden Abschnitten werden für die einzelnen Typen verschiedene Theodolite gezeigt, die nur als Beispiel gelten. Es wird damit kein Werturteil über diese oder andere nicht genannte Instrumente abgegeben.

11.6.1 Bautheodolite (Theodolite niederer Genauigkeit)

Es sind einfache Instrumente für Vermessungsaufgaben bei Bauvermessungen, Forstvermessungen, geologische und landwirtschaftliche Vermessungen sowie für einfache topographische Aufnahmen.

[1] Diese Theodolite übersteigen den Rahmen dieses Buches und werden nicht behandelt.

11.36 Digitaler Bautheodolit T 105 (Leica)

a) Analoge Bautheodolite

Die Fernrohrvergrößerung ist bei diesen Instrumenten $15 \cdots 25$fach, die Angabe der Querlibelle $30 \cdots 60''$, die der Dosenlibelle $8 \cdots 10'$. Der Horizontalkreis hat einen Durchmesser von $50 \cdots 100$ mm, der Vertikalkreis einen solchen von $46 \cdots 75$ mm. Die Kreise bestehen aus Metall oder Glas. Die Schätzgenauigkeit beträgt für den Horizontalkreis und für den Vertikalkreis 1 mgon bis 2 cgon. Die zu erwartende Standardabweichung für eine einmal in beiden Fernrohrlagen gemessene Richtung ist ± 6 mgon.

b) Digitale Bautheodolite (11.36, 11.38)

Über ein elektronisches Kreisabtastsystem werden die Winkelwerte automatisch ermittelt und digital angezeigt. Die Fernrohrvergrößerung ist 30fach. In das angeschlossene Registriergerät (elektronisches Feldbuch) können die Daten übertragen und gespeichert werden. Die Standardabweichung für eine einmal in beiden Fernrohrlagen gemessene Richtung ist ± 2 mgon.

11.6.2 Ingenieurtheodolite (Theodolite mittlerer Genauigkeit)

Diese Instrumente sind für alle vermessungstechnischen Ingenieuraufgaben über und unter Tage einzusetzen, wie Polygonierungen, Triangulationen III. und IV. Ordnung, topographische Aufnahmen, Straßen-, Eisenbahn- und Flussvermessungen. Absteckungen im Hoch und Tiefbau: Hallen- und Fabrikbauten, Kanal-, Hafen-, Kraftwerk-, Stollenbau, Bau von Staumauern und -dämmen, Elektrizitätsversorgung, Kanalisation; Beschaffung von Planunterlagen für Bauprojekte, Profilaufnahmen, Massenbestimmungen von Aushub und Auftrag usw.

a)

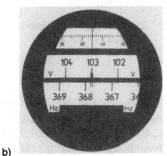

b)

11.38 Digitaler Ingenieur- und Bautheo-
dolit ETh 50 (Trimble/Zeiss)

11.37 a) Ingenieur-Theodolit TEAUT
(Breithaupt)
Befestigung: Grundplatte mit
Federplatte.
Autom. Höhenindex
Ablesung: Strichmikroskop
mit opt. Mikrometer
b) Gesichtsfeld des Ablese-
mikroskops TEAUT
Ablesung: V 103,348 gon

Die Ingenieurtheodolite sind moderne Instrumente für fast alle Arbeitsgebiete in den
Fachbereichen Architektur, Bauingenieur- und Vermessungswesen, deren herausragende
Eigenschaften die einfache und schnelle Aufstellung, die ungestörte Instrumentenzentrie-
rung durch das optische Lot, die umschaltfreie Grob-Fein-Fokussierung und damit die
volle Ausnutzung der Bildqualität und die vereinfachte Zenitwinkelmessung durch den
automatischen Höhenindex sind.

11.39 Digitaler Ingenieur-Theodo-
lit T1100/T1800 (Leica)

a) Analoge Ingenieurtheodolite (11.37)

Die Fernrohrvergrößerung ist $20 \cdots 32$fach, die Angabe der Querlibelle $20 \cdots 45''$, der Durchmesser des Horizontalkreises beträgt $50 \cdots 98\,\text{mm}$, der des Vertikalkreises $50 \cdots 86\,\text{mm}$. Die Kreise bestehen vorwiegend aus Glas; die Ablesegenauigkeit liegt meistens zwischen $1\,\text{mgon}$ und $2\,\text{mgon}$. Die Standardabweichung für eine einmal in beiden Fernrohrlagen gemessene Richtung ist $\pm 1,5\,\text{mgon}$.

b) Digitale Ingenieurtheodolite (11.38, 11.39)

Wie bei den digitalen Bautheodoliten werden auch hier die Winkelwerte automatisch über ein elektronisches Kreisabtastsystem ermittelt und digital angezeigt. Die Fernrohrvergrößerung ist $30 \cdots 32$fach. Die Daten können automatisch in ein Registriergerät (elektronisches Feldbuch) übertragen und gespeichert werden. Die zu erwartende Standardabweichung für eine einmal in beiden Fernrohrlagen gemessenen Richtung ist $\pm 0,6\,\text{mgon}$.

11.6.3 Feinmesstheodolite (Theodolite hoher Genauigkeit)

Mit einer Schätzgenauigkeit bis zu $0,1\,\text{mgon}$ werden sie bei Triangulationen höherer Ordnung, optischer Entfernungsmessung mittels Basislatte, astronomischen Abschlussmessungen, Justierungen im Werkzeugmaschinenbau, Ingenieuraufgaben hoher Genauigkeit, Setzungsbeobachtungen an Brücken, Hochbauten, Staumauern usw. eingesetzt.

11.40 Digitaler Feinmesstheodolit ETh 2
(Zeiss)

Die Feinmesstheodolite sind Präzisionsinstrumente, bei denen die Teilkreisablesung der analogen Instrumente meistens digitalisiert ist und so weitgehend Ablesefehler ausgeschaltet werden. Weitere Vorteile sind die Koinzidenzeinstellung der Teilkreisstriche, das optische Lot zur Instrumentenzentrierung, die hohe Qualität des apochromatischen Fernrohrs und damit die genaue Erfassung des Zieles, der automatische Höhenindex und damit die vereinfachte Zenitwinkelmessung, die funktions- und griffgerechte Anordnung der Bedienungselemente für einen zügigen und bequemen Ablauf der Messung.

a) Analoge Feinmesstheodolite

Die Fernrohrvergrößerung ist bei diesen Instrumenten $30 \cdots 32$fach, die Angabe der Querlibelle $20''$, der Durchmesser des Horizontalkreises beträgt $80 \cdots 100\,mm$, der des Vertikalkreises $70 \cdots 86\,mm$. Die Feinmesstheodolite besitzen einen verstellbaren Teilkreis. Die Standardabweichung für eine einmal in beiden Fernrohrlagen gemessene Richtung ist $\pm 0{,}3$ bis $0{,}4\,mgon$.

b) Digitale Feinmesstheodolite (**11.40, 11.**41)

Sie verfügen über ein Kreisabgriffsystem mit elektronischer Abtastung hoher Präzision; die digitale Angabe der Winkel erfolgt auf 4 Dezimalstellen. Die Standardabweichung einer in zwei Fernrohrlagen gemessenen und gemittelten Richtung beträgt $\pm 0{,}15\,mgon$.

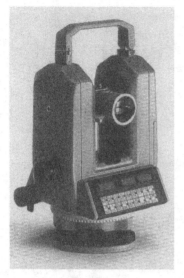

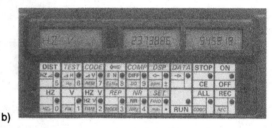

a) b)

11.41 a) elektronischer Feinmesstheodolit T2002 (Leica). Automatische Kompensation aller Achsfelder. Anzeige der Winkel digital
b) Bedienungspanel und Anzeigefenster des T 2002
Ablesung: *H* 237,3886 gon *V* 94,5919 gon

Die Fernrohrvergrößerung ist 32fach. Nach dem Baukastenprinzip lassen sich um diese Instrumente weitere Geräte gruppieren, so dass ein universelles Mess- und Registriersystem entsteht.

11.7 Sonderzubehör

Um das Messen mit dem Theodolit zu erleichtern, gibt es für Nachtbeobachtungen eine elektrische Beleuchtung und eine aufsteckbare Beleuchtung für das Strichkreuz. Okularprismen werden bei steilen Sichten auf das Fernrohr und das Ablesemikroskop aufgesetzt.

Eine aufsetzbare Bussole (Kreis- oder Röhrenbussole) verwendet man beim Messen von Bussolenzügen.

Eine Zwangszentrierung schaltet Zentrierfehler aus. Sie besteht aus Zieltafeln (**11.42**), die gegen den Theodolit ausgetauscht werden können. Der Theodolit wird von seinem Dreifuß gelöst und die Zieltafel mit dem Steckzapfen (DIN 18719) in den auf dem Stativ verbliebenen Dreifuß eingefügt. Bei dem Zentrierstativ sitzt die Zieltafel direkt auf dem Stativkopf. Die Zielpunkte sind dann nicht mehr mit einem Fluchtstab, sondern mit einem Stativ mit Zieltafel gekennzeichnet. Eine Zieltafel in Verbindung mit einem Reflektor (Prisma) dient zum gleichzeitigen Messen der Entfernung mit einem elektronischen Tachymeter.

11.42 Zieltafel mit Steckzapfen
(DIN 18719) auf Dreifuß
für Klauensysteme (Zeiss)

11.43 Pfeileraufsatz (Zeiss)

Für genaueste Messungen wird als Instrumentenstandpunkt anstelle des Stativs ein gemauerter Pfeiler verwendet, auf den ein Pfeileraufsatz (**11.43**) montiert wird, der das Instrument aufnimmt.

11.8 Prüfen und Berichtigen des Theodolits

Die in Bild **11**.44 dargestellten vier Achsen, die

Vertikalachse (Stehachse) VV
Libellenachse LL
Ziellinie (Kollimationsachse) ZZ
Kippachse (Horizontalachse) KK

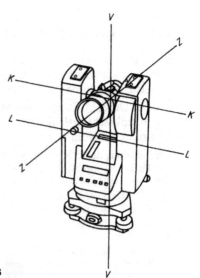

11.44 Achsen des Theodolits

sollen untereinander in bestimmten Beziehungen stehen. Dabei werden folgende Bedingungen an einen messbereiten Theodolit gestellt:

1. im Fernrohr und im Ablesemikroskop dürfen keine Parallaxen vorhanden und der Vertikalstrich des Strichkreuzes muss vertikal sein

2. $V \perp L$, die Stehachse soll senkrecht zur Libellenachse stehen (Senkrechtstellen der Stehachse)

3. $Z \perp K$, die Ziellinie soll senkrecht zur Kippachse stehen (Beseitigen des Ziellinienfehlers)

4. $K \perp V$, die Kippachse soll senkrecht zur Stehachse stehen (Beseitigen des Kippachsenfehlers)

5. die Achse des starren bzw. des optischen Lotes soll mit der Stehachse zusammenfallen

6. der Indexfehler soll beseitigt sein.

11.8.1 Beseitigen der Parallaxe und Vertikalstellen des Strichkreuzes

Das vom Objektiv erzeugte Bild muss in der Ebene des Strichkreuzes liegen. Um dies zu überprüfen, zielt man mit dem Fernrohr auf einen hellen Hintergrund und stellt das Strichkreuz durch Drehen des Okularringes scharf ein. Man dreht den Okularring von plus nach minus und zwar nicht zu weit in negativer Richtung, um ein Ermüden der Augen zu vermeiden. Sodann wird das Bild durch Drehen des Fokussierknopfes scharf eingestellt. Beim Bewegen des Auges vor dem Okular muss das Strichkreuz auf demselben Bildpunkt bleiben. Ist das nicht der Fall, liegt eine Parallaxe vor und der Vorgang ist zu wiederholen.

Zur Überprüfung der Vertikalstellung des Strichkreuzes zielt man bei horizontiertem Instrument einen Punkt an einem Ende des Vertikalstriches an und kippt das Fernrohr. Der Punkt muss auf dem Vertikalstrich bleiben. Wandert er aus, so ist das Strichkreuz so weit zu drehen, bis diese Forderung erfüllt ist.

11.8.2 Senkrechtstellen der Stehachse, $V \perp L$ (Justieren der Horizontierlibelle)

Wenn die Stehachse nicht senkrecht steht, handelt es sich um einen Aufstellfehler; es ist kein Instrumentenfehler. Das scharfe Senkrechtstellen der Stehachse geschieht durch Libellen, also durch die Horizontierung.

Mit der Dosenlibelle kann die Stehachse grob, mit der Röhrenlibelle (Horizontierlibelle) genau senkrecht gestellt werden. Dies gilt jedoch nur, wenn die Libellen justiert oder ihre Spielpunkte bestimmt sind.

Zur Justierung der Röhrenlibelle (Horizontierlibelle) stellt man diese parallel zu zwei Fußschrauben und lässt sie einspielen. Die Libellenblase folgt hierbei dem Zeigefinger der rechten Hand. Die Alhidade wird dann um 100 gon gedreht und die Libelle mit der dritten Fußschraube zum Einspielen gebracht. Die erste Stellung der Libelle parallel zu zwei Fußschrauben wird noch einmal überprüft und die Alhidade um 200 gon gedreht. Ein sich zeigender Ausschlag der Libellenblase ist zur Hälfte mit den Fußschrauben, zur Hälfte mit den Libellenjustierschrauben zu beseitigen. Der Vorgang ist zu wiederholen.

Der Libellenausschlag nach Drehen der Alhidade um 200 gon gibt den doppelten Fehler an, um den die Stehachse schief steht. Nachdem der halbe Ausschlag mit den Fußschrauben beseitigt ist, steht die Libelle im Spielpunkt. Wird die Alhidade um 100 gon weitergedreht und die Libellenblase mit der

dritten Fußschraube in den Spielpunkt gebracht, so steht die Stehachse senkrecht. Beim Beseitigen der zweiten Hälfte des Libellenausschlags mit den Libellenjustierschrauben wird der Spielpunkt der Libelle in die Mitte der Libellenteilung verschoben.

Die Dosenlibelle wird bei der Prüfung der Horizontierlibelle mitgeprüft. Wenn die Horizontierlibelle in allen Richtungen einspielt, muss auch die Dosenlibelle einspielen. Ein eventueller Ausschlag ist ganz mit den Justierschrauben der Dosenlibelle zu beseitigen. Dasselbe gilt für die Kreuzlibelle.

Die Schiefe der Stehachse kann durch keine Messungsanordnung eliminiert werden. Auf eine gute Horizontierung des Instrumentes, besonders bei steilen Zielen, ist deshalb zu achten.

11.8.3 Beseitigen des Ziellinienfehlers, $Z \perp K$ (Justieren der Ziellinie)

Die Ziellinie soll senkrecht zur Kippachse sein. In diesem Fall liegt die Ziellinie beim Kippen des Fernrohrs in einer Ebene. Die Prüfung kann auf verschiedenen Wegen geschehen:

1. Durch Verstellen des Teilkreises um 200 gon

Ein $\approx 100\,\text{m}$ entfernter, in Höhe des Instrumentes liegender Punkt A wird angezielt, der Horizontalwinkel abgelesen und die Alhidade genau um 200 gon gedreht, so daß Punkt A' im Gesichtsfeld erscheinen würde (**11.45**). Das Fernrohr wird nun durchgeschlagen. Erscheint jetzt anstelle von A der Punkt A'' im Gesichtsfeld, so ist der Winkel $A I A''$ der doppelte Ziellinienfehler. Das Mittel von $A A''$ ergibt Punkt B, auf den das Strichkreuz mit den horizontal wirkenden Justierschrauben verschoben wird. Die Justierschrauben des Strichkreuzes werden nach Abschrauben einer Schutzkappe am Okularkopf zugänglich.

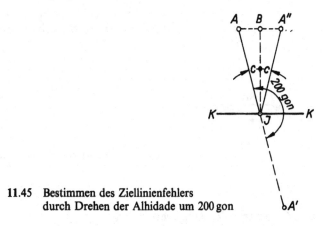

11.45 Bestimmen des Ziellinienfehlers
 durch Drehen der Alhidade um 200 gon

2. Durch Winkelmessung

Ein in Höhe des Instrumentes liegender Punkt A wird angezielt, am Horizontalkreis r_1 abgelesen, das Fernrohr durchgeschlagen, Punkt A erneut angezielt und am Teilkreis r_2 abgelesen. Es müsste $r_2 = r_1 \pm 200\,\text{gon}$ sein.

Ist das nicht der Fall, wird das Mittel $1/2\,(r_2 + r_1 \pm 200\,\text{gon})$ am Horizontalkreis eingestellt und das Strichkreuz mit den Justierschrauben in das Ziel gebracht.

Bei elektronischen Theodoliten wird die Ziellinienverbesserung ebenfalls durch Messung in zwei Fernrohrlagen nach einem gut sichtbaren Ziel in Höhe des Instrumentes bestimmt, gespeichert und vielfach bei den Folgemessungen jeweils auch automatisch berücksich-

tigt. Voraussetzung ist jedoch, dass der Ziellinienfehler eine bestimmte Größe – meistens 0,05 gon – nicht übersteigt. Ist dies der Fall, ist das Strichkreuz des Fernrohrs manuell, wie zuvor beschrieben, zu justieren.

Allgemein gilt:

Man kann mit einem Theodolit, dessen Ziellinienfehler nicht beseitigt ist, durch Beobachtung in zwei Fernrohrlagen fehlerfrei messen.

11.8.4 Beseitigen des Kippachsenfehlers, $K \perp V$ (Justieren der Kippachslager)

Die Kippachslager der neueren Theodolite sind so genau gefertigt, dass dieser Fehler kaum noch auftritt. Bei diesen Instrumenten sind keine Justiervorrichtungen für die Kippachse mehr vorhanden; ein Kippachsenfehler könnte nur von der Herstellerfirma beseitigt werden. Er wird wie der Ziellinienfehler beim Messen in zwei Fernrohrlagen eliminiert. Es folgt deshalb nur eine Methode zur Feststellung des Kippachsenfehlers.

Nach Beseitigen des Ziellinienfehlers liegt die Ziellinie beim Kippen des Fernrohrs in einer Ebene; diese soll jetzt senkrecht stehen. Um das zu erreichen, wird ein hochgelegener Punkt in beiden Fernrohrlagen auf einen in Höhe des Instrumentes angebrachten Maßstab herabgelotet und l_1 und l_2 abgelesen (11.46). Decken sich l_1 und l_2, so liegt die Ziellinie in einer Vertikalebene, sonst ist $l_2 - l_1$ der doppelte Kippachsenfehler. Man beseitigt ihn (nur noch bei älteren Instrumenten möglich), indem man den Mittelwert $\frac{l_1 + l_2}{2}$ auf dem Maßstab einstellt, das Fernrohr nach oben kippt und das mit Justierschrauben versehene Kippachslager hebt oder senkt, bis sich Strichkreuz und Zielpunkt decken.

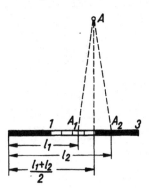

11.46 Bestimmen des Kippachsenfehlers

11.8.5 Justieren der Ablotevorrichtung

Zur Prüfung eines starren Lotes (11.15) wird die Dosenlibelle des Lotes über den Horizont gedreht. Der größte Ausschlag ist der doppelte Fehler. Die eine Hälfte wird durch Verschieben des Instrumentes auf dem Stativteller (womit der Spielpunkt der Libelle gefunden ist), die zweite Hälfte über die Libellenjustierschrauben beseitigt.

Die Überprüfung des mit dem Theodolit verbundenen optischen Lotes (11.16) und des auswechselbaren optischen Lotes (11.17) ist gleich. Das optische Lot soll so justiert sein, dass beim Drehen die Kreismarke (Strichkreuz) des Lotes mit dem Zentrierpunkt stets zusammenfällt.

Um dies zu prüfen, markiert man bei horizontiertem Theodolit (horizontiertem Lot) die Kreismarke (Strichkreuz) des Lotes auf ein Stück Papier, das auf den Boden gelegt wurde. Nun wird dieser Punkt beim Drehen des Instrumentes (Lotes) über den ganzen Horizont beobachtet. Die Stelle des größten Ausschlags gibt den doppelten Fehler des optischen Lotes an. Der halbe Ausschlag wird mit den Justierschrauben für das optische Lot oder durch Verstellen seines Objektivs beseitigt. Das Instrument ist neu zu zentrieren und der Vorgang zu wiederholen. Die Justierung ist bei den einzelnen Instrumenten verschieden. Man beachte die dem Instrument beigegebene Bedienungsanweisung.

Man kann auch mit nicht justierter Ziellinie des optischen Lotes richtig zentrieren. Die Kreismarke (Strichkreuz) muss dann beim Drehen des Instrumentes immer gleich weit von dem heraufzulotenden Punkt sein.

11.8.6 Beseitigen des Indexfehlers

Zwei Forderungen werden gestellt (**11.**47):

a) Die Projektion der Ziellinie in die Ebene des Vertikalkreises soll mit der Verbindungslinie 100 gon/300 gon des Teilkreises zusammenfallen.

b) Die Libellenachse soll parallel zum Halbmesser des Höhenkreises durch die Ablesemarke verlaufen. Bei zwei diametralen Ablesestellen ist es der Durchmesser.

Ist dies nicht der Fall, so entsteht bei a) ein Winkel δ_1, bei b) ein Winkel δ_2. Beide zusammen ergeben den Indexfehler oder die Indexkorrektion k_z [1]).

$$k_z = \delta_1 + \delta_2$$

Wenn die für die Vertikalwinkelmessung angebrachte Röhrenlibelle (Höhenindexlibelle oder Fernrohrlibelle) vor jeder Ablesung einspielt, ist der Mittelwert aus den Vertikalkreisablesungen in beiden Fernrohrlagen frei vom Indexfehler. Man beseitigt den Indexfehler möglichst. Dies ist vor allem beim Messen der Vertikalwinkel in nur einer Fernrohrlage (z. B. bei der Tachymeteraufnahme) zweckmäßig, da sonst an jede Ablesung die Indexkorrektion angebracht werden müsste.

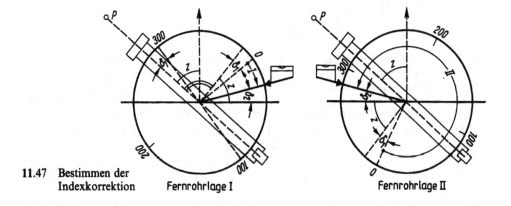

11.47 Bestimmen der
 Indexkorrektion Fernrohrlage I Fernrohrlage II

[1]) Die Korrektion hat den gleichen absoluten Zahlenwert wie der Fehler, aber das entgegengesetzte Vorzeichen.

Die meisten Theodolite sind mit einer Höhenindexlibelle oder mit einem automatischen Höhenindex ausgerüstet. Um auch einfache Nivellements ausführen zu können, kann zusätzlich eine Fernrohrlibelle vorhanden sein; sie kann bei einfachen Theodoliten zum Messen der Vertikalwinkel dienen.

Die Untersuchungen sind für die einzelnen Libellen verschieden.

1. Prüfen und Berichtigen über die Höhenindexlibelle

Zur Bestimmung der Indexkorrektion wird ein entfernter, scharf markierter Punkt in beiden Fernrohrlagen angezielt. Die Ablesungen sind I und II. Nach Bild **11.**47 findet man dann den Zenitwinkel

$$\text{Lage I} \qquad z = \text{I} + \delta_1 + \delta_2 = \text{I} + k_z$$
$$\text{Lage II} \qquad z = 400 - (\text{II} + \delta_1 + \delta_2) = 400 - (\text{II} + k_z)$$

Hieraus ergibt sich die Indexkorrektion k_z

$$\text{I} + k_z = 400 - \text{II} - k_z$$
$$2k_z = 400 - (\text{I} + \text{II})$$
$$k_z = \frac{400 - (\text{I} + \text{II})}{2} = 200 - \frac{\text{I} + \text{II}}{2}$$

Die fehlerfreien Ablesungen sind $\text{I} + k_z$ und $\text{II} + k_z$. Man kann auch die fehlerfreie Sollablesung der Lage I aus der Summe der Zenitwinkel z in Lage I und II einfach bestimmen

$$\text{Soll I} = \frac{1}{2}(\text{I} + 400 - \text{II})$$

Beispiel.

Ablesung I	97,345 gon
	+ 400,000 gon
	497,345 gon
Ablesung II	− 302,623 gon
	194,722 gon
Sollwert I	97,361 gon

Der Sollwert wird bei angezieltem Punkt P am Vertikalkreis mittels Höhenindextrieb (Feinstellschraube der Höhenindexlibelle) eingestellt. Bei Theodoliten mit Mikrometer geschieht dies durch Einstellen der Zenti- und Milligon mit dem Mikrometer und Wiederherstellen der verlorengegangenen Koinzidenz der Hauptteilung mit dem Höhenindextrieb. Der Ausschlag der Höhenindexlibelle wird ganz mit den Libellenjustierschrauben beseitigt. Der Vorgang ist zu wiederholen.

Bei Theodoliten mit automatischem Höhenindex tritt auch ein Indexfehler auf, der beseitigt werden kann. Die Feststellung der Indexkorrektion geschieht in der angegebenen Form. Die Beseitigung ist bei den einzelnen Instrumenten verschieden, zum Teil kann sie nur in der Werkstatt erfolgen. Man beachte die den Instrumenten beigegebene Justieranweisung.

Ein Beispiel sei angeführt: Bei dem Fennel-Theodolit FT 1 A wird nach Bilden der Summe der Vertikalkreisablesungen in beiden Fernrohrlagen und Verbessern der Ablesung in Fernrohrlage I um den halben Widerspruch gegen 400 gon der Sollwert

mittels der Höhenfeinstellschraube im Mikroskop eingestellt. Dann wird das Strichkreuz mit den vertikal wirkenden Justierschrauben ins Ziel gebracht.

2. Prüfen und Berichtigen über die Fernrohrlibelle

Zunächst muss die Ziellinie parallel der Libellenachse sein. Bei einer vorhandenen Wendelibelle wird eine $\approx 50\,\text{m}$ entfernte Nivellierlatte in beiden Fernrohrlagen bei einspielender Libelle abgelesen. Das Strichkreuz ist auf den Mittelwert einzustellen und die Libelle mit ihren Justierschrauben zum Einspielen zu bringen. Ist nur eine einfache Libelle vorhanden, so wird die Forderung wie beim Nivellierinstrument durch Nivellieren aus der Mitte untersucht.

Wenn die Fernrohrlibelle bei einfachen Theodoliten auch zum Messen der Vertikalwinkel verwendet wird, sollte bei einspielender Libelle an der Ablesemarke des Vertikalkreises 0 gon bzw. 100 gon abgelesen werden. Das wird erreicht, indem die Ablesemarke mit ihren Justierschrauben auf die Nullstellung des Vertikalkreises gebracht wird.

11.8.7 Weitere, nicht justierbare Fehler des Theodolits

Es sind dies die Alhidadenexzentrizität, die Zeigerknickung und die Kreisteilungsfehler.

Eine Alhidadenexzentrizität liegt vor, wenn der Drehpunkt der Alhidade A nicht mit dem Mittelpunkt des Horizontalkreises B zusammenfällt (**11.48**). Die gegenüberliegenden Ablesestellen zeigen in ihrer Ausgangsstellung auf 0 gon bzw. 200 gon. Nach einer Drehung um 100 gon ergeben die Zeigerablesungen nicht 100 gon bzw. 300 gon, sondern Z_1 bzw. Z_2. Der Zeiger 1 gibt einen um a zu kleinen, der Zeiger 2 einen um a zu großen Wert an. Die Mittelbildung aus beiden Ablesungen ist frei von dem Exzentrizitätsfehler. Der Einfluss der Exzentrizität ist in der Richtung BA gleich null, senkrecht dazu am größten; er kann eine Messung erheblich beeinflussen.

Nach Bild **11.48** ist

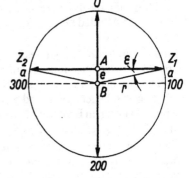

$$\varepsilon = \frac{e}{r}\ \text{rad}$$

Bei modernen Theodoliten wird die Exzentrizität kleiner als $1\,\mu$ sein. Für $e = 1\,\mu$ und einem Teilkreisdurchmesser von 90 mm ($r = 45\,\text{mm}$) wäre

$$\varepsilon = \frac{0,001}{45} \cdot 63,7 = 0,0014\,\text{gon} = 1,4\,\text{mgon}$$

Der Fehler der Alhidadenexzentrizität wird durch Ablesen an zwei Zeigern eliminiert. Bei Instrumenten

11.48 Alhidadenexzentrizität

mit nur einer Ablesestelle wird die Exzentrizität durch Messen in zwei Fernrohrlagen unschädlich gemacht.

Eine Zeigerknickung kann bei Instrumenten mit zwei Ablesestellen auftreten, wenn die Ablesestellen sich nicht genau gegenüberliegen. Der Fehler ist konstant, er wird durch Messen in zwei Fernrohrlagen eliminiert.

Die Teilkreise der Theodolite werden mittels Teilkreismaschinen sehr genau aufgetragen. Etwaige Kreisteilungsfehler versucht man auszuschalten, indem die Ablesungen für einen Zielpunkt an verschiedenen, gleichmäßig über den Kreis verteilten Stellen erfolgen.

11.8.8 Automatische Kompensation der Fehler bei digitalen Theodoliten

Eine hervorragende Eigenschaft der digitalen Theodolite mit Zweiachsenkompensator ist die Erfassung der Stehachsneigung in Ziel- und Kippachsrichtung. Hieraus werden über den Mikroprozessor die Korrekturwerte für die Horizontal- und Vertikalkreisablesungen berechnet und automatisch berücksichtigt.

Die Indexkorrektion wird aus einem in beiden Fernrohrlagen angezielten Punkt ermittelt, im Theodolit gespeichert und automatisch bei der Winkelmessung berücksichtigt, auch wenn diese nur in einer Fernrohrlage erfolgt.

11.9 Behandlung und Pflege des Theodolits

Der Theodolit ist ein optisches Präzisionsinstrument; er ist pfleglich zu behandeln. Ältere Instrumente sind in Holzkästen, die neueren Instrumente vielfach in Metallhauben verpackt. Beim Transport soll der Theodolit keinen Erschütterungen ausgesetzt werden, damit die Justierungen erhalten bleiben.

Vor dem Auspacken sollte man sich merken, wie das Instrument im Kasten liegt bzw. wie es auf der Bodenplatte der Haube befestigt ist. In derselben Lage wird es später wieder eingepackt. Auf keinen Fall darf der Kasten oder die Haube mit Gewalt geschlossen werden. Klemmt etwas, so ist das Instrument nicht richtig verpackt.

Beim Herausnehmen aus dem Behälter wird der Theodolit mit beiden Händen an den Fernrohrträgern angefasst, sofern nicht ein Tragegriff vorhanden ist. Beim Befestigen auf dem Stativ hält die linke Hand das Instrument, die rechte bedient die Anzugschraube. Das Drehen der Alhidade erfolgt durch sanften Druck auf die Fernrohrträger, nicht auf das Fernrohr.

Ein auf dem Stativ befestigtes Instrument wird so getragen, dass die Stehachse ungefähr lotrecht ist. Der Theodolit ist vor Regen, Schnee, Staub und starker Sonneneinstrahlung zu schützen. Eine Plastikhaube bietet dem aufgebauten Instrument an seinem Standort Schutz gegen Feuchtigkeit und Staub. Ein nass gewordenes Instrument darf nie länger als unbedingt nötig im Behälter bleiben; erst wenn es vollkommen trocken ist, darf der Kasten oder die Haube geschlossen werden.

Die Fußschrauben sollen einen satten Gang haben; sie sind von Zeit zu Zeit zu überprüfen und der Gang der Schrauben mit den dazu vorgesehenen Vorrichtungen zu regulieren.

Beim Einsatz digitaler Theodolite Aufladen der Batterien nicht versäumen.

In jedem Fall sind die den Instrumenten beigefügten Bedienungsanleitungen zu beachten.

12 Winkelmessung

Der Theodolit wird vor der Winkelmessung auf die in Abschn. 11.8 gestellten Forderungen überprüft. Um instrumentelle Restfehler zu eliminieren, beobachtet man in zwei Fernrohrlagen. Eine Ausnahme bildet die Winkelmessung bei der Tachymeteraufnahme in einer Fernrohrlage.

12.1 Zentrieren und Horizontieren

Die Winkelmessung erfolgt im Scheitelpunkt des Winkels, über dem der Theodolit zentrisch aufzustellen und zu horizontieren ist. Das Zentrieren des Instrumentes erfolgt mit einem Schnurlot oder mit einem optischen Lot. Das starre Lot (Zentrierstock) wird selten verwendet.

Das Stativ des Instrumentes wird nach Augenmaß grob über dem Bodenpunkt aufgestellt. Die Stativbeine werden bei weichem Untergrund fest in den Boden eingetreten.

Beim Zentrieren mit dem Schnurlot wird dieses mit einem Laufknoten am Lothaken befestigt. Durch Verschieben des Dreifußes auf der Stativplatte wird das Instrument zentriert (Lot genau über Bodenpunkt) und anschließend mit Hilfe der Röhrenlibellen horizontiert. Dabei wird die Röhrenlibelle wie in 11.8.2 beschrieben, parallel zu zwei Fußschrauben gestellt und zum Einspielen gebracht. Dann wird die Libelle um 100 gon gedreht und mit der dritten Fußschraube zum Einspielen gebracht. Der Vorgang ist zu wiederholen.

Beim Zentrieren eines Instrumentes mit eingebautem optischen Lot erfolgt zunächst eine Grobzentrierung mit einem Schnurlot. Dann bringt man das Strichkreuz des optischen Lotes durch Drehen der Fußschrauben mit dem Bodenpunkt zur Deckung. Nun wird das Instrument mittels Dosenlibelle durch Verändern der Stativbeinhöhen grob und schließlich mit der Röhrenlibelle und den Fußschrauben fein horizontiert. Die Zentrierung ist zu überprüfen und evtl. durch Verschieben des Instrumentes auf dem Stativteller zu berichtigen. Der Vorgang ist zu wiederholen.

12.2 Einstellen des Fernrohrs auf das Ziel

Das Fernrohr wird im Uhrzeigersinn gedreht, bis es nach Augenmaß ungefähr auf das Ziel zeigt. Dann sucht man mit der auf dem Fernrohr befindlichen Visiereinrichtung das Ziel auf und zieht die Klemmen an. Mit der Fokussierschraube wird das Bild scharf eingestellt und mit dem Seiten- und mit dem Höhen-

12.1 Anzielen eines Fluchtstabes mit dem Theodolit

feintrieb das Ziel mit dem Strickkreuz zur Deckung gebracht. Fluchtstäbe sind möglichst tief anzuzielen (12.1), da ein schief stehender Fluchtstab, dessen oberes Ende als Ziel gewählt wird, einen Zentrierfehler bewirkt.

12.3 Horizontalwinkel

Ein Winkel hat zwei Schenkel; jeder dieser Schenkel ist örtlich durch den Theodolitstandpunkt und ein Ziel gegeben. Von einem Standpunkt können auch mehr als zwei Ziele (Richtungen) beobachtet und zu einem Richtungssatz zusammengefasst werden, z.B. bei der Triangulation oder wenn mehrere Polygonzüge auf einem Punkt enden.

Man unterscheidet

1. die einfache Winkelmessung

 a) in einer Fernrohrlage, z.B. bei der Tachymeteraufnahme (ein Halbsatz)
 b) in beiden Fernrohrlagen ohne Verstellen des Teilkreises (ein voller Satz)
 c) in beiden Fernrohrlagen mit Verstellen des Teilkreises (zwei Halbsätze)
2. die Repetitionswinkelmessung
3. die Richtungsbeobachtung (zu mehr als zwei Zielen)

Es gibt noch die Winkelmessung in Sektoren, in allen Kombinationen und mit Horizontschluss, auf die im Rahmen dieses Buches nicht eingegangen wird.

12.3.1 Einfache Winkelmessung

Man liest den Winkelwert (Ablesemikroskop, Anzeigefenster) nach Einstellen der beiden Ziele jeweils ab und findet die Größe des Winkels aus der Differenz rechte minus linke Ablesung. Dies wird als Halbsatz bezeichnet. Bei der Tachymeteraufnahme werden von einem Standpunkt aus mehrere Ziele beobachtet.

Um die Restfehler des Theodolits auszuschalten, wird das Fernrohr durchgeschlagen und in der Lage II die Messung wiederholt, indem man jetzt zuerst das rechte und dann das linke Ziel beobachtet. Diese Beobachtung in beiden Fernrohrlagen ohne Verstellen des Teilkreises ist ein voller Satz. Er kann mehrere Ziele einschließen.

Beispiel: Einfache Winkelmessung mit einem Bautheodolit in beiden Fernrohrlagen ohne Verstellen des Teilkreises (ein voller Satz).

Tafel 12.2 Vordruck und Beispiel für einfache Winkelmessung (voller Satz)

Instrument: Wetter:
Datum: Gemessen durch:

1	2	3	4	5	6	7
Stand-punkt	Ziel-punkt	Ablesung		Winkel		
		Lage I gon	Lage II gon	Lage I gon	Lage II gon	Mittel gon
15	14	17,38	217,37			
	16	104,87	304,88	87,49	87,51	87,50

Sp. 1 gibt den Theodolitstandpunkt, Sp. 2 die Zielpunkte an. In Sp. 3 sind die Ablesungen in Fernrohrlage I von oben nach unten eingetragen. Nach Durchschlagen des Fernrohrs werden die Ziele in umgekehrter Reihenfolge beobachtet und die Ablesungen in Sp. 4 von unten nach oben vermerkt. Sp. 5 gibt den Winkel als Differenz der Ablesungen von Sp. 3, Sp. 6 die Differenz der Sp. 4 an. Das Mittel aus den Spalten 5 und 6 ergibt den Winkel in Sp. 7.

Die Winkelmessung kann auf demselben Punkt wiederholt werden. Um eventuellen Kreisteilungsfehlern entgegenzuwirken, werden dann die Ablesungen gleichmäßig über den Horizont verteilt. Bei n-Sätzen wird der Teilkreis jeweils um zwei Rechte dividiert durch n verstellt. Bei dreifacher Messung wäre in dem Beispiel der Teilkreis jeweils um etwa $200/3 \approx 66$ gon zu verstellen.

Beispiel: Winkelmessung mit einem Ingenieurtheodolit in beiden Fernrohrlagen mit Verstellen des Teilkreises (2 Halbsätze).

Dies ist eine wichtige Messungsanordnung, die man z. B. bei der Polygonwinkelmessung anwendet. Die Winkel werden auf mgon in den Vordruck eingetragen.

Tafel **12**.3 Vordruck und Beispiel für Winkelmessung in 2 Halbsätzen

| Instrument: | | | | Wetter: sonnig, gute Sicht | | |
| Datum: | | | | Gemessen durch: NN | | |

1	2	3	4	5	6	7
Stand-punkt	Ziel-punkt	Ablesung Lage I gon	Ablesung Lage II gon	Lage I reduziert gon	Lage II reduziert gon	Satzmittel gon
A	B	125,148	328,662	0,000	0,000	0,000
	1	236,091	39,607	110,943	110,945	110,944
	25	378,795	182,310	253,647	253,648	253,6475
	C	19,870	223,383	294,722	294,721	294,7215
1	A	186,664	382,172	0,000	0,000	0,000
	2	394,549	190,059	207,885	207,887	207,886
		117	193			199
		310				

$$2 \cdot 199 = 398$$
$$+4\,(148 + 662) = 240$$
$$+2\,(664 + 172) = 672 \Big\} \text{ (volle Gon unberücksichtigt lassen)}$$
$$\overline{310}$$

Um sich gegen grobe Fehler zu sichern, verstellt man den Teilkreis nach dem Beobachten in der ersten Lage um $1 \cdots 4$ gon. Durch die Messung in zwei Lagen werden der Ziellinienfehler, der Kippachsenfehler und die Alhidadenexzentrizität eliminiert.

Im Beispiel sind zwei Standpunkte behandelt. Auf dem Trigonometrischen Punkt A beginnen zwei Polygonzüge (12.4). Vier Ziele (B, 1, 25, C) wurden der Reihe nach in erster Fernrohrlage angezielt. Nach Ablesen des letzten Zieles C wird der Teilkreis um $1 \cdots 4$ gon verstellt, der Teilkreis mit der Alhidade festgeklemmt (mittels Alhidadenklemme oder Kreisklemme), die Limbusklemme gelöst und das letzte Ziel nochmals eingestellt. Nach Feststellen des Limbus und Lösen der Alhidade (mittels Alhidadenklemme oder Kreisklemme) wird das Fernrohr durchgeschlagen und der letzte

12.4 Winkelmessung in 2 Halbsätzen
(Anschluss von 2 Polygonzügen an
einen Trigonometrischen Punkt)

Punkt *C* erneut angezielt. Die Beobachtung erfolgt nun in der zweiten Fernrohrlage in rückläufiger Reihenfolge. Demnach werden die Winkel in Sp. 3 von oben nach unten, in Sp. 4 von unten nach oben eingetragen. In Sp. 5 sind die Ablesungen der Sp. 3 auf die Richtung des ersten Punktes reduziert, d. h., von jedem gemessenen Wert wurde die Ablesung des ersten Punktes substrahiert. Sp. 6 zeigt die reduzierten Richtungen der zweiten Fernrohrlage und Sp. 7 das Mittel aus 5 und 6.

Damit sind die Winkel *BA*1, *BA*25, *BAC* gefunden. Es werden also keine Einzelwinkel, sondern die Winkel gegen eine bestimmte Nullrichtung (hier *A B*) gerechnet. Auf Punkt 1 ist der Polygonwinkel *A*1−2 in derselben Messungsanordnung beobachtet.

Die Rechnung ist seitenweise durch Summenproben zu sichern:

$$[\text{Sp. 3}] + [\text{Sp. 4}] = 2 \cdot [\text{Sp. 7}] + s \cdot [\text{Nullrichtungen der Sp. 3 und Sp. 4}]$$

s = Anzahl der Ziele in einem Satz

12.3.2 Repetitions-Winkelmessung

Die Repetitions-Winkelmessung wird angewandt, wenn ein Winkel sehr genau bestimmt werden soll und die Ablesegenauigkeit des Instrumentes nicht ausreicht. Repetition nennt man die mechanische Addition desselben Winkels auf dem Teilkreis. Man kann jeweils nur einen einzelnen Winkel durch Repetitionsmessung bestimmen. Die Differenz zwischen Anfangs- und Endablesung dividiert man durch die Anzahl der Repetitionen und erhält so den Mittelwert. Man repetiert gewöhnlich 8 ··· 12mal, in jeder Fernrohrlage 4 ··· 6mal. Die 10malige Repetition ergibt die einfachste Rechnung.

Beispiel: Repetitions-Winkelmessung mit einem Ingenieurtheodolit mit Strichmikroskop und optischem Mikrometer (10malige Repetition).

Um die Messung zu vereinfachen, stellt man als Ausgangswert einen Winkel nahe Null ein und misst wie folgt:

Punkt 1 anzielen, ablesen (Tafel **12.**5 Sp. 4), Limbus fest, Alhidade lösen; Punkt 2 anzielen, grob ablesen (Wert in Klammern in Sp. 4), Alhidade fest, Limbus lösen und auf Ziel 1 zurückdrehen; Limbus fest, Alhidade lösen und Punkt 2 einstellen. Dieser Vorgang wird bei *n*-facher Repetition *n*/2mal wiederholt, im Beispiel 5mal. Dann wird Punkt 2 abgelesen (Sp. 4). Die Gonablesung nach 5maliger Repetition müsste eigentlich 430 gon lauten, da der Teilkreis über 400 gon gedreht wurde. Dies ist leicht aus der ersten Grobablesung abzuleiten; im Beispiel 5 · 86 gon = 430 gon.

Nun wird der Teilkreis um 1 ··· 4 gon und die Mikrometerskala um ihre halbe Länge verschoben, das Fernrohr durchgeschlagen, Punkt 2 angezielt und die gleiche Messung rückwärts ausgeführt (Sp. 6). In die Rechnung ist der Ausgangswert in Sp. 6 mit 634,954 einzuführen (430 + 5 + 200). Die beiden Ablesungen in Lage I und II werden in den Sp. 7 und 8 reduziert, addiert und durch *n* (im Beispiel *n* = 10) dividiert. Daraus findet man den genauen Winkel 1 *A* 2 mit 85,7404 gon (Sp. 9).

Tafel 12.5 Vordruck und Beispiel für Repetitions-Winkelmessung

| Instrument: | | | | | | Wetter: bedeckt, gute Sicht | | |
| Datum: | | | | | | Gemessen durch: NN | | |

1	2	3	4	5	6	7	8	9
Stand-punkt	Ziel-punkt	Anzahl Repet.	Ablesung Lage I gon	Anzahl Repet.	Ablesung Lage II gon	Lage I reduziert gon	Lage II reduziert gon	Winkel gon
A	1	0	1,783	5	206,251	0,000	0,000	0,0000
		1	(87,524)	1	(149,212)			
	2	5	30,484	0	234,954	428,701	428,703	85,7404
						857,404 : 10		

12.3.3 Richtungsbeobachtungen (Satzweise Winkelmessung)

Bei dieser Anordnung werden auf einem Punkt nach mehreren Zielen mehrere volle Sätze gemessen. In der zweiten Fernrohrlage sind die Ziele ohne Verstellen des Teilkreises in umgekehrter Reihenfolge zu beobachten. Hierbei ist bei besonderen Präzisionsmessungen die Drehung des Instrumentes im rechtsläufigen Sinn angebracht. Hiermit soll einer Pfeilerdrehung (Drehen der Unterlage des Theodolits) entgegengewirkt werden.

Beispiel: Richtungsbeobachtung mit einem Feinmesstheodolit in zwei vollen Sätzen.

In Tafel 12.6 Sp. 3 sind die Ablesungen der Fernrohrlage I von oben nach unten, in Sp. 4 die der Lage II von unten nach oben (Messung rückläufig) eingetragen. Der Teilkreis wurde nach dem 1. Satz um $\approx \dfrac{200 \, \text{gon}}{n} \approx \dfrac{200 \, \text{gon}}{2} \approx 100$ gon verstellt und der 2. Satz in gleicher Weise gemessen. In Sp. 5 ist das Mittel aus Lage I und II (Sp. 3 und 4) gebildet, wobei die vollen Gon der Sp. 3 übernommen werden. In Sp. 6 sind die Mittelwerte der Sp. 5 auf die erste Richtung als Nullrichtung reduziert. Sp. 7 weist das Mittel aus den Werten der Sp. 6 als endgültige Richtung aus. Es können auch mehr als 2 Sätze gemessen werden, um die Genauigkeit zu steigern. Die Rechnung wird für die auf einem Standpunkt zusammengefaßten Sätze verprobt.

$$[\text{Sp. 3} + \text{Sp. 4}] = 2n \, [\text{Sp. 7}] + s \, [\text{Nullrichtungen der Sp. 3 und 4}]$$

n = Anzahl der Sätze s = Anzahl der Ziele in einem Satz

Das Kriterium der Genauigkeit ist die Standardabweichung. Diese wird für eine beobachtete Richtung in einem Satz berechnet nach

$$s_{\text{r}} = \sqrt{\frac{[vv]}{(n-1)(s-1)}} \,{}^{1)} .$$

n = Anzahl der Sätze s = Anzahl der beobachteten Strahlen

[1] Auf die Ableitung kann hier nicht näher eingegangen werden. Näheres s. Großmann, W.: Grundzüge der Ausgleichsrechnung, 3. Aufl. Berlin–Göttingen–Heidelberg 1969.

Tafel **12.6** Vordruck und Beispiel für Richtungsbeobachtung (2 volle Sätze)

Instrument:					Wetter: leicht bedeckt, gute Sicht				
Datum:					Gemessen durch: NN				

1	2	3	4	5	6	7	8	9	10
Stand-punkt	Ziel-punkt	Ablesung Lage I	Ablesung Lage II	Mittel aus I und II	Mittel reduziert	Richtung endgültig	d Sp. 7 − Sp. 6	v $= d -$ $\frac{[d]}{s}$	vv
		gon	gon	gon	gon		mgon	mgon	
36	5	174,1807	374,1863	174,1835	0,0000	0,0000	0,0	+0,2	0,04
	17	304,1296	104,1346	304,1321	129,9486	129,9483	−0,3	−0,1	0,01
	12	18,0408	218,0460	18,0434	243,8599	243,8596	−0,3	−0,1	0,01
						$[d] =$	−0,6	0	
						$\frac{[d]}{s} =$	−0,2·		
36	5	268,7453	68,7400	268,7427	0,0000		0,0	−0,2	0,04
	17	398,6933	198,6880	398,6907	129,9480		+0,3	+0,1	0,01
	12	112,6043	312,5994	112,6019	243,8592		+0,4	+0,2	0,04
						$[d] =$	+0,7	+0,1	0,15
						$\frac{[d]}{s} =$	+0,2		
		3940 | 3943				8079			
		7883							

$$4 \cdot 8079 = 2316$$
$$3\,(1807 + 1863 + 7453 + 7400) = 5569 \quad \text{(volle Gon unberücksichtigt lassen)}$$
$$7885$$

und für eine aus allen Sätzen gemittelte Richtung

$$s_x = \frac{s_r}{\sqrt{n}}$$

[vv] bestimmt man folgendermaßen: Zunächst wird in Sp. 8 die Differenz d aus dem reduzierten Mittel und der endglütigen Richtung gebildet (Sp. 7 minus Sp. 6). Die Summe der Werte d jedes einzelnen Satzes wird durch die Anzahl der Strahlen s dividiert und damit für jede Richtung $v = d - \frac{[d]}{s}$ in Sp. 9 gewonnen. Die Summe der Werte v für jeden Satz muss bis auf Abrundungsunge-nauigkeiten Null sein. Die v-Werte werden quadriert und als vv in Sp. 10 vermerkt.

$$s_r = \sqrt{\frac{[vv]}{(n-1)(s-1)}} = \sqrt{\frac{0,15}{(2-1)(3-1)}} = \sqrt{\frac{0,15}{1 \cdot 2}} = \sqrt{0,075} = 0,27\,\text{mgon}$$

$$s_x = \frac{s_r}{\sqrt{n}} = \frac{0,27}{\sqrt{2}} = 0,19\,\text{mgon}$$

Beim Einsatz eines digitalen Theodolits werden die Messwerte in der Regel auf einem internen Speicher oder auf einer PCMCIA-Karte abgelegt. Wenn der Theodolit mit einer Schnittstelle ausgestattet ist und über keinen internen Speicher verfügt, können die Messwerte zu einem externen elektronischen Feldbuch übertragen werden. Das Speichern der Daten vereinfacht und beschleunigt die örtliche Messung erheblich und schließt Übertragungsfehler aus.

12.4 Vertikalwinkel

Sie werden meistens in zwei Lagen gemessen, um einen restlichen Indexfehler zu eliminieren. Nur bei einfachen Messungen (Tachymetrie) begnügt man sich mit einer Fernrohrlage.

Es sei erwähnt, dass bei Ablesungen an nur einem Zeiger, wie es bei Ingenieur-Theodoliten der Fall ist, eine vorhandene Exzentrizität des Vertikalkreises bei der Beobachtung in zwei Fernrohrlagen nicht eliminiert wird. Um dies zu erreichen, müsste mit Gegenzielungen gearbeitet werden.

Vor jeder Messung in Lage I und II muss die Höhenindexlibelle mit dem Höhenindextrieb zum Einspielen gebracht werden. Wenn diese nicht vorhanden ist, muss man die Fernrohrträgerlibelle mit den Fußschrauben bzw. die Fernrohrlibelle mit dem Höhenfeintrieb scharf einspielen lassen. Bei Instrumenten mit automatischem Höhenindex stellt sich der Index selbsttätig ein. Die Vertikalkreise sind so eingerichtet, dass Zenitwinkel z gemessen werden. Dabei verkleinern sich beim Kippen des Fernrohrs nach oben in Fernrohrlage I die Winkelwerte, in Fernrohrlage II vergrößern sie sich. Jedes Ziel wird bei der Messung in Fernrohrlage I und II hintereinander beobachtet, um eine Veränderung des Spielpunktes der Höhenindexlibelle (z. B. durch Sonneneinstrahlung) zu vermeiden. Man misst zweckmäßig in zwei Sätzen. Die auftretende Indexkorrektion ist ein konstanter Wert; sie muss in jedem Satz ungefähr gleich groß sein. Die Genauigkeit der Vertikalwinkelmessung hängt weitgehend von der Einstellung der Höhenindexlibelle bzw. von dem Kompensator ab.

Beispiel: Vertikalwinkelmessung mit einem Ingenieur-Theodolit

In Tafel 12.7 Sp. 1 wird die Instrumentenhöhe i vom Bodenpunkt bis zur Kippachse und in Sp. 2 die Höhe t des Zielpunktes über Boden vermerkt. Das Ziel wird eingestellt. Wenn eine Höhenindexlibelle vorhanden ist, lässt man sie mit der dafür vorgesehenen Feinstellschraube (Höhenindextrieb) scharf einspielen und liest am Höhenkreis in Fernrohrlage I ab (Sp. 3), schlägt das Fernrohr durch, stellt das Ziel in Lage II ein, lässt die Höhenindexlibelle erneut genau einspielen und liest wieder am Höhenkreis ab (Sp. 4). Der Vorgang wird als 2. Satz wiederholt. Da der Vertikalkreis sich nicht verstellen lässt, werden beide Ablesungen ungefähr gleich sein.

Nach Abschn. 11.8.6 ist der Zenitwinkel

$$z = I + k_z = 400 - (II + k_z)$$

und die Indexkorrektion

$$k_z = \frac{400 - (I + II)}{2}$$

Aus beiden Gleichungen findet man

$$z = \frac{400 + I - II}{2}$$

Die Summen der Ablesungen I und II werden in Sp. 5 vermerkt. Die Summe der Sp. 5 zu 800 gon ergänzt, ergibt bei der Messung in zwei Sätzen die vierfache Indexkorrektion.

Tafel 12.7 Vordruck und Beispiel für Vertikalwinkelmessung (Zenitwinkel)

| Instrument: | | | | | Wetter: bewölkt, gute Sicht | | |
| Datum: | | | | | Gemessen durch: NN | | |

1	2	3	4	5	6	7	8
Stand-punkt	Ziel-punkt	Ablesung Lage I	Ablesung Lage II	$I + II$ $k_z = \dfrac{400 - (I + II)}{2}$	$2z = I - II$	$z = \dfrac{I - II}{2}$	Zenitwinkel z gemittelt
		gon	gon	gon	gon	gon	gon
A $i = 1{,}43$	B $t = 2{,}00$	103,546 103,547 ‾‾‾ 093 085 ‾‾‾ 1015	296,445 296,445	399,991 399,992 ‾‾‾ 983 $4k_z =$ 17 $2k_z =$ 085 $k_z =$ 042	207,101 207,102	103,5505 103,5510	103,5508 ‾‾‾ 5508 ×2 = 1016
C $i = 1{,}50$	D $t = 3{,}80$	96,728 96,729 ‾‾‾ 457 085 ‾‾‾ 4655	303,265 303,261	399,993 399,990 ‾‾‾ 983 $4k_z =$ 17 $2k_z =$ 085 $k_z =$ 042	193,463 193,468	96,7315 96,7340	96,7328 ‾‾‾ 7328 ×2 = 4656

In Sp. 6 wird $400 + I - II$ gebildet. Im Kopf des Vordrucks ist der Wert 400 gon nicht angegeben, da ein Winkel sich nicht ändert, wenn er mit 400 gon oder einem Vielfachen von 400 gon in Verbindung gebracht wird.

Sp. 7 gibt den Zenitwinkel $\dfrac{I - II}{2}$ für jeden gemessenen Satz an, Sp. 8 das Mittel aus beiden gemessenen Sätzen. Den Höhenwinkel findet man aus $\alpha = 100 - z$
Es ist zweckmäßig, die Summenproben satzweise durchzuführen:

$$[Sp. 3] + [k_z] = 2 \cdot Sp. 8$$

Beim Messen von Vertikalwinkeln mit einem digitalen Theodolit wird die Höhenindexkorrektion automatisch berücksichtigt. Bei Anschluss eines Registriergerätes (elektronisches Feldbuch) können die Messdaten gespeichert werden, wodurch das Feldbuch überflüssig wird.

12.5 Praktische Hinweise zur Winkelmessung

1. Gängigkeit der Stativbeine kontrollieren. Lockere Stativbeine beeinträchtigen die Messung. Theodolit nach Abschn. 11.8 prüfen und berichtigen. Wenn auch die meisten Fehler durch bestimmte Messungsanordnungen ausgeschaltet werden können, sollte doch zum bequemeren Messen der Theodolit justiert sein. Jedoch nur dann justieren, wenn es unbedingt erforderlich ist.

2. Bei starken Temperaturunterschieden zwischen Innen- und Außentemperatur soll man nicht sofort mit der Messung beginnen. Man öffnet den Instrumentenkasten

und gönnt dem Instrument eine Pause von soviel Minuten, wie der Temperaturunterschied in Grad beträgt.

3. Vor starker Sonneneinstrahlung, Regen, Schnee und Staub ist der Theodolit zu schützen (Schirm, Haube). Bei starkem Luftflimmern sind möglichst keine Winkelmessungen auszuführen.

4. Ziele genau signalisieren. Fluchtstäbe sind lotrecht und zentrisch auf den Punkt (Stein, Pfahl) zu stellen und durch Stabstative zu stützen.

5. Theodolit scharf zentrieren. Besondere Aufmerksamkeit ist bei Theodoliten mit Schnurlot angezeigt. Die Fehler nach Punkt 4 und 5 können erheblich sein und gehen voll in die Messung ein. Beim Messen mit Zwangszentrierung werden Zentrierfehler ganz ausgeschaltet.

6. Theodolit gut horizontieren. Die Stehachse wird damit senkrecht gestellt. Ein Stehachsenfehler verfälscht die Messung, er ist durch keine Messungsanordnung zu beseitigen. Deshalb soll die Horizontierung im Laufe der Messung überprüft werden.

7. Ziele genau in das Strichkreuz bringen. Fluchtstäbe sind möglichst bodennah anzuzielen.

8. Die Horizontalwinkelmessung erfolgt in zwei Fernrohrlagen. Hierdurch werden der Ziellinienfehler, der Kippachsenfehler und die Alhidadenexzentrizität eliminiert. Nur bei einfachen Messungen (Tachymetrie) wird in einer Fernrohrlage beobachtet.

9. Gegen grobe Ablesefehler schützt eine zweite Messung mit veränderten Werten. Dies erfolgt durch Messen mehrerer voller Sätze oder durch Messen von zwei Halbsätzen.

10. Eine Genauigkeitssteigerung wird durch mehrmalige Wiederholung der Messung erreicht. Bei Richtungsbeobachtungen werden in der Regel $2 \cdots 4$ volle Sätze gemessen. Diese werden über den Horizont gleichmäßig verteilt. Der Teilkreis wird jedoch um 200 gon/n (n gleich Anzahl der Sätze) verschoben.

11. Polygonwinkel werden in zwei Halbsätzen gemessen. Bei Theodoliten mit einer Ablesestelle (vorwiegend Bau- und Ingenieurtheodolite) verschiebt man den Teilkreis zwischen dem ersten und zweiten Halbsatz um $1 \cdots 4$ gon. Durch die Messung in zwei Fernrohrlagen werden der Ziellinienfehler, der Kippachsenfehler und die Alhidadenexzentrizität nicht wirksam. Bei Theodoliten mit zwei Ablesestellen werden zwischen dem ersten und zweiten Halbsatz der Teilkreis um 200 gon/n (n gleich Anzahl der Halbsätze) verstellt.

12. Vertikalwinkel misst man in zwei Fernrohrlagen; hierdurch wird der Indexfehler ausgeschaltet.

13. Der Vordruck für die verschiedenen Messmethoden ist einheitlich. Der Schreiber wiederholt laut die ihm vom Beobachter genannten Werte. An Ort und Stelle werden die Halbsätze reduziert bzw. von mehreren Sätzen die Satzmittel gebildet, um eventuelle Widersprüche sofort aufklären zu können. Der Vordruck, in dem das Datum der Beobachtung, Wetter, Sicht und Instrument zu vermerken sind, wird vom Beobachter unterschrieben.

14. Der Einsatz digitaler Theodolite erleichtert die Messung. Beim Einschalten eines elektronischen Feldbuches werden die Messdaten automatisch erfasst.

15. Wenn das Instrument beim Transport zu einem neuen Standpunkt auf dem Stativ verbleibt, soll es so getragen werden, dass es aufrecht steht.

Schrifttum

Baumann, E.: Vermessungskunde Bd. 1, 5. Aufl. (1999), Bd. 2, 6. Aufl. (1999), Bonn: Dümmler

Deumlich, F.; Steiger, R.: Instrumentenkunde der Vermessungstechnik, 9. Aufl., 2002, Heidelberg: Wichmann

Häßler, J.; Wachsmuth, H.: Formelsammlung für den Vermessungsberuf, 3. Aufl., 1984, Korbach: Bing

Joeckel, R.; Stober, M.: Elektronische Entfernungs- und Richtungsmessung, 4. Aufl., 1999, Stuttgart: Wittwer

Kahmen, H: Vermessungskunde, 19. Aufl., 1997, Berlin, Walter de Gruyter

Resnik, B.; Bill, R.: Vermessungskunde für den Planungs-, Bau- und Umweltbereich, 2000, Heidelberg: Wichmann

Schütze, B.; Engler, A.; Weber, H.: Vermessung-Grundwissen, 2001, Dresden: Eigenverlag

Witte, B.; Schmidt, H.: Vermessungskunde und Grundlagen der Statistik für das Bauwesen, 4. Aufl., 2000, Stuttgart: Wittwer

DIN-Taschenbuch Bd. 111: Vermessungswesen, Normen, 10. Aufl. 1998, Berlin: Beuth

Sachverzeichnis